Louis Rémy Mignot

THE LANDSCAPES OF

Louis Rémy Mignot

A SOUTHERN PAINTER ABROAD

KATHERINE E. MANTHORNE
WITH JOHN W. COFFEY

PUBLISHED FOR
THE NORTH CAROLINA MUSEUM OF ART
BY SMITHSONIAN INSTITUTION PRESS
WASHINGTON AND LONDON

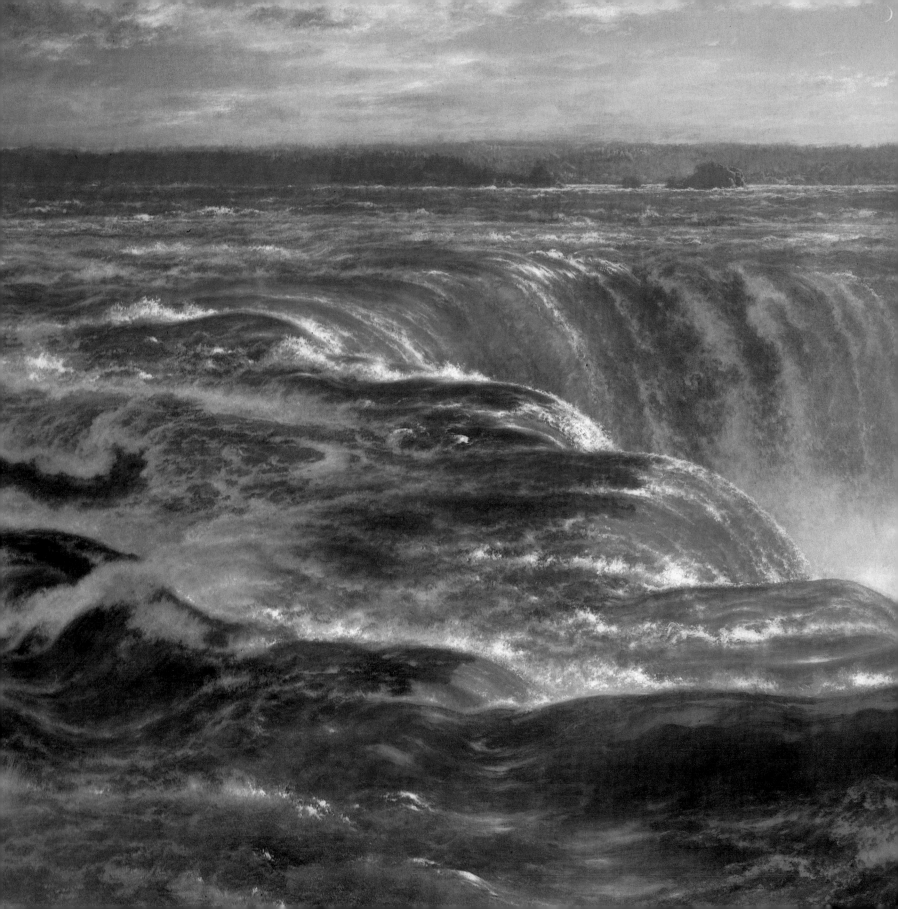

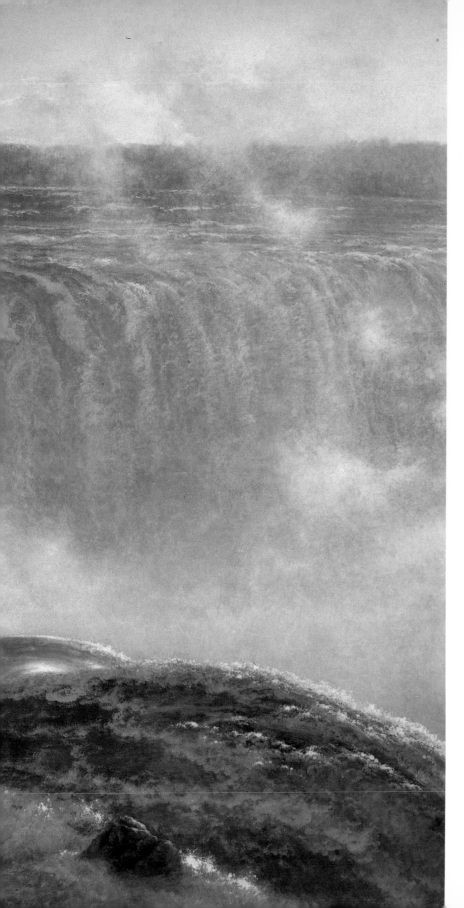

Contents

Copyright © 1996 North Carolina Museum of Art

Published on the occasion of the exhibition *Louis Rémy Mignot:
A Southern Painter Abroad,* organized by the North Carolina
Museum of Art.
Exhibition itinerary:
North Carolina Museum of Art, Raleigh, N.C., 20 October 1996–19 January 1997
National Academy of Design, New York, N.Y., 20 February–11 May 1997
The exhibition and catalogue were made possible by generous grants from The Henry
Luce Foundation, Inc. Additional support was provided by the National Endowment
for the Arts and the North Carolina Museum of Art Foundation.

Acquiring editor: Amy Pastan
Editor: Jack Kirshbaum
Designer: Linda McKnight
Production manager: Ken Sabol
Printed in the United Kingdom by Balding +Mansell.

∞ The paper used in this publication meets the minimum requirements of the
American National Standard for Permanence of Paper for Printed Library Materials
Z39.48-1984..

Jacket illustration: Louis Rémy Mignot, *River Scene, Ecuador (I)* . See cat. no. 33.

Library of Congress Cataloging-in-Publication Data
Manthorne, Katherine
 The landscapes of Louis Rémy Mignot : a southern painter abroad / Katherine E.
Manthorne with John W. Coffey
 p. cm.
 Exhibitions: North Carolina Museum of Art, Raleigh, N.C.,
20 Oct. 1996–19 Jan. 1997 and National Academy of Design,
New York, N.Y. 13 Feb.–11 May 1997.
 Includes bibliographical information references and index.
 ISBN 1-56098-701-4 (cloth). — 1-56098-702-2 (pbk.)
 1. Mignot, L. R. (Louis Rémy), 1831–1870—Exhibitions. 2. Mignot, L. R. (Louis
Rémy), 1831–1870. 3. Landscape painters—United States—Biography. I. Coffey, John
W. (John William), 1954– . II. North Carolina Museum of Art. III. National
Academy of Design (U.S.) IV. Title.
ND237.5465A4 1996
759.13—dc20 96-18739
British Library Cataloging-in-Publication data available
02 01 00 99 98 97 96 5 4 3 2 1

The following catalogue illustrations have been used for display details in the text as
part of front matter and chapter opening pages: 43 *Landscape in Ecuador* (pp. ii–iii),
102 *Niagara* (pp. iv–v), 100 *Moonlight over a Marsh in Ecuador* (pp. xii–1), 28 *Autumn (I)*
(pp. 6–7), 11 *A Pastoral Landscape* (pp. 22–23), 9 *Winter Scene, Holland* (pp. 34–35), 18
The Old Bog Hole (pp. 46–47), 43 *Landscape in Ecuador* (pp. 68–69), 63 *Sunset on
White Mountains* (pp. 102–3), 78 *Morning in the Andes* (pp. 136–37), and 96 *Bal de
Nuit, Paris* (pp. 156–57).

Foreword

Surveying the paintings of Louis Rémy Mignot, it seems unimaginable, certainly unacceptable, that this artist was for so long forgotten. His landscapes, whether lush and verdant tropical scenes or solitary winter sunsets, unite acuity of observation with an abiding affection for the elusive poetry of nature. It is a privilege for the North Carolina Museum of Art to sponsor the rediscovery of this extraordinary artist. It is also fitting, for Mignot was the most accomplished landscape painter born and bred in the American South. Appraisal of his career and art should prompt new questions about the shape and character of the southern imagination.

This book and exhibition have been a collaboration between Katherine E. Manthorne, associate professor and chairperson of art history at the University of Illinois at Urbana-Champaign, and John W. Coffey, curator of American and modern art and chair of the curatorial department at the North Carolina Museum of Art. Both Manthorne and Coffey have brought passionate devotion and considerable scholarship to bear in fleshing-out Mignot's life, locating and cataloguing his scattered oeuvre, and assessing his achievement. This book and the accompanying exhibition should confirm their judgment of Louis Mignot as an ambitious painter of consummate skill, refined perception, and often striking originality, wholly deserving of an honored place in the history of mid-nineteenth-century American art.

We are delighted that the exhibition will be presented in New York at the National Academy of Design. In a sense it is a homecoming: Louis Mignot was an honored member of the academy, a regular participant in its annual exhibitions, and active in its affairs throughout his residency in New York. For their early and enthusiastic endorsement of this project we thank Edward P. Gallagher, director, and Dita Amory, former curator.

A project of this scale would have been unthinkable without the early and generous support of the Henry Luce Foundation. When the museum first approached the foundation in 1992, we were convinced that Louis Mignot was an artist worthy of attention, but we had little evidence to support that conviction. Even so, the foundation was sufficiently intrigued that it offered to fund the research phase of the project, noting that additional support might be forthcoming if we proved that Mignot deserved an exhibition and a book. Happily, we did so and now stand doubly grateful to the Luce Foundation. For supplemental support, we thank the North Carolina Museum of Art Foundation and the National Endowment for the Arts.

Lawrence J. Wheeler
Director
North Carolina Museum of Art

Acknowledgments

Many people contributed to the rediscovery of *Louis Rémy Mignot.*
This book and the accompanying exhibition would not have been real-
ized without the generous and far-sighted support of the Henry Luce
Foundation, Inc., which provided not only funding but also the
encouragement to undertake what at first seemed a quixotic quest. For
additional funding support, we thank the North Carolina Museum of
Art Foundation and the National Endowment for the Arts.

The support of the trustees and staff of the North Carolina
Museum of Art has been essential from beginning to end. We would
like to acknowledge especially those most directly involved with this
project: Lawrence J. Wheeler, director; Richard S. Schneiderman, for-
mer director; Georganne Bingham, director of external afairs; Jean M.
Livaudais, assistant director of development; Elizabeth Holloway, for-
mer communications officer, and Lisa Eveleigh, former publications
officer; Theda Tiffany, NCMA Foundation business manager; Anna
M. Dvořák, librarian, and Patricia Stack, library assistant; Carrie
Hedrick, registrar; William M. Gage, head photographer; David E.
Findley, chief conservator; Eric Gaard, head exhibition designer;
Katharine Douglass, former head graphic designer; Rebecca Martin
Nagy, associate director of education; Deborah Reid-Murphy, coordi-
nator of outreach education; and Paula L. Mehlhop, curatorial admin-
istrative assistant.

We are grateful to the many fortunate owners of works by

Mignot for their invaluable assistance and cooperation. They have patiently suffered repeated inquiries and requests from us. Many have welcomed us into their homes. We trust this book is some compensation.

When it came to addressing Mignot's early life in Charleston we have gratefully deferred to David Moltke-Hansen, director of the Center for the Study of the American South at the University of North Carolina at Chapel Hill, and the preeminent scholar on the cultural history of antebellum Charleston.

At the beginning of this project we benefited from the counsel of an advisory committee composed of Annette Blaugrund, then of the New-York Historical Society; Anthony F. Janson, then of the North Carolina Museum of Art; and Franklin W. Kelly of the National Gallery of Art. Invaluable research assistance has been provided by Jill E. Blondin, Virginia Burden, Marnie Coleman, James C. Cooke, Maureen Cross, Shelley Dekker, Christine Huber, and Gay McDonald.

Merl M. Moore, Jr., deserves a special mention not only for his indefatigable research, but especially for his unstinting generosity in sharing it. In addition, for many favors great and small we are indebted to the following colleagues: Kevin J. Avery, Teresa A. Carbone, Nicolai Cikovsky, Jr., Paul S. D'Ambrosio, David B. Dearinger, James D. Dilts, Linda S. Ferber, Madeleine Fidell-Beaufort, Walker J. Fraser, William H. Gerdts, Susie Grant, C. Patton Hash, Jonathan P. Harding, Mattie Kelley, Elizabeth W. Kiefer, Elizabeth Kornhauser, Judy L. Larson, Rebecca Lawton, Heather Lemonedes, Angela D. Mack, Leo Mazow, Christine Meadows, Anthony Mullin, Charles Nugent, M. M. Op de Coul, Gwendolyn L. Owens, Pauline Pierce, Carrie Rebora, Betsy Rosasco, James Ryan, Martha R. Severens, Nancy Rivard Shaw, John J. Sillevis, Marc Simpson, J. Gray Sweeney, William S. Talbot, Gilbert T. Vincent, Laurie Warner, Andrew Wilton, Ann S. Woolsey, and Karen Zukowski.

In the course of our research we made great use of—and great demands upon—numerous libraries and archives. We happily record our appreciation to the staffs of the following institution. In the United States: Maryland State Archives, Annapolis; Museum and Library of Maryland History, Baltimore; Boston Athenaeum; The Brooklyn Museum; Hawthorne-Longfellow Library, Bowdoin College, Brunswick, Me.; Albright-Knox Art Gallery and the Buffalo and Erie County Historical Society, Buffalo, N.Y.; Davis Library, University of North Carolina at Chapel Hill; South Carolina Historical Society, Charleston; Charleston Public Library; Chicago Historical Society; Western Reserve Historical Society, Cleveland; South Carolina Department of Archives and History, Columbia; Perkins Library, Duke University, Durham, N.C.; Greenwich Library, Greenwich, Conn.; Mount Vernon Archives, Mount Vernon Ladies' Association of the Union, Mount Vernon, Va.; Art and Architecture Library and the Yale Center for British Art, Yale University, New Haven; Historic New Orleans Collection, New Orleans; Frick Art Reference Library, New York; Metropolitan Museum of Art, New York; New-York Historical Society, New York; New York Public Library, New York; Museum of Art of the Pennsylvania Academy of the Fine Arts, Philadelphia; North Carolina State Library, Raleigh; D. H. Hill Library, North Carolina State University, Raleigh; Missouri Historical Society, St. Louis; National Archives, Silver Springs, Md.; Stockbridge Library Association, Stockbridge, Mass.; Rensselaer County Historical Society and the Troy Public Library, Troy, N.Y.; Archives of American Art, Smithsonian Institution, Washington, D.C., Boston, and New York; Corcoran Gallery of Art, Washington, D.C.; National Museum of American Art, Smithsonian Institution, Washington, D.C.; Martin Luther King Public Library, Washington, D.C.; The Octagon Museum, Washington, D.C.; Washington Historical Society, Washington, D.C. In France: Archives du Louvre, Paris; Bibliothèque Nationale, Paris. In the United Kingdom: Brighton Central Library; The Pavilion, Brighton; Bristol Central Library; The Mitchell Library, Glasgow; Liverpool Central Libraries; The Newspaper Library of The British Library, London; Print Room, The British Museum, London; Witt Computer Index, Courtauld Institute of Art, London; The London Library; Archives

and Library, National Portrait Gallery, London; National Art Library, Victoria and Albert Museum, London; The Royal Academy of Arts, London; and the Manchester City Art Gallery. In the Netherlands: Netherlands Institute for Art History, The Hague; Municipal Archives, The Hague; Royal Archives, The Hague.

For help in locating and documenting Mignot pictures, we are grateful to Alexander Acevedo, Robert Adams, Jeffrey Brown, Bruce N. Chambers, Jeffrey W. Cooley, Terry DeLapp, John Driscoll, Stuart P. Feld, Elizabeth Glassie, Howard Godel, Mark Hoffman, Dan Hynes, Vance Jordan, Sandra Kline, Mark LaSalle, Kenneth Lux, Robert Mayo, M. P. Naud, David Nisinson, Alan Pensler, Lauren Rabb, Alexander Raydon, Anne W. Schmoll, Andrew L. Schoelkopf, Mark Selker, George J. Turak, William Vareika, Eric Widing, and Richard York.

Others who have provided generous assistance include Joan Barnes, Masco Corp.; Sister M. Anne Francis Campbell, OLM, archivist, The Diocese of Charleston; Carl B. Cobb; Erin E. Gamse, Dr. Samuel D. Harris National Museum of Dentistry, Baltimore; Alfred C. Harrison, Jr.; Paul M. Hertzmann; the Rev. Msgr. John A. Simonin, St. Mary's Church, Charleston; and Gerrit VanDerwerker.

Through the artist Dan Flavin we learned of a living branch of the Mignot family in the Netherlands. Descendants of Louis's half-brother, Dorine, Adolphe, and Marianne Mignot happily shared with us much new information on the artist's family.

Katherine Manthorne acknowledges with pleasure the following people. At the University of Illinois at Urbana-Champaign, I enjoy an unusually congenial atmosphere provided by my colleagues. In particular, I wish to acknowledge Theodore Zernich, director of the School of Art and Design, who has been a primary champion of all my endeavors; Claire Dolske, who has assisted me in keeping the Art History Program afloat while completing this project; Jonathan Fineberg, for providing warm camaraderie; director Jane Block and Christopher Quinn of the Ricker Art and Architecture Library, who have been zealous in helping me track down materials; and the many graduate students who have worked with me in American art and stimulated my scholarship. Amy Pastan's enthusiastic endorsement of this publication has meant a great deal. Maria Isabel Silva and Alexandra Kennedy-Troya have generously shared insights into Mignot's renderings of their native Ecuador. Louisette W. Zuidema and Tom Zuidema have acted as able advisors and friends. Among colleagues in American art, Elizabeth Broun and William H. Treuttner of the National Museum of American Art have been unfailing in their encouragement of my work. Elizabeth Garrity-Ellis, Lois Fink, Vivien Green-Fryd, Toni Junkin, and Janice Simon have lent needed assurance and insight at various points. From Barbara Novak, I first learned of the name Mignot, and much more than I can express. John Coffey has been there through every step of this project, providing support in uncountable ways. My mother, father, Patricia, Mark, and Jay Manthorne, and Donald Clark have, as always, been an integral part of my life.

As co-curator of the exhibition and contributor to this volume, John Coffey acknowledges the following individuals. My greatest and most lasting debt is to my family: my wife, Ann Roth, and our sons, Evan and Larkin. For nearly four years they have lived patiently with a mysterious painter, thin and dapper with a courtly southern accent. They have rarely complained. From them I have borrowed many—far too many—evenings and weekends. I thank them for the loan, pledging to repay each hour with interest—and love. To end, I wish through this work to remember the smile of Helen Semerdjian Dubé (1954–95).

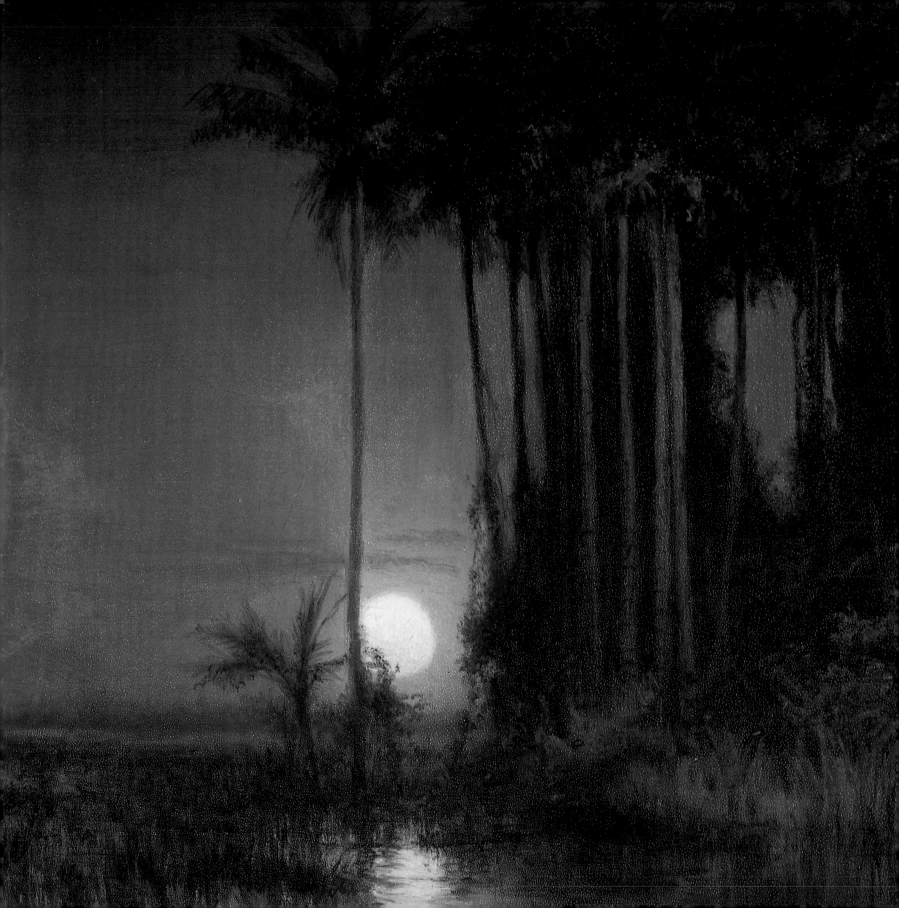

Mignot's Place in American Art

Louis Rémy Mignot was a painter of extraordinary dimension who through the vicissitudes of history had been essentially lost to us. The sheer quality of his work alone—documented by critics in his own day and confirmed by current reappraisal—demands the excavation of his oeuvre and the reestablishment of his reputation. The significance of this endeavor, however, extends beyond the art historical. Equally important are the intersecting questions of regional, sectional, and national identity that have reemerged with new force in recent years and that involve the psychological and political interpretations of art. To comprehend how a monographic study of Mignot's work might illuminate such timely issues, a brief overview of his career is needed.

Mignot was born in 1831 in Charleston, South Carolina, the son of a confectioner of French Catholic birth. At age seventeen he departed for the Netherlands; there he studied with the leading landscapist Andreas Schelfhout, whose studio attracted an international following. Five years later he returned to the United States and settled not in his home state but in New York City, where he was soon recognized in the competitive climate of the Hudson River School for his distinctive talent. In 1857 he traveled with the celebrated American landscapist Frederic Church to Ecuador, where he found the tropical subject that would cement his reputation. When the Civil War broke out, Mignot, strongly identifying with the southern cause, found it impossible to remain in the North and took up voluntary exile in London. There he

1

resumed his career and created a new body of work in yet another artistic culture and climate. He died in Britain in 1870 at the age of thirty-nine, leaving his wife and only son the keepers of his reputation. In 1876 she organized a retrospective of his work, which was shown in London and Brighton.[1] Writing three years later, critic Samuel G. W. Benjamin judged Louis Mignot "one of the finest artists of our country." His "was also a mind fired by a wide range of sympathies, and whether it was the superb splendor of the tropical scenery of the Rio Bamba, in South America, the sublime maddening rush of iris-circled water at Niagara, or the fairy-like grace, the exquisite and ethereal loveliness, of new-fallen snow, he was equally happy in rendering the varied aspects of nature."[2] From that time until now there has been no comprehensive treatment of his singular contribution to American art.

Related to the establishment of Mignot's place in nineteenth-century art is the necessity to situate him with respect to his own geographical place. First, there is the region of his birth. James Whistler once quipped "I did not choose to be born in Lowell," a rejoinder that might serve as an epigraph for much of the criticism and history written about art in the United States. There has been such a premium placed on defining the *American* qualities of American art that until recently unity has been emphasized over diversity, and immense regional differences have been ignored or downplayed. The circumstances of Mignot's life and art offer a fascinating case by which to challenge these accepted norms and to establish that even within the inner circle of the Hudson River School—that supposed bastion of white Anglo-Saxon Protestant males that defined the eastern art establishment—a newcomer of French Catholic descent and Confederate sympathies could earn a firm place. This monograph therefore begins to theorize regionalism as it applies to nineteenth-century landscape art.

This concept of place is significant in that Mignot's career is punctuated by several radical displacements. It therefore provides one of the book's organizing principles, and underlies its methodological approach. In each of these major locales—Charleston, The Hague, New York, and London—Mignot was prompted to redefine himself in an effort to fit in and win the approval of the ever-elusive public. He appears at times chameleon-like in his ability to alter not only subject (something that we would expect as a matter of course) but also style. Paradoxically, the regional affiliation that motivated his migratory life and artistic transformations remained the one constant feature of his identity. These competing forces gave rise to the tensions and complexities that underpin his best canvases.

How has it been possible to tell the history of American art in the formative period 1855–62 without mention of him? Literature on Church and Eastman Johnson—two artists closely associated with him—barely hint at his existence. He lived eight years in Victorian England, yet accounts of Anglo-American interactions in this period rarely refer to him. In other words, we seem to have gotten along fine without him. Is there a danger here of overestimating his importance, his presence? I admit to a certain prejudice on his behalf, but nonetheless a reciprocal question needs to be asked: What do we gain by his "rediscovery" and reinsertion into his successive artistic spheres? Acknowledging his achievement forces us to question some of the assumptions we have held, including the view of the mid-nineteenth-century American landscapists as a band of like-minded men who sprang from similar backgrounds. This notion of homogeneity is self-perpetuating, compelling us to push to the fringes those who do not fit the mold by simply leaving them out of the narrative. (The extraordinary achievements of George Inness and Samuel Colman are victims of this tendency; they might be individually recognized, but rarely are they integrated into synthetic analyses.) This perspective is changing and we are discovering that the New York art world in the years straddling the Civil War was far richer and more complex than we had given it credit for being. In asserting the presence of a southern-born French Catholic who could succeed alongside German immigrants and Connecticut-born Yankees, we add immeasurably to our comprehension of American art.

These efforts at biography and interpretation must of necessity be tentative. We still know more about the end of Mignot's too-short life than we do about its beginning. Art criticism, biographies, and obituaries—although sometimes contradictory—allow us to chronicle the outlines of his career: his studies at The Hague, activities in New York City, and eight years residence in London emerge in far greater detail than do his formative years, when "family tradition" must often substitute for documentation (for example, no record has yet been found of his birth). Similarly, a considerable portion of his oeuvre has been recovered, but its distribution tends to be uneven, with the majority representing either South America or the eastern United States. British, Swiss, and French subjects have proven far more difficult to locate, a fact that is especially lamentable since in his assessment Benjamin insisted on the power of those works: "It is greatly to be regretted that the most important works of this artist are owned in England, whither he resorted at the opening of the civil war. *Snow in Hyde Park,* which he painted not long before his death, is one of the noblest results of American landscape painting."[3]

I first began "tracking" Louis Mignot when I came across one of his views of the tropics, so distinctive from the majority of images by artists from the United States who traveled in Latin America. Once I had a sample of that phase of his work, I was determined to learn more of this enigmatic figure, whose place in art history up to that point had been as Frederic Church's "sidekick" on the expedition to Ecuador. Early on, John Coffey and I discovered we were both on the same quest, kindred spirits in our belief that Mignot was indeed worth resurrecting. The generous assistance of the Henry Luce Foundation enabled us to push the investigation forward with new intensity, and since then we have recovered more than six times the number of paintings we had when we commenced. It must be admitted, however, there are probably twice as many more out there somewhere, living a secret life, whose true identity may be unknown even to their owners or perhaps are cherished in private. Then, too, few personal documents from Mignot's hand have ever emerged. As far as possible, I have allowed Mignot's art to guide me in the telling of his story, according to the following organization.

Throughout his peripatetic career, Mignot occupied the status of an outsider. He was the son of his father's first marriage, whose offsprings were apparently not embraced by his second wife; a Catholic in a predominantly Protestant country; a southerner in the North; an American in Queen Victoria's England; and a romantic-idealist in an increasingly commercialized society. He was, in other words, a man always a little out of step with his time and place. Chapter 1 therefore introduces Mignot and attempts to locate the distinctive and even unique aspects that defined him as an artist. One necessary step is to consider his relationship with Church, which loomed so large in his life and over his subsequent reputation. Adopting Church as a role model, we discover, was just one of the many masks Mignot took up over the course of his career. As a Confederate in the chaotic years bracketing the Civil War, Mignot had a need for a second skin. Utilizing the construct of the masquerade, I argue that in his work we can detect a breakdown of a monolithic self. This is, in my view, how Mignot's regional or sectional affinities came into play. He is not a "southern artist" in the way that term is usually defined; he did not spend the active years of his career in the South, nor did he paint local subjects. Being a southerner at that critical moment in American art and history, however, necessitated a reversal or at least a subversion of the protocols of art, detectable in a variety of guises throughout his career.

Growing up in Charleston's tightly knit enclave of French Catholics, Mignot inherited a view of art and nature quite distinct from his contemporaries in New York and New England. Their early efforts at forging a national landscape art, and indeed the sort of Christianized pantheism upon which it was predicated, would have been largely foreign to his community. In chapter 2, David Moltke-Hansen provides a portrait of Mignot's Charleston, situating him within the city's artistic life, and the experiences of his generation.

Arriving in the Netherlands from Charleston by January 1849, the seventeen-year-old art student embarked on a course of study that would occupy him there for the better part of five years. The Hague was an international center for artistic study, and landscapist Andreas Schelfhout was one of the most popular teachers there. Mignot sought out his instruction, and still listed himself many years later—when a mature artist exhibiting at the Salon—as the pupil of Schelfhout. Chapter 3 is a consideration of these years, an attempt to elucidate the experience of an American artist studying within a northern European tradition, subject to the tensions between past and contemporary art and between art and nature.

Chapter 4 provides analysis of the artist's initial experiences upon arriving in New York, where he was quickly assimilated into the native landscape school. Yet this must have been a difficult time for a European-trained Carolinian to negotiate the waters of its art establishment. Not only did these years see the American artistic agenda cast in specifically northeastern terms, but Mignot's arrival also coincided with the passage of the Kansas-Nebraska Act of 1854, which made slavery the most urgent issue of the time and signaled the turmoil that would mount throughout the decade. The artistic decisions Mignot made are therefore telling as he charted his way in this new social and political environment.

The year 1857 marks a break, when from May to September he and Church were away on an expedition to Ecuador. Chapter 5 surveys that South American interlude and its aftermath, the tropical canvases he continued to paint until 1870.[4] These pictures are in many ways the most deeply felt works of his career. In his early Dutch views, and even in those painted in upstate New York and along the Hudson, one senses an emotional detachment, a lack of engagement that comes into full play in his South American subjects. They are rich in the signs of the Catholic faith, which are embedded convincingly into his landscape vision, as exemplified in his evolving series of *Ave Maria* paintings. Here he depicted the local rivers as paths of civilization and commerce,

featuring the dwellings of local peoples and evidences of expanding trade in tropical goods. These pictures are analyzed within both the American and the British contexts, in which Mignot continued to essay his South American subjects for the second half of his career. This dual audience contributed to the distinctive nature of his tropical vision.

Chapter 6 then resumes the narrative with his return to New York, where conflict between North and South was escalating. With the outbreak of war, artistic as well as political relations broke down; even those who had once called Mignot friend came to regard him as a secessionist and even as a traitor. It becomes particularly critical then to survey the ways in which his landscape conceptions mediated among regional, sectional, and national affiliations. After a year of warfare, it was no longer possible for the artist or his public to maintain a balance between those conflicting forces; in June 1862 he left the country.

Arriving in London at age thirty-one, Mignot's mature career evolved in Britain. Chapter 7 opens with his debut at the Royal Academy, which prompted immediate praise from the *Athenaeum*'s critic: "We have not often seen a landscape so brilliantly or artistically painted as Mr. Mignot's *Lagoon of the Guayaquil.*" And indeed his work, including the large-scale *Niagara*, continued to garner such encomiums. Enriched by his associations with the Rossetti circle and with Tom Taylor, playwright and editor of *Punch,* Mignot's art and life in England are here sketched out for the first time.

Perhaps feeling the restraints of Victorian artistic society, Mignot sought the continental adventures that are recounted in chapter 8. He made excursions to Switzerland in 1868 and 1869, which led to another substantial body of work. Between 1867 and his death in 1870, he increasingly spent time in Paris, where there are tantalizing mentions of breakfast with Whistler and transactions with well-known dealers George Lucas and Samuel Avery. Until now an art historical blank, this overview of Mignot's last years offers a diverse perspective on the American expatriate experience.

The vocabulary of uncertainty—probably, perhaps, apparently,

and their synonyms—appears with greater frequency throughout these pages than I would have preferred. I am convinced nonetheless that the interpretation of his life and career presented here moves us closer to resolving at least some of those uncertainties. What *is* certain is that Mignot's was a significant artistic life, one whose time is long overdue to be revealed.

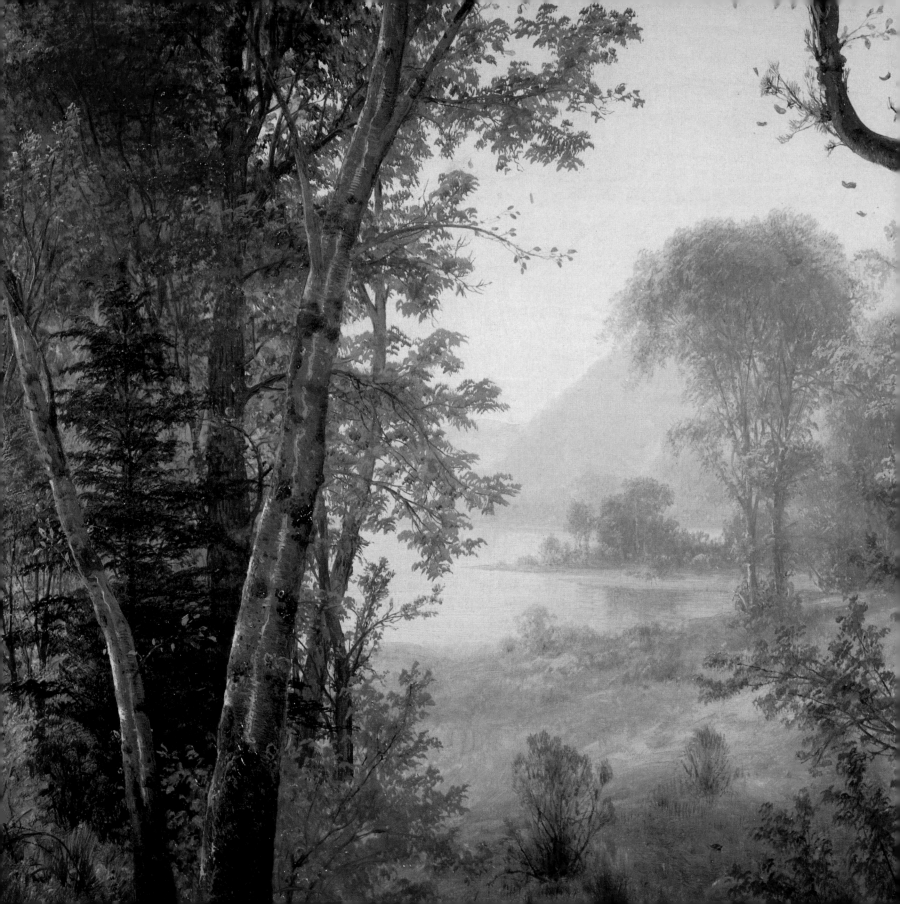

Louis Mignot and the Redefinition of Self

Life is a pic-nic en costume; *one must take a part, assume a*
character, stand ready in a sensible way to play the fool. To come
in plain clothes, with a long face, as a wiseacre, only makes one a
discomfort to himself, and a blot upon the scene.

—Herman Melville, *The Confidence Man: His Masquerade* (1857)[1]

The masquerade provides an apt construct for a discussion of Mignot's
biography and art, for his peripatetic life foregrounds the process defin-
ing and redefining his multiple artistic persona. There is, on the face of
it, nothing startling about this claim. Indeed, many writers have insist-
ed that the masquerade is an appropriate analogy for life, arguing that
the process of becoming an American in part involves the making of a
new self: divesting oneself of a former identity, breaking radically with
the past. The construction of identity becomes a significant theme in
American writing, recognizable as a tradition: it is present in the essays
of Ralph Waldo Emerson, in Hester's rebellion and repentance in *The
Scarlet Letter,* in Henry David Thoreau's move to Walden, and on into
F. Scott Fitzgerald's *Great Gatsby,* Ernest Hemingway's Nick Adams sto-
ries, and Ralph Ellison's *Invisible Man.* As Harold Beaver put it, "America

. . . seemed a stage set for masquerade, since Americans by their origins placed a peculiar insistence on rites of transition and metamorphosis."[2] Recent art historical scholarship has revealed the role that conscious self-invention played in the careers of George Caleb Bingham, Albert Bierstadt, and James McNeill Whistler.[3] Mignot, however, probably shares less with Bierstadt or Thoreau than he does with the fictional Huck Finn, whose various masquerades were a matter of sheer survival. He proffers a similarly extreme example of this phenomenon, undergoing multiple rebirths: he arrived in Holland an inexperienced teenager and departed a European-trained painter of some sophistication, who then tried to recast himself as authentically American; he was a southerner who gained entrée into the northeastern art establishment in the years just proceeding the Civil War; and as a Confederate-in-exile in Victorian London he won acclaim for his distinctive landscapes when many of his compatriots were dismissed as provincials. In addition, evidence suggests that had he lived he would have transplanted himself once more, for a life in Paris. In the course of his short life he underwent several self-transformations to suit diverse (and adverse) artistic and sociopolitical climates. But in the end one cannot help but think that—like Melville's confidence man—"it was plain that he was, in the extremest sense of the word, a stranger."[4]

The masquerade aids our comprehension of Mignot the artist and the man. It also helps us to understand why a painter of such talent remained nearly obscure for more than 125 years: his modus operandi confounded the usual channels of remembrance. The very fluidity and technical facility that allowed him to reinvent himself personally and artistically meant that no single voice, character, or theme could be ascribed to him. Audiences could formulate no permanent idea of who he was, they had no easy pigeonhole into which he fit. Public memory is strange phenomenon, which seems to rely on the one-idea career, on fixed identification. Mignot afforded no such easy access; in his efforts at self-preservation, he nearly achieved self-destruction.

Mignot's career involved a complex aggregate of components that must be distilled and analyzed individually. Primary is his southern birthright and regional affiliations, which grounded him in place. This identity is inextricably linked to the state of cultural politics in the Northeast during his years of residency, 1855–62, which in effect recast his regional affiliations into sectional ones. He felt compelled to leave the United States, thus undergoing another displacement. Paradoxically then his grounding in place, and the one constant feature of his identity, propelled him on this life of wandering. It is important to consider how these conditions contributed to the construction of his persona as a painter and to his artistic praxis.

ARTISTIC PERSONA

Grounding in Place: The South

Place is an all-encompassing condition of life; it informs our identity. "To be rooted is perhaps the most important and least recognized need of the human soul," as Simone Weil expressed it.[5] The terrain of late childhood is especially potent, nurturing the developing intellect and dwelling in adult memory as a guiding image of coherence. Psychologists have shown that if a child is exposed to a particular environment at a susceptible moment, he or she will continue to perceive reality in the shapes of that environment. Indeed, some argue that memory itself exists only as it is anchored to remembered places. Early memories of land are lodged in our minds, deeply influencing the course of our lives, as Annie Dillard so poignantly observed. "When everything else has gone from my brain—the President's name, the state capitals, neighborhoods where I lived, and then my own name and what it was on earth I sought, and then at length the faces of my friends, and finally the faces of my family—when all has dissolved, what will be left, I believe, is topology: the dreaming memory of the land as it lay this way and that."[6]

Mignot was born in 1831 in Charleston, more than a generation after romantic painter Washington Allston's birth in the same locale. One cannot help but wonder if that signal fact made its imprint on both, if Mignot did not experience what Allston described as the development at an early age for "a stronger love for the wild and marvellous. I delighted in being terrified by the tales of witches and hags, which the negroes used to tell me; and I well remember with how much pleasure I recalled these feelings on my return to Carolina."[7] There seems always to be something exceptional and mysterious about Mignot's pictures, effects handled with a chromatic facility and delicacy of touch that distinguishes him from his northern contemporaries and that allies him with traditions in the South, particularly in Charleston.

Unlike Allston, Mignot was raised in the city's small, circumscribed community of French Catholics. The nature of that experience in the 1830s and 1840s grounded him in a culture and mode of seeing quite distinct from those that spawned his subsequent rival Church, who traced his lineage to the earliest settlers of New England and was tutored by Thomas Cole, father of the national school of landscape art. Even long after leaving the South, Mignot strengthened his regional ties when in 1860 he married Zaidee Harris, a young woman from an established Baltimore family. How did these experiences inform his vision of nature? How did he formulate his desire to become an artist? What kind of training did the youth receive before departing for the Netherlands? What sort of opportunities for patronage existed at that moment in South Carolina? How did he come by his fascination with landscape? Here parallels to the literary and intellectual figures of the day help to establish the cultural and intellectual context from which the would-be painter emerged. Writer William Gilmore Simms, brought up at about the same time in Charleston, complained, "Here . . . I am nothing and can be and do nothing. The South don't care a d—n for literature or art. Your best neighbour and kindred never think to buy books. . . . You will write for & defend their institutions in vain. They will not pay the expense of printing your essays." Unlike Simms,

Mignot departed the South, but he carried it always with him across three continents.

Mignot was arguably the most accomplished southern-born painter of his generation. Yet scholars in that field debate the degree to which he should be classified as a southern artist, and the method by which to define the regional and southern qualities of his art. His birthright is countered by his leaving home as a young man, apparently never to return.[8] There are no paintings of southern locations that can securely be attributed to him; even his *Southern Idyll* (cat. no. 80) bears no obvious ties to the region. He spent five years in Europe and then relocated to New York. On the surface these are decisive acts that seem to suggest a desire to leave his relatively provincial background behind and acquire a more worldly, cosmopolitan air. These observations reinforce the parallel between Mignot and Allston, though Mignot's life and art are further complicated by the unfolding of his career in the years bracketing the Civil War. It was a difficult time for a young Carolinian to make his way in the North, and, ultimately, the outbreak of war prompted his second and final departure from the United States.

These biographical circumstances raise the question of the degree to which Mignot was identified with the contemporary political debate over regional or sectional versus national affiliations. In the absence of the artist's own testimony, we must look to his colleagues for clues to their attitudes toward him. In the mid-to-late 1850s in New York City, Mignot enjoyed the friendship of middle- and upper-middle-class intellectuals, a circle that included George Templeton Strong (fig. 1). A New York lawyer, Strong was known as a snob so absolute in his opinions that he broke off relations with his own son because he disproved of his ambition to become a practicing musician instead of pursuing some more respectable profession.[9] His diaries in these years are filled with passages that express his antislavery and pro-Union views; sometimes on the same page that he mentions an evening spent in Mignot's company he pens some reference to the intensifying political turmoil.

FIGURE I. Unidentified photographer, *Portrait of George Templeton Strong*. c. 1857. Collection of The New-York Historical Society.

In November 1859, for example, he made the following entry. "The South is frightened into frenzy, utterly without reason, but that makes no difference. Fanatics and sedition-mongers at the North are doing all they can to exasperate and irritate—and Virginia is giving them a batch of martyrs to stimulate their sentimentalism and flavor their

vaporings on platform and pulpit. This next Congress and the Charleston Democratic Convention and the next presidential election are full of peril. God grant that the Union may survive them!" And almost thereafter he mentions going to hear *The Magic Flute*, where Mignot was one of his party.[10] Surely his fervent Unionist sentiment would not have allowed him to hobnob with an openly secessionist artist. Evidence suggests that it was only gradually, as the war proceeded, that Mignot's sectional affiliation asserted itself; art took precedence over politics as long as it was feasible. Even as late as 29 May 1861, six weeks after the attack on Fort Sumter, Mignot joined other New York artists in donating paintings to an exhibition and sale on behalf of the Artists' Patriotic Fund "for the support of the families of those who have gone to fight the battles of the Country."[11]

The timing of his decisions to leave the United States and to hold an auction sale of his work is one measure of the acuteness of his position. Records at the Century Association indicate that in January 1862 he was elected to its Admissions Committee. This was a substantive commitment, for which he would not have allowed his nomination to be put forward had he known that he was leaving the country. His plans must have taken shape gradually and gelled only at the last minute. By September 1862 artist Jasper Cropsey, living in London, recorded in his journal a visit from the recently arrived Mignots, leaving no doubt of their stand: "I am so grieved about the Civil War in my dear country. A few days ago Mr. & Mrs. Mignot came out both of whom are 'secessionist' and desire to see their country destroyed. I cannot understand it, it seems to me to be a wicked infatuation. Mr. Mignot is a brother artist, Mrs. is a Baltimore woman. I am happy however to know that only a few of my profession have turned rebels while some are behaving so nobly as to enter the service for the Union."[12] More than one commentator portrayed Mignot as being passionate about the Confederate cause. "A South Carolinian by birth, Mr. Mignot ardently espoused the cause of the south during the rebellion, and was unwilling to remain in New York during the war,

although he was well established there, and a growing favorite. As he could not return to his home, he scornfully shook the dust of the north from his feet, and went to London."[13]

We will probably never know exactly how Mignot's political position was perceived, or when it became an issue serious enough to jeopardize long-standing relations. It is my contention, however, that before and after the war years his persona was defined in regionalist terms. Based on attachment to a particular place and an identifiable landscape, regionalism is simultaneously compatible with nationalism, construed as a partnership of equals enjoying the benefits of the whole. Men such as Strong, Church, Rutherfurd Stuyvesant, and Eastman Johnson probably enjoyed the diverse perspective Mignot brought to their circle, and may have even congratulated themselves on embracing someone outside their immediate homogeneous society. As war raged, however, his Carolina heritage could no longer be viewed as charming for its regionalist difference, and therefore came to be redefined as sectionalism, which denies any possibility of shared culture, setting loyalty to a particular place above allegiance to the Union.[14] In the postwar years the situation would be different. It became aesthetically and politically expedient to stress the concept of the United States as an amalgam of all its individual regions, in which the South and West were to have representation equal to that previously accorded to the Northeast. In this climate it was desirable to emphasize the geographical diversity of the American art world. Throughout the remainder of his career and long after his death, then, Mignot continued to be linked with the South. Writing in 1867, critic Henry T. Tuckerman believed that Mignot's unique aesthetic was a direct product of his heritage: "Quite diverse from the exactitude and vivid forest tints of many of our Eastern painters, are the southern effects so remarkably rendered by Louis R. Mignot, whose nativity, temperament, and taste combine to make him the efficient delineator of tropical atmosphere and vegetation."[15] In 1879 S. G. W. Benjamin wrote his epitaph: "Louis Mignot, of South Carolina, . . . appears to us to have been one of the most remarkable

artists of our country." The same author did not feel obliged to mention Church's Connecticut background, or Johnson's in Maine; but from the vantage point of the last quarter of the nineteenth century, Mignot's roots served as proof of America's claim of a truly national art that—like the country itself—united North and South.[16]

Displacement

Existing in contrapuntal relationship with the artist's grounding in place is the problem of displacement. Cultural geographers have only begun to conduct systematic studies of the displaced individual, or migrant; most migration study is group-oriented and is derived from data that allow only glimpses at fragments of the individual experience. But those who have begun to probe "inner geography" are developing a framework of analysis that proves useful in theorizing Mignot's life. As they explain, we speak of some experiences as "moving" and others as "unsettling," terms connoting a dislodgment from daily routine, a marked shift in one's basic assumptions. Any considerable migratory experience is at once "moving" and "unsettling." The migrant exchanges one home for another, and, in terms of inner geography, there are few cultural transactions that are quite so basic. The drama of migration centers upon the departure from the old home and the arrival at the new. In its very commonplaceness, the old home supplied orientation; it was where one "belonged." As oral histories reveal, leaving home behind for good is a disorienting experience that is likely to be remembered for a long time, and in disproportionate detail. Arrival at the destination reverses the process. Lacking orientation, the migrant in the new place is "neither here nor there." Over time, he or she faces the dilemma of how to reconcile incommensurates: the culture of the old place and that of the new. For most, the dilemma remains unresolved. Their lives take on a "hyphenated" quality between the two worlds, and for some living with this dilemma involves a lifelong unease, a not quite coming to rest.[17] A three-time migrant, Mignot

moved great distances to strange places. He must in some degree have been excited and "moved" by the adventure of putting the familiar behind him. These were not, however, episodes from which he could return; he was perpetually "unsettled," a condition permanently imprinted onto his character.

The Man Himself

A half-length portrait by Mignot's friend Eastman Johnson (fig. 2), painted between 1851 and 1854 during their student days together in

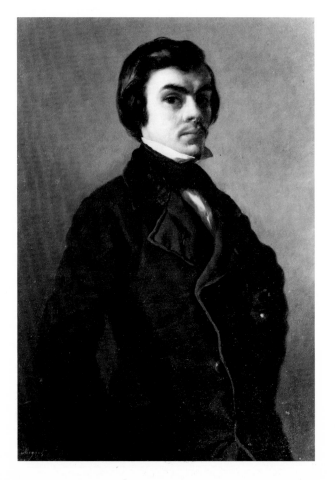

FIGURE 2. Eastman Johnson, *Portrait of Louis R. Mignot,* oil on canvas, 20¾ × 14¼"; c. 1851–54. Baron M. L. van Reigersberg Versluys.

Holland, confronts us with a serious young man dressed in a dark suit jacket with a soft collar and matching cravat. His stand is not fully frontal but at an angle, so that his right arm and shoulder occupy the left foreground and his left arm, held akimbo, recedes into the neutral background. To look out of the picture plane he must turn his head, with the result that he is seen emerging from the shadow. Light falls on the right side of his face, revealing his broad nose, darkly lidded eyes, and full lips. This stance connotes a guarded, wary public persona; but at the same time there is an appeal for connectedness in the direct gesture of his gaze, a desire for comprehension of himself and his art. No easel, no brush, no palette are visible; in fact, we see none of the customary trappings of the painter. Mignot stands before us a well-dressed gentleman, proud in bearing and a trifle wistful in expression. In this he bears analogy with his great artistic predecessor Allston, with whom he shared birthright and European training. These two factors distinguished them from most of their contemporaries and contributed to their evocative, romantic sensibilities.[18]

Contrary to his American contemporaries Church, Bierstadt, Cropsey, Asher B. Durand, James Suydam, and Thomas Rossiter, Mignot never seems to have acquired a permanent residence. He worked in rented studios, the addresses of which changed from year to year. Like Thomas Hotchkiss, recently brought to light by Barbara Novak, he fits the romanticized pattern of the immensely gifted artist who dies young, poor, and far from home. But unlike Hotchkiss, who transplanted himself to Italy and remained there, Mignot lived a more dislocated life, spanning three continents, and calling at various times

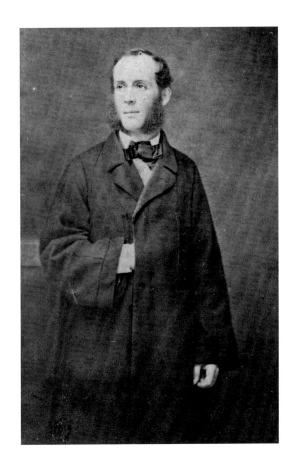

FIGURE 3. Matthew Brady Studio, *Portrait of Frederic E. Church,* n.d., carte-de-visite photograph. Courtesy of Paul Hertzmann & Susan Herzig, Paul M. Hertzmann, Inc., San Francisco.

five different cities in four separate countries home. In his migratory lifestyle he shares something with Martin Heade, yet even Heade in his later years made his permanent residence in Florida, where he seems to have found some measure of contentment. By contrast Mignot was continually on the move. These moves, furthermore, took him from one troubled and often violent situation to another. Economic hardship had plagued the Charleston he had left behind. Shortly after he arrived in New York, and just as his career was taking off, a severe economic crash occurred in 1857, followed by a drawn-out recession; as the financial situation improved the political one worsened, culminating in the Civil War. Social unrest also characterized contemporary Britain to which he had fled, where there was a cotton famine caused by war in the United States; 500,000 people in the textile districts alone received poor relief or private charity.[19] And he had the tragic misfortune of being caught up in the siege of Paris during the Franco-Prussian War. His pictures appear on the surface to offer repose, serenity, an antidote to the surrounding discord; yet as we shall discover, there is a subversiveness, an anxiety that underlies them.

From various sources we can begin to assemble a picture of his personal demeanor. Tom Taylor, who knew the Mignots in Britain, suggests that he was independent minded, even as a young man, for he fixed upon art as his profession "against the wish of his father." He seems to have been a dedicated family man, a much loved husband and father to his only son. And he must have been an extremely intense individual, who "threw himself with all the ardour of an intense and

enthusiastic character into the practise of landscape."[20] Beyond these insights, we have primarily the evidence of his pictures upon which to judge.

"Neck and Neck": The Mignot-Church Relationship

What then of Mignot's relationship with Frederic Church (fig. 3), whose shadow looms large not only over Mignot's entire career, but also over his subsequent reputation? How are we to reconstruct this artistic relation between the Connecticut Yankee and the Southern Cavalier?[21] At the time of their meeting Mignot was the new kid on

the block, and five year's Church's junior; Church already had one South American expedition behind him, and was the rising star of the New York art world. But theirs was hardly the inequitable relationship these facts might suggest; from the moment of his arrival in New York City Mignot was recognized as an original and promising talent in his own right, one with extensive European training and experience under his belt. Church was something of a snob and associated almost exclusively with those he regarded as socially correct. He seems, on other occasions, to have enjoyed good relations with southerners—such as those he met on a trip to Virginia—and probably would have held Mignot in similar regard. Influence undoubtedly passed both ways between them, and the inevitable friendly competition was fueled by the press.

In one of the most famous and romanticized self-reinventions in the history of American literature, F. Scott Fitzgerald pinpoints the moment when James Gatz of North Dakota metamorphosed into Jay Gatsby:

> James Gatz—that was really, or at least legally, his name. He had changed it at the age of seventeen and at the specific moment that witnessed the beginning of his career—when he saw Dan Cody's yacht drop anchor over the most insidious flat on Lake Superior. It was James Gatz who had been loafing along the beach that afternoon in a torn green jersey and a pair of canvas pants, but it was already Jay Gatsby who borrowed a rowboat, pulled out to the *Twolomee*, and informed Cody that a wind might catch him and break him up in half an hour.[22]

We can imagine that Mignot must have had a similar moment of revelation. He had settled in New York by 1855, a singularly auspicious moment for a nascent landscapist to find himself standing for the first time on the banks of the Hudson. That year the *Crayon*, mouthpiece of the Hudson River School, began publication, with Durand's "Letters on Landscape Painting" featured prominently in the first volumes.

Thus Durand surely would have appeared as a highly successful and respected painter, whose example any newcomer would do well to emulate. At the time, however, Durand was pushing sixty, and therefore not the most accessible of role models for a young man. That same year Church completed and exhibited *The Andes of Ecuador* (1855; Reynolda House), the masterpiece of his first trip to South America; we can only assume that Mignot was among those who admired its flood of celestial fire, and felt the full force of its "magic power." It was at that moment, I believe, that Mignot recognized in Church the artist he wished to become. And from that moment he strove to shed both his southern demeanor and his more recently acquired Old World skin by emulating this rising painter of the New World. But of course that process involved as much invention as emulation. "The truth was," as Fitzgerald's narrator continued, "that Jay Gatsby of West Egg, Long Island, sprang from his Platonic conception of himself."[23]

Coming into contact with Church, then, probably served as a kind of catalyst. It is unclear when and under what circumstances they met, but the metropolitan art world of the 1850s was a relatively small, close-knit circle with ample opportunities for meeting and pursuing mutual interests in ways that went completely unrecorded. Perhaps Church received a visit from Mignot, a picture under his arm by way of introduction. Or mutual friends would very likely have introduced them. However it happened, their acquaintance was sufficiently advanced that in May 1857 they departed together for five months in Ecuador, an expedition that would have required months of preparatory discussion and planning together. In any case, from the moment Mignot arrived on the scene his name was coupled with that of Church. An early instance occurred in February 1856, when a critic on a visit to the Art-Union Building noted that "a young artist, Mignot, succeeds in happily combining Church's style with his own."[24] This remark may be an "innocent" suggestion of one artist's style just happening to resemble another's, but more likely it reflected an awareness of their already-budding artistic relationship.

Mignot subjected himself to a kind of mental apprenticeship under Church. This involved not training per se; in that, Mignot might have been said to exceed Church, for five years in Europe had provided him with a firm grounding in the techniques of art. But Mignot's background and training had left him twice branded: as a southerner and as a practitioner of the Dutch–northern European style. Mignot saw in Church a truly *American* painter; thus he must have willingly assumed the subservient position for the advantages it promised him: insights into the in-crowd, the New England mind, the establishment. Like all prodigious talents, he recognized and pursued those things that would better his art.

By May 1857, as they were leaving the city for South America, each sent an autumn scene to the National Academy of Design; Mignot may have sent his *Autumn* (cat. no. 28) but we remain uncertain about Church's entry.[25] Given that they must have been in touch as they made the final arrangements for their expedition, it is difficult to believe that they remained unaware of each other's intended submissions. And since upon their return their work would inevitably invite comparison, we might wonder why they seemed bent on an early "showdown." Whether deliberate or not, however, observers took advantage of the opportunity, each taking "sides." A newspaper critic declared that "the best landscape in the rooms is an elaborate view of the Andes of Equador by Church; its atmosphere is wonderfully and locally true to nature; he has also a rich American autumnal scene; and one almost as creditable to the artist, of the same kind, is by Mignon [sic], a young man of great promise, and now the companion of Church on his expedition to South America."[26] Summarizing the contents of the exhibition for Cropsey, H. C. Westervelt favored Mignot's version over Church's : "An Autumn by F. E. Church is not as fine as An Autumn by L. Mignot, who is rather of the Düsseldorf order—yet exceedingly fine."[27] The *Evening Post* critic went further: in Church's *Autumn* "the effect is decidedly theatrical, and tawdry in a degree inexcusable in so great a proficient in landscape painting." On the other hand, "Perhaps the best autumnal picture in the exhibition is No. 281, by L.R. Mignot, which is free from exaggeration of color or drawing, while it reflects, with unusual correctness, the sentiment and hectic beauty of the autumnal season. The softened outlines of trees and hills, and the admirably managed distance, are particularly noticeable."[28] When Church was in South America, Theodore Winthrop, who kept him abreast of art matters at home, wrote that "Mignot's *Autumn*, which was new to me is admirable—a very fine thing indeed."[29] Was this intended as a reminder to his friend to keep an eye on his traveling companion? In any case the competition was on, as declared outright in June 1857 by the *Home Journal:* "Mignot has fearlessly entered on a race with Church, with whom he has painted, it is understood. It may yet be 'neck and neck.'"[30]

Church apparently continued to follow Mignot's work after their return; on 22 November 1859, for example, he was reported in attendance at a private viewing of *Washington and Lafayette at Mount Vernon, 1784* (cat. no. 52):

> Art-Reunions are quite the order of the day, or rather of the evening, in New York. The "private view" of the *White Captain* and of Rossiter and Mignot's *Washington at Mount Vernon,*—brought together a large and distinguished company. . . .
>
> These occasions have a special value; we noticed at this Art-Conversazione—Wier [sic] and Gray, Bryant and Leutze, White and Botta Ingham, Judge Roosevelt, Curtis Noyes, Richards, Church, Kensett, Hicks, numerous editors, physicians, lawyers, and merchants interested in art and glad of such an opportunity to compare notes on the subject.[31]

Church was known to have owned at least one work by Mignot and probably owned several. Tuckerman reported that "*Holland Winter Scene,* [belongs] to F.E. Church."[32] A work on paper of a winter scene (cat. no. B) has been located at Church's hilltop home, Olana; the sub-

ject, however, is more likely in the United States than in Holland. Whether Tuckerman was mistaken about the subject or was referring to yet another work is not known. *Tropical River Landscape* (cat. no. 32), inscribed "To Fred from L.R. Mignot, Riobamba, July 10, 1857), was presumably a gift commemorating a stop on the trip they made together.[33] The visual evidence of their pictures, however, asserts the importance of the extended dialogue that went on between them, reverberating from the halls of the Tenth Street Studio Building in New York to the banks of a river in Ecuador.

A journalist's account of Mignot's wedding in January 1860 does not mention Church as being among the "bridesmen" in attendance, though other New York artists are named. His preoccupation with the completion of *Twilight in the Wilderness*, and the purchase of "The Farm" at Hudson (finalized on 31 March) may have prevented him from making the excursion to Baltimore.[34] But then neither is there any evidence of Mignot's presence at Church's wedding in June of that year. In 1867–68 Church was traveling with his familial entourage in the Near East and Europe. He could have rendezvoused with Mignot in Paris, on the last leg of his journey, a reunion in celebration of their Ecuadorian expedition ten years before. To date, no record of such a meeting has been found. But perhaps this coda would have been inappropriate, their friendship belonging to a distinct moment in each of their lives, when they were ambitious young bachelor-artists on the move.

PRAXIS

Experimentation vs. Replication

Viewed as an organic whole, Mignot's oeuvre demonstrates two contradictory impulses: the one toward change and bold experimentation; the other to repetition and even replication. The first and only real opportunity to discern these tendencies, until now, had been the retrospec-

tive exhibition of 1876, which offered viewers the opportunity to survey the more than one hundred pictures that his widow had assembled. Held in Britain fourteen years after Mignot departed the United States, the show was necessarily lean in works from his American period. Allowing for that, the extensive commentary generated by that occasion provides the historical underpinnings for a discussion of how these impulses were regarded by the artist's contemporaries.

A major theme that emerges from the commentary is that the distinctive and original quality of his work derived from his willingness to push his art in new directions, even if that meant that he could not always bring an individual picture to successful resolution. "If the same completeness of artistic effect is not always secured in the larger and more ambitious designs, it must be remembered that here Mr. Mignot was breaking new ground, where the example of earlier art could not be but of little service to him. This consideration must be steadily kept in view in any judgment that is passed upon the various examples of tropical landscape, and still more in the presence of such a painting as that of the Falls of Niagara."[35] Even a picture of the ambition and scale of *Niagara* (cat. no. 102) was recognized as a testing ground, a work in progress; and in fact, following the exhibition of canvas in 1866 at Colnaghi's he continued to rework it, and only signed and dated it in 1870. Thus, as the critic further cautioned, "Many of the works that he left are to be regarded in the light of bold experiments in an almost untrodden region of landscape painting, and had his life been prolonged there can be little doubt that he would have gained more complete mastery in the interpretation of a kind of scenery that does not readily submit itself to the requirements of pictorial representation."[36]

Creativity is based on change. We expect that an artist whom history accords a major status develops over the course of her or his career. On the other hand, there is a presumption that multiple shifts in subject matter and style are a mark of manic searching, of desperation. Mignot probably fits somewhere in between these two extremes. Among his fellow landscapists, perhaps only Heade had as diverse a

production; but Heade's unfolded over more than a half-century, whereas Mignot's (poststudent) career was of fifteen-year duration.

This tendency to metamorphosis was buttressed by a fixed dependence on certain motifs and images, to the extent that certain pictures were done in near replicas. Those that exist in multiple versions include *Sources of the Susquehanna* (cat. no. 27); *Autumn* (cat. nos. 28 and 29); *Vespers, Guayaquil River, Ecuador* (cat. nos. 74 and 75); *Ave Maria* (cat. nos. 64, 73, and 86), and *In the Tropics* (cat. nos. 87 and 88). The concept of thematic variation is the touchstone of creativity. Close to home, the Ecuadorian volcano Cotopaxi became an important motif for Church, and provided him with the basis for a progression of pictures that track his changing views of both art and natural history.[37] Among fellow landscapists Thomas Hotchkiss is another who demonstrated this tendency. Barbara Novak has detected in his repetitions

> a certain mild obsessiveness in choice of subject, for Hotchkiss, once he had identified a subject, returned to it again and again. Versions and series of his key subjects exist: the Theater at Taormina, Torre dei Schiavi, the Roman Aqueduct , the Colosseum. This could be seen simply as standard practice, developing an idea from sketch to finished picture in larger and smaller versions. But the need to define and refine certain images has, in Hotchkiss's case, a different urgency. While he reclaimed the icons of the Italian landscape for his purposes, he turned them, through repetition, into emblems of his individual reverie. Hotchkiss's identification with these subjects is thus intense, an urge (to paraphrase Cézanne) to *realize* his dream, to make it palpable, inhabiting and reinhabiting the same places and monuments. They bear him back into the infinite stretches of antiquity, where the dying body could be shielded from the depredations of time. There it survives in the elusive signs of process that describe space, volume, and substance. As Bachelard puts it: "the man of reverie is . . . *in* his world, in an *inside* which has no *outside* . . . the dreamer is *plunged* in his reverie. The world no longer poses any opposition to him."[38]

In Mignot's hands, the lagoons of South America took on similar overtones; the motif from *Ave Maria* became a kind of signature for him, repeated and varied throughout many of the late South American landscapes as the terrain itself receded in his memory.

Riverscapes and Ruins

Rivers are a primary element in the world Mignot configures on canvas. At first glance, this is hardly remarkable since water was a major component of Hudson River School compositions (cat. no. 70) and of landscapes generally. Analyzing his oeuvre in toto, and in comparison to his contemporaries, however, brings into focus the significance these waterways had for him. Other river painters are associated primarily with a single waterway; we immediately link Bingham with the Missouri, Thomas Eakins with the Schuylkyll, and Joseph M. W. Turner with the Thames. Especially significant here is the example of Turner, whose work Mignot could have studied in the New York collections of his friends Elias Magoon and James Suydam before he ever went to Britain. To Turner the Thames was truly home; but he depicted other rivers as well, some of which were accessible in engraved editions such as *The Rivers of France* and *The Harbors of England*. They provided compositional prototypes, but did they share the same meaning?

Rivers represented lines of power: commerce and imperialism. They are also tied to regional and national mythology. Simon Schama outlines the dilemma for the American artist:

> What, though, were river artists to do in a country where none of these conventional markers of history were available? For the first generation of American landscapists the issue was acute since, following the Lewis and Clark expedition up the headwaters of the Missouri, it was evident that national destiny was charted along the course of the transcontinental rivers. The realization that there seemed, after all, to be no "great western river" that would connect

the Missouri with the Pacific was one of Jefferson's bitterest disappointments. But the Hudson, the Ohio, the Mississippi, in their different ways, still provided the extended lines of circulation along which the busy commercial traffic of the new Republic streamed.[39]

Are these the associations of Mignot's fluvial geography? He floated the waterways of the globe, from the Canadian border to South America, through the British Isles and across Europe, characterizing each by vegetation, color, and indigenous river life. Moving beyond the Hudson, he embraced the Susquehanna, Passaic, Hackensack, Housatonic, Potomac, and Patterson along the eastern seaboard; in South America the Guayaquil was a frequent subject; and in Europe the local waterways of The Hague later gave way to the Seine, Avon, and Thames.[40] The rivers of the Americas most closely associated with his name are the Susquehanna and Ecuador's Guayaquil; in diverse ways his images of them represent meditations on nature and its settlement, on issues of access, on progress and tradition (see chapters 4 and 5, respectively, for extended discussion).

Although coastal and marine views are one means for an artist of connoting the immensity of the unknown, Mignot generally avoided them. The conspicuous absence of seascapes from his work is a noteworthy omission since they were painted with such frequency in America beginning in the mid-1850s, when his own career was escalating. In this he shared more with Durand, than he did with his friend John Frederick Kensett. The few identified works he did of the coast tend to be of a domesticated stretch (cat. no. 95), with the viewer's (and the artist's) feet firmly near a pier or boardwalk, that afforded a safe view of the nearby water. (One of the few exceptions is the *Beach at Sunset with Offshore Shipwreck* (cat. no. 48), which does suggest kinship with Kensett.) No crashing waves, no storm-tossed ships for him. Rather, his preferred subject was the protected inland lake or pond to which the river traced its source, or more frequently the riverway itself. His renderings (see, e.g., cat. nos. 58 and 101) provide an interesting compari-

son to Porte Crayon's (David Hunter Strother) images of the Dismal Swamp, or to many paintings of swamps by Joseph Rusling Meeker.[41] In contrast, Mignot's waterways are far less claustrophobic. Horizon lines are low, spaces are often open and empty; when they are not, a clearing can usually be glimpsed through the vegetation. His are not spaces that trap or confine, but rather they open up access and possibility, a means of assimilating the unknown.

Motifs of ruin and decay are another element that recur in his paintings. Dilapidated ruins occupy a prominent position in the Dutch pictures (cat. no. 3); thereafter the theme takes on altered forms in diverse locales, but it is still present in the landscape throughout his work, including *Sunset on a Mountainous Landscape* (cat. no. 7) and *Marsh Landscape with Architectural Fragments [Pontine Marshes?]* (cat. no. 14). Indeed he inserts them into his landscapes with an insistence that also characterizes some of the American artist-travelers in Italy, where the ruin serves as a vehicle to reverie of a long-lost Arcadia. For a southerner, however, dilapidation and ruin carried different connotations. As one scholar put it, "ruins are vivid in Southern thought long before Columbia [South Carolina] was reduced to ashes." The intellectuals of Mignot's region and generation were not on the whole a cheerful lot; the predominant tone of antebellum southern romanticism is unmistakably melancholy.[42] Several writers, including William Gilmore Simms, focused upon problems of deterioration and were disturbed and unnerved by the feeling that the South was in a potentially terminal state of decline. Their feelings were summed up by the Virginian author William Alexander Caruthers, writing of his home state but thinking also of other states besides his own: "There are the dilapidated houses, and overgrown fields, and all the evidence of a desperate struggle with circumstances far beyond . . . control. . . . Poor, exhausted Virginia! she is in her dotage." Building upon this, they tried to find the reasons for this decay, distancing their inquiry sometimes by setting it in the past, but at others concentrating on the immediate present or even the future. Nor did they stop there: diagnosis was frequently

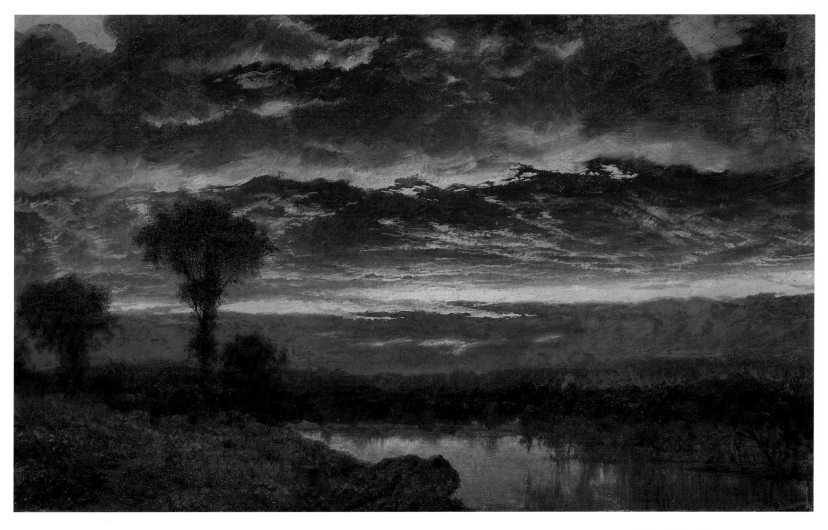

CAT. NO. 49.
Sunset

accompanied by the tentative formulation of some remedies, sugges-tions for the projected revival of the South and its people.[43] The crum-bling structures that so often appear in Mignot's landscapes, backlit by a sunset sky, can to some degree be interpreted as the pictorial equivalent of their literary expression. Like the writers, he avoids depicting a ruin-filled southern landscape; rather, he projects them onto the far-off sites of Holland or especially South America, which in a very real way offered to him the most apt repository for these meditations on the Old South.

Twilight

Twilight had a particular appeal for this artist, whose renderings of its effects were frequently commented upon in the press: "His skies are very remarkable. Sunsets would seem to have been his delight; and no wonder, for his facility for representing upon canvas the delicate and beautiful tints produced by the rays of declining light illuminating the fringy edges of clouds, is perfectly marvellous."[44] To judge from his total output—including both located pictures and titles of works yet to resurface—his interest in twilight amounted to a fixation. This inclination was present from some of the earliest known pictures done in Holland, in which the minute gradations in the sky form a subtle backdrop to the scene (cat. no. 9). It reaches its zenith in the tropical scenes from which the critics declared that they could actually feel the heat emanating. He studied these effects in small-scale works (cat. nos. 25 and 49), where the paint plays freely across the sky, with only minimal landforms indicated. And it continued in his vision of the Adirondacks and the British countryside.

This subject is another point of confluence with Church, who was himself said to possess "an eye for sunset." From the earliest days of Church's career in the mid-1840s until his final years at Olana, he studied and painted the sunset sky.[45] At the other end of the spectrum is Mignot's colleague of Parisian days Whistler, who perfected the art of a distilled memory of nightfall in his Crepuscules and Nocturnes. Stylistically, Mignot's handling of the twilit sky fits somewhere in between them, between Hudson River realism and aestheticism. In content, however, they diverge; Church's twilights are linked with nationalist rhetoric of sublime nature, and Whistler denied his any significance other than the aesthetic. Mignot's, alternately, provide his imagery with an expressive dimension, conveying a sense of loss at the passing of day, of time, of civilization—a touch of melancholy, that aligns him with contemporary southern intellectuals.

Painterly Stroke and Color

A painter's stroke carries with it some of the associations of the fingerprint: a distinguishing sign of the individual, what critic James Jackson Jarves referred to as the "labor trail." Mignot seemed to think in terms of color rather than of line, of mass over contours. His painterly syntax is the verbal equivalent of "possibly" and "apparently"; reviewers employed terms such as "delicate," "refined," "vague," and "indistinct" to describe the artist's ability to capture the effects of a twilight sky, or a snowy stretch of countryside. These are qualities that came to be highly valued later in the century, but in Mignot's lifetime they were little appreciated by a public that favored certainty and confidence, conveyed through a profusion of minute detail. His were skills many thought were more effectively applied to small, intimate works rather than the large-scale scenes he ambitiously attempted: "That Mr. Mignot possessed a refined and even fastidious artistic taste may be shown conclusively from some of the smaller studies where the subject has left him free to express his sense of beauty in completeness. We may particularly mention a small winter scene of very delicate colouring, and a view of the Dover cliffs from the sea, where a single impression is successfully maintained by the most skilful management of subdued tones. In these examples . . . the painter's gifts as a colourist and his understanding of the laws of tone are conclusively asserted."[46]

Exactly where or how he acquired these talents is difficult to pinpoint. In Holland his teacher Schelfhout favored the pencil drawings over colored sketches for the study of landscape, but Mignot also enjoyed access there to Old Master paintings. Although more amorphous and unsatisfactory as a source, there seems to be a tie between this colorist sensibility and his southern roots, which also gave rise to Washington Allston, with whom Mignot has been compared for his abilities as a colorist.

Space

Space is especially eloquent in Mignot's work. He demonstrates none of the *horror vacui* so characteristic of many of his contemporaries, who were driven by the need to fill all available space. Instead he displays a rare ability to portray vacant, open spaces with a power we tend to associate with early modernism. From small studies such as *Tropical Sunset* (cat. no. 30) and *Sunset* (cat. no. 49) to large-scale works like *Parting Day . . .* (cat. no. 89), from the mid-1850s in *Sunset over a Marsh Landscape* (cat. no. 13) to the end of his career (as in *Low Tide, Hastings,* cat. no. 94), and from the northeastern United States (as in *Twilight on the Passaic,* cat. no. 59) to northwestern South America (see *Tropical Landscape,* cat. nos. 37 and 85), Mignot painted canvases in which a flat strip of land and a single silhouetted tree provide the minimal compositional elements out of which he created fantastic skyscapes. In his tendency to forgo narrative or temporal references in favor of spatial cues, he looks to the next generation of painters. In his ability to conceive and paint these open lands, however, he reasserts his ties to the art of America, where space has a language and a meaning all its own. In the end, in spite of his migratory life, he remained an artist whose mode of expression had been forged by the land of birth, as more than one British critic realized. "His career, moreover, gains additional interest from the fact that his art was American by a stronger claim than the accident of his birth. Although educated out[side] of his own country, he remained to the last deeply fascinated by the grander forms of American scenery; and by a constant study of these larger aspects of natural beauty his art acquired a character of its own that sufficiently distinguishes it from the familiar forms of European landscape."[47]

I began this discussion by asserting that Mignot's southern birthright played a strong role in formulating his artistic persona; it also precipitates an interesting dynamic in the aftermath of the Civil War. Between the time he departed New York in 1862 and the end of the war years, he seems to have avoided painting any major pictures with North American themes. Then, in 1866, he paints and exhibits the huge *Niagara* (cat. no. 102). Is this an endorsement of the newly mended Union, an act of recognition that the South is from that moment on an American region, and Mignot an artist who can again be identified with both region and nation?

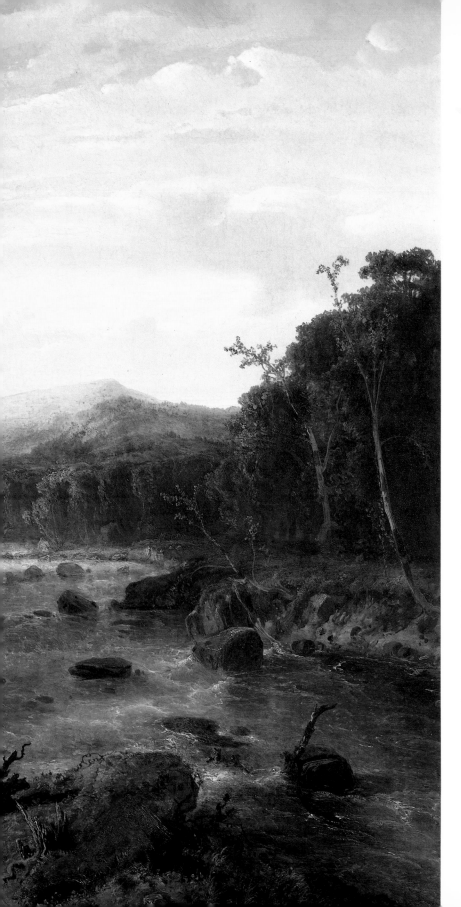

Roots and Influences
Mignot and Charleston

DAVID MOLTKE-HANSEN

The pattern is as familiar at the end of the twentieth century as it was in the middle of the nineteenth. A young man grows up in the provinces. Determined to make his mark in the larger world, he leaves home to pursue his career, whether as actor, artist, author, diplomat, doctor, or lawyer in the great centers of metropolitan culture. Friends of the family help. He has luck. In the end, however, his talent and hard work are most critical to his success. His growing eminence distances him yet further from his childhood home. If he visits at all, it is only briefly. Yet his provincial past remains a part of him. Unlike children of cosmopolitan centers, he lives with the tension between the metropolitan and the provincial. He has more than one identity or, to express it differently, one layer of identity. In part, it may be that he is running from one toward another. It also may well be that he finds that their competing claims on him make him a citizen of the world in a way that people with less complex or more localized identities and attachments are not. His personal commitments are to individuals, his profession, to the concept of cosmopolitan culture, to the idea of place—not so much to specific communities. He learns to read local customs, behaviors, and attachments as partial reflections of universals.

Louis Rémy Mignot's upbringing in Charleston, South Carolina, and subsequent career in The Hague, New York, London, and Paris suggest just such a pattern. Although there is almost no documentation for the earlier parts of that archetypal story in Mignot's case,

23

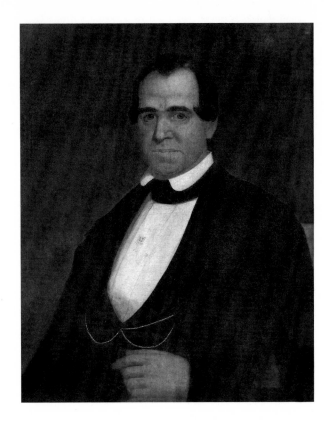

FIGURE 4. Unidentified artist, *Portrait of Rémy Mignot* (father of the artist). Collection of Frank Mignot.

easier for them to make their way in their new home, which they did quickly. The pattern that Rémy Mignot followed in pursuing success was typical: he used profits from mercantile ventures—a coffee house and confectionery—and alliances with better established and wealthy fellow countrymen to acquire real estate, make loans and borrow, purchase slaves, and eventually, buy a plantation.[3] In the process, he became a substantial member not only of Charleston's French community, which he served by standing as godparent repeatedly and offering surety for notes, but also in the broader community, where he joined, for instance, the Odd Fellows.[4] A further indication of his success was the location of his establishment on increasingly fashionable King Street—an area, according to artist Charles Fraser, transformed in the decades after the American Revolution from a den of "hucksters, pedlars, and tavern keepers" to a center of "gorgeous windows and dazzling display of goods emulating a Turkish Bazaar, and inviting . . . daily fashionable promenade."[5] The final reckoning of Mignot's success, of course, was the inventory of his estate at his death from dropsy at age forty-seven. That he owned a dozen slaves and a pianoforte suggests that he had both assimilated well into and done well in his adopted community.[6]

Mignot's use of his background in pursuing this success was also typical. The mutual aid societies that immigrants began establishing in the port city in the mid-eighteenth century generally defined themselves along ethnic lines.[7] Rémy's ready adaptation to the slave society in which he found himself was characteristic of his countrymen in Charleston. At the same time, however, as the French were increasing their social status in the larger community, they also continued to set

a review of the artist's background yields a number of clues that seem to encourage such an analysis.

The first point to consider is that Louis was a son of immigrants, Elizabeth and Rémy Mignot (fig. 4). His father came from Granville on the Normandy coast in France, as had other families among whom Louis grew up. That Rémy bought a slave in Charleston in 1828 from someone with the same last name—Moisson—as his mother's further suggests that a cluster of families may have immigrated together, if not all at once, then over time.[1] If so, then Louis shared in a trans-Atlantic identity that distinguished him from most native-born children in Charleston.

Apparently the Mignots were also distinguished by their prominence in the Normandy that they had left.[2] Their background made it

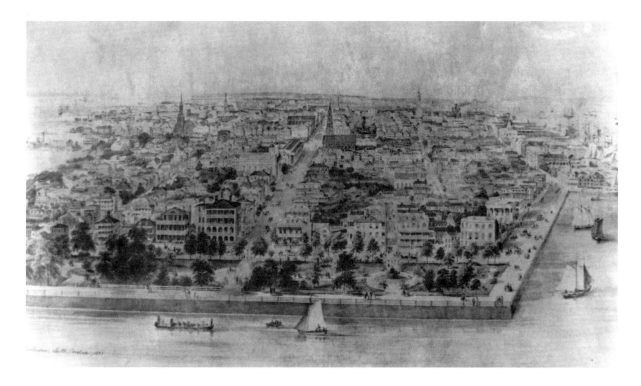

themselves, or to be set, apart from the majority of whites in various ways. They were Catholic, whereas most native whites were Protestant. They also did not mingle much with other Catholic immigrants—primarily Irish and German. They went to different churches, and they tended to pursue different kinds of business, engaging much more in the luxury trades. Reflecting the education and the culture informing this social standing as well as the kinds of collective self-sufficiency and self-segregation that the French practiced are the French language newspaper and theater that the community supported for a time.[8]

Such bonds and activities helped to assert and sustain the common ethnic identity of people who had divergent backgrounds. The earliest French Catholic immigrants to come to Charleston in significant numbers were refugees from the revolution that saw former slaves seize Saint-Dominque from their one-time colonial French masters.[9] Rémy

Mignot's second wife, Louis's stepmother, was the eldest daughter of one of these refugee families, the (de la) Riviéres.[10] French speakers who immigrated to Charleston a generation later, after the Napoleonic Wars, tended, rather, to come from France directly. Some, like Rémy, reportedly were dedicated to the exiled French emperor and were leaving behind the restoration monarchy. Others were simply pursuing the opportunity that America represented.

Although Granville and Saint-Dominque were provincial, the immigrants from these communities helped give Charleston (fig. 5) a cosmopolitan flavor. The city's extraordinary wealth enhanced that cast to its social and cultural life. At the time of Louis's birth, about 1831, Charleston was still the wealthiest city in the United States. Even though approximately half its inhabitants were slaves without taxable property or income, Charleston had roughly four times the mean

wealth of America as a whole and twice the mean wealth of the American South.[11] Yet this extraordinary level of income did not insulate the port from the consequences of repeated recessions or gluts on world commodity markets. Consequently, Louis grew to boyhood in a city that had stopped growing. Between 1830 and 1840, immigration slowed to a trickle in the face of the economic difficulties that sent Charlestonians westward in swelling numbers. To many of the inhabitants left behind, the city seemed to have stagnated, not only economically, but politically and culturally as well. As Charleston saw its clout diminish in Washington, it also saw the failure of the ambition that had led to the creation of its South Carolina Academy of Fine Arts in 1821, the same year that Rémy Mignot apparently first came to the port.[12]

Earlier there had been occasional art exhibitions—for instance, one at the College of Charleston in 1791. And visiting artists had often displayed their work, as Raphael and Rembrandt Peale had done in 1796 and 1804 and as Samuel F. B. Morse had between 1818 and 1821. Occasionally, too, entrepreneurs had brought exhibitions to town for display in bookstores, churches, society halls, and elsewhere. Never before, however, had there been as ambitious an exhibition in Charleston as the new academy staged in 1822. Advertisements invited "artists and amateurs at home and abroad" to submit "paintings, casts, models, etc."[13] Yet, despite initial success and a string of annual exhibitions through 1828, the academy could not sustain itself. Consequently, in the fraught decade of the 1830s, residents could only see occasional traveling exhibits. Charleston had no galleries, although local artists such as history painter John Blake White, miniaturist Charles Fraser, and sculptor John Stevens Cogdell did manage occasional showings.

In the face of such difficulties, Charleston's young necessarily had to curtail their expectations of their native city's, and so their own, futures. Like their older siblings, cousins, and neighbors who were moving west, they increasingly saw opportunity leading ambitious people away from the community that had drawn earlier immigrants in large numbers—numbers great enough to make Charleston the fourth largest city in British North America through most of the eighteenth century and still the United States' fifth largest city in 1840. Things improved somewhat as Louis approached adolescence. The city started to grow again, increasing in population by at least 50 percent over the last two decades before the Civil War.[14] Early in this period of renewed prosperity, too, the Charleston Apprentices Library Society began staging art exhibitions. Many artists with local ties, from Thomas Sully and J. J. Audubon to Morse and Fraser, were exhibited repeatedly, as were such European masters as Rembrandt, Rubens, Romney, Titian, and Wouverman. Later—in 1849, too late for young Louis to participate before sailing for Europe—the South Carolina Institute started the series of annual exhibitions to which the young artist would himself submit paintings in 1855, winning a silver medal.[15]

Further complicating Louis Mignot's relationship to his native city and country was another development of the 1830s that gained increased meaning as the 1840s advanced: the emergence of southern identity. When Rémy Mignot first came to Charleston, that identity did not exist. The population movements that were bringing Virginians and Carolinians together in Tennessee, Alabama, Mississippi, and the other new states and territories of the old Southwest, however, were also creating the necessity for a new identity. Charlestonians in Alabama could no longer think of themselves as Carolinians, yet their new identity as Alabamians did not recognize their shared antecedents. The notion of a southern identity united Alabamians and Carolinians. Increasing numbers of people articulated elements of that identity as the 1820s advanced, but it was not until about the time of Louis Mignot's birth that it began to take hold. Illustrative is the fact that, in 1829, when Tennessean Andrew Jackson became president of the United States, most Americans with knowledge of the subject thought of him as a westerner (that is, someone from west of the Appalachians); by his death in 1845, however, many saw him as a southerner (that is, someone from south of the Maryland-Pennsylvania border). The consequence of this shift for Louis Mignot and his generation is that they

would be the first to grow up with this new identity, which both complicated and enriched their understanding of who they were—not only Charlestonians, Carolinians, and Americans, but also southerners.[16]

All white Charleston-reared youth born during Jackson's presidency shared to one degree or another this layered sense of themselves. How Louis Mignot perceived and related to these identities was a function, however, of his individual circumstances as filtered through his character and upbringing. Son of a coffee shop and confectionery owner but also stepson of the daughter of a French nobleman, Louis was neither precisely a petit bourgeois nor an aristocrat. He lived with ambiguity in other ways as well. Although his father eventually acquired a plantation, he did not belong to the planter class. A Catholic and a child of French parents in a largely Protestant and Anglophone city, and so member of a marginal subgroup, Louis also belonged to a leading family in the leading parish of the diocesan seat of his denomination, and therefore had position and influence as his birthright. Seemingly a beloved grandchild, who lived with an apparently indulgent grandfather, he yet may have lived outside the family circle that his stepmother drew; for his name does not appear along with his half-siblings' in surviving documents from the settlement of his father's estate, which his stepmother served as administrator.[17]

That Louis Mignot would live with a wealthy grandparent rather than at home was less extraordinary than it might seem in retrospect. Maternal grandparents often helped with, or took over, responsibility for their grandchildren after the death of the mother—a frequent occurrence. So, nearly a quarter century before Louis's birth in 1831, the infant William Gilmore Simms, who would become one of the antebellum South's most important men of letters, was placed in the care of his maternal grandmother in Charleston.

In Simms's case, scholars agree that his loss of his mother, coupled with apparent, albeit temporary rejection by his father and life in the household of an elderly person, were critical factors in the writer's development. Simms found reading and, later, imaginative writing to be ways to counteract loneliness, give color to his days, and use as well as direct his longings and ambitions.[18] There is not enough information to fully compare the cases of Simms and Mignot, but this much seems clear: Louis early became as captivated by drawing and painting as Simms by literature.

There are other points of comparison. Both boys grew up in households of some means and with useful family connections. They each resisted encouragement to pursue more practical careers. Both earned not only local but national attention for their work by their mid-twenties, and in doing so they early claimed praise for their innovativeness. This focus has led to critical discussion on the extent to which each man was an autodidact. This exaggerated notion of the self-generative quality of each one's work led some contemporaries to argue for the peculiarly American nature and values of the works and to ritualistically aver, further, the necessity of American independence from European masters and models.[19]

Yet in one major respect the two men did not have parallel lives. Despite frequent impulses to the contrary, Simms stayed in the Charleston of his grandmother rather than either follow his father to Mississippi or become a full-time member of the New York literary community, in which he had many friends. Mignot, on the other hand, left Charleston for good at an early opportunity. The different choices did not merely reflect differences between painting and literature as studies or careers. Many of Charleston's best-known painters, sculptors, and architects as well as writers—Charles Fraser, John Blake White, Edward Brickell White, John Stevens Cogdell, Paul Hamilton Hayne, Henry Timrod—stayed home, even becoming lawyers and accountants to support themselves when their art would not. Others among the most successful of Charleston's artist as well as its editors and writers left, putting career before place. Portraitist Thomas Sully, epic historical painter Washington Allston, and architect Robert Mills achieved distinction in their fields beyond that of anyone who stayed in Charleston. Because those who stayed and those who left were contem-

poraries of one another and spanned the generations from Allston and Fraser (children of the American Revolution) to Hayne and Mignot (young men on the eve of the Civil War), changing patterns of opportunity cannot explain such choices either.[20]

There may have been particular reasons for Louis Mignot to leave Charleston when he did, in the fall of 1848. The death of Rémy Mignot earlier that same year cut one of Louis's principal ties to Carolina. As Rémy reportedly had resisted the idea of Louis becoming an artist, the elder Mignot's death may have freed the younger to pursue his ambition. Clearly, if not from Rémy's estate, Louis obtained enough money from somewhere—perhaps a grandparent—to pursue art studies in the Netherlands. The choice was remarkable. Growing numbers of Charlestonians may have been doing what their colonial ancestors had done: going to Europe to study or to make the grand tour. Amsterdam, if not The Hague nearby, was sometimes a principal destination. Those seeking artistic training, however, much more often went to Düsseldorf, Rome, or Paris than to the Netherlands.[21]

By the fall of 1848, Louis Mignot was of an age when many young men of means from Charleston made such voyages. Also drawing youth with money and metropolitan cultural ambitions that particular year was the ferment of the recent nationalist revolutions across Europe. Suddenly, the Old World seemed to be joining the New in pursuing a revolutionary future by asserting the importance of national cultures, ideals, and experiences in shaping peoples' self-images and destinies. The message was potent for young southerners asking what their regional identity should mean. It was powerful, too, among the writers and artists who had anticipated, or were reinforcing, the revolutions' themes in their explorations of the distinctive characters or geniuses of individual places and peoples. So, George Bancroft had begun exploring America's distinctive heritage in his monumental national history, launched in 1834. That same year Simms had also begun his fictional treatments of the American South's development and character.[22]

Making it easier for Louis Mignot to sail for the Netherlands were the friends whom his family had there and who could look after him. That Louis's stepmother would soon marry a Dutch immigrant to Charleston is suggestive here, and the fact that Louis's stepsiblings all married Hollanders indicates how strong these trans-Atlantic ties were. The strength of such bonds may have served to counteract to some degree Charleston's pull on Louis Mignot. In consequence, Louis simply may not have given the same priority to local attachments that Simms or many others did. Moreover, his international connections may also have made a metropolitan career and cosmopolitan life seem more desirable and less difficult to him than to many Charlestonians.

That most Charlestonians did not share such perceptions did not mean that the city resisted cosmopolitan impulses. The Saint-Dominque refugees had been attracted to the South Carolina port at the end of the eighteenth century in part because the city was more cosmopolitan than most in America. In turn, the refugees added to the city's cultural tone. Many of South Carolina's wealthiest planters sent their daughters to Charleston finishing schools established by members of the refugee community. So, Louis Mignot's contemporary, famed Civil War diarist Mary Boykin Chesnut, daughter of former South Carolina governor Stephen D. Miller, attended Madame Talvande's.[23]

Charlestonians had complex relations to metropolitan culture and to modernity. A number of assumptions and concerns informed these relations. The arts figured prominently. Charleston physician Samuel Henry Dickson's 1842 Phi Beta Kappa Society address in New Haven, Connecticut, illustrated one recurring theme. In reviewing "The Characteristics of Civilization," Dickson defended painting "with all its immediate kindred, etching, engraving, lithography, etc." and argued for the wisdom of educating "the mass" to elevating and enriching pleasures, such as those of art, music, and literature provide.[24] A year later, lawyer and legislator William Dennison Porter's address before the Apprentices Library Society appeared in the Charleston

Courier. It argued "The Value of the Arts and Sciences to the Practical Mechanic" and observed: "In our great sister cities of the north, a mechanics' exhibition is one of the most imposing of spectacles that can be witnessed. . . . It is thus that the arts are trained to excellence, and their cultivators taught to respect their calling and themselves. . . . May the time not be distant, when our city shall have its annual exhibition; and when this hall shall be fitly decorated with the manifold and beautiful creations of southern art."[25]

In his argument for "The Necessity of a Southern Literature," in volume one (1842) of the *Southern Quarterly Review*, editor Daniel K. Whitaker similarly called for the South to encourage its own culture and productive capacities, though he did so for different reasons. "The plantation states, bound together by common pursuits and common ties of interest must cooperate and move together in this matter, and must exert all their strength for their own protection," Whitaker argued. He saw this need for defensive self-development stemming from "rumors of danger in the distance, coming even from the land of the Puritans."[26]

This defensive, regional argument had a nationalistic corollary. As Joel Roberts Poinsett, noted South Carolina planter, U.S. representative to Mexico and Chile, and U.S. Secretary of War, observed in an 1841 address before the National Institute for the Promotion of Science and the Useful Arts, "Literature and the fine arts go hand in hand. . . . Their progress has everywhere kept pace with that of the moral and social condition of mankind, and their history marks, with unerring truth, the rise and fall of nations."[27] The argument earlier had led Poinsett to support the failed South Carolina Academy of Art and was also a reason for his subsequent support of exhibitions at Charleston's Apprentices Library Society.[28] Others in Charleston, even when subscribing to these exhibitions, were more skeptical. While agreeing that "the patriot and the philanthropist" regarded the fine arts "as the evidences of social improvement and national prosperity," Charles Fraser, for example, felt constrained to warn the American Lyceum in 1835:

As the husbandman in vain bestows his labor upon a barren and unprofitable soil, so does the painter, however liberally endowed by nature, or improved by education, unprofitably devote his time to the cultivation of his art, in a community possessing the amplest means of patronage, but wanting taste and congeniality. . . .

In canvassing the causes most likely to retard the progress of the liberal arts [in the United States], we cannot be indifferent to the practical habits of the American people, so much at variance with all the pursuits that adorn the leisure, or minister to the tastes of society. These habits, which were forced upon the early colonists by a stern necessity, have been transmitted to their descendants, and are strengthened by the institutions of the country.[29]

In leaving Charleston, Louis Mignot may have thought that he was profiting from the experience behind such skeptical understanding. He may have had another apparently practical artistic reason as well. Although Charleston housed innumerable instructors in draftsmanship and painting, many of them Saint-Dominque refugees and some of them proficient enough to have trained local artists of note, the city did not support a large art school where students of varying degrees of sophistication could both learn from and teach each other while also getting solid academic training from professionals of varying backgrounds and interests.[30] When Porter urged local exhibitions of the mechanical and fine arts, he was addressing aspects of this deficiency. He also was recognizing that larger cities in the North had outstripped Charleston. In fact the port would drop from fifth to twenty-second in relative size among American cities between 1840 and 1860.[31] South Carolina's largest town simply was not growing fast enough to support the array of specialized cultural institutions that New York, Philadelphia, and other larger, more rapidly expanding cities were developing.

Charlestonians who recognized their relative disadvantage often felt competitive with northern cities, but, when choosing where to go to school for training beyond what Charleston and South Carolina offered, they increasingly did what Louis Mignot would do: look to

Europe instead. These Charlestonians were in effect asserting the superiority of European over northern institutions and instruction. They also avoided seeking tutelage in a North that seemed increasingly hostile to southerners and southern interests. Further, they diminished the claims on them of a northern-dominated national culture by asserting the value of cosmopolitan, trans-Atlantic culture.[32]

Mignot did not need to be conscious of all of the ins and outs of such thinking to have imbibed it. Neither did he have to have known either Poinsett or physician J. G. F. Wurdemann, author of *Notes on Cuba* (1844), to have assimilated some of the interest in Latin American affairs and nature represented by their, and other Charlestonians', engagements and writings.[33] Even though ornithologist and artist J. J. Audubon visited Charleston repeatedly during Mignot's youth, one cannot know either whether the boy ever met the artist or even if he knew Audubon's local collaborators, the Rev. Dr. John Bachman and Maria Martin. That such connections reflected Charlestonians' broad and long-standing interest in natural science and art, however, clearly suggests something of the culture in which Louis Mignot grew up and developed his passion for landscape painting.

"Who can paint like Nature?" Bachman asked in an 1836 essay in the *Southern Literary Journal*.[34] No Charlestonian wrote more about landscape painting than Charles Fraser. Nearly fifty years Mignot's elder, Fraser wrote for national as well as local periodicals. Mignot could have read several of the older artist's poems in 1843, for instance, in a contemporary local journal, the *Magnolia*. "Claude Lorraine" was a reflection on scenes made memorable by the French artist and, so, on the power of art. "Nature Made for Man" similarly gave poetic expression to the impact and artistic value of nature—also themes of an essay by Fraser commissioned eight or nine years earlier by the American Lyceum. There the artist had voiced a judgment so common that it had long resonated in balder form as a cliché: "If our country were favored in no other respect, it would be remarkable for the variety of its scenery, exhibiting every feature of grandeur and beauty that taste

delights to dwell on. . . . If to this rich diversity . . . be added our pure skies, and our sunsets as cloudless and glowing as were ever beheld from the Pincian mount;—the American landscape painter may be said to imbibe the principles of beauty and sublimity with his earliest perceptions. He owes an obligation to nature for this gratuitous profusion which a life of study could not discharge. . . . His converse is with nature in her 'unwalled temple.'"[35]

Fraser's observation carried conviction. Many of his sketches, watercolors, and oil paintings were the fruits of trips he took to the North—to the White Mountains of New Hampshire, to Niagara Falls, and to the Passaic River and Falls in New Jersey, all subjects later painted by Mignot as well. Because several of these Fraser landscapes appeared as engravings in the *Analectic Magazine* and similar publications, Mignot may have seen them or others in back issues, if not in local exhibitions of the originals.[36]

The depth and directness of such influences are imponderable, but their cast and character are clear. There also are other ways to try to enter Mignot's childhood world and assess its later effect. One is simply to be a tourist.

No one appears to know where Louis lived with his grandfather. Yet, despite the fires that swept Louis's father's and stepmother's neighborhoods in 1838 and 1861, possibly consuming their properties, much of the city that the boy knew still survives (fig. 6). Walking westward on Hasell Street from the intersection with Anson, where his father's coffee house was briefly located after the fire of 1838,[37] one still passes the Colonel Rhett house, oldest surviving mansion in the city, on one's right hand and sees a block away, on one's left, the City Market, completed in 1841. Then, crossing Meeting Street, one comes to St. Mary's Church and, across the street, the first Reform Jewish synagogue in America, Kahal Kadosh Beth Elohim. The Mignot family would have known the earlier structures on these sites and have seen both sanctuaries go up in the wake of the fire that consumed nearly a fifth of the city. The Mignots lived near the center of this conflagra-

CHARLESTON THEATRE, CHARLESTON, S. C.

FIGURE 6. Charles F. Reichardt, Charleston Theater (or Meeting Street Theater), 1835–37, engraving, 6 × 9½". Courtesy of the South Carolina Historical Society.

tion,[38] and from this position they saw modernity emerging from the rubble where the late twentieth-century tourist sees sometimes quaint, sometimes elegant history. Even today, however, the tourist can get some sense of the complexity and the richness of this part of the city of 150 years ago. The German Lutheran church at the corner of Hasell and Anson (1841–42) bears witness to another ethnic community. Following on the heels of Irish Catholics, Germans came to Charleston in increasing numbers during the 1840s and 1850s.[39] Many built on land cleared by the fire. Yet Charleston's classes and races were not residentially segregated. Surviving and newly built houses of planters, wealthy merchants, and professional men were scattered through the same neighborhoods. So were the residences of free blacks and slaves. Many are still standing.

Moving on to King Street, where there are iron fronts from the 1850s and where the Mignot confectionery was located around the corner and down the street from St. Mary's, the scale of the street and the welter and elegance of small businesses there are still suggestive of the

womb Louis left in 1848, even if many of the buildings date from later. Several blocks south of Hasell, too, on Meeting Street, the brand new South Carolina Institute Hall, where Louis exhibited in 1855, burned in 1861. The Apprentices Library Society was close by. A couple of blocks north of Hasell and another west of King, the College of Charleston's main campus looks similar to what Louis presumably saw in 1848, after several additions over the previous decade. (Charles Fraser's library fittingly is part of the College Library's Special Collections, for Fraser long served as a trustee of his, Sully's, and Simms's alma mater.)

What has changed dramatically since 1848 is the extent of the city. The changes had begun earlier, in Mignot's boyhood. So, Louis saw the Military College of South Carolina go up just north of the old city wall. He also saw free blacks and Irish immigrants building shacks and small houses still further up the peninsula, on the "Neck, where early slums developed."[40] Even there, however, until well into the twentieth century, fields and expanses of marsh still shaped vistas where now hospitals, hotels, fast food outlets, schools, sports complexes, and residential neighborhoods sprawl. Louis, then, had very different perspectives than do people today. He saw bucolic landscapes where modern inhabitants and visitors see urban development. Even the most devoted tourist or antiquary, therefore, has difficulty capturing the physical place that Louis knew, much less the social meanings and relationships or cultural values of his childhood community.

Some of those meanings and values are suggested by a place five hundred miles to the north. Many Southerners saw the view as they

returned homeward from trips to Saratoga Springs or to Washington and Philadelphia; for the house and outbuildings at Mount Vernon, plantation home of American founding father George Washington, dominated the vista as well as travelers' consciousnesses.

When coming to paint this scene with Thomas Rossiter in the late 1850s, Mignot was rendering a place redolent with particular meanings for South Carolinians. What was special was not the iconographic significance of the property—the conversion either of a private place into a public symbol or of such common sights as fields and forests into visions charged with meaning and suffused with beauty. Americans generally shared this iconographic understanding. They easily grasped as well the symbol of George Washington, farmer and father, as nurturer and patriarch of his country. But Mount Vernon had also become for South Carolinians, unlike other Americans, a symbolic battle ground where they fought over the legacy of the American Revolution and sought to position themselves in relation to the issues fueling the impending crisis of the Civil War.

An early chapter in this saga was written during Mignot's adolescence. In lengthy review essays, published in 1846, Charlestonian Simms attacked Ann Pamela Cunningham for her defense of her up-country South Carolina tory ancestors' roles in the American Revolution. Outraged, she called for help from mutual friend, Benjamin Franklin Perry, editor of the Greenville, South Carolina, *Mountaineer*. When Simms apologized through Perry for having written anything "that might have given pain to a creature so delicately constituted," he angered Cunningham all the more. "Mind has no sex," she declared. Nevertheless, she also decided that she would write no more, and so would avoid subjecting herself to the public criticism to which such public displays make one liable.[41]

It was with this battle behind her that Cunningham received a letter from her mother in the fall of 1853. On the way back to South Carolina from Philadelphia a week before her daughter, Mrs. Cunningham caught a distant glimpse of Mount Vernon standing in "ruin and desolation" on the Potomac. "Why was it," she wondered, "that the women of this country did not try to keep [the place] in repair, if the men could not do it?" Here was the opportunity for the granddaughter of a tory to act patriotically and for women to be successful in a male-dominated world.[42]

While Ann Pamela Cunningham was negotiating with the Washington family for purchase of Mount Vernon by the newly created Mount Vernon Ladies Association of the Union, eminent historian George Bancroft and others invited Simms on a lecture tour through New York state. Simms chose to speak on South Carolina's role in the American Revolution, hoping to counteract the state's reputation for harboring more tories than any other state by arguing the extraordinary sacrifices of South Carolina's whigs during the civil war that pitted neighbors against one another in the Palmetto State between 1775 and 1782. The 1856 tour was a disaster. Often ill attended, the lectures also evoked savage reviews, some of which Mignot might well have read in New York city papers. The reviewers understood Simms to be defending Carolina and attacking northern historians out of concern over contemporary sectional issues and dismissed any defense of the Palmetto State as sectional partisanship. Their reaction, like Simms's, was colored by the furor over the recent caning of Senator Charles Sumner of Massachusetts by Representative Preston Brooks of South Carolina.[43]

Many Americans found it a relief to turn from such controversy to support Ann Pamela Cunningham's mission. Leading Massachusetts intellectual and politician Edward Everett, Harvard College president and former secretary of state, joined in the crusade, and by 1858 the Mount Vernon Ladies Association of the Union could report its success in obtaining what in effect would become the first national historic site.

Inevitably, when Mignot visited the site, he also confronted the issues it symbolized: American identity, sectional relations, and the nature and uses of the country's revolutionary legacy. Like nearly all Charlestonians, Mignot not only found these conflicts inescapable, but

he found his perceptions of them specially colored. Whatever his relationships to individuals living in the South Carolina port, to its French and artistic communities, or to currents of thought and sentiment there, Mignot carried these conflicts, and white Charlestonians' perspectives on them, with him and within himself. He may have become a cosmopolitan. He may not have visited his birthplace more than once or twice, if ever, after having left to pursue an artistic career. He may never have painted a South Carolina scene in his maturity. Yet his Charleston and southern identities remained part of him and his vision.

Training at The Hague

WRITTEN IN COLLABORATION
WITH LOUISETTE W. ZUIDEMA

Louis Mignot disembarked from his trans-Atlantic journey in November 1848 at Rotterdam, the Netherlands.[1] By the first of January the seventeen year old was enrolled in the Academy of Fine Arts at The Hague, where he spent the better part of the next five years.[2] Centered on the activities of the nearby Royal Court, the spaciously laid-out city possessed a more gracious countenance than its neighbors and was perhaps reminiscent of his native Charleston.[3] Employees from the Dutch colonial plantations in the East Indies, who were accustomed to spending their long leaves at The Hague, added to its easy-going pace. The conservative atmosphere had led August Belmont, who held a U.S. diplomatic post there from 1853 to 1857, to quote Heinrich Heine's remark that "they are in everything about half a century behind the rest of Europe," although he later came to appreciate its cultural life, particularly the "rich galleries of magnificent paintings."[4] For The Hague also was home to major cultural institutions: the Royal Library, the Mauritshuis Museum, as well as the Academy of Fine Arts. What had led this young man to make his way from Charleston to The Hague? What did he hope to find there?

 Although the origins of his artistic calling remain obscure, it is clear that his inclination had always been toward nature. According to family tradition, "From his childhood he showed an overpowering bent to the study of landscape and the use of the pencil, and at the age of sixteen, against the wish of his father, had fixed upon Art as his profes-

FIGURE 7. A. Nett, *Portrait of Andreas Schelfhout,* print, from J. Immerzeel Jr., *De Levens en Werken der Hollandsche en Vlaamsche Kunstschilders, Beeldhouwers, Graveurs en Bouwmeesters* (1855; rpt. Amsterdam: B.bM. Israël, 1974), 3:64.

sion. As means for the training of a painter were hardly to be procured in his native town, young Mignot was despatched to the care of friends in Holland, where he was placed in the studio of Schelfhout for instruction."[5] He found himself in the ideal environment. For while various academies throughout Holland specialized in the human figure, still-life, or even livestock, nature was the focus at The Hague, where academy director Bart van Hove drew townscapes and Andreas Schelfhout painted landscapes. Schelfhout (fig. 7) was regarded as the preeminent Dutch landscapist of his day and as one of the most popular teachers, who counted among his numerous students promising artists like his son-in-law Wijnand Nuyen and Johan Barthold Jongkind.[6] Coming from an artisan background (his father was a gilder and framemaker in whose studio he assisted until age twenty-four), he studied under Johannes Breckenheymer, a theater and decorative painter, before turning to the direct observation of the scenery surrounding The Hague.[7] His first public exhibition was in 1815, and by 1824 the influential art critic Jeronimo de Vries judged one of his works "excelling in simplicity and truth-

fulness, the faithful companions of eternal beauty."[8] Thereafter he gained in prestige, earning epithets such as the "Claude Lorrain of the winter views" and "our modern king of landscape art."[9] Schelfhout was more practically than theoretically minded. During a career that spanned more than fifty years, he produced a large body of paintings and trained a small army of students, but seems never to have committed his philosophy of art to paper. As an instructor, he always favored studying and drawing from nature, taking his students for long walks among the dunes, sketchbook in hand. He insisted on the use of the pencil over the brush, however, and discouraged his students from working in oils outdoors, which he regarded as a waste of paint.[10] Few drawings by Mignot have surfaced, but a *Study of Trees* (cat. no. A) may belong to these student years. When Mignot arrived at The Hague, the sixty-two-year-old Schelfhout was at the peak of his long career. Little is known of the exact nature of their relationship. We can only suppose that Mignot enjoyed the same benefits extended to fellow students, which included the opportunity to accompany the master on his travels, share his many international contacts, exhibit their work, acquire technical proficiency, and deepen their appreciation of nature through his tutelage.

Other opportunities that Mignot enjoyed at The Hague were the result of a deliberate campaign begun earlier in the century to restore to Dutch art some of the glory it had achieved in the seventeenth century. The opening of academies in several major cities were part of this strategy. In 1814 King William I became patron of The Hague Academy of Fine Arts (Haagse Academie voor Beeldende Kunsten), founded in 1682 and the oldest in the country.[11] By 1839 this institution found a new home on one of the canals, Princessegracht, in a classically styled building designed expressly for it. It offered drawing instruction exclusively to as many as 400 students who gathered in the elegant Cast Room, drawing from the sculpture; study from nude models was also part of the curriculum.[12] Painting classes were not offered by the academy, but were taken in the studios of local artists, presumably by private

arrangement.[13] Generally daylight hours were devoted to painting and drawing classes were held in the evenings.

In another effort to renew art life in the Netherlands, the so-called Exhibitions of Living Masters were established in 1814 and were held regularly thereafter in different cities, offering young and experienced artists alike an opportunity to show their work. Records indicate that Mignot, his contemporaries, and his teachers participated in these important exhibits, which were reviewed in the daily press and in art journals such as the *Kunstkronijk*; they provided a welcome opportunity for art sales to the general public as well as the government.[14] By the time of Mignot's arrival, the artists' society "Pulchri Studio" had also been founded (1847), which provided additional opportunities for community exchange.[15]

One of the advantages The Hague offered over popular artistic centers such as Düsseldorf was that it combined contemporary art with the art of the past. After the defeat of Napoleon in 1813, King William I had taken a personal interest in the holdings of the Mauritshuis; he wielded his influence at auctions to augment the already outstanding collections of seventeenth-century Dutch art assembled by his predecessors. Beginning in 1822 the museum was open to the public twice a week, and on other days available to artists and experts.[16] Works by van Ruisdael, Vermeer, and particularly Rembrandt attracted many international visitors, including American figure painter Eastman Johnson (fig. 8), who abandoned Düsseldorf for the benefits of The Hague, as he explained in a letter written shortly after his arrival in November 1851. "I am at present . . . at the Hague, where I find I am deriving much advantage from studying the splendid works of Rembrandt and a few other of the old Dutch masters, who I find are only to be seen in Holland. I shall probably continue here a good portion of the winter. I must say I regret having spent so long a time in Düsseldorf when there is nothing to see but the present artists, who, whatever their merits may be, are very deficient in some of the chief requisites, as in color."[17]

As it turned out Johnson extended his stay far beyond the winter

FIGURE 8. Matthew Brady, *Portrait of Eastman Johnson*, n.d. (c. 1860), carte-de-visite photograph. Courtesy of Paul Hertzmann & Susan Herzig, Paul M. Hertzmann, Inc., San Francisco.

of 1851–52, remaining there until 1855. During that time he and Mignot became fast friends; Johnson painted a portrait of Mignot (see fig. 2), they collaborated on at least one painting (cat. no. 8), and we can imagine that they must have traveled and copied the Old Masters together. A painting by Mignot entitled *Birth Place of Rembrandt* (exhibited at the National Academy of Design in 1853) suggests that he shared Johnson's admiration of Rembrandt, and perhaps made a pilgrimage to Leiden to seek out his place of origins in preparation for this homage. The aim of their art historical exercise was ultimately to locate seventeenth-century models that could serve as templates for their own paintings, and here the figure and landscape painters may have diverged in their choices. Mignot's *Two Figures on a Country Road next to a Cottage* (cat. no. 2) relies on compositions by Meindert Hobbema such as *The Farm* (fig. 9), in which the dense foliage at the

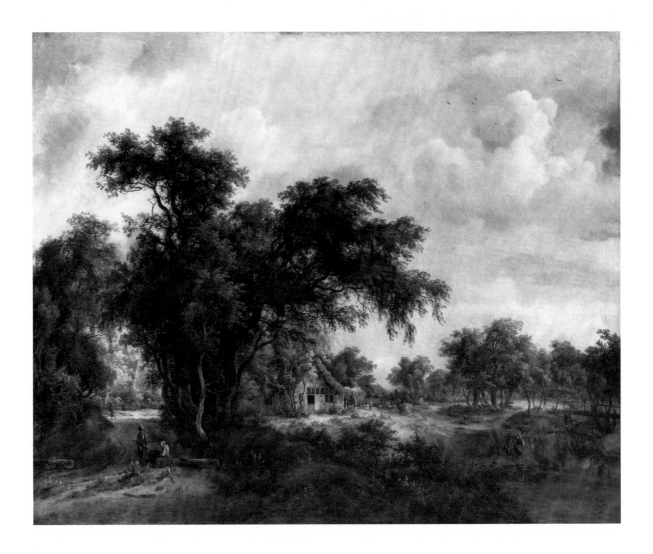

FIGURE 9. Meindert Hobbema, *La Ferme (The Farm),* 1662, oil on canvas, 31 × 40". The Louvre, R.F. 1526. Agence Photographique de la Réunion des Musées Nationaux.

left overhanging the farmhouse gives way to the relatively open space at the right. Following Hobbema, he provides the viewer with two lines of sight: one up the path commencing at the left edge of the picture plane, leading directly into an alley of trees, and the other out to the open space illuminated by rich sunlight at the right. Throughout his career he continued to repeat this double pictorial axis, suggesting that the compositional prototypes first studied at The Hague became deeply ingrained into his artistic praxis.

Another practice that Mignot adopted in Holland was the collaboration with figure painters. A work of this sort is the *Doorway of a Castle in Winter* with figures by Eastman Johnson (cat. no. 8), shown in the Exhibition of Living Masters of 1852 held in Rotterdam. Comparison with a small, related pencil drawing by Johnson indicates the process whereby such pictures were generated, in which Mignot must have conceived and painted the architectural and landscape elements, while Johnson inserted the three figures by the doorway, more or less as

FIGURE 10. Eastman Johnson, *Three Dutch Figures (Study for Doorway of a Castle in Winter,* cat. no. 8), pencil with body color on paper, 6½ × 10⅞". The Brooklyn Museum, Purchased with Funds given by Mr. & Mrs. Leonard L. Milbert, acces. no. 1990.101.6.

he had drawn them first on paper (fig. 10). That they were able to include this painting in the same show where Schelfhout's *Lichtbaak aan de Haarlemmermeer* (Lightbeacon on the Haarlem Lake) also hung suggests that it was held in some esteem by artists and the public alike, and it was purchased by George Folsom, then American chargé d'affaires at The Hague (1850–53). When it was subsequently shown at the National Academy of Design in 1857, however, the critics were conspicuously silent about it.[18] Upon returning to the States, Mignot and Johnson continued their relationship and on at least one known occasion—in the *Street View in Guayaquil* (cat. no. 47)—Johnson sketched on the reverse of the canvas several studies of figures before adding them to the finished picture. They probably were planning a joint image of Washington and Lafayette, which Johnson subsequently abandoned and Mignot continued with Thomas Rossiter. On other occasions Mignot collaborated with figure painters Julius Gollmann and John W. Ehninger, both of whom had been trained abroad. The practice was far more widespread among painters than has been recognized, for in an art world where talents were increasingly specialized, they commonly called upon one another to add a figure here or a tree there. In these works by Mignot, however, his associates are not called upon to add incidental staffage but figures that are integral to the meaning of the picture, and therefore must have been working in a spirit of camaraderie characteristic of their European experiences.

Schelfhout had painted the changing faces of his native land throughout the various seasons, but he was universally favored for his winter views (fig. 11).[19] A comparison between his work and that produced by Mignot while in Holland indicates a definite kinship between master and student. Mignot's lifelong predilection for winter scenes was one aspect of the legacy of Schelfhout and his Dutch training, and closer consideration reveals others as well. Completed within a year or so of his arrival, Mignot's *Winter Scene, Holland* (cat. no. 3) demonstrates his absorption of the motifs of his teacher. The small groups of people gathered on the ice around a horse-drawn sled, the crumbling ruin along the canal, the pollard willow (a tree common along Dutch waterways) laden with snow, and the ubiquitous windmill providing the *genius loci* in the background are familiar as the building blocks

FIGURE 11. Andreas Schelfhout, *Winterlandschap (Winter Landscape),* 1844, oil on panel, 47 × 63 cm. Haags Gemeentemuseum, inv. no. 10-1928.

from which Schelfhout constructed many of his pictures. In another *Winter Scene in Holland* (cat. no. 4), Mignot uses similar motifs but to somewhat different effect as he contrasts the populated sheet of frozen river at left with the womblike opening through the trees at the right, all seen against the bluish tonalities of the late winter sky. These are already competent pictures, although it is difficult to gauge his progress precisely since no earlier work from his Charleston days can be securely identified with his hand.[20] But within the next few years he divested himself of the multiplicity of genre details that contemporaries had valued so highly in Schelfhout's work for the pleasant view they provided of Dutch life. By 1853 Mignot painted *Winter Scene, Holland* (cat. no. 9) and the related *Winter Sunset with Ruined Tower* (cat. no. 10), in which a crumbling tower or silhouetted tree provide the only foil to the atmospheric effects, which occupy the majority of the canvas. The jolly groups of skaters have disappeared, replaced by a solitary figure in the shadow of the building. The handling of the sky as well as the ice, with its glassy, reflective surface, is proof of the technical mastery he had attained. He also studied the distribution of forms in Schelfhout's work, which frequently present bisected compositions where an open, empty, vista contrasts with strong, weighted structures; but the master on other occasions—as in his less-favored summer landscapes— returned to and revitalized the panoramas of the seventeenth century, lowering the horizon and allowing the open sky full reign (fig. 12). These prototypes would serve the American well over the years as an alternative to the Claudian symmetry upon which so many of his com-

patriots relied. In subject and mood he has already begun to strike out in a different direction from that of his teacher. He is more willing to leave the picture empty, more dependent upon light and color than on anecdotal interest.

We can imagine the young student seeking solitude in the boldly horizontal landscape: the meadows or polders with their winding waterways. But he sought out other scenery as well. Further to the east there was another center for landscape painting in Gelderland and nearby Cleves, which offered a change of pace from the polders of The Hague, with its heaths and woods punctuated by picturesque paths and country roads.[21] Although there is no written record of where Mignot traveled during his student years, he, like Schelfhout and others, undoubtedly found his way to the area in and around Gelderland, which probably inspired *Travelers on a Roadside* (cat. no. 6), a canvas depicting a wide expanse of heath bounded at the left by trees and bushes of the types found in that region of the country. The strong

CAT. NO. 3.
Winter Scene, Holland

resemblance detected between his student work and that of the Cleves-based painter B. C. Koekkoek—compare, for example, Mignot's *Pastoral Landscape* of 1853 (cat. no. 11) and a picture by Koekkoek of a few years before (fig. 13)—indicates that they likely had contact. Given the great mobility of all the young artists there, and the easy access not

only to other areas of the Netherlands but also to neighboring countries, it would be surprising if Mignot had not taken advantage of the opportunities for travel outside The Hague. Subjects of Schelfhout's drawings indicate that he toured Germany, France, and England, often accompanied by one or more of his students. That Mignot accompa-

nied him or fellow students on at least one of these sojourns is indicated by the titles of unidentified works such as *Recollections of Germany* and by other paintings that date from this period but clearly represent someplace other than Holland: his *Forest Scene with Waterfall* (cat. no. 1) of c. 1850 falls into this category. Even more difficult to locate geographically is *Hunters in a Deep Wood* (cat. no. 12), which—like the *Skaters on a River* (cat. no. 5)—may represent an idealized or imaginary scene, perhaps derived from literature. Given the considerable number of books of picturesque voyages in Schelfhout's private library, he certainly must have emphasized the value of travel to his students and was perhaps planning to produce such an album himself.[22] Under his guidance, Mignot would have learned how to put his wanderlust to the service of his art.

What influence did the years in Holland leave on Mignot's art? That neither the character nor the duration of his studies with Schelfhout is certain poses one difficulty in making a determination;

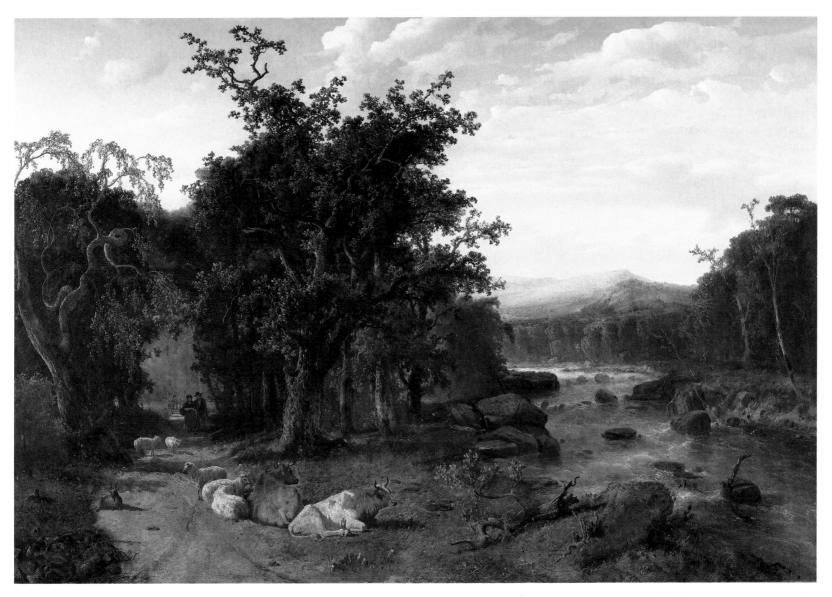

CAT. NO. II.
A Pastoral Landscape

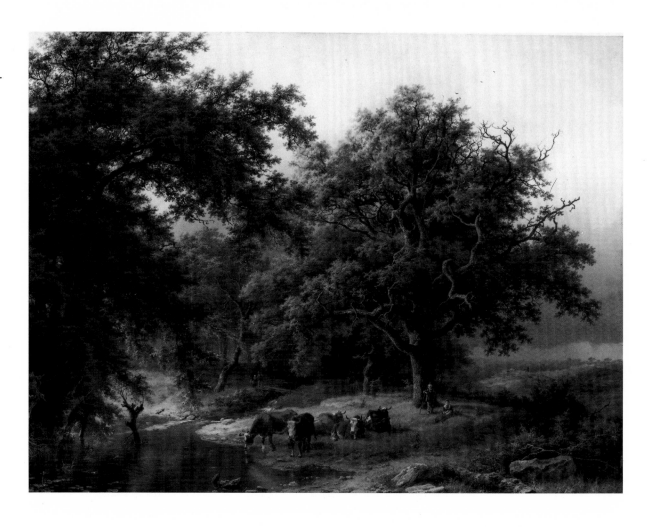

FIGURE 13. B. C. Koekkoek, *Oude eik aan bosrand,* 1849. Haags Gemeentemuseum, inv. no. 1-x-1923.

the absence of pictures from the pre-Dutch years another. It must be supposed, however, that these formative experiences did leave an indelible imprint on his fundamental means of artistic expression, however much place or subject might vary over the subsequent course of his career. Adopting this operative assumption, it is clear that three constant elements in his art were nurtured at The Hague: devotion to nature, a remarkable facility with paint and color, and an attitude toward space that might be considered unique among his American contemporaries. Throughout the critical commentary on his work, the link between the unusual qualities of his art and his sensitivity toward the natural world is repeated. The free-spirited attitude of the training he received there must have left ample time for strolling and hiking outdoors, sketching or just looking. A drawing by his friend Johnson, depicting an artist—as the title indicates—*Sketching at Dongen* (fig. 14), records these on-the-spot drawing and sketching campaigns. This kind of empirical observation in combination with the study of old

Whether Schelfhout looked over Mignot's shoulder on a daily basis, whether the instruction lasted six months or five years, is in the end inconsequential; access to his panoramic pictures (see fig. 12) and those of his seventeenth-century predecessors provided the significant access he needed. For American painters Dutch art has always been the liberating route to a spatial expression more expansive than was provided by Claude, Salvator, or Poussin. The low horizon lines and radiant skies of Fitz Hugh Lane are one measure of that. Mignot's innate temperament ultimately lead him toward a more coloristic and painterly mode than that practiced by Lane and the Luminists, but this common grounding in the art of the Netherlands was critical.[23] He acknowledged his indebtedness to those early days, and specifically the influence of his Dutch teacher, when he exhibited a snow scene with a tropical subject in the Paris Salon of 1870 (ironically, the year of both their deaths), identifying himself in the catalogue as "pupil of Andreas Schelfhout." At the end of five years of study he left for New York, having formulated under the guidance of his teacher his lifelong habit of alternating studio work with outdoor observation. As Tom Taylor noted, "After acquiring from this master the rudiments of technical knowledge, he threw himself with all the ardour of an intense and enthusiastic character into the practise of landscape, and returned to America."[24] Also important, but sometimes overlooked, was the opportunity to live side-by-side with professional painters, to learn not only their techniques but also their very method of existence. He learned, in other words, how to be an artist. And if Eastman Johnson's portrait of him is any indicator, he departed a rather confident one.

and living masters reinforced one another in the methods of art, and it also encouraged practice in the use of materials. The manipulation of pencils, oil paints, and watercolors must have become second nature in five years of observing art all around him. Certainly Mignot's ability to handle color was praised in terms that often verged on disbelief, and confirm a level of ability attained by few of his peers. What is surprising, however, is that it was here Mignot first learned to define his pictures in terms of space rather than of time. This was, after all, the same atmosphere that spawned some of the most insistently narrative of genre pictures (such as those painted by his friend Johnson). Yet over the course of his studies here, he learned to reduce the temporal references. Already in the Netherlands space is becoming the most important element in his work.

Becoming an American Landscapist
Mignot in New York

Sectionalism dominated the American political and social milieu by the mid-1850s. In 1854 the Kansas-Nebraska Act had been put into effect, placing slavery at center stage of the conflict. Allowing citizens of the newly settled areas to determine whether their territories should become slave or free states, it opened the way for the Western Territories to become slave-holding. A substantial segment of the recently founded Republican party in fact came to define slavery not only as a primary issue, but as the sole issue of their platform. This strategy had two likely consequences: the break-up of the Union or Civil War, for as Abraham Lincoln reminded his countrymen in his famous "House Divided" speech, the Union could not survive half slave and half free but would become "*all* one thing, or *all* the other." In May 1856 Preston Brooks, a congressman from South Carolina, bludgeoned Senator Charles Sumner of Massachusetts in the Senate chamber. Sumner hung

between life and death for several days, and he remained an invalid for the rest of his life. The incident stunned the North; Brooks became a hero in the South.[1] This political sensation poignantly conveys the growing split between North and South.

A second social problem plaguing that decade was related to the huge influx of immigrants to the United States—2.5 million between 1850 and 1856—most of whom settled in the North. Immigrants constituted half the population of New York City, the majority of whom came from Germany and southern Ireland. The fear that these newcomers would usurp jobs, resources, and political power all contributed to the surge of antiforeign sentiment, but to the nativists by far the most distressing fact about them was that the majority were Roman Catholics. Before the 1850s the United States had been overwhelmingly Protestant; now the presence of a substantial Catholic minority posed another threat, which resulted in an anti-Catholic nativism. These political issues spilled over into every aspect of American culture; they were especially critical in New York City which—with its cosmopolitan population of 600,000—had become the cultural capital of the country.[2]

This was a precarious moment indeed for a young artist of French Catholic background to come from South Carolina via Holland. In this increasingly polarized climate, Mignot's birthright and his family status as slave owners must surely have been at issue. Also critical, however, was his northern European training, for some of the same xenophobia that dominated the political arena informed the cultural and artistic programs of the American Art-Union and other institutions of artistic patronage and exposition. There is evidence to suggest that Mignot suffered as a result of this prejudice. And third, the specifically anti-Catholic sentiment was another extremely strong social as well as political force in this era; in identifying himself as a Roman Catholic, Mignot aligned himself with what was what was regarded as an antidemocratic, antiprogressive system of belief.[3] It is imperative to consider the ways in which his art negotiated these concerns.

From the moment of his arrival, Mignot was aware of his outside status in birthright, training, and religion, and he continually strove, however unconsciously, to disguise himself in the second skin of his new environment. For a landscapist, this carried with it requisite demands on pictorial style and content. The scenery of New York, his adopted home, was the material whereby he first made his name in America; as Taylor remarked, Mignot "soon won distinction among his contemporaries by his subjects from the river and mountain scenery of New York State."[4] Not long after his arrival, he rented a studio at 497 Broadway and spent that first summer in residence at a Cooperstown hotel.[5] So the young southerner began boldly staking out his claim for membership in the Hudson River School. He cruised the waters of that river and the inland lakes that constituted its established repertoire. His technical facility enabled him to master quickly the region's characteristic seasonal extremes, and "he was particularly successful in his record of the brilliant autumnal and winter effects of North American landscape."[6] He aimed to link himself systematically with its regional associations via local scenery, authors, and gentry, and to do so in a manner consistent with the leading American painters of the day. The process of redefining himself in these specifically northeastern terms of nationalism would preoccupy him, and inform his art, over the next five years.

THE TWO-EDGED SWORD OF EUROPEAN TRAINING

Before 1855, if he was familiar to New York audiences at all, then he was known as a painter of Dutch and occasionally German scenes. As early as 1850 (he was age 19, and in Holland only a year) he had sent at least one painting for consideration to the American Art-Union. *Winter Scene, Holland* was selected for lottery distribution on 20 December. The description of the 36 × 26" work that appeared in their catalogue seems to match a picture, known through a photograph (cat. no. 3).[7] In 1851 he was again in negotiation with the American Art-Union over

one large (5 × 4') and three smaller works (which remained unspecified), but apparently they were rejected. They may very well have been the same ones that appeared at the National Academy of Design in 1853, presumably held over and resubmitted by Gabriel Coit, who acted as an agent for the artist. In any case, the pictures shown at the academy appeared in the catalogue as: *Recollections of Germany; View of the Hague Woods, Morning;* and *Birth Place of Rembrandt.*[8] This evidence suggests that the American Art-Union was not positively disposed toward Mignot's pictures, probably because of their European subjects. That organization's insistence upon national qualities in art paralleled the country's own anxieties about its culturally colonial status at the time. As Elias Magoon phrased it, "the diversified landscapes of our country exert no slight influence in creating our character as individuals, and in confirming our destiny as a nation." Hence the preference for national and specifically northeastern regional subjects.[9] Images such as Mignot's *Birth Place of Rembrandt,* which paid homage to the Old Masters, were hardly in keeping with its artistic program. Similarly, his views of Holland and Germany (cat. no. 15) ran counter to the taste the Union hoped to foster for pride of American place. This clash over foreign versus native subjects might account for the terse tone of Mignot's letter inquiring about the fate of his pictures in 1851, as he perhaps realized the futility of disposing of his Hague-based pictures through them.[10]

European training was a two-edged sword, for on one hand it provided him with the hard-won skills to which he would not have had access in Charleston; on the other hand, it continued to be a cause for complaint in Mignot's art for several years after his arrival in New York. In fact, it was one of the few specific criticisms leveled against him. His entry to the National Academy of Design for 1856, *Fishkill from "Highland Grove,"* was a case in point; while a critic for the *Crayon* complimented "a fine picture by Mignot, no. 180" as "well painted," he criticized what he saw as "evidence of the Dutch school's influence."[11] Others thought that they detected a touch of the Düsseldorf manner.[12]

Given the prevailing attitudes of the day, we can only assume that many shared these expressed opinions. The message was clear. Mignot could not be embraced wholeheartedly as a member of the American landscape school as long as his art manifested these traces of foreign influence. In a chameleon-like way he set about accommodating his artistic persona to his new circumstances. By the following year, he created in *The Sources of the Susquehanna* (cat. no. 27) a canvas declared a completely American picture, in which the talents he had acquired in Europe were more fully synthesized with, and brought to bear upon, the direct observation of American nature.

SEASONAL EXTREMES: WINTER

Winter scenes were a favorite subject throughout Mignot's career. Snowscapes were among his first and last public works, from his *Winter Scene, Holland* (cat. no. 3), painted early in his training and submitted in 1850 to the American Art-Union, to his *Snow in Hyde Park,* mentioned by S. G. W. Benjamin as having been painted in Britain "not long before his death."[13] Given their close links with his European training, and the artist's strong need at that moment to sever those ties and to assert his identity as an American painter, the natural inclination might have been to abandon them, at least temporarily. Instead, however, he accepted the challenge head-on: in 1856, as he was becoming settled in New York City, he painted a series of North American winterscapes (cat. nos. 19–23) that forced his critics to sit up and take notice of the advance in and Americanization of his style.

Comparison with snow scenes by other artists, and with Mignot's own earlier versions of similar subjects, helps to identify the truly distinctive features of these works. Consider *Winter, Close of Day* (Cleveland Museum of Art) by George Inness, who filled his picture with color caused by special lighting situations. Twilit skies—like the bright blue ones with bold cloud patterns utilized by other artists—provide

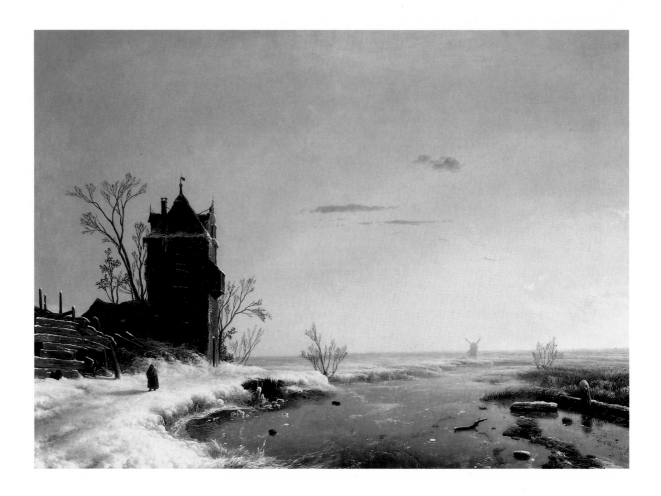

visual interest. Mignot relied on this technique in *Winter Scene, Holland* (cat. no. 9), an extraordinary work for an artist of twenty-two. Two-thirds of its surface is devoted to sky, filled with wonderful gradations of pink, orange, and yellow. The Dutch influence is very much in evidence in this characteristic compositional division, in the treatment of ice, in the reliance on a strong architectural form as a foil against the low horizon line, and in the stylized tree in the manner of Schelfhout. By 1856, however, he had begun to synthesize his Hague training and his more recent experiences in North America, evident in works such as

Snow Scene (cat. no. 22). In the company of Hudson River School confreres, he was observing nature more closely and imitating art less. Moving away from the open horizontality of the Dutch view in *Winter Scene, Holland* or the related *Winter Sunset with Ruined Tower* (cat. no. 10), he leads from the same icy foreground meeting the lower edge of the frame into a gentle progression of hills to low-lying mountains. But whereas in the earlier work he had offset the monochromatic, relatively inactive areas of ice and snow below with an impressive chromatic display above, here he is rather more daring. The white foreground cover-

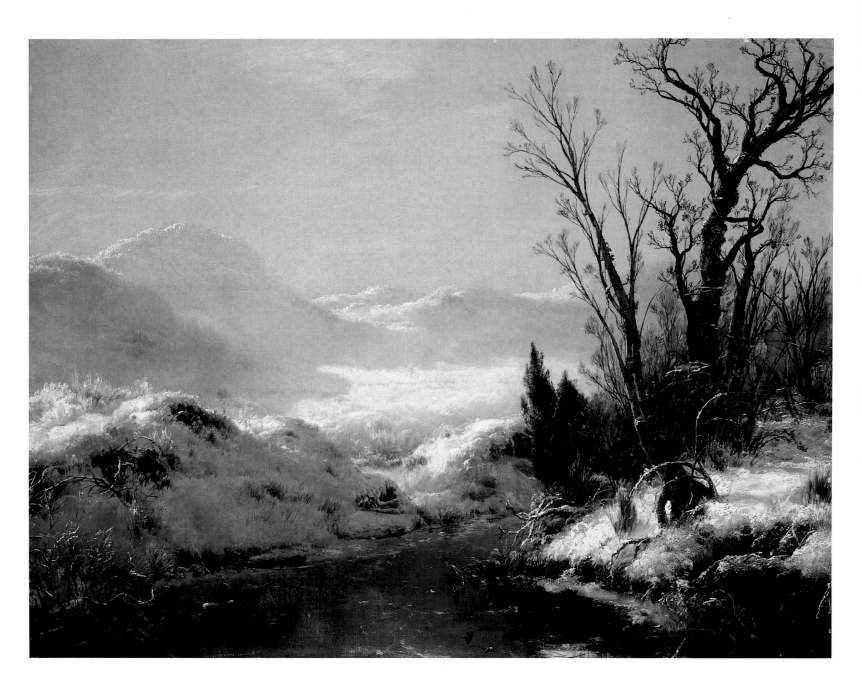

CAT. NO. 22.
Snow Scene

FIGURE 15. Harley, after Mignot, *A Winter Scene.* From *Harper's New Monthly Magazine* 59 (July 1879): 256.

included an appraisal of Mignot in his retrospective analysis of American art, he reproduced an engraving (fig. 15) after the drawing in Church's collection, so closely associated were these winter scenes with his name.

On a visit in February 1856 to the studios in the Art-Union building, a writer for the *Home Journal* reported that "Mignot . . . is painting a large and impressive winter-scene,"[15] likely referring to the *Winter Scene* (cat. no. 20) completed and dated later that year. It and several other pictures in this group, presumably done around Newburgh, on the Hudson, looking west to the hills; in them the artist experimented with the addition of a stone wall and a figure, which introduce a possibility for narrative content that is not fully resolved. *Winter View from Newburgh ("Souvinir d'Hivir" [sic])* (cat. no. 19) and *Winter Scene* depict extensive stone walls crossing a mountain clearing. They and the *Winter Landscape* (cat. no. 21) include a lone figure. In *Winter View from Newburgh,* the stocky figure, dressed in red—presumably a country woman—stands with open mouth and raised hands in a manner that suggests she is trying to call someone; but to what end? In the other two canvases her mouth is closed, her arms down, but her presence is no less puzzling. She seems to have appeared in the midst of this landscape out of nowhere, standing on the edge of the dark forest from which she must have emerged (no path or footprints suggest alternative readings). The stone wall, with its opening lined up on the central axis of the picture, suggests a boundary through which she will pass, but no more is decipherable.

The completion and sale of *Winter View from Newburgh* to Magoon was undoubtedly one of the artist's first important transactions in New York City. It must have passed immediately from the artist's easel to its new owner, for in December 1856 it was listed among the collector's holdings of "sketches and pictures in oil" by American landscapists that included Church, Cropsey, John W. Casilear, Samuel Colman, Thomas Doughty, Durand, Régis Gignoux, William Hart, Inness, Johnson, Kensett, Walter M. Oddie, William Trost Richards,

ing is little differentiated from its backdrop of snow established by the hills in the middle distance, both of which are seen against a white wintry sky. Close inspection of the hills at left reveal just the tips of grass on the hillside poking through the thin crust of snow, thus providing the barest contour. Only the brush and leafless tree silhouettes at right break up the field, enriching the surface with their subtle nuancing of green-browns. Neither human figure nor man-made form breaks the field. The result is an exercise in tonal contrasts, a study in white-on-white. A related drawing owned by Church demonstrates Mignot's attempts to achieve similar effects with quick squiggles and feathered layers of white chalk on paper (cat. no. B). We can well understand why Mignot's winter pictures were the coveted possessions of astute collectors such as Elias Magoon and William T. Blodgett and fellow-artists including Kensett and Church.[14] And in fact when Benjamin

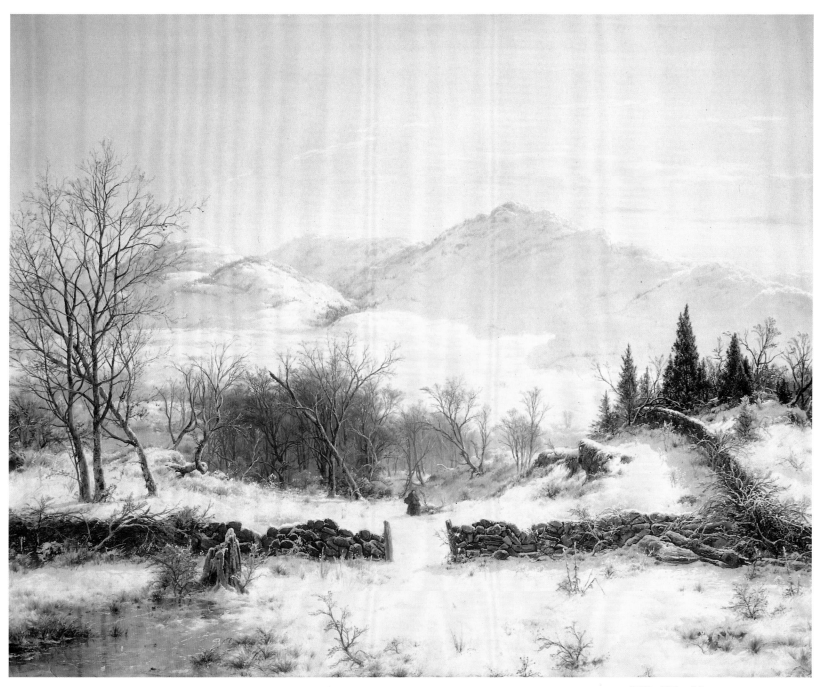

CAT. NO. 20.

Winter Scene

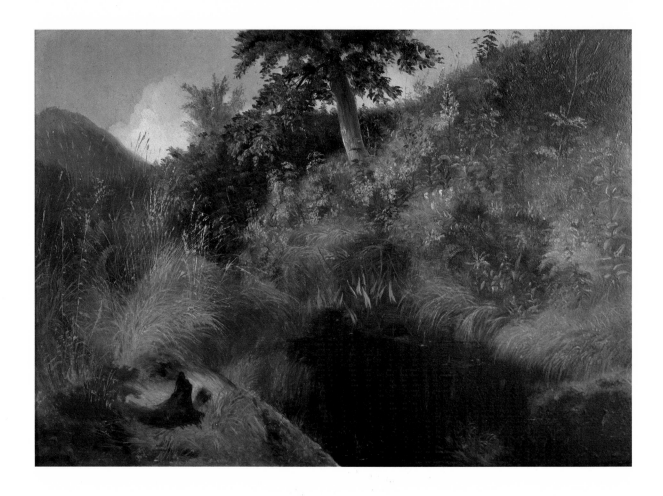

and Aaron D. Shattuck.[16] The painting's small size, the fact that it is on wood panel (one of the few works by Mignot on a wood support), the misspelled inscription that reads "Souvinir d'Hivir," and the immediacy of the freshly observed scene indicate that it was done on-the-spot. The work's resemblance to a larger one of the same year (cat. no. 20) suggests that it was a preparatory study. The link between the winter subjects and Magoon is telling, for in an essay entitled "Scenery and Mind," published in *The Home Book of the Picturesque*, Magoon articulated the common argument that scenery shaped national character,

defining it in specific northeastern terms. He supported his general observations with reference to Daniel Webster, who had been raised in alpine New Hampshire, "where all is cool, colossal, and sublime." Immersing himself in the rigorous conditions of winters in the Northeast, Mignot was able to overlay the enervating effects of sultry heat that were associated with the moral decay of his native Carolinas with the invigorating qualities of these snowy climes.[17]

His snowscapes fall, as his work generally does, somewhere in the artistic spectrum between Hudson River realism and aestheticism. He

invites comparison with Gignoux, who made something of a specialty of winter scenes. The older, Brooklyn-based artist was in Europe during 1856–57 and would have become an associate of Mignot's as fellow tenants in the Tenth Street Studio Building the following year. There must have been a competitive element in their relationship, for Mignot excelled in a specialty Gignoux had carved out for himself in an increasingly crowded landscape market. But Mignot's subtle handling also anticipates that achieved by John LaFarge in his extraordinary group of snow studies from the mid-1860s. His *Snow Storm* (1865; private collection), for example, has almost nothing for its subject—a single scrub oak on a snow-covered hillside—yet the delicacy of contrast of the purple-blue shadows and the browned vegetation against the white provide more than sufficient interest. And so it is with Mignot, whose snowscapes provide little in the way of narrative interest (his attempts to do so in fact prove distracting) but instead tell the story of nature's moods and cycles in their own fashion. As is evident in this sequence of winterscapes, the mannerisms that critics had termed "Dutch" or "Düsseldorf" were gradually being replaced by a softening of painterly touch and greater subtlety of tone. This stylistic metamorphosis, motivated in part by a desire to "belong," was undoubtedly enhanced by sensitive observations of his new surroundings. The lessons practiced in the snowscapes were by no means limited to them and can be detected in his renderings of other, sometimes modest subjects from this moment such as *The Old Bog Hole* (cat. no. 18).

ALONG THE BANKS OF THE HUDSON

The sketching forays made along the Hudson after his arrival led to *Fishkill Mountains: from "Highland Grove"* shown at the National Academy in 1856.[18] This was not technically speaking his debut, since works sent back from Holland had been seen there a few years before. Now that he was on the scene and trying to establish himself, however, pub-

lic response took on a different importance. And as he was probably learning quickly, choice of subject had a different resonance in Holland than it did with this new audience, for whom scenes rich in national overtones were the order of the day. The newcomer needed to acquaint himself with the specific character of the greater New York area and with its literary and historical associations. Highland is located along the Hudson just north of Newburgh, in an area known for its apple orchards or groves, so the title may refer to the physical qualities of the site.[19] What prompted him to paint first in this area, and to feature it at the academy?[20] It was comfortably reached from the metropolis, but the actual appeal was more than just ease of access. *The Home Book of the Picturesque*—published a few years before, in 1852— included a chapter on "The Highland Terrace above West Point" by Nathaniel Parker Willis, which sang the general praises of country areas within easy access to cities and the benefits to be derived from the combination of town and country life. Predicting that the Hudson, as far as West Point, "will be but a fifty-mile extension of Broadway," he identified "Highland Terrace" and Fishkill as advantageous locales: "The river-side length of the Terrace is about five miles—Cornwall at one end and Newburgh at the other. At both these places are landings for the steamers, and from both these are steam ferries to the opposite side of the river, bringing the fine neighborhoods of Fishkill and Cold Spring within easy reach."

Durand's name was closely associated with this area. Willis noted him among a number of distinguished residents:

> Newburgh is the metropolis of [Highland] Terrace—with its city-like markets, hotels, stores, trades and mechanic arts—an epitome of New-York convenience within the distance of an errand. Downing, one of our most eminent horticulturists, resides here, and Powell, one of the most enterprising of our men of wealth; and, along one of the high acclivities of the Terrace, are the beautiful country seats of Durand, our first landscape painter; Miller, who has presented the

neighborhood with a costly and beautiful church of stone, Verplanck, Sands, and many others whose taste in grounds and improvements adds beauty to the river drive.[21]

Durand completed at least two views of the area that same year: *Fishkill Mountains, New York Hudson River* (Peabody Institute of the City of Baltimore; on extended loan to the Baltimore Museum of Art) and *View of the Fishkill Mountains* (New-York Historical Society). It is tempting to speculate, therefore, that Mignot might have visited there at Durand's invitation or was guided by him in discovering the charms of the area.

In addition to its esteemed residents and its salutary climate, Highland Terrace was also noteworthy because "it is *the spot on the Hudson where the two greatest thoroughfares of the North are to cross each other.*"[22] The intended route from Boston to Lake Erie here intersects the rail-and-river route between New York and Albany. It combined all the advantages of rural life with those of home.

> We take pains to specify, once more, that it is to a certain class, in view of a certain new phase of the philosophy of life, that these remarks are addressed. . . . for those who have their time in some degree at their own disposal—who have competent means or luxurious independence—who have rural tastes and metropolitan refinements rationally blended— . . . for this class—the class, as we said before, made up of Leisure, Refinement and Luxury—modern and recent changes are preparing a new theory of what is enjoyable in life. It is a mixture of city and country, with the home in the country. And the spot with the most advantages for the first American trial of this combination is, we venture to confidently record, the HIGHLAND TERRACE encircle in the extended arm of the mountains above West Point.[23]

I discuss this locale at length (in spite of the fact that the picture itself remains to date unlocated) because in it Mignot basically defined the class of subject that in one form or another would frequently preoccupy him thereafter. He favored the interstices between civilization and wilderness. He was *not* by temperament a painter of wild and untamed nature; in this he diverged sharply from Bierstadt and Church. However, he only rarely explored the coastline that so captivated his friends Kensett and Suydam. He preferred to follow the rivers, paths of commerce and settlement, and felt more comfortable in the open meadows or lagoons than he did at sublime mountain heights or along the seacoast. In that sense he asserted a certain contemporaneity. These features were, in effect, what defined Mignot's art and the stratum of society who found it attractive. They were middle- and upper-middle-class urban dwellers, many of whom were either medical and dental professionals or businessmen connected with shipping and transport.

As a subject, then, Fishkill was of its moment: situated on a potentially critical transportation thoroughfare, anticipating the suburban mentality, and linked to Durand and Andrew Jackson Downing, contemporary leaders in defining attitudes toward nature. About 1855, however, the parameters of American landscape art were still in flux; Durand's "Letters on Landscape Painting" preached the importance of going directly to nature, and yet Cole's insistence on higher inspiration was still fresh in the public mind.[24] Perhaps, too, the southern penchant for literary associations was still strong in Mignot. Whatever the reason, the pull of James Fenimore Cooper was powerful. Pushing further upstate from Newburgh and Fishkill, he headed to Cooperstown, where census records place him by 20 June 1855.

JAMES FENIMORE COOPER AND COOPERSTOWN

Cooperstown lies at the southern end of Lake Otsego, an important component of Cooper's life and of his fiction. Over the years it grew in symbolic importance in direct proportion to his disillusionment with the society who lived on its shores. This lake that he named "The

Glimmerglass" figured prominently in three of his novels. It provides only background scenery in *The Pioneers* (1823) whereas in *Home as Found* (1838)—written upon his return from Europe—its waters are treated with affectionate nostalgia. Finally in *The Deerslayer* (1841), the last of the Leatherstocking tales, it is the focus of an adventure acted out on its surface and immediate shores. By setting his story at a time before permanent white settlement in 1745, Cooper rid himself of the quarrelsome inhabitants of his fictional village of "Templeton." Mignot's paintings followed a similar progression over an abbreviated time frame: he moved from the precise rendering of its topography and leading citizens in *Cooperstown from Three Mile Point, Otsego Lake, New York* (cat. no. 16) and *Lake Party at Three Mile Point, Otsego Lake, New York* (cat. no. 17) to *Sources of the Susquehanna* (cat. no. 27), where he too moves back to presettlement days, to a place and time yet untouched by the advance of civilization.

In *The Chronicles of Cooperstown*, Cooper wrote, "Lake Otsego is a sheet of limpid water, extending . . . about nine miles, and varying in width from about three quarters of a mile to a mile and a half. It has many bays and points, and as the first are graceful and sweeping, and the last are low and wooded, they contribute to its beauty."[25] His attention to the points is telling, for no spot on the lake had more associations with Cooper than Three Mile Point. It is there that Mignot took up residence in the summer of 1855 at the public house run by James Gooding. From this vantage, the artist made the sketches and studies that soon culminated in two important works.

In *Cooperstown from Three Mile Point* (cat. no. 16), Mignot created a visual testimony to the well-being of the town that the Cooper family had helped to found, evident in the neatly ordered buildings on the far shore and in the cultivated lands that surround it. The town itself has been brought closer than it would actually appear from Three Mile Point, allowing identification of several houses. There is little doubt that this is a portrait of a prosperous upstate New York village, punctuated with church steeples and anchored by a number of substantial structures. The financial basis of its existence is also indicated in the groomed fields of alternating greens belonging to the local farms and estates that ring the town, and framed by the woodlands beyond, still to be cleared. The townscape in the middle distance is balanced by the wedge of land in the immediate foreground, where there is visible a corner of a field of hops, a crop that was just beginning to contribute to Cooperstown's economy. And, in fact, if the artist still found himself there in early September, he could have attended the Hops Dances held Friday evenings throughout the month at the Three Mile Point House, his hotel. This early example of Mignot's American oeuvre hints at a sensitivity he demonstrated throughout his career to regional habits, customs, and cultures.

On the road that runs alongside the hops field and that leads to the hotel, there is a red-bearded man just at the threshold of the picture who moves forward almost in an attitude of welcome. He has been identified as Judge Levi C. Turner, one of Cooperstown leading residents and owner of one of the houses seen in the painting.[26] He appears characteristically attired as an angler, for his love of "trouting" was well-known through his articles in local newspapers and his "Auto-Biographic." His presence then provides a gloss on the entire image: he is not a fisherman who must actually support himself by these activities, but a prominent judge who dons this costume for his leisure pursuits.[27] A similar message is conveyed in the sailboats on the water. Before 1850 sailing craft were few and primitive; but thereafter, as the town grew increasingly comfortable, many were built for private and public use and the lake became dotted with them. Through every detail of the picture, Mignot reinforces the image of a prosperous town on a warm, sunny day, in complete harmony with its natural surroundings.

Closely related to *Cooperstown from Three Mile Point* is *Lake Party* (cat. no. 17), in which the figures of the townspeople in the foreground now take precedence over the contours of the town, which recede obligingly into the distance. For this canvas Mignot collaborated with Julius Gollmann, a German-born painter who had emigrated from

FIGURE 16. Henry J. Harden-burgh, key to figures depicted in Mignot's *Lake Party*. 1. Robert Campbell. 2. Miss Julia Crafts. 3. Oliver Morse. 4. Theodore Keese. 5. William H. Averell. 6. William W. Campbell. 7. Hiram Kinne. 8. Alfred Beach. 9. Kenneth G. White. 10. Miss Mann. 11. Rachel Prentiss. 12. Henry B. Scott. 13. George W. Ernst. 14. Frederic A. Lee. 15. Joseph L. White. 16. Samuel Nelson. 17. L. C. Turner. 18. Gen. Brown. 19. Henry J. Bowers. 20. Col. J. H. Prentiss. 21. Alfred Clarke. 22. John R. Worthington. 23. Barkeeper. 24. George A. Starkweather. 25. David H. Little. 26. Joseph Thomas Husbands. Collection, New York State Historical Association, Cooperstown, N.Y.

FIGURE 17. Unidentified photographer, detail of a carte de visite of a lake party, c. 1850s. Collection New York State Historical Association, Cooperstown, N.Y.

FIGURE 18. Unidentified photographer, *Portrait of Joe Tom (Joseph Thomas Husbands)*, after 1850. Collection New York State Historical Association, Cooperstown, N.Y.

ration he had made portrait studies from life of every individual but two to appear in the finished work, including William W. Campbell and Samuel Nelson, from nearby Cherry Valley, who subsequently appear in *Lake Party*. This suggests that they were instrumental in Gollmann's visit upstate and possibly in the actual commission of the picture. Notices in the local *Freeman's Journal* announced his availability to do portraits in the summers of 1854, 1855, and 1858, when he was staying at the Empire House (owned by Mr. Brown, whose likeness is also included in *Lake Party*). During the summer of 1855, perhaps by previous arrangement, Gollmann and Mignot began work on the project, which must have continued in New York City that fall and winter. By February 1856 the *Crayon* reported, "Mr. Mignot has also made a number of very interesting studies from nature, in the vicinity of Cooperstown, N.Y. They are characterized by an evidently faithful study, and a decided love for the objects chosen." [28] And in the same month, on a visit to the Art-Union building, a writer for the *Home Journal* reported in February 1856 that Mignot "has a felicitous view of Cooperstown."[29] The picture is a fascinating document of the artists's absorption in "Cooper country," the meaning of which is only beginning to be unraveled.[30]

Three Mile Point is a low, wooded tongue of land on the western shore of Otsego Lake, so-named in reference to its distance from Cooperstown. From early in the town's history it was a favorite resort for picnics and boating parties of the sort depicted here; on one level, then, it is a genre-portrait of life in mid-nineteenth-century Otsego County. But given the specificity of the place depicted, the relation of this site to Cooper, and the identity of the townspeople assembled here, it is possible to discern a more pointed social and artistic agenda underlying it. When in 1834 Cooper returned from Europe to the village, he found that the free use of the Point by the populace had given rise to the notion that it was community property. He went to great pains to correct this misconception: first insisting that it was owned by the descendants of Judge William Cooper (of whose will he was the

Hamburg about 1849 and visited Cooperstown during several summers in the 1850s in search of portrait commissions. Exactly how the collaboration evolved remains a mystery. Gollmann had painted an earlier group portrait of the *Distinguished Americans at a Meeting of the New-York Historical Society* (New-York Historical Society) in 1854. In prepa-

executor) and eventually warning the public against trespassing on Three Mile Point. The townspeople rose up in protest against the author's "arrogant pretensions" in "denying to the citizens the right of using [Three Mile Point], as they have been accustomed to from time immemorial, without being indebted to the LIBERALITY of any one man, whether native or foreign."[31] This represented an odd reversal on the part of Cooper, subsequently attributed to his disillusionment with Jacksonian democracy. Indeed, Cooper's words began to resemble Judge Temple's assertion of land rights in *The Pioneers,* and the railings of the townspeople against Cooper sounded as if they were plucked out of the mouth of Leatherstocking.[32] But Cooper was not to be dissuaded from what he regarded as the righteous course of action. The results of the controversy were far-reaching, including a long series of libel suits and Cooper's unfortunate book *Home as Found,* in which he laid out the principles involved in the Three Mile Point controversy. He died in 1851 and Otsego Hall, his home, burned down in 1853. The subsequent real estate transactions, recorded in the lawsuit, were determined by William Cooper's will: the land was leased by the Village Improvement Society and in 1899 sold outright to the town. By the time Mignot and Gollmann visited there in 1855, Three Mile Point had become a symbol of the tensions between Cooper and the town, a fact of which the artists could not possibly have been unaware, given their involvement with the principal actors in the drama.

A key, subsequently drawn up by Henry J. Hardenburgh—an architect who worked for local resident Edward Clark—allows identification of the participants gathered for a lake party (fig. 16). These occasions—traditionally held at Three Mile Point—were a prominent feature of the area's social life, as depicted in a contemporary carte de visite (fig. 17). They were held on major holidays or in celebration of events of local significance; whether the painting commemorates an actual gathering at one of these times or constructs an imaginary one is not known. These parties followed a prescribed ritual, the details of which were enumerated in private diaries and published journals. The

first order of the day was to transport the participants from the town out to the point. In Mignot's time this was accomplished by the freedman Joseph Thomas ("Joe Tom") Husbands (fig. 18), who appears at the far right of the painting by the campfire, the only African American in the scene. Although rumors circulated that he had been a former slave of the Cooper family, he more likely came to the village at a young age with the Husbands family and grew up there. He was a jack of all trades, "the factotum of many a social party—would freeze the ice cream, attend the door, wait on the table, and finally speed the parting guests." As long legend had it, he was indispensable to a successful boating party: "No picnic was complete without him. He would furnish the hands and row the scow to the Point, then clean the fish, stew the potatoes, make the coffee and announce the meal. Rowing back in the cool of the evening he would awake the echoes of Natty Bumppo's Cave for the entertainment of the company."[33]

The artists seem to have captured the group in mid-festivities, with figures frozen, interrupted in their socializing. In this the canvas seems to share something with the Dutch group portrait tradition, with which Mignot and Gollmann would certainly have been familiar from their training in northern Europe. In the background men and women stroll down along a path in the woods at the right, others move toward the cabin for dancing, without indicating any clear action. Perhaps following the lead of Hals or Rembrandt, Gollmann grouped the foreground figures in a manner that provides some clue to their relative significance. Many of these men are either lawyers or judges. Two groups stand out from the "line-up." One is the pointing man and the couple accompanying him at the far left , perhaps a humorous play on the name of the point.[34] The second is the group of three figures in the center, two of whom are the only gentlemen in the entire group to appear without hats.

At left is Hon. Joseph L. White, M.C., who seems to defer slightly to the other two.[35] Judge Turner, who had appeared in *Cooperstown from Three Mile Point* (cat. no. 16), stands at the right. Known locally

as the editor of the *Otsego Republican* for over sixteen years, he was county judge from 1855 to 1862, when he became judge advocate in the War Department. The Honorable Samuel Nelson, in the center, holds the key to the picture. He settled in Cooperstown in 1824 and served as a local justice. Nelson later acquired Fenimore Farm, and even after he went on the state and federal supreme courts, he continued to summer in Cooperstown for the rest of his life. (He also appears in Gollmann's New-York Historical Society painting "The Knickerbocker Birthday" of 1854.)

With their companions they make up a gathering of the powers of jurisprudence in Otsego County. These individuals were involved in various ways in the dispute over the use of Three Mile Point. Their joint presence in this place emblematizes, in essence, many of the themes Cooper had developed in his novels involving land rights and settlement: issues of collective ownership and the dilemma between common property and property rights of private individuals. The picture portrays a community in conflict with its most famous native son, proud of his achievements but dismayed and disillusioned with his efforts to bar them from property that they believed they shared as neighbors. In the end Judge Nelson helped to end the controversy, and to heal the village's wounds, by facilitating its shared use. *Lake Party* served as an expressive vehicle for the legal agenda of the citizens of Cooperstown, celebrating collective over individual property rights. And here the presence of Joseph Thomas Husbands becomes intriguing, raising the issue of the property rights of African Americans, who then constituted a substantial portion of the community. It stands as pictorial testimony to the happy fact that the townspeople could once again enjoying undisturbed a lake party at Three Mile Point.

This painting and its companion piece not only fulfilled the social agendas of the locals but they also served the artists who created them. Neither Mignot nor Gollmann was from the Otsego area; in fact, both had recently come from Europe. Their attraction to this regional subject was based on the demands of their own careers at that moment: to establish for themselves a native base, to appeal to the New York public. In the shortest practical time, Mignot was trying to achieve the goal he must have set for himself while still a student in Holland: to become assimilated into the American art world. And he was not taking any chances. In choosing a Cooper-related subject, he was moving into the territory already proven by Morse, Doughty, and Cole, forefathers of the national school whose presence was still strongly felt. Interest in Cooper was in the air in the wake of his death, as the petty feuds of the man receded and the myth emerged. In style, Mignot also demonstrated a change. He now creates landscapes cast in the canonical mode of the mid-1850s—Claudian breadth combined with near detail. That is, he is paying homage through not only the subjects but also the visual language most appropriate to the founders of the American school. He would rely on this technical strategy at several junctures in his career: he assimilates the prevailing mode without direct emulation, thus personalizing it. His efforts here, to project an absorption of the Hudson River School mode updated to the style of the reigning leaders Church and Durand seemed to have paid off. As a critic commented of his work from upstate New York: "Mignot succeeds in happily combining Church's style with his own."[36]

Sources of the Susquehanna

By critical consensus Mignot's major picture of 1857 was *Sources of the Susquehanna* (cat. no. 27), and yet we are probably still lacking the primary version.[37] Even here, the presence could be felt of Frederic Church, who had painted an early view of *Rapids of the Susquehanna* (fig. 19). The longest river in the Eastern United States, the Susquehanna runs a twisted course through New York and areas of Pennsylvania before emptying into the Chesapeake. It rises in Otsego Lake, whose shores Mignot had painted the previous year. Continuing to draw upon regional and national sentiment, he here represents a deepening

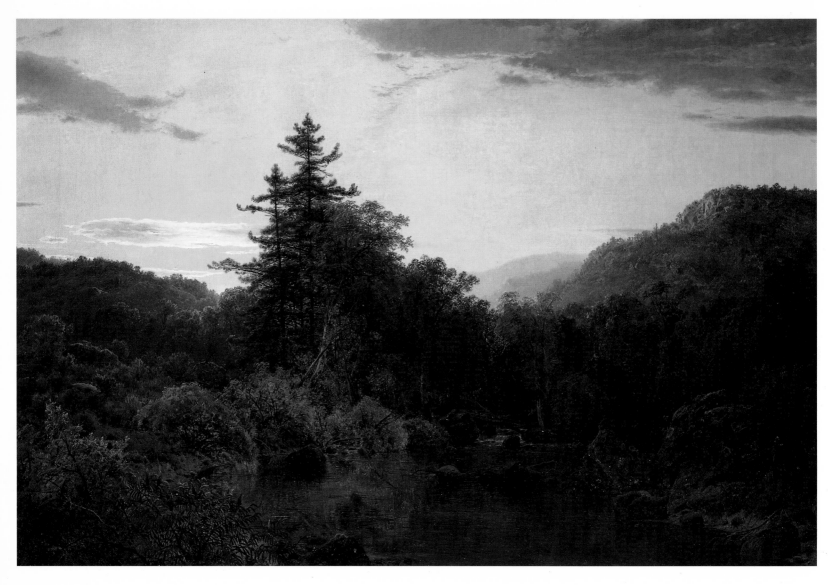

CAT. NO. 27.
Sources of the Susquehanna

of his engagement with the fiction of Cooper, for as its title indicates, it derives directly from *The Pioneers, or the Sources of the Susquehanna; A Descriptive Tale* (1823). Characterized as "peculiarly a painter's novel," it had provided material for painters since Thomas Doughty exhibited

two (unidentified) landscapes from the novel at the Pennsylvania Academy of the Fine Arts only a year after its publication.[38]

But why did Mignot turn to it in 1857? He must have returned and spent additional time there after his summer on Three Mile Point, for

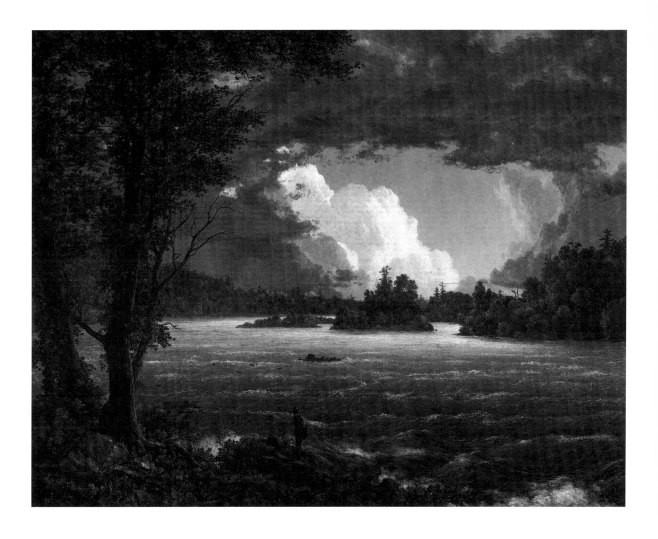

FIGURE 19. Frederic E. Church, *Rapids of the Susquehanna*, oil on canvas, 22¼ × 30³/₁₆". Courtesy Wadsworth Athenaeum, Hartford, Conn.

as the *Crayon* noted in February 1857: "Mr. M's studies have been confined to various localities in Otsego County."³⁹ A small picture, *Mountain Landscape, Otsego County, New York* (cat. no. 26) may very well be one of the studies referred to, since it relates closely to the larger work. Compared to his earlier trip, however, this time his attention shifted from the highly public location on the shores of the lake to its secluded and anonymous origins described in the opening lines of the novel:

Near the centre of the State of New-York lies an extensive district of country, whose surface is a succession of hills and dales, or, to speak with greater deference to geographical definitions, of mountains and valleys. It is among these hills that the Delaware takes its rise; and flowing from the limpid lakes and thousand springs of this region, the numerous sources of the Susquehanna meander through the valleys, until, uniting their streams, they form one of the proudest rivers in the United States.⁴⁰

It is as though Mignot, like Cooper, turned his back on the contemporary inhabitants of the region whom Gollmann had portrayed and traveled back in time to the presettlement period. Here the epigraph to Cooper's seventh chapter, excerpted from "The Indian Student" by American poet and journalist Philip Morin Freneau, may have further inspired him:

> From Susquehanna's utmost springs,
> Where savage tribes pursue their game,
> His blanket tied with yellow strings,
> The shepherd of the forest came.[41]

This spirit of the native peoples is implied the landscape that Mignot had deliberately left empty, inhabited by neither race. As Roger Stein has convincingly demonstrated, Mignot's conception of the Susquehanna as unsettled ran contrary to its more usual portrayal as a settled landscape, a land reclaimed from the wilderness and adapted for human use.[42] The river that in the canvases of other artists appeared an important transport link is traced to its origins in a dank pond. Mignot, we know, was well aware that the region was becoming increasingly populated; in fact, his pictures of Three Mile Point celebrated the degree to which civilization had already triumphed over wilderness. Here, however, he goes back to the moments yet unspoiled by people. It represents his meditation on the interaction of civilization and wilderness, as they found expression in Cooper.

In *The Pioneers* the opposing sides of the social question are represented by two main characters. Judge Temple, squire of the territory and its legal and social spokesman, represents the settled landscape against the Leatherstocking Natty Bumppo, defender of the forest against the ax and the plough. Through them Cooper asks whether the benefits of a tamed landscape outweigh the loss of the natural world, the handiwork of God. In his painted responses, what does Mignot

conclude? The meaning of *Sources of the Susquehanna* remains ultimately ambiguous, for while the lower register of the forest is overgrown and engulfed in shadow because the sun cannot fully penetrate the intertwined foliage, enough of the filtered light gets through to kiss the land with a wonderful rich glow. Thus it can be characterized neither as an idyllic landscape, sunny and inviting, nor as a troubled and brooding vision. The answer, like the question, was a deeply conflicted one for Americans in 1857. In the very act of posing it, the artist was knowingly inserting himself into a debate that was in the forefront of the public consciousness. Resisting simplistic resolution, the picture was much appreciated over the long term. It apparently existed in several versions. The painter and collector James Suydam acquired one, which was exhibited at the National Academy of Design and the Pennsylvania Academy of the Fine Arts; it remained in his collection until his death in 1865, when it was bequeathed to National Academy. New Jersey shipping magnate and collector William P. Wright acquired another and probably larger composition of the same subject, which upon the break-up of Wright's estate fell into the hands of art dealer H. W. Derby, who lent it to the American exhibition at the Paris Exposition of 1867. The words of one critic summarize the effect it had on Mignot's audiences:

> A grand production. This is, perhaps, the most powerful, deeply *American* landscape in existence, after Church's *"Niagara."* Others may paint what may be termed cosmopolitan scenes, but here the artist has dipped his brush in the "colors of America," stern and rough-hewn as her face is and hard as a sculpture in bronze, but none the less true to nature,—with its evergreens which are hardly ever quite green, its deep brown streams, and its skies blurred and blotted, as it were, with lumps of cloud edged with fire. The man who draws such treasures out of his country and plants them to her honor is fit to rank with the author of *Hiawatha* among Americans, or the painter of *Ismaila* among Frenchmen.[43]

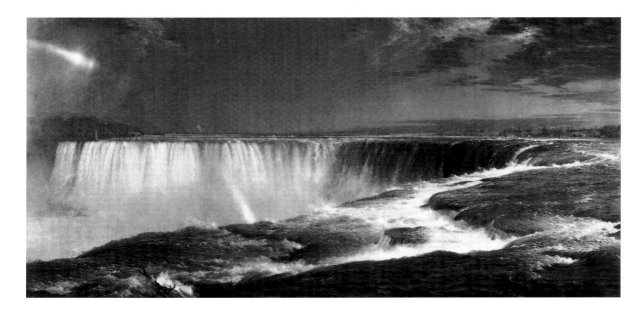

FIGURE 20. Frederic E. Church, *Niagara*, 1857, oil on canvas, 42½ × 90½". The Corcoran Gallery of Art, Washington, D.C., Museum Purchase, Gallery Fund.

The comparison to his fellow artist reminds us that *Sources of the Susquehanna* was completed and exhibited almost simultaneously with Church's *Niagara* (fig. 20), which cinched his fame and became a national landscape icon. But whereas the bravura of Church's work is born of his confidence that by depicting the great falls of northeastern United States he is depicting America, Mignot's is more subversive in its reminder that the country was made up of both North and South, as the very course of this largest river in the Eastern United States manifests. For the Susquehanna links the interior regions of upstate New York with Maryland and the Chesapeake Bay, running a path from North to South. Bayard Taylor, Mignot's mutual friend through Church, had meandered its waters in early summer:

> The first fifteen miles led through a lovely region of farms and villages—a country of richer and more garden-like beauty than any which can be seen this side of England. The semi-tropical summer of Southern Pennsylvania and Virginia had just fairly opened in its prodigal splendor. Hedge-rows of black and white thorn lined the road; fields were covered, as with a purple mist, by the blossoms of clover; and the tall tulip-trees sparkled with meteoric showers of golden stars. June, in this latitude, is as gorgeous as the Indian Isles.

For him the boundary between Pennsylvania and Maryland (surveyed by Charles Mason and Jeremiah Dixon from 1763 to 1767 and thereafter regarded as the line of demarcation between the North and the South) was inscribed in nature itself:

> As the hills, however, begin to subside towards Chesapeake Bay, the scenery changes. The soil becomes more thin and sandy; the pine and the rough-barked persimmons supplant the oak and elm; thickets of paw-paw—our northern banana—and *chincapin* (a shrub variety of the chestnut) appear in the warm hollows, and barren tracts covered with a kind of scrub oak, called "black jack," along the Eastern Shore, thrust themselves between the cultivated farms. Mason

CAT. NO. 28.
Autumn (I)

and Dixon's line seems here to mark the boundary between different zones of vegetation. The last northern elm waves its arms to the first southern cypress.[44]

The picture was born in troubled political and economic times. From the Dred Scott decision to open warfare in Kansas, from the financial panic to President Buchanan's disastrous proslavery decision, 1857 was a year when the troubled nation seemed to be spinning out of control.

Sources of the Susquehanna was only one of a group of works to come out of that key year. After producing a succession of proficient, solid works following his return from Holland, he seemed intent on making an especially strong showing at the National Academy of Design. The novel exhibition policy adopted that year allowed him an unusual opportunity, as a writer for *Putnam's* explained in advance to his readers: "Formerly the annual exhibitions have been limited to new pictures, or, rather, to original pictures, never before shown in any public gallery; but we learn that it is the intention of the Academy this year, to indulge the lovers of art with a retrospective view of what has been done in past years, and allow the artists to make such selections from their works as they please. . . . We may, therefore, expect a rich show of art treasures."[45] Along with *Sources of the Susquehanna,* Mignot exhibited three works that together were calculated to demonstrate the range of his talents and the scope of his ambition. *Susquehanna* and *Autumn* (possibly cat. no. 28 or 29), both North American landscapes, were bracketed by two rather different sorts of pictures in which Mignot collaborated with popular genre painters of his day: *Doorway of a Castle in Winter* (cat. no. 8) with Eastman Johnson and *The Foray* (cat. no. 24) with John W. Ehninger. Previewed in Washington, D.C., before the New York exhibition (and shown the following year at the Pennsylvania Academy of the Fine Arts), *The Foray* was a work of which the artist felt especially proud. As he described it, "The scene is laid in England in the time of Cromwell. It represents a band of Puritans returning home with pillage, after sacking. It is something quite

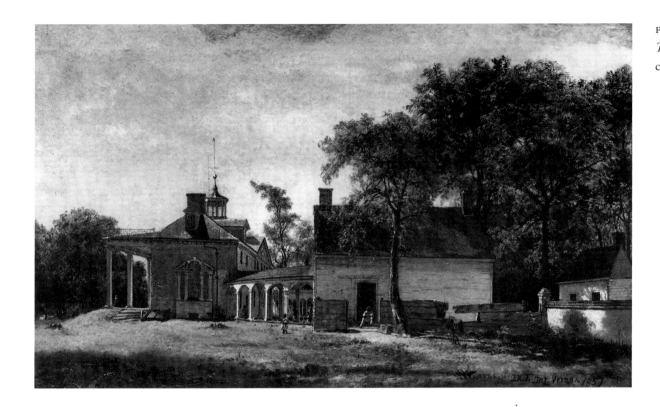

FIGURE 21. Eastman Johnson, *The Old Mount Vernon,* 1857, oil on canvas. Fraunces Tavern, New York.

new in Art and ... is the only thing of the kind that has been attempted by American Artists." [46]

In the company of Eastman Johnson, Mignot visited Mount Vernon sometime during 1857 (either in the late spring, before his South American trip, or in the late summer, following his return in early September). One report has it that they spent several weeks as the guests of Col. John Washington, who was then in residence: "In 1857 Johnson and the late Mr. Mignot (also an artist) bore a letter to Col. John Washington at Mt. Vernon and they were allowed to make studies at the old manor. Mr. Johnson says that Col. Washington was a most charming host." [47] Apparently, Johnson had planned to paint a large canvas of George Washington and the Marquis de Lafayette at Mount Vernon; his view of *The Old Mount Vernon* (fig. 21) of 1857 was probably an early study for the unfinished project. In 1895 Johnson recalled, "I painted a number of other things there in the summer, 1857, mainly in view of painting a larger picture of *Washington* himself at *Mount Vernon,* with his people about him and Lafayette his guest. But I didn't carry it out—." [48] The trip was undertaken to explore the possibility of another joint effort, from which they were perhaps discouraged in the wake of the lack of critical attention to their *Winter Scene, Holland.* Subsequently Mignot, who had made at least one study of the mansion on site (cat. no. 50), would team up with Rossiter on a large-scale canvas of the subject as Johnson described it. [49] But in the meantime, on 5 May 1857, he departed on an extended expedition to Ecuador, which provided a supply of novel subjects that would last until the end of his days.

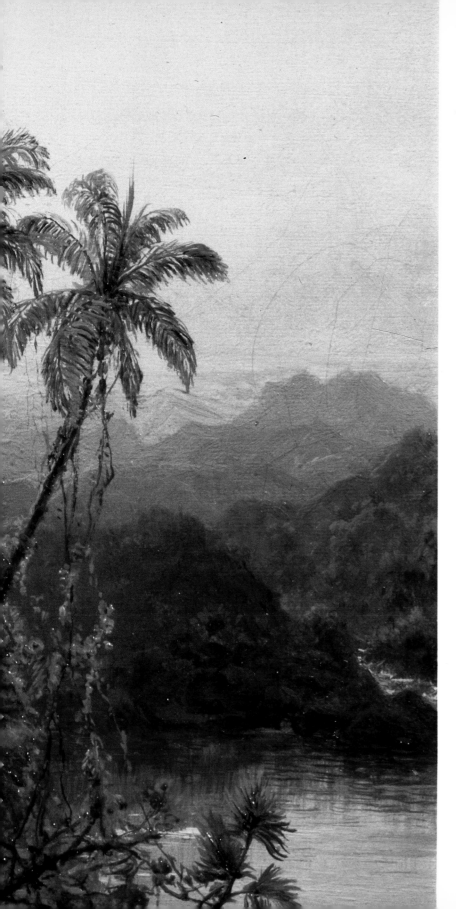

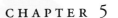

CHAPTER 5

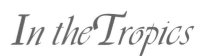

In the Tropics

South America offered Mignot a spiritual haven. From the time he set foot on the soil of Ecuador, he painted its contours more than any other single theme. It took hold of him and he of it, as he configured and reconfigured its rivers and mountains on canvases created between 1857 and his death. To follow the transformations that occurred in his conceptions of the subject is to understand the trajectory of his art from New York in the fifties to London in sixties. His tropical canvases constitute the backbone of his oeuvre and are the ground for bold experimentation with color and form. Critics raved about them, puzzled over them, and in the end came to define his art on the basis of them: "The really distinctive quality of his genius appears to us to have been developed by his visit to South America . . . , which gave rise to some of his finest and most original productions, and seems to have had a permanent influence in defining and developing his style."[1]

AN ICONOLOGY OF PROGRESS

Together these tropical pictures possess an internal cohesion that, following Erwin Panofsky, is best termed their (group) iconology. Beyond the formal basis of an image, Panofsky isolated three levels of meaning: (1) "primal" meaning, including the recognition of acts and expres-

sions; (2) iconography or conventional meaning, involving the connections between motifs and themes, between images and ideas; and (3) iconology or intrinsic meaning, to be "apprehended by ascertaining those underlying principles which reveal the basic attitude of a nation, a period, a class, a religious or philosophical persuasion—qualified into one personality and condensed into one work."[2] Mignot's South American images represent his meditations on the nature and consequences of Progress. This issue was an obsession for his entire generation and was in the forefront of the national dialogue during the course of his career. At the same time that he addressed national concerns, however, his formulations on the subject were informed by the unique position he held as the only major southern and Catholic landscapist within the eastern art establishment, and later as an American in Britain when the Civil War was impinging on that country's economy. The motifs embedded into his tropical imagery of trade and commerce, of religion,

and of the customs and habits of the people are therefore analyzed as part of this iconological program.

As a subject, the landscape of Ecuador lent itself readily to such musings on progress for several reasons. First, the duality of nature versus civilization—a standard leitmotif in landscape art of this era—took on a distinct variation here. Quito (fig. 22) had been the second capital of the Incas, and the oldest continuously inhabited city in the Americas; it presented itself as a contemporary urban center built upon ancient foundations. Past and present melded here, each reinforcing the other; this attitude was quite distinct from that discernible in the northeastern United States, where the present was constantly in the process of destroying the past. The difference between nature and culture (represented by the colonial structures and pre-Columbian ruins) was more accentuated than in the United States. Then too it was far from New York or London, and therefore a convenient location on

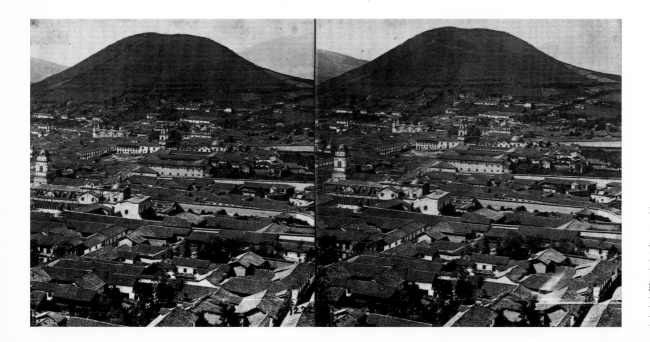

FIGURE 22. Camillus Farrand, *View of Quito,* stereograph, c. 1865–70. Miriam and Ira D. Wallach Division of Art, Prints and Photographs, The New York Public Library, Astor, Lenox and Tilden Foundations.

which to project cherished ideas and emotions. As debate about the advantages of modern development versus the charms of tradition heated up over the thirteen years following his visit, he recalled its visage and projected his own solutions onto its contours.

PHYSICAL DETAILS OF TRAVEL

In early May 1857 he and Church departed to Ecuador for a trip of four months duration. No sketchbook, diary, or correspondence kept by Mignot on the trip has been found, and so we must rely for the details of the excursion on those of his companion. The route from New York lay through Panama: travelers could take a steamer to the Atlantic coast of Panama, cross the isthmus by way of the newly completed Panama Railroad, and catch another steamer at the Pacific terminus, which headed south along the coast to Guayaquil. By 27 May, Church was able to report their safe arrival to his friend Aaron Goodman: "We had a fine passage from N. York to Panama and we got their just in time to hit the English steamer, so that we were enabled to reach Guayaquil in just 14 days. The Thermometer stands at 80 here and the climate is very agreeable—Old Chimborazo, 150 miles distant, looms up like a white cloud in the East and makes a noble landmark for our journey."[3]

Guayaquil is situated on the Guayas River (cat. no. 35), some sixty miles from its mouth, where at sea level can be found the hot, steamy climate, complete with palm trees and other lush vegetation, that is sometimes mistakenly associated with the entire continent. Here Church and Mignot spent several days exploring the area and getting accustomed to the new environment. Mignot likely found Guayaquil congenial, with a climate and southern-style architecture that recalled Charleston. The small wood-panel *Tropical Sunset* (cat. no. 30) is representative of the sort of colored studies he must have made here, with the searing reds, oranges, and yellows quickly and energetically applied above the flat lagoon. On the twenty-ninth they proceeded to Quito,

in the mountainous interior, going as far as they could by river before transferring to horseback and mules. "So you may imagine us," as Church wrote Goodman, "trailing along with eight or nine mules in Indian file zig zagging up the mountains."[4] But while Church mentally as well as physically left the lowland waterways behind as he eagerly anticipated the Andean scenery, Mignot was more attentive to their unique character. *South American River Scene* (cat. no. 31), done in oil on paper, is probably an on-the-spot sketch of that aspect of their journey, to be rehearsed over and over in finished paintings.

After a short stay in Quito, they moved on to Riobamba, their base of operations in the central highlands. The road between the two cities lay along the so-called Avenue of Volcanoes, one of the most impressive stretches of scenery on the continent. In one sweep they passed Cayambe, Pichincha, Antisana, Cotopaxi, Chimborazo, El Altar, Tunguragua, and Carihuairazo. Their ultimate destination, however, was the peak of Sangay, located in the eastern cordillera, which even today remains a remote mountain wilderness. To reach it Mignot and Church ascended to ten thousand feet above sea level by mule and then on foot, with a native guide who spoke only the Indian dialect of Quechua into a desolate territory where few outsiders had set foot. Although a snowstorm prevented them from attaining the summit, the four-day outbound trek (the only portion of the trip chronicled in Church's diary) must have been one of the most extraordinary events of their lives. Having had their concentrated lesson in Andean geography, it was time to return home, and so they retraced their steps from the desolation of the Sangay wilderness, through Riobamba, Quito, Guayaquil, and Panama, before arriving back in New York harbor.[5]

We should remind ourselves of the extreme hardships and dangers these artists faced in the service of their art. If overland travel was tough, then sea travel was even more treacherous. Church and Mignot arrived at Staten Island on 3 September. If they had been on the vessel that cruised the same route the following week, they would have been shipwrecked; the steamer *Central America,* en route from Havana to

New York, sank with the loss of four hundred lives. "Every day a ship is lost," wrote a New York editor as he reviewed recent marine disasters.[6]

EARLY SOUTH AMERICAN CANVASES

The Andes Mountains form the spine of the Pacific coast of South America. The nineteenth-century German explorer Alexander von Humboldt had climbed some of the major peaks and had written extensively and persuasively of their geological as well artistic importance. And though Humboldt had described many other types of topography and locales (to read his *Personal Narrative of Travel . . .*, for instance, is to realize how absolutely monotonous long river voyages can be), to Church, Mignot, Heade, Norton Bush, and many other artists headed for South America after 1850, the mountain sublime was the dominant typology in landscape painting. Hence, they seized upon those portions of Humboldt's writing that suited their own pictorial needs. Church led the way in defining the South American landscape in this mode, in a popular series of paintings from *Andes of Ecuador* (1855; Reynolda House) through *Heart of the Andes* (1859; Metropolitan Museum of Art) to *Cotopaxi* (1862; Detroit Institute of Arts). Little wonder then that Mignot's first attempts to essay the Ecuadorian landscape were cast in the mode utilized by his successful traveling companion (cat. no. 40); in Mignot's work, however, the Andean peaks appear as only one dimension of the region, interspersed with the lowland riverways and town life.

In the Andes (cat. no. 41) represents one such early effort. In fact, its kinship to Church's work led to it being attributed to him, although it can now more logically be understood in the context of Mignot's work.[7] In overall conception and individual details, it must have been close to—and likely a large-scale study for—his *Among the Cordilleras*, presently unlocated but described in a number of reviews upon its exhibition at the National Academy of Design in 1858. The *Crayon*

noted the work-in-progress in January 1858: "Mr. Mignot, now in the Tenth street building . . . accompanied Mr. Church to South America, and is now painting one of the peculiar mountain views of that 'far countrie.' The canvas is a large one, and the picture promises to be highly interesting."[8] When the show opened to the public in April, *Among the Cordilleras* was declared "the pride of this room and in some respects the masterpiece of all" and "the most striking landscape of the exhibition." The work was praised for its fidelity to nature, its ability to subordinate detail to overall effect, and its gorgeous chromatic effects.[9] And yet the same reviewers who praised the painting so highly were forced to conclude, in one way or another, "from some cause the entire work has not the impress of sublimity, nor does it produce a sense of pleasure in the mind: and after appreciating its separate excellent parts, the whole confuses and perplexes."[10] Mignot was not suited by temperament or inclination to full-blown expressions of the sublime, and his mountain vistas—in comparison with those by Church and others—would continue to confuse and perplex as he formulated his personal vision.

When confined to a smaller scale, however, his renderings of peaks and mountains could be quite successful. One example is *Cotopaxi* (cat. no. 45), which may be related to a pair of works painted from nature that he exhibited at the Maryland Historical Society in November 1858: *Landscape—View of the Cordilleras, near Cotopaxi, S. Amer. from Nature* and *Volcanic Regions near Cotopaxi, S. America from Nature*. Within limited dimensions (14¼ x 17⅛"), it creates an effective contrast between the foreground, with its minutely rendered dark green vegetation and wonderfully textured rock face and the light-filled middle ground and aerial distance. The smoking profile of the snow-capped cone and the multiple rock striations visible at right make this one of the few works by Mignot in which the geological concepts that so concerned Church can be detected. In conception and handling both this work and *In the Cordilleras* are predecessors to *Landscape in Ecuador*.

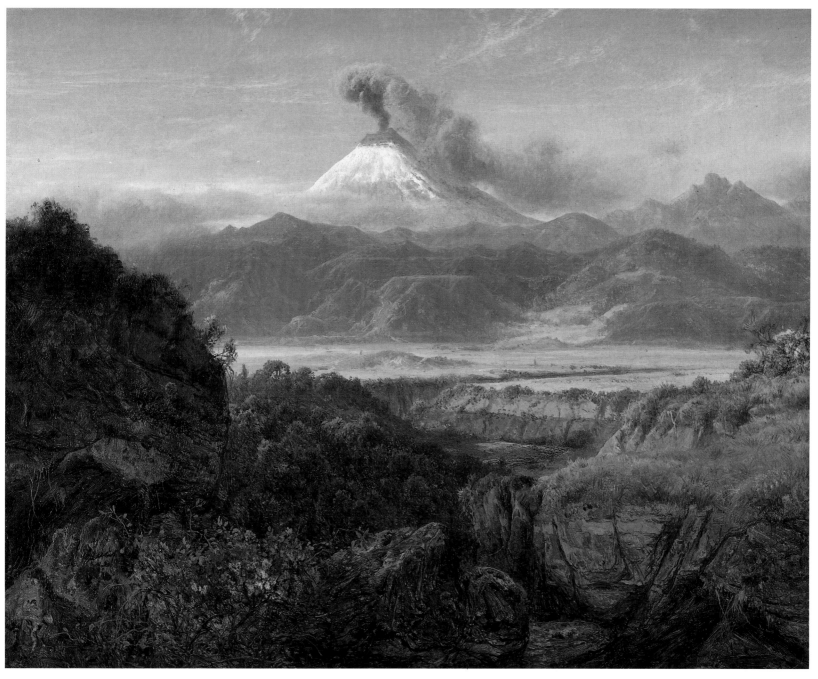

CAT. NO. 45.
Cotopaxi

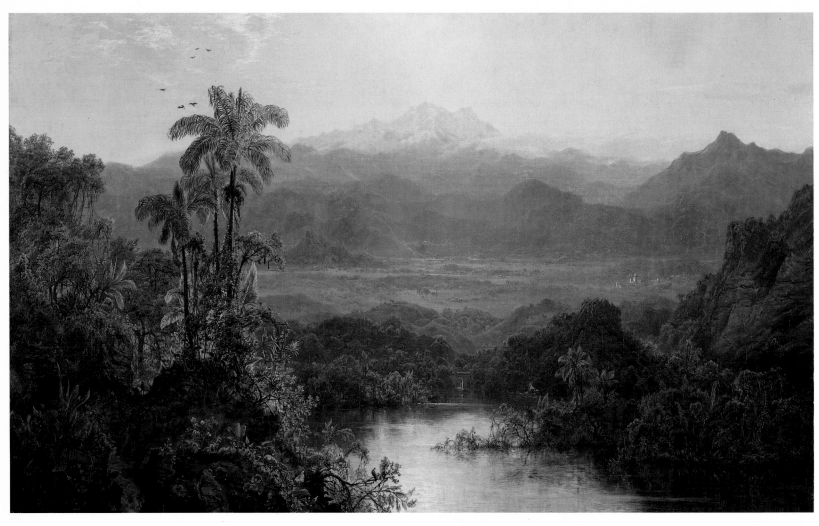

CAT. NO. 43.
Landscape in Ecuador

THE WORKS OF 1859

In 1859, as Mignot and his fellow New York artists were undoubtedly aware, Church had begun his intended blockbuster *Heart of the Andes.* Thus it is little wonder that his example was on Mignot's mind as he worked. *Landscape in Ecuador* (cat. no. 43) of that year is the most

Church-like of Mignot's imagery. It looks to earlier pictures such as Church's *Tamaca Palms* (1854; fig. 23) for its recasting of the Claudian template, complete with snow-capped mountain and framing palm trees. Yet even here, where their work converges, subtle differences distinguish their sensibilities. Mignot's painterly touch—with its blurred edges and softened forms—contrasts with Church's more sharply

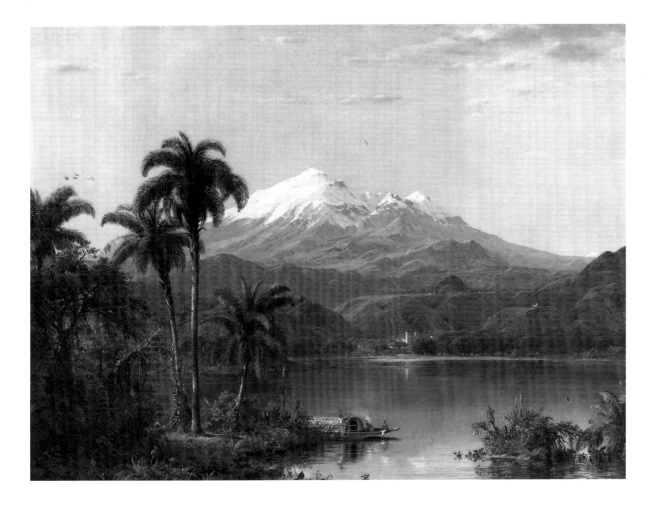

FIGURE 23. Frederic E. Church, *Tamaca Palms,* 1854, oil on canvas, 27¾ × 36½". The Corcoran Gallery of Art, Washington, D.C., Gift of William Wilson Corcoran.

delineated vegetation. And Mignot substituted the clear light of midday with the soft glow of the awakening dawn. Examined in the context of several other of his own Ecuadorian scenes from that year, however, it takes on a different meaning. It is possible to read *Landscape in Ecuador* as one endpoint in a sequence of works painted in 1859, including *View of Riobamba, Ecuador, Looking North towards Mt. Chimborazo* (cat. no. 46) and *Street View in Guayaquil, Ecuador* (cat. no. 47) which together trace the transformation from wilderness to civilization and constitute part of the artist's iconological program onthe nature of progress.

Landscape in Ecuador depicts the region of Riobamba, which had been their starting point for the expedition to Sangay volcano. The town "lies in the bowl formed by the green slopes of Chimborazo, Tunguragua and El Altar," Church noted in his diary, "and from any part of the town noble views of these lofty mountains can be seen."[11] The painting features in the central distance El Altar, which presents a markedly different countenance. Whereas Chimborazo rises into one mighty pinnacle, the summit of El Altar appears as a cluster of broken spires. Awed by the sight of this massive collapsed volcano and its

CAT. NO. 44.
Tropical Landscape

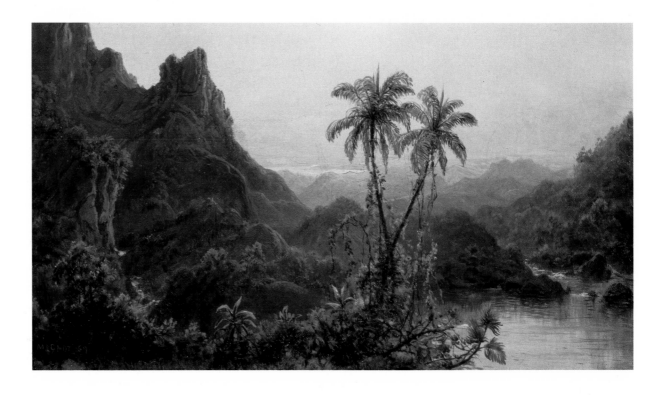

crescent peaks, the Incas had called it "Capac-Urcu-Almighty Mountain." When the Spanish arrived they saw this same mountain as a titanic cathedral and named it El Altar, with the northern summit christened the Canon, the eastern the Tabernacle, and the southern the Bishop.[12] It is likely that Mignot and Church were acquainted with this local lore.

What Mignot depicts here, in essence, is mountain wilderness. To the right of the central mountain, a tower and the outlines of other buildings suggest the presence of a town, but otherwise the natural world is little disturbed. The only other sign of human habitation is the small figure on the road at the right. The tangled vegetation and rough terrain all suggest a place and a moment before civilization encroached. A passage from Church's diary that may have been written very near the spot that inspired Mignot's picture emphasized the wild state of the nature through which they passed:

about nine mounted our horses again and commenced our journey by crossing a river which was swelled by the recent rain and we had considerable difficulty in getting the animals to cross—our path became more indistinct being nearly lost among the clumps of Paramo grass which was from two to four feet high and often so interwoven that the foremost Indian—the leader frequently was compelled to reach forward over his horse and disentangle the grass with his hands. Our movements were necessarily very slow owing to the blindness of the path the terrible grass and the rarity of the air— we were now about 13,000 feet above the sea—and we were fre-

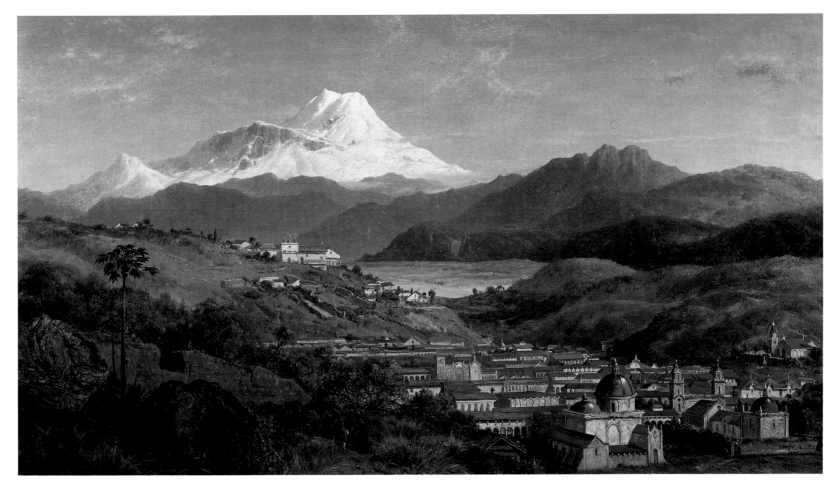

CAT. NO. 46.
View of Riobamba, Ecuador, Looking toward Mt. Chimborazo

quently obliged to dismount in order to assist the animal through some difficult passage.[13]

In the final canvas, as well as in the related study (cat. no. 44), Mignot strove to convey this sense of nature overgrown and untamed by man.

From there the artist transports us to a more settled region of the highlands in *View of Riobamba, Ecuador, Looking North toward Mt.* *Chimborazo* (cat. no. 46). The capital of Chimborazo province, Riobamba is built on a large plain surrounded by mountains. The artist has constructed a recognizable townscape with the low roofs, colonnades, church cupolas, and street design all reminiscent of the this period in its history. The backdrop is constituted by the massive snow-covered head of what Símon Bolívar called "the watchtower of the universe," which occupies a good half of the skyline, with the sur-

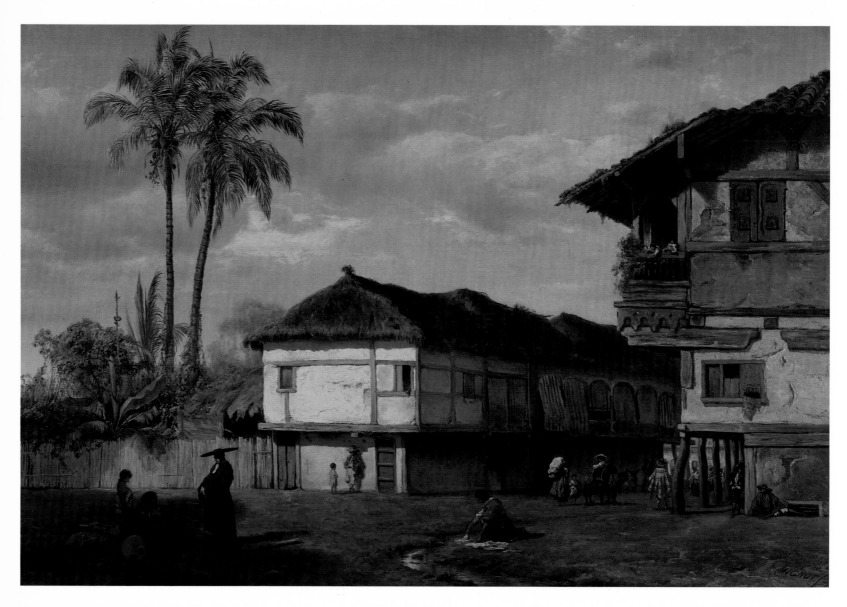

CAT. NO. 47.
Street View in Guayaquil, Ecuador

FIGURE 24. Unidentified photographer, *Street View in Guayaquil, possibly the Malecón,* c. 1900, photograph. Private collection.

rounding mountains condensed in around it. Situating himself just above the grid-planned town and looking north toward the great peak of Chimborazo, Mignot presents a view of civilization firmly anchored within (and holding its own against) its natural surroundings.

The third stage in this implied journey from wilderness to civilization is represented by *Street View in Guayaquil* (cat. no. 47) in which he has depicted a colonnaded street with a sampling of the populace. *View of Riobamba* also includes a colonnade, which appears to the left of and just behind the domed cathedral, with its rounded arches parallel to the picture plane; comparison of the two demonstrates the care he has taken to distinguish the individual coastal and highland regional styles. Taking a position in *Street View in Guayaquil* close-up and at the end of the street allows him to highlight a number of distinctive fea-

tures of the coastal architecture (fig. 24). First, these *bajareque* ("mud wall") structures, entirely typical of Guayaquil, are constructed of a wooden framework that is filled in with material the consistency of mud (they can still be seen today in the Las Peñas neighborhood); the building on the left is shown with a straw roof, on the right a roof of tiles. The supports of the building at right follow the shape of the tree trunks, as is often the case there, demonstrating the artist's attention to each detail. The street, furthermore, is populated by a variety of characters, added by Eastman Johnson to Mignot's specifications: the padre in a wide-brimmed hat, a native woman with a heavy parcel strapped to her back, and other passers-by.[14] This suggests a possible cross-fertilization with *costumbrista* paintings: images of customs and manners that featured just such local types, whose role was subsequently subsumed

FIGURE 25. Camillus Farrand, "Going to Market with Wood," c. 1865–70, stereograph. Miriam and Ira D. Wallach Division of Art, Prints and Photographs, The New York Public Library, Astor, Lenox and Tilden Foundations.

by photography (fig. 25). The artist tried to enliven the scene further with a variety of window treatments along the building at the left, a bright red textile hanging in the prominent opening at right, and the exuberant vegetation so characteristic of Mignot's work that bursts up from behind the fence at left.

Ultimately, though, the result of devoting so much of the surface to mud and timber structures means that the lower two-thirds of the canvas is rather heavy and inert. Although one reviewer admitted that the picture "is interesting as an example of the architecture of the tropical region," he otherwise responded negatively when it was subsequently shown at the National Academy of Design, Mignot's only submission there in 1859. "We miss this accomplished artist's works, scarcely recog-

nising in this passage from a South American town his method and treatment, although there is much skillful painting in the sky, textures of the old buildings, and manipulation, which marks the master. The old walls and thatched roofs are inimitable for good honest painting; but the picture as a whole would be better with more care in the foreground, although with a greater elaboration it might not gain in force or effect."[15] Others, however, seemed to have recognized its further merits, for its presence is mentioned in the esteemed collections of both Shepherd Gandy and Robert L. Stuart. The comments of another reviewer touched upon the intrinsic interest of this "unpretending but well-balanced and successful" picture with respect to the iconology of progress: "we have jotted down a note of wonder that the world can

ever trouble itself touching the affairs of such a place, if this be one of its main avenues. A few lazy monks and lounging natives; a row of mud houses and a few palm-trees: *voilà tout.*"[16] In particular, he raises two important points. First, this principal thoroughfare of the most important port in this country is portrayed as sleepy and nonprosperous. Second, the composition of the population itself is telling. For along side the "lounging natives" is a member of the Catholic clergy, identified by his robes and wide-brimmed hat and reinforced by the crucifix hanging on the wall behind him, who are perpetually stereotyped as "lazy monks." (A closely related figure appears in the *View of Riobamba,* standing on the hillside at left, looking down over the steeples and domes of the town below.) Similar remarks filled the contemporary travel literature on Catholic countries; they were not so much anti-Catholic as anticlerical, growing out of the Protestant suspicion that Catholicism was essentially antidemocratic and antiprogressive. If, as is sometimes argued, these artists were charting the course of Manifest Destiny in South America, then the remarks of the reviewer seem to indicate that Mignot's picture achieves the completely opposite effect. As his tone implied, why bother?

Motifs relating to the Catholic religion that had converted Ecuador along with the rest of the continent are ubiquitous in Mignot's tropical imagery. Crumbling buildings with crucifix-topped orbs (cat. nos. 74 and 75), vine-choked church edifices, and male clerics all suggest the presence of this institution here. As a Catholic himself, Mignot was perhaps commenting upon the power of the church in ways an outsider could not. Ultimately, it is impossible to discern from images alone his view of its belief system, but rather as a pervasive force in the lives of average Ecuadorians, who were held back from material progress by their allegiance to their faith. This canvas, then, painted in the immediate aftermath of travel, contains the seeds for a number of themes he developed over time in his tropical works: religion, commerce, and glimpses of the life of typical inhabitants through which he presented his ideas on progress versus tradition.

RIVERWAYS

Rivers, their tributaries, and sources, are a nearly ubiquitous element in Mignot's tropical vision. This emphasis is logical on a purely practical level, given that in his day rivers were the most dependable means of access to the interior of the continent—a point impressed upon both him and Church in the course of their expedition. A traveler stuck to the boats, to the river, for as long as possible, and under extreme conditions no matter how uncomfortable, for the alternative was far worse. Railroads were then essentially nonexistent in Ecuador, and land travel by horse or mule was extremely difficult and time-consuming. It is little wonder then that a survey of Mignot's tropical oeuvre is the pictorial equivalent of an extended cruise along the inland waterways of the country, recapitulating their journey between the lowlands and highlands as the scenery shifts from flat to mountainous. They stretch like a river panorama across the course of his career and include: *River Scene, Ecuador I* (cat. no. 33) of 1857; *River Scene, Ecuador II* (cat. no. 34) of 1857; *Tropical Landscape* (cat. no. 36) of 1858; *In the Tropics* (cat. no. 58) of 1860; *Sunset on the Guayaquil River* (cat. no. 60) of 1861; [*Lagoon of the Guayaquil, South America?*] (cat. no. 77), c. 1863; *Gathering Plantains, Guayaquil, Ecuador* (cat. no. 81) of 1866; and *Sunset on the Guayaquil* (cat. no. 101) of 1869. To consider these works, such as *In the Tropics,* side-by-side with a stereograph of the same river from 1907 (fig. 26) is to realize how deftly Mignot configures the interspersion of land with water, the quality of sunlight on the equator, and the distinctive silhouettes that characterize the region. But in what context is the central place of rivers in Mignot's work comprehensible? In the geopolitical discourse of the day, rivers were symbols of commerce, arteries of trade. This message underlay a wide variety of images, from George Caleb Bingham's pictures of Missouri raftsmen to Samuel Colman's of the Hudson (see, e.g., his *Storm King on the Hudson* of 1866 in the National Museum of American Art). To compare their renderings of those busy thoroughfares with his portrayal of the Guayas, however, is

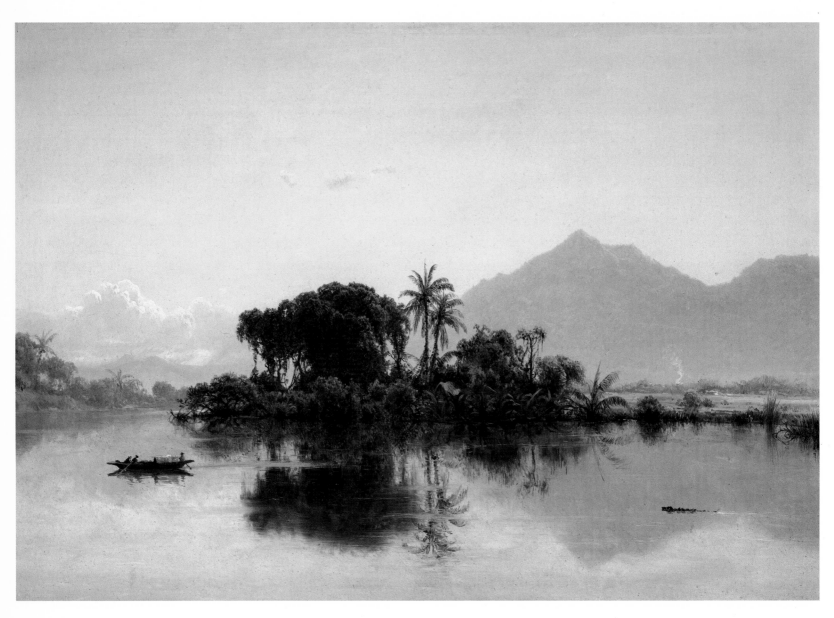

CAT. NO. 33.
River Scene, Ecuador

FIGURE 26. Underwood and Underwood, *River, Ecuador,* ca. 1907, stereograph, Miriam and Ira D. Wallach Division of Art, Prints and Photographs, The New York Public Library, Astor, Lenox and Tilden Foundations.

to realize that they are worlds apart. His imagery, in other words, runs contrary to the dominant voice that declared:

> Rivers are the progressive and public element in . . . geographical expression. They throw the continent open; they are doors and windows, through which the nations look forth upon the world, and leave and enter their own household. They are the hospitality of the continent—every river-mouth chanting out over the sea a perpetual "Walk in," to all the world. Or again, they are geographical senses,— eyes, ears, and speech; for of these supreme mediators in the body, voice, vision, and hearing, it is the office, as of rivers, to open communication between the interior and exterior world; they are rivers of access to the outlying universe of men and thing, which enters them and approaches the soul through the freighted suggestions of sight and sound. Rivers, lastly, are the geographical symbol of public spirit, the flowing and connecting element, suggesting common interests and large systems of action.[17]

The travel literature on South America produced in the United States at this moment was frequently based on the exploration of navigable rivers, with a special emphasis on the Amazon. Not surprisingly, they were brimming with the rhetoric of American enterprise and progress. The operative assumption of writers such as William Herndon and Thomas Jefferson Page was that all the people in these tropical climes needed was a good shot of Yankee ambition to get things rolling, and to harness their abundant natural resources in the name of progress. They brazenly claimed that the Amazon and the La Plata were but the southern extensions of the Hudson or the Mississippi, envisioning a day when steamers would move with ease along them

from one end of the hemisphere to the other.[18] And, as I have discussed elsewhere, the South had its own manifest destiny in South America, a self-appointed stewardship based on geographical determinism.[19] Is this to suggest, then, an image of Mignot, confederate flag in hand, sitting in the bow of his boat and claiming the lands along the Guayaquil in the name of the South? No, in fact, quite the opposite. His attraction to these lands was situated precisely in its resistance to manifest destiny. On Mignot's waterways there usually appears, to be sure, a rivercraft of the sort used to convey produce to market; but it is so small and indolent, and the river is so static, that there seems little likelihood of transforming this waterway into a throbbing artery. Furthermore, his rivers usually flow parallel to the picture plane, past us rather than toward us; there is little prospect that it will connect with the world beyond. What was perceived as an unhurried pace of life, the simple faith of the people, and the lazy and almost imperceptible flow of the river contribute to an alternate rhythm in Mignot's pictures, and align him with a different view of progress. To judge from his paintings, he was more temperate in his views than many of his countrymen, less willing to accept rhetoric over reality. He possessed a greater sensitivity to the differences that divided north from south, Catholic from Protestant. He appreciated the finer distinctions of geography and culture, and presented a counter-current imagery on the master narrative of progress.

Occasionally in his river scenes reference is made to commerce and the marketplace. *Gathering Plantains on the Guayaquil* (cat. no. 81) is important to analyze in this regard. The title, scripted on an old label that appears to be in Mignot's hand, calls our attention to what was to become a new trading commodity: the plantain, a starchy, green-skinned, cooking banana. A quick inventory of the boat does not reveal the plantains, which must have already been gathered and stowed under the boat's covering. We do see cuttings of leafy branches, which probably contain other fruit or berries, and the broad fronds of the tree overhanging the boat remind us of the source from which they came. A

parrot is also among the cargo, another coveted tropical item on the European market.

Just when or how the first banana was brought into the United States is a matter of conjecture. Bananas were introduced in Cuba several centuries ago by the Spanish conquerors of that island, and some ship may have brought a few over-ripe specimens to one of the ports on the mainland. It was recorded that in 1804 the schooner *Reynard*, on voyage from Cuba, brought thirty bunches of this strange yellow fruit to New York. If true, the feat was rendered possible by favorable temperatures and kindly winds. For in all the years prior to the advent of steam navigation, the banana necessarily remained a curiosity and not an extensive article of commerce. They were virtually unknown in Western Europe and the states until 1866, when Carl B. Frank started importing bananas to New York from plantations in Colombia. At the Philadelphia Centennial of 1876, bananas wrapped in tinfoil were sold to intrigued buyers at ten cents apiece. A century later, the banana had become a staple in every home.[20]

In Mignot's day, most of the bearing plants were growing on river banks, where the channels provided natural drainage. Practically all the plantings were in small, isolated plots surrounded by swamp and jungle. Banana harvests are bulky, heavy, and extremely perishable; their efficient harvesting requires that the fruit be cut frequently throughout the year and shipped to market punctually. Thus, the entire enterprise was dependent upon an efficient transport system; yet regular service from Central America north did not even exist before 1855.[21]

This picture shows neither a plantation, nor the extraordinary industry that would develop to convey these fruits from their tropical habitat to the urban dining rooms across Europe and North America. But it does hint at its new place as market commodity. Mignot's choice of motif is telling, for the banana and the industry that grew up around it—eventually taking the form of the United Fruit Company—became in the poetry and fiction of contemporary Latin American writers a potent symbol of the politics of dependency from which their

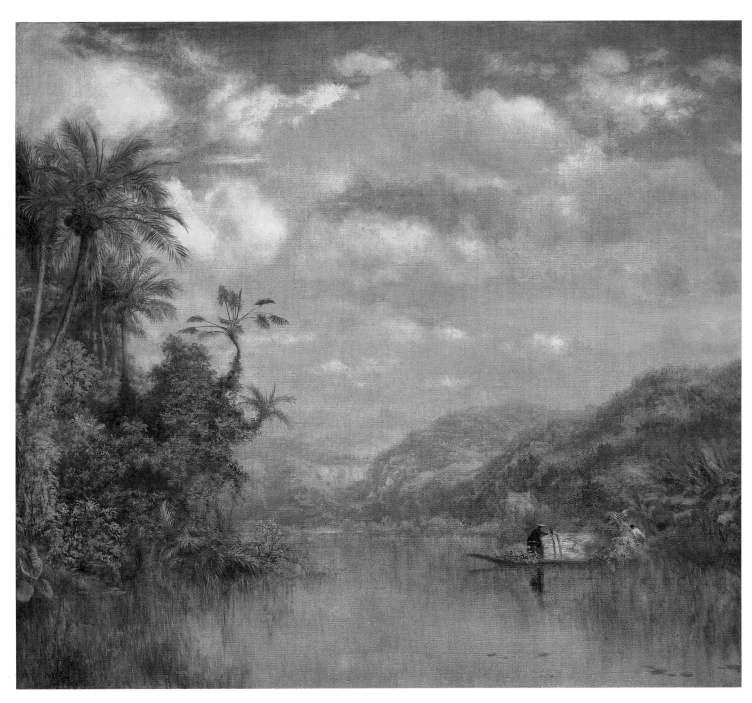

CAT. NO. 81.
Gathering Plantains, Guayaquil, Ecuador

countries suffer. In the novels of Gabriel García Márquez his fictional town of Macondo serves as a microcosm for the state of Latin America itself, which has been made a satellite of outside interests. The United Fruit Company was a Boston-based organization that made its entrance in García Márquez's native Colombia in 1889; it represented an imperialist force in the local economy, one of the many instances in Latin America in which investment capital originates outside the country, and acts in the interest of the foreign rather than local concerns. As the novelist put it in his *Leafstorm*: "Shaken by the invisible breath of destruction, [Macondo] too is on the eve of a silent and final collapse. All of Macondo has been like that ever since it was squeezed by the banana company."[22] This fruit, with its uses and abuses, has served as a powerful symbol over time, making its appearance in Pablo Neruda's encyclopedic poem *Canto General*:

> When the trumpets had sounded and all
> was in readiness on the face of the earth
> Jehoval divided his universe;
> Coca-Cola Inc., Anaconda,
> Ford Motors and similar concerns:
> the United Fruit Company Incorporated
> reserved for itself the most succulent
> morsel of all, the midsection
> and coasts of my country
> the sweet waist of America.[23]

Mignot is depicting a mode of existence that clearly antedates the capitalist invasion as Neruda and García Márquez knew it, but it is one that contains the seeds of change. It is perhaps noteworthy that while earlier pictures by him included these produce-laden champan—the signs at the very least of a local market economy; but this picture, specifically titled to draw attention to this activity, was done in 1866, the year that this type of trade started in earnest. With hindsight, one of García Marquéz's characters could complain: "Look at the mess we've got ourselves into just because we invited a gringo to eat some bananas."[24] Mignot's canvas is a harbinger of things to come.

This motif of plantain gathering was one instance of the kind of romantic engagement with the inhabitants of these regions that enriched Mignot's canvases. This effect was achieved through the introduction of folkloric elements through which the distinctive quality of their lives was implied. The operative assumption was that the southern climes had greater potential for this, as minister and Brazilian traveler Rev. J. C. Fletcher claimed: "Whether we consider the natural aspects of the country, or the picturesque descendants of the Southern Europeans and the aborigines, there is a fascination which is never to be found surrounding the more prosaic nature and the less romantic people of our Northern land."[25] Used with reference to scenes along the Guayas River or of the harbor at Rio de Janeiro, the term "picturesque" became synonymous with the unusual, the novel, or the extraordinary, and aroused in the northern viewer a reaction of curiosity tinged with compassion or pity. It came to connote, therefore, a particular feeling when applied to tropical scenery that could provide a means of humanistic access into these otherwise far removed and quite foreign places.

Sunset on the Guayaquil, Ecuador (cat. no. 60) of 1861 exemplifies of this quality. An evening scene along a tropical river, it initially impresses the viewer as a study of tone and mood. Closer inspection brings appreciation of the details. The sharp angle of the riverbank is painted with such precision that it can be identified as riparian scenery near Daule. The raft or "balsa" at right, with a house on top, is a typical river dwelling, with genre motifs such as the laundry hanging out to dry adding a touch of local color. Another structure, the hut on stilts, appears at the crest of the riverbank. Comparison with a stereographic view of "Life on the River Guayas" (fig. 27), which slightly postdates the painting and contains many of these same elements, reveals the degree to which Mignot studied specific regional details. The public's keen interest in this sort of imagery is indicated by the presence of this view in an inventory of popular stereographs of South America and by

their response to this aspect of Mignot's work. In the case of the exhibited work *Lamona* (cat. no. 56), we have the testimony of the critics as witness. It was described as showing "an inclosure bounded by trees, with pools of water, and rank floral vegetation under a gorgeous sunset effect." However admirably the landscape features were portrayed, however, it was felt that its interest was "heightened by a glimpse of South American life within a tenement peculiar to that country."[26] A small oil-on-paper study (cat. no. 31) pinpoints his initial on-the-spot study of these typical constructions on stilts, at a point in the rainy season when it could only be reached by boat, as shown. The alternating floods and recessions of the river's waters were a constant of life there; when the artist later came to do the full-scale *Lamona*, he showed it at dry season, when the waters had receded.

These interests continued after he moved to Britain. In *Lagoon of the Guayaquil* (cat. no. 76), a hyperextended trunk of a palm tree leads the eye of the viewer to the ground, and to the typical rivercraft and rounded dwelling situated just below it. The signs of life within are barely discernible in the dimming twilight. Later images, best described as synthetic recollections, elaborate on these details. In *Tropical Sunset* (cat. no. 82), for example, a hammock makes its appearance next to a small hutlike structure into which the viewer is encouraged to peer in order to see a distinctively shaped jug just inside the opening. *Two Women in a Tropical Landscape* (cat. no. 83) depicts two figures by a crumbling well, with laundry basket and jug. General audiences and reviewers alike savored the tantalizing glimpses he offered into the picturesque existence of these remote peoples.

FIGURE 27. Camillus Farrand, "Life on the River Guayas," ca. 1865–70, stereograph. Miriam and Ira D. Wallach Division of Art, Prints and Photographs, The New York Public Library, Astor, Lenox and Tilden Foundations.

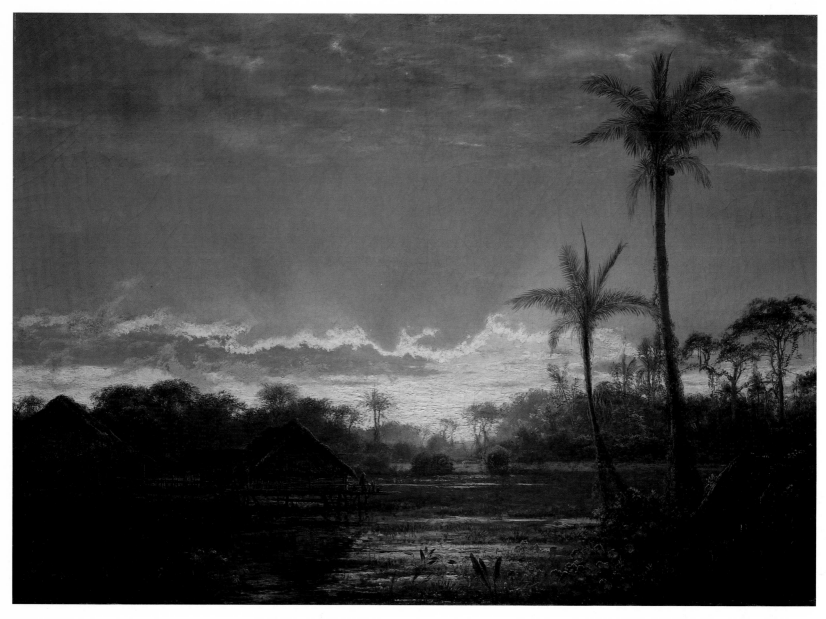

CAT. NO. 56.
[Lamona]

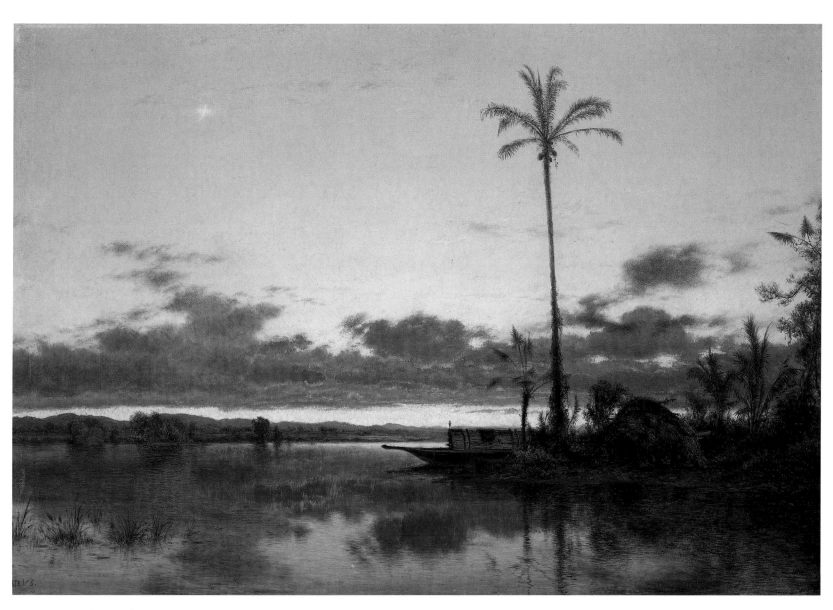

CAT. NO. 76.
Lagoon of the Guayaquil

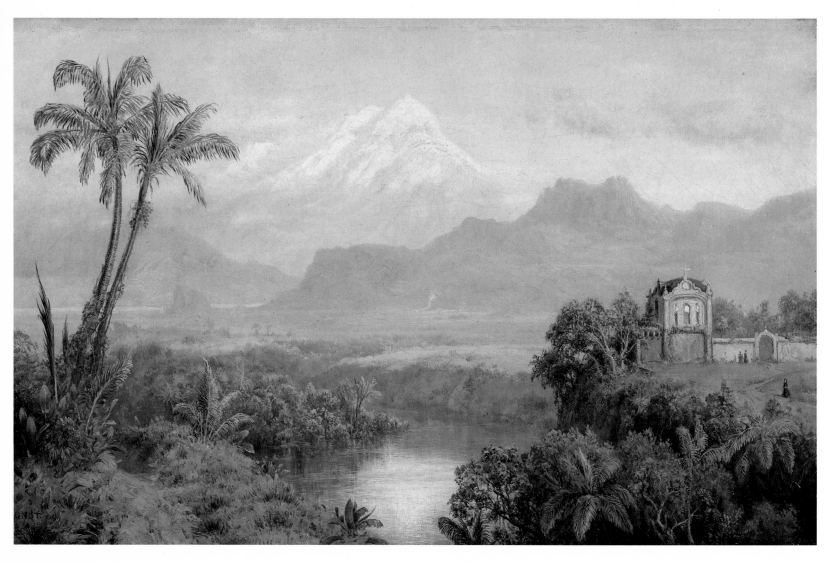

CAT. NO. 57.
Karhuikazo

COMPOSITE LANDSCAPES, 1860–1862

Between 1860 and 1862 Mignot created a group of composite land-scapes, including *Karhuikazo* (cat. no. 57) of 1860. It juxtaposes the profiles of several Andean peaks with a view of the still waterways and

vegetation characteristic of the lowlands, combining the best of both into a single upward-sweeping vista. This was the synthetic method employed by Church in his *Heart of the Andes* (1859) and explicated by Theodore Winthrop in an accompanying pamphlet; thus it is entirely plausible that in the wake of that picture's success Mignot turned to the

same technique.[27] Carihuairazo, as it is now spelled, is the ninth highest of Ecuador's great peaks and lies just north of the Chimborazo. Humboldt's discussion of it, accompanied by an illustration after one of his own drawings, appeared in his *Researches Concerning the Institutions and Monuments of the Ancient Inhabitants of America, with Descriptions and Views of Some of the Most Striking Scenes in the Cordilleras,* which became known as his *Picturesque Atlas.*[28] Mignot's painting follows the pairing of the two peaks much as Humboldt illustrated them (fig. 28), with the loftier, conical mass of the Chimborazo contrasting with the truncated form of Carihuairazo, "a great part of which fell in on the night of the 19th of July, 1698," as his text explained. That this painting can be traced back to Humboldt is a use-

ful reminder that although Mignot's art does not seem to have been as consistently informed by a study of natural history as was Church's, he too was conversant with its literature.[29] Taking Humboldt's configuration of the peaks as the central building block, he adds the foreground water and framing elements of palm trees and the architectural assembly at the right. The walls and gate are typical of the highlands; and the presence of several figures—one on the path and two silhouetted against the wall—bring a human dimension to this imposing scene.

He used this formula on other occasions, in *Vespers, Guayaquil River, Ecuador I* (cat. no. 74) and *Vespers, Guayaquil River, Ecuador II* (cat. no. 75). Here again he has taken an implied position along the coastal river and combined it with a view of the mountains, which

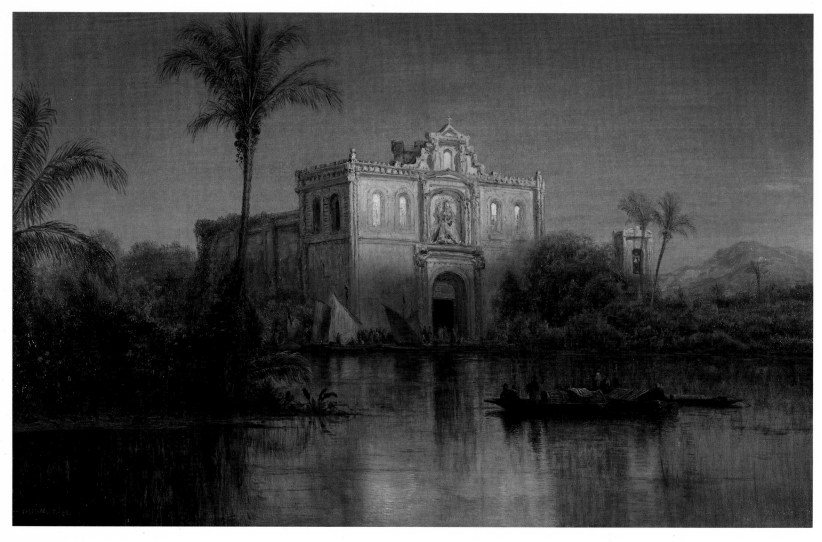

CAT. NO. 64.
"Ave Maria": Evening in the Tropics (I)

begin to rise about 10,000 feet above sea level. These mountains are less distinctive; lacking the eternal cap of snow that identifies the highest peaks, they appear as an extended purple backdrop. The foreground elements, by contrast, have become more prominent; the crumbling bell tower topped by crucifix seems to trace its origins back to his Dutch teacher Schelfhout, who so frequently depicted a strong architectural form as foil against sky. Its boxlike shape is overgrown with vegetation, indicating its state of disuse, of decay. This is contrasted with substantial buildings on the far shore, suggesting the presence of a more vital town, and with the activity of the figure in the boat.

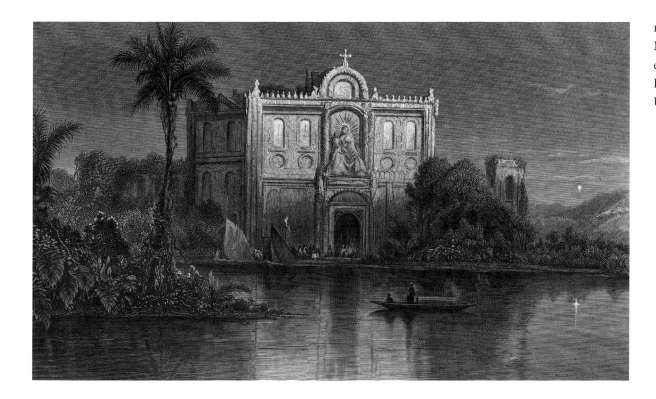

FIGURE 29. S. V. Hunt after Mignot, *Evening in the Tropics,* 1862, engraving. Avery Architectural and Fine Arts Library, Columbia University in the City of New York.

Mignot's painting of the *Vespers* in near replicas indicates that the general public favored this type of composite scene—representing the multiple facets of the South American landscape—to some of his more original experiments.

AVE MARIA

The artist painted *"Ave Maria": Evening in the Tropics* in at least four versions, three of which have been identified: I (cat. no. 64); II (cat. no. 73,) and III (cat. no. 86); another canvas of the same subject, larger than the others (25 × 34"), was sold with the collection of Mrs. S. B. Caldwell in 1870. In contrast to other pictures in which he actually replicated existing compositions with little or no variation, in this case the image undergoes metamorphosis over time. It was engraved (fig. 29) and copied by others, and became recognized as "one of the most effective subjects painted by this artist."[30] His rendering of the church became a kind of signature motif for him, inserted into the background of other, especially late works (cat. no. 88). On the basis of sheer numbers alone, this image deserves attention. Extending across the decade of the sixties, beginning in New York and continuing in London, this series charts his stylistic evolution. More important, however, it represents his most sustained response to Catholicism in Ecuador.

What is this structure that dominates the scene? Efforts to identify it specifically with any known ecclesiastical architecture in Ecuador

have proven futile. In the many cities, towns, and villages through which he passed on his travels he must have seen a wide variety of churches, ranging from humble to grand (drawings by Frederic Church record some of these).[31] The pictured example, however, is rather imposing, indicating its status as a major monument. Quito boasts several magnificent specimens: along with the Cathedral there is La Merced and La Compañia, the Jesuit church with an ornate and richly sculpted façade (fig. 30). And Guayaquil, whose outlying lowlands Mignot has depicted here, also has several noteworthy churches, including Santo Domingo and La Merced, as well as the secular Moorish clocktower on the waterfront avenue the Malecón.[32] None of these provides a precise model, however, only general inspiration and some specific motifs. (We may note, in fact, that the details of the building were altered by the artist from one version to the next.) Rather, Mignot's church appears on the far shore of the lake as a dreamlike

vision, a creation from the artist's imagination, although clearly maintaining vestiges of its kinship with Spanish Colonial architecture.

The structure has been enlarged out of all proportion to any building seen elsewhere in his art. Its size, position at the edge of the lagoon, and alignment in the middle of the composition draw the eye toward it. The real subject of the picture, however, is the act of faithful devotion itself. This is not a picture of a church, but a picture about people going to church; or, as Tuckerman put it, it "represents a chapel on the border of a lake, and worshippers passing in to vespers." To read down the central axis of the picture, is to encounter the crucifix atop the structure, the gigantic statue of the Virgin Mary, the gaping opening to its interior, and finally the minute figures filing inside. Boats of all sorts, from those actually found on Ecuadorian waterways to fantastic orientalized gondolas, convey the people to their destination and have been left tied up just beyond the entrance at left. To compare *Ave*

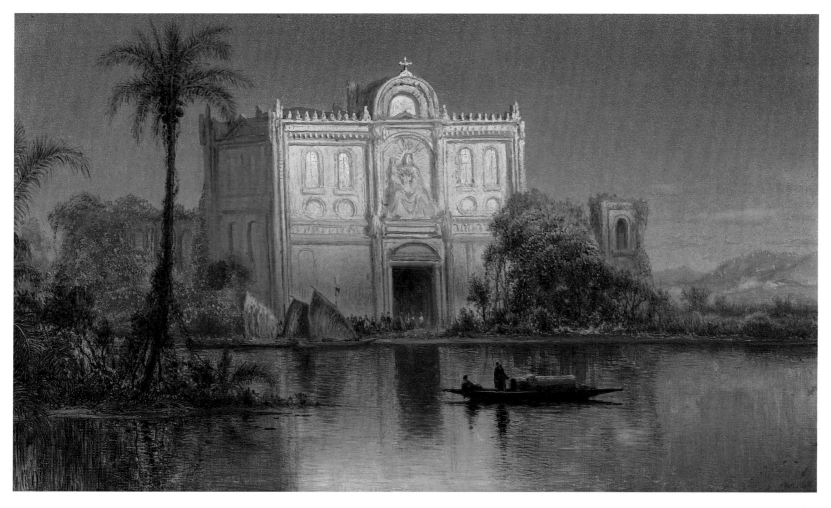

CAT. NO. 73.
"Ave Maria": Evening in the Tropics (II)

Maria II (cat. no. 73) with *Sunset, Winter* (cat. no. 71)—a work of the same year depicting a church at dusk in North America and a conceptual pendant of sorts—is to recognize the point Mignot is making about life in South America. What is probably the Episcopal church built by Richard Upjohn at Stockbridge, Massachusetts (see fig. 45), does not dominate its natural surroundings, but is at one with them. In the Ecuadorian scene, by contrast, the church looms large with its huge

relief sculpture of the Virgin Mary over the door. Since the importance accorded to Mary in the Catholic Church is in no way matched by Protestants (who regarded it as Mariolatry, bordering on the idolatrous), this detail identifies the scene unmistakably with the Church of Rome. This religious focus is reinforced by the title of the painting, that of a frequently repeated Catholic prayer, Hail Mary. The gathering of plantains, the trading of commodities, all has ceased as the boats are

employed in transporting the faithful to services. People in these countries are tiny and their activities insignificant when seen in light of this divine omnipotent force.[33]

How are we to account for the artist's fixation on this theme, which led him to these multiple variations upon it? It ties in, I believe, with the meditations on progress out of which his South American paintings were constructed, and which set him apart from his Protestant contemporaries. Their quarrel with the Catholic Church had its foundations not so much in religious doctrine as in temporal policy. The worst fault of Catholicism, as they saw it, was that it was the church of the past and therefore stood in the way of progress. "Many, very many, all too many ways lead to Rome," historian George Bancroft wrote in a letter that summarizes most of his countrymen's typical objections to Catholicism. "Idleness leads there; for Rome saves the trouble of independent thought. Dissoluteness leads there, for it impairs mental vigor. Conservatism, foolish conservatism, leads there, in the hope that the conservation of the oldest abuses will be a shield for all abuses. Sensualism leads there, for it delights in parade and magnificent forms. Materialism leads there, for the superstitious can adore an image and think to become purified by bodily torments, hair-shirts, and fastings, turning all religion into acts of the physical organ."[34]

Mignot was not issuing a similar castigation in paint; rather, he himself took refuge in the acts of profound faith and ritual that he witnessed in South America as an antidote to the hectic life that surrounded him in New York and subsequently London. This was, in fact, a standard practice of southern writers of his generation, whose works expressed their need to discover an alternate set of values that would provide perspective on their own times, on the Puritan-Yankee-utilitarian present, the syndrome of values that they referred to as "the Progress." In novels such as *Rob of the Bowl,* John Kennedy of Baltimore used similar strategies, sentimentalizing Catholicism and locating values in the past that could not be found in the present. If Protestant, acquisitive America dominated the present with its driving ambition to

FIGURE 31. *Advertisement for Chimborazo, Art Journal* (Chicago) (July 1869).

succeed, he looked to a Catholic past, tolerant and reasonable, when men were motivated by purity of heart and chivalric honor.[35] Mignot's pictures partake of similar solutions in response to like concerns. He created an image of South America that suited his needs, slow-paced and devout. The miniaturized church structure that appears on the far shore of his late pictures such as *In the Tropics I* and *II* (cat. nos. 87 and 88), conveys a kindred message; these lands represent an oasis in the midst of an increasingly fast-paced modern capitalist society.

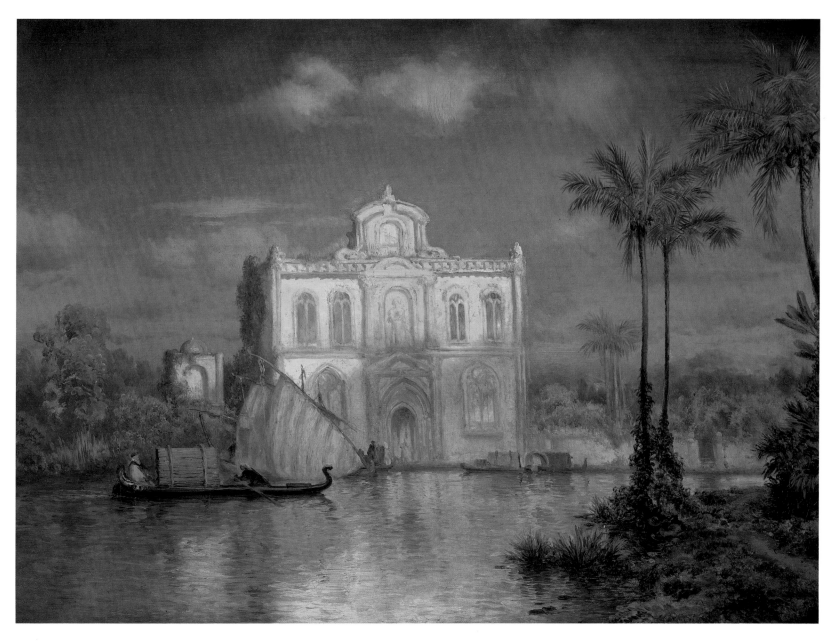

CAT. NO. 86.
"Ave Maria": Scene of the Guayaquil River, Ecuador (III)

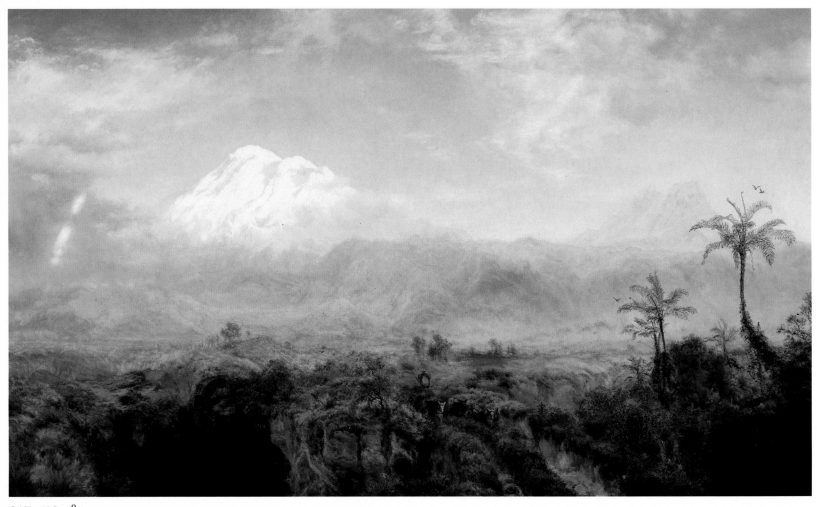

CAT. NO. 84.
Mount Chimborazo(Table Lands of Rio Bamba, Ecuador?)

Painted about 1866, *Mount Chimborazo (Table Lands of the Riobamba)* (cat. no. 84) returns us to a theme Mignot had left for a while, the expression of mountain sublimity. The end of the Civil War and his renewed attention to Niagara as a national emblem might have rekin-

dled his interest in Mount Chimborazo, what was in effect the landscape icon of the northwest corner of South America. This may have been the canvas on view in Chicago's Opera House Art Gallery during the summer of 1869, as advertised in the city's *Art Journal* (fig. 31). Certainly its large scale and painterly illusionism of mist and rainbows could hold their own against Bierstadt's *Mount Vesuvius* or Bachelder's "great historical painting" *The Last Hours of Lincoln* that were simulta-

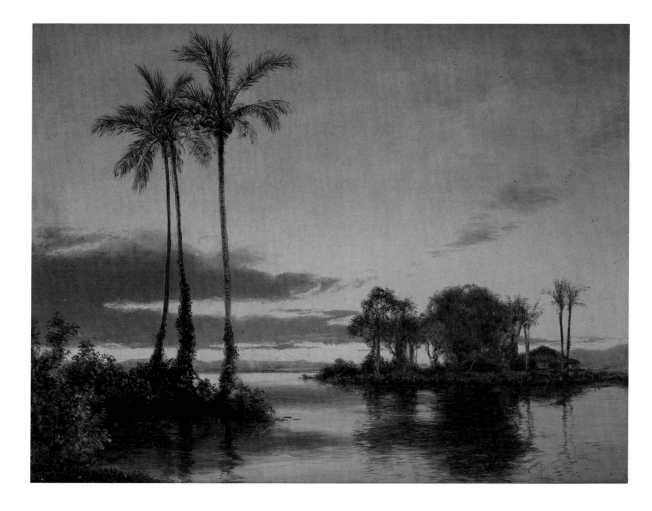

neously on view. Its snow-capped peak breaking through the clouds just left of center is meant to represent the hoary monument of Chimborazo, as seen from Riobamba.

Here Mignot has allowed light and atmosphere to dissolve the mountain form, a painterly act that is loaded with import. Once we could have assumed that a painting of this region, this subject, would have prominently featured Chimborazo; mountain form defined pictorial composition. By contrast, here its obdurate mass has been allowed to dissolve in the mist. But to what end? The observations made by a critic at Mignot's memorial exhibit help to make sense of these late works:

> The wealth of tropical landscape, its vivid colouring and brilliant lighting, cannot readily be translated into the limited language of painting. The artist who affects to interpret such scenes is constantly confronted by the need of sacrifice, while he is at the same time urged forward by the desire to reproduce unspoiled the vivid beauty

CAT. NO. 100.

Moonlight over a Marsh in Ecuador

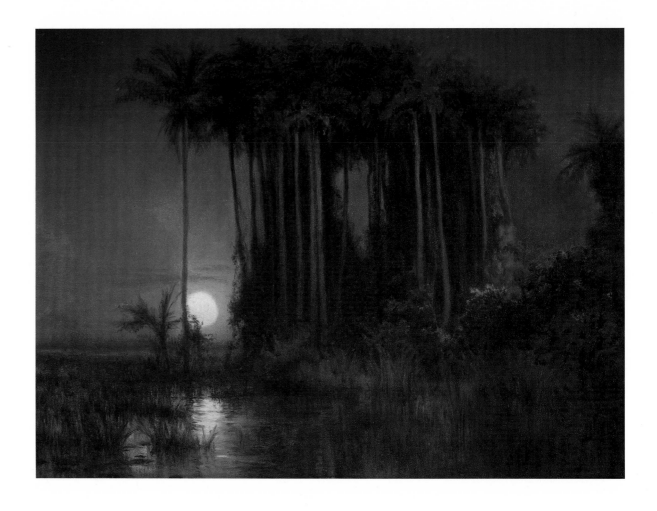

of nature. To reconcile these conflicting claims requires all the powers of the artist at their highest point of development, and to the student so earnest in his devotion to nature as was the late Mr. Mignot the first experiments are almost certain to lack something of the balance and harmony proper to a perfect work of art.[36]

Whereas earlier in his work the mountains and rivers were configured in an envelope of space that complemented and enhanced their appearance and message, now the envelope of space itself is becoming the vehicle of expression and meaning.

These efforts were continued in the format of the lowland lagoons, which perhaps lent themselves more readily to the artistic manipulations of space than did the mountains. Works such as *Tropical Landscape* (cat. no. 85) and *Parting Day . . .* (see cat. no. 89 and p. 144) are empty in terms of subject matter, but they are filled with the coloristic effects of twilight. To compare his *Lagoon of the Guayaquil* and *[Lagoon*

of the Guayaquil, South America?] (cat. nos. 76 and 77) of 1863 with *Parting Day* of c. 1867 is to recognize this direction in which he pushed his art. In the earlier paintings, the land and water occupy a minimal portion of the canvas, the majority having been given over to the glorious sunset sky; even in the lower register, however, the reflective surface of the water repeats the configurations in a way that merges the earth with the heavens. But here too the presence of the boat (in cat. no. 76) and the modest dwelling on the slip of land at right (in both)—however "natural" and inconspicuous they appear—serve to fulfill the expectations of traditional landscape art by introducing a narrative element. They establish a continuity between the pictured landscape and the world of the viewer by establishing a temporal dimension. In *Parting Day* all such temporal cues have been eliminated, except of course for the fading light itself. Space is the medium through which he now expresses himself, a disconcertingly empty space that is especially haunting on the relatively large scale of this canvas (38 × 59"). The picture bespeaks anxiety, one born in part, however, of its own lack of resolution. The artist himself, in other words, is not entirely comfortable with his own formulation. For at the same time that he eliminated the traces of narrative detail, he exhibited the picture with the appendage of a literary text: "Parting day / Dies like the dolphin, whom each / pang imbues / with a new colour as it gasps / away / —Byron." Text therefore enhances image, underscoring its anxious mood and underlying sense of loss.[38] The line is from *Childe Harold's Pilgrimage*, reminding us also of the parallels between the life of Byron's fictional hero and that of Mignot himself, whose own voyage brought him to the margins of a tropical lagoon in search of the object of his quest, as suggested by the figures that appear in his imagery heading deeper into the unknown (fig. 32).

FIGURE 32. Detail from cat. no. 43.

This picture, along with the pair of small, loosely painted scenes *Moonlight over a Marsh in Ecuador* (cat. no. 100) and *Sunset on the Guayaquil* (cat. no. 101) painted in 1869, transport us along the river of time to a moment before settlement. If, in the accepted vocabulary of the day, progress was synonymous with conquest and nation-building, then his vision of Ecuador, of the tropics, was resistant to progress. The level at which commerce and industry were conducted, the lifestyle of the average inhabitant, the omnipresent spirit of the past, and the presence of the Catholic Church, all militated against the best efforts of Yankee enterprise.

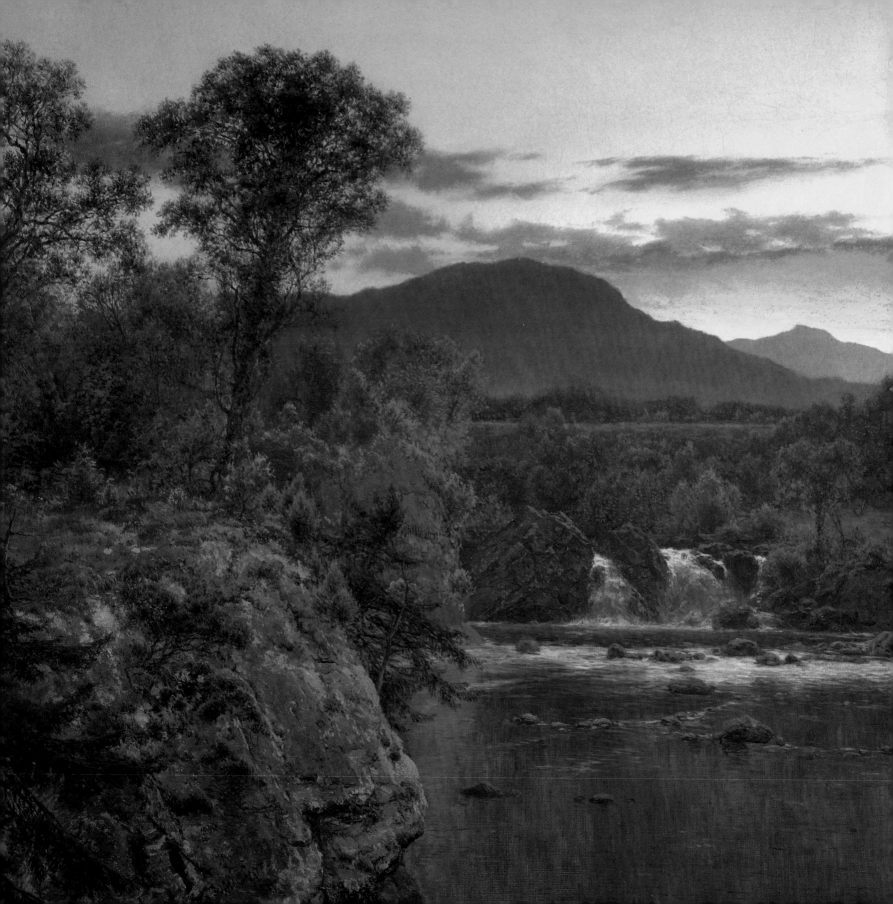

Hudson River School Successes

Settling on board ship for their South American expedition, Mignot and Church had every reason to expect a ready market for the paintings that would result from their trip. A general optimism had prevailed throughout the United States during the previous decade of prosperous growth. Much of the economic boom had been the product of feverish railroad construction and the consolidation of smaller trunk lines such as the Boston and Albany, the New York Central, the New York and Erie, and the Baltimore and Ohio. During the decade more than 20,000 miles of track had been laid (of which nearly 2,500 were completed in 1857 alone). Another indicator was the rise in the number of banks. In an effort to meet the credit needs of the expanding economy, the number of banks nearly doubled between 1850 and 1857, totaling by then more than 1,500.[1] Yes, the commercial prospects for art appeared most promising.

All the more surprising then when on 24 August the president of the Ohio Life and Trust—one of the most highly respected financial institutions in New York City—made the following announcement: "The unpleasant duty has devolved upon me to state that this company has suspended payment." Panic began among the New York banks, most of which were creditors of Ohio Life and Trust, and spread to Wall Street. At the heart of the panic was the fear that the fragile American banking system would be unable to withstand the pressures suddenly placed upon it. The blight of the panic and recession brought

FIGURE 33. *Studio Building, 15 (later 51) West Tenth Street, New York, N.Y.,* 1857–58. Demolished. Richard Morris Hunt, architect (1827–95). The Prints and Drawings Collection, The Octagon Museum, The American Architectural Foundation, Washington, D.C.

hardship to the urban clerks, factory workers, mechanics, domestics—both immigrants and native born—who were turned out on the streets as employers shut down businesses. Estimates of unemployment in New York and Brooklyn eventually ranged from 30,000 to 100,000. And of course it crippled the fortunes of bankers, merchants, manufacturers, railroad entrepreneurs, investors in land and securities—the class of individuals who constituted the art-buying public. New York in autumn of 1857 was a very different place from what it had been the previous spring. The reality of the collapsing financial center must have impressed itself upon the artists, with labor demonstrations and closed businesses everywhere apparent, once the quarantine was lifted and they disembarked their vessel in New York.[2]

ARTISTIC SOCIETY

By 1858 Mignot had begun to establish a firm footing in the New York art world. In January he was elected to the Century Association, a good place to make useful contacts. He was planning to participate in the artists' receptions, starting to define a wider group of buyers for his work, and settling into his quarters in the new Tenth Street Building (fig. 33), where he apparently moved the previous December.[3] Designed by Richard Morris Hunt, it was one of the first structures built exclusively as commercial space for artists to provide large, well-lit painting rooms and an exhibition hall for sales. It was situated on the north side of West Tenth Street, between Fifth and Sixth Avenues, and was therefore conveniently located between the downtown financial district and the new uptown residential neighborhoods. One of the building's primary benefits was the companionship of other artists, which we can be sure Mignot enjoyed.[4] He was one of twenty-one tenants who filled the Studio Building to capacity upon its official opening in 1858. His fellow

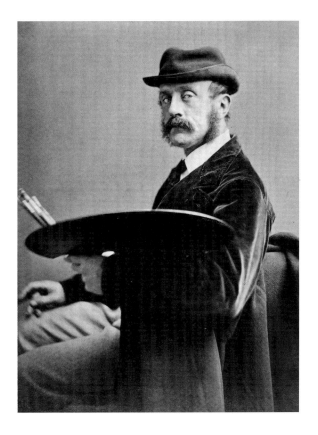

circle. Eastman Johnson, Church, Ehninger, Julius Gollmann, and Thomas Rossiter are documented associates. His acquaintance with Johnson, which began as fellow students in Europe and continued as they rose through the ranks, must have been a source of mutual support. He worked with Ehninger (fig. 34), a genre painter and illustrator, on several occasions in the late fifties. A New Yorker by birth, Ehninger studied classics and linguistics at Columbia College and graduated in 1847. A member of a wealthy Knickerbocker family, he had little concern for an immediate means of supporting himself, and departed for extended European travel and artistic training that took in France, Germany, and Italy. He was back in New York by 1854, when he exhibited annually at the National Academy of Design throughout the 1850s and frequently thereafter. He collaborated with Mignot on *The Foray* (cat. no. 24) and invited him to participate in his *Autograph Etchings* (cat. no. C), published in 1859. He numbered among his friends the Rutherfurd-Stuyvesants, another old New York family, and George Templeton Strong, a fellow Columbia alumnus who subsequently associated with Mignot. In short, Ehninger was an artist who enjoyed great social privilege, education, and culture—a profile that fits several of Mignot's closest associates.

Johnson (see fig. 2), Richard M. Staigg (c. 1864; National Academy of Design), and Samuel Rowse did portraits of Mignot.[6] Several other artists owned paintings by him, including John Frederick Kensett, James Suydam, and John Casilear. Kensett was a "bridesmen" at Mignot's wedding and nominated him for election to the Century

artists, writers, and architects were: William F. Atwood, George Boughton, James R. Brevoort, Frederic Church, Anna Mary Freeman, Sanford R. Gifford, Régis Gignoux, William Hart, William J. Hays, John Henry Hill, Richard Hubbard, Richard Morris Hunt, John La Farge, Edward Nichols, William J. Stillman, James Suydam, George Thorndike, Henry White, and Theodore Winthrop. In 1859 critic Henry Tuckerman moved in, probably because of his friendship with Hunt, and thus gained first-hand access to the art of the residents he was to describe in *Book of the Artists* (1867).[5] Mignot participated in the receptions where they showcased their work and interacted with the attending public.

Through friends in the building, Mignot widened his social

Association. He owned three of Mignot's works: *The Evening Bath, Painted Ship on a Painted Ocean,* and *Snow Scene.*[7] Suydam, who was devoted to Kensett, also served as a bridesman for Mignot. Perhaps Suydam's Dutch background provided a link between the two artists. He was well-known in New York as an artist-amateur and collector, and in 1857 he acquired Mignot's *Sources of the Susquehanna* (subsequently bequeathed with the rest of his holdings to the National Academy of Design). John La Farge, an amateur painter with a law practice at the time Tenth Street opened, was reserved in manner, yet despite his unsociability one supposes that he and Mignot might have hit it off. Stylistically they demonstrated a move away from the prevailing Ruskinian detail. They also shared a cosmopolitanism that derived from extensive residence in Europe and a French Catholic background that separated them from the majority of their colleagues. In 1859 Mignot and Suydam were part of the group who formed the Artists' Fund Society—which included Casilear, Gifford, Gignoux, Hubbard, and Thompson—to provide relief to impoverished artists and their families. Church, we know, was also an important part of this circle.[8] This artistic company provides one measure of Mignot's ambition and of his success at gaining acceptance.

The New York City in which these artists lived and worked must have been charged with an atmosphere of intense rivalry, filled with disappointments and triumphs as they maneuvered for commissions, angled for buyers. Mignot's residency there, from 1855 to 1862, were turbulent years of economic uncertainty and social unrest. The competition grew more formidable as the number of artists exhibiting each year at the academy seemed to rise. And the market had changed substantially. The "aristocrats" who acted as guardians of art and culture were disappearing, being replaced by an undereducated, upper-middle-class, moneyed group whose identity was more shaky than that of the artists; that is, they were not confident of their own taste, and therefore did not provide a firm footing or support for the arts.[9] At the same time, the artists themselves were assuming a new role: no longer sub-servient to the aristocratic buyer, subject to whims of moneyed class, but his own man. In increasingly troubled times the nation looked to culture as the hope for America, and to artists as the keepers of culture. This attitude is reflected in G. T. Strong's remarks about one of his soirées held in April 1858: "Rossiter, Kensett, Mignot, Darley, and other artists assisted, whom it's not only creditable but aesthetic and refined to have at one's parties."[10] Times were hard, but it must have been an exciting moment for Mignot and his fellow artists who sensed the potential of their new status.

Mignot's transaction with Elias Magoon for *Winter View from Newburgh* in 1856 (discussed in chapter 4) was one of his first important sales in New York City. A successful author and persuasive orator, Magoon seriously turned his attention to the assembling of an art collection about 1853, a collection that came to include not only contemporary American art but also more than three thousand European drawings, prints, and watercolors.[11] Among these works were three watercolors illustrations by J. M. W. Turner, some of the earliest of his works to come to the United States. We can imagine that Mignot was among the group that enjoyed of the privilege of studying them, for "artists and amateurs are much indebted to his enthusiasm for these foreign contributions to the Art-treasures of our city, and certainly to his courtesy for the facilities afforded for their inspection."

Magoon sets the pattern for the enlightened collectors who frequently favored Mignot's work. And although questions still abound as to the nature of these arrangements generally, and with this artist specifically, a compilation of collectors helps to establish Mignot's reputation. William T. Blodgett owned a *Winter Landscape.* Cyrus Butler lent his *On the Passaic* to the Brooklyn Long Island Fair of 1864. George Folsom, an acquaintance of Strong's, who described him as "erudite," was the owner of *Doorway of a Castle in Winter* (cat. no. 8) by Mignot, with figures by Eastman Johnson. Gandy Shepherd owned *Street View in Guayaquil* (cat. no. 47), probably the one subsequently acquired by Robert L. Stuart, who also owned *Harvest Moon* (cat. no.

55).[12] Mignot had presented as a gift a small tropical view to Strong's wife, Ellie, and they may have acquired others as well. Across the Hudson in Weehawken, William Wright was actively engaged in assembling one of the most ambitious art collections in the area including his commission for a series representing the artists, men of science, literary men, and merchants of America. He owned Mignot's *Sources of the Susquehanna,* which represented him at the Paris Exposition of 1867.[13] Marshall Owen Roberts, Rutherfurd Stuyvesant, and William Webb were among the other well-known New Yorkers of the day who possessed works by Mignot. But his work also began to find a home with other collectors whose names and profiles are less familiar:. D. R. Barker owned *Vespers on the Guayaquil;* S. B. Caldwell, a version of *Ave Maria;* and A.M. White, *Twin Elms.*[14]

Brooklyn resident Henry Bowman Cromwell typifies a new class of collectors of contemporary art, many of whom engaged in shipping and trade. He owned Mignot's *The Well of San José, Panama* (possibly a study for *Vespers, Guayaquil River, Ecuador, I & II;* cat. nos. 74 and 75) and *A Cool Evening on the Housatonic.* Cromwell shared with the artist strong ties to the South through his shipping business, an enterprise that grew to include steam lines between New York and many southern ports. Although Cromwell's commercial interests were so largely connected with the south, when the Civil War began he sold nearly all his vessels to the government and, unlike Mignot, he firmly upheld the cause of the government during the war.[15] Another Brooklyn patron was John C. Force, who owned the *Winter Scene* (cat. no. 20). And J. H. Kidder is listed as owner of a *Landscape* by Mignot, exhibited at the Brooklyn Art Association in December 1864.[16]

BEYOND NEW YORK CITY

Over the years since Mignot had arrived in New York City, the annual exhibitions at the National Academy of Design had diminished in importance as venue for artists to reach the public and thereby establish a reputation. Instead, they took advantage of growing numbers of private galleries and other commercial opportunities, and they ceased to send their "best" (i.e., most salable) works to its annual exhibitions, as Thomas Seir Cummings, artist and chronicler of the academy, pointed out:

> Annual Exhibitions are not, either to the artist or public, what they were twenty years ago. The present Exhibition, and the comments thereon, fully confirm that opinion—the '*general excellence,*' as it is called; but want of prominent pictures is universally stated and believed. That is so; and how does it arise? Simply from the fact that, years ago, the Artist had no place, no matter *what* the extent or merit of his picture, in which to exhibit it, but the Annual Exhibition. Now, if the work is of any size or merit, private enterprise is ready to claim and receive it, exhibit it, engrave and publish it, obtain subscribers, and return the artist profit, freed of trouble. Is it to be wondered at that the Exhibition should be wanting in such works? Depend upon it, hereafter works of such merit as will command a support of private exhibition, will not come to the Annual display.[17]

In collaboration with Rossiter, Mignot would employ commercial techniques—pamphlets, prints, great picture format and display—for *Washington and Lafayette.* Other selected pictures were issued as prints. In general, however, he seems to have been reluctant to gear up for that level of commercial promotion on his own, a reluctance made perhaps even more noteworthy given his close ties to Frederic Church during the boom years between *Niagara* and *Heart of the Andes.* He simply did not conform to the "high-profile entrepreneurial persona" that Linda Ferber has described as one of Albert Bierstadt's assets and that was requisite for the sustaining the activity of creating and promoting large-scale dramatic works. His work did not have intrinsic popular appeal; as critics pointed out, his art was of a more refined and "highbrow" taste, which is perhaps what led to natural

FIGURE 35. David Acheson Woodward, *Portrait of Dr. Chapin A. Harris,* 1853, oil on canvas. Collection of Dr. Samuel D. Harris, National Museum of Dentistry, Baltimore, Md.

associations with New York "elites," including Strong and Stuyvesant.

Mignot recognized from the start the need to establish a broad base of patronage and pursued available opportunities for participating in art organizations and exhibits beyond New York City. As Buffalo and Troy began to demonstrate greater concern with fostering culture, they presented fertile ground.[18] With the invention of the sewing machine in the 1850s, Troy's characteristic industry was launched: the manufacture of shirts, collars, and cuffs. Increased prosperity brought with it increased interest in art. Organizations such as the Young Men's Association of Troy became the host for regular art exhibitions. Spring 1858 witnessed its first annual exhibit, held at Troy's Athenaeum. Mignot's *Forest Scene at the Hague* and *Winter Scene at the Hague,* lent from the collection of G. B. Warren Jr., hung, along with works by a number of other artists from "down river," where they were noticed in the *Crayon* as "very carefully finished productions."[19]

Mignot also looked south. His involvement with the Washington Art Association provides one example of his efforts to attain greater visibility. It also sheds light on how New York–based artists in general sought opportunities to display and sell their work in the nation's capital. During its five-year existence, the association achieved notable progress in that direction: it organized four annual exhibitions (complete with catalogues for the years 1857–60) and created the National Art Association, which in turn led to the U.S. Art Commission. Loosely structured after the National Academy of Design, it drew member-

ship of patrons as well as painters and sculptors from the leading eastern art centers from Pittsburgh and Boston to Charleston. The president throughout its existence was Dr. Horatio Stone, sculptor and physician; his dual interest in art and science seemed to epitomize those of its constituency. The first exhibition opened on 10 March 1857 with more than a hundred works, including *Snow Scene and The Foray,* a collaboration with Ehninger. Mignot continued to submit works there, with showings of *Autumnal Scene* in 1858 and *Among the Cordilleras* and *Sunset* in 1859. In the months after settling in New York, when he must have felt some pangs of homesickness for his home state, the Washington Art Association would have provided contact with other southerners. The organization's vice president, William Washing-

ton, was a Virginian. Unfortunately, the threat of war brought about great divisions in the association, and sharply divided points of view within its membership led to its demise in 1860.[20]

Baltimore also afforded a variety of opportunities. Beginning in 1858 Mignot participated in exhibitions held at the Maryland Institute for the Promotion of the Mechanic Arts, the Maryland Historical Society, as well as at its short-lived Allston Society (1858–63).[21] Here he made the acquaintance of Dr. Chapin A. Harris (fig. 35), a leading figure in the dental-medical profession of the city who became a loyal collector and eventually his father-in-law. By the following July he wrote to Rossiter in terms that implied that he had spent extended time there, and that they were both well acquainted with the family: "Baltimore seems more to be doing better. . . . All the folks here are very well. Mrs. Blandy sends her kind regards as do all the Harris family."[22] Through Harris he presumably met other members of the Baltimore medical profession, including William H. Keener. In addition to Mignot, Keener patronized the work of sculptor William H. Rinehart, whose correspondence provides insight into his taste and travels. So absorbed did he become in the pursuit of art and literature that he abandoned medicine altogether about 1870, living mostly abroad until his death in 1880.[23] Another patron-physician was Ruggin Buckler, who practiced in Baltimore for forty years and twice served as Maryland's surgeon general. Perhaps he first developed a taste for art during his hospital service in Europe following the completion of his degree (1853–57), for he acquired a North American scene by Mignot shortly after his return.[24] Mignot also found support for his work among rising industrialists. In Baltimore, David L. Bartlett was representative of this group. Owner of an iron foundry, he was a largely self-educated man who had been one of the managers of the Maryland Institute, where he must have encountered the artist.[25]

The recorded titles of several (still unlocated) pictures indicate that Mignot at least occasionally painted the local sites. One work simply went by the title *Baltimore,* and other titles suggest his interest in Druid Hill Park, the third oldest public park in the country.[26] Inaugurated on 19 October 1860, it was mainly composed of the 475-acre Druid Hill estate north of the city owned by Lloyd Nicolas Rogers, who decided to sell it when city officials put out a call that year for "parties willing to dispose of their property for a public park." Rogers and his estate had been familiar to John Frederick Kensett, who painted Druid Hill in a work dated 1864. It is likely, however, that he painted it from a sketch made on an earlier visit to his elder brother, Thomas. A pioneer oyster packer and canner, Thomas Kensett had settled in Baltimore in 1849 and had a summer home that adjoined the Rogers mansion.[27] Thus we can imagine Kensett visiting and sketching Druid Park in the company of his friend Mignot, possibly also with Rossiter. It may have been through Kensett and his brother that Mignot first went to Baltimore and met the Harrises. Given that Eastman Johnson painted Dr. Harris's portrait, it is likely that he too formed part of their artistic society.[28]

Druid Hill Park in essence established a continuum within Mignot's personal landscape iconography. That is, like Fishkill and other locales, as a subject it provided a mix of presettlement lore and contemporaneity—both part of the territory of the lost race of the Susquehanna and an area with thriving enterprises in railroad and shipping in the 1850s and 1860s.[29] In fact its establishment as a public park was closely linked to the growth of the railway system in Baltimore. As railroad companies bid and were selected to lay their lines through this growing metropolis, they were required to return to the city one-fifth of the gross receipts for the purchase and improvement of city parks. With some of these profits, Druid Hill Park became a "600-acre oasis for the masses."[30] The alliance between railroad interests and artistic culture were forged when, in June 1858, Mignot and other artists participated in the Artists' Excursion, sponsored by the Baltimore & Ohio Railroad (fig. 36).

The task of selecting the painters likely fell to Charles Gould of the Ohio and Mississippi Railroad. His invitation list for New York

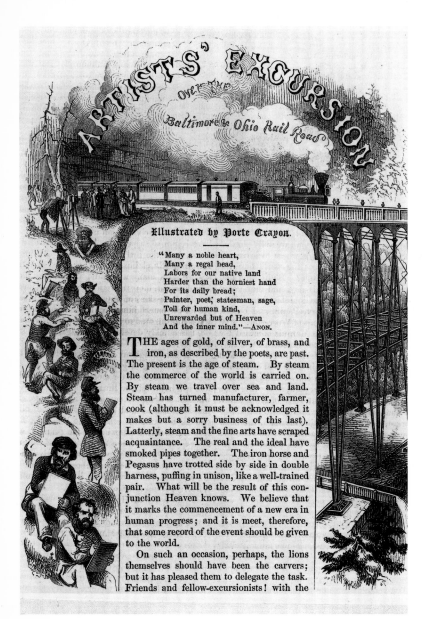

FIGURE 36. Porte Crayon,
"Artists' Excursion over the
Baltimore and Ohio Railroad,"
Harper's New Monthly Magazine 19
(June 1859): 1.

FIGURE 37. Unidentified photographer, "The Artists' Excursion, Baltimore and Ohio Railroad, beyond Piedmont, near Oakland," 1858. Collection, Maryland Historical Society, Baltimore.

artists embraced Mignot's immediate circle, including Ehninger, Thomas Hicks, D. C. Hitchcock, Kensett, Louis Lang, Rossiter, and Suydam. Also along for the trip were D. G. Henderson, J. R. Johnston, and F. B. Mayer from Baltimore; Joseph Ames from Boston; J. H. Beard and W. W. Fosdick from Cincinnati; and D. H. Strother ("Porte Crayon") from Berkeley Springs, Virginia. The group—which grew to include photographers, reporters, and railroad officials—assembled at the Gilmore House in Baltimore on 31 May for a "bountiful dinner" and the next morning departed from Camden Station for their leisurely four-day, 379-mile journey. A photograph of three ladies and their attendants perched on the iron horse (fig. 37), which may include

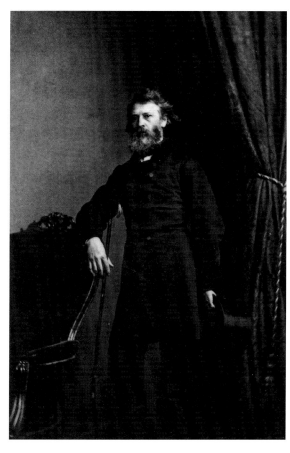

FIGURE 38. Unidentified photographer, "The Artists' Excursion, Baltimore and Ohio Railroad, Tray Run Viaduct over the Cheat River," 1858. Collection, Maryland Historical Society.

FIGURE 39. Matthew Brady Studio, *Portrait of Thomas P. Rossiter,* n.d., carte-de-visite photograph. Courtesy of Paul Hertzmann & Susan Herzig, Paul M. Herzmann, Inc., San Francisco.

Mignot (perhaps the waving figure?), suggests the spirit of fun that pervaded the event. The point of the excursion was to observe and endorse the scenery along the railroad line (fig. 38), but if the B & O officials banked on a rich yield of finished paintings to advertise their line, then they were destined to be disappointed.[31] A painting by Mignot that had gone by the title *Patterson River, Virginia* (cat. no. 39) is, I believe, one of the few known works to result from that trip. Dated 1858, it measures 10¼ × 18¼", a scale consistent with a sketch or study, and

was completed on the trip or shortly thereafter. The location is Patterson Creek, West Virginia (then Virginia). One of the photographs taken on the excursion of "Bridge over Patterson Creek, near Cumberland" (Maryland Historical Society, Baltimore) probably represents the spot where Mignot descended from the train in order to make his sketch, which features a V-shaped expanse of water flanked by its foliated banks.[32] Shortly thereafter the excursion terminated, and the participants were deposited back in Baltimore; this would have afforded

Mignot and Rossiter the opportunity to make a detour to Mount Vernon on their way back to New York. It seems likely that they took advantage of it as the plans for their large-scale recreation of Washington and Lafayette advanced.

THE SYMBOL OF GEORGE WASHINGTON

Mignot's career evolved as a complicated dialectical interaction that reflected a period of increasing sectional conflict and cultural strain. At several critical points his southern affiliation played a decisive role. One such juncture was spotlighted when, in November 1859, the major canvas Mignot had painted in collaboration with Thomas Rossiter (fig. 39) made its debut in New York City. *Washington and Lafayette at Mount Vernon* (also known as *Washington at Home;* cat. no. 52) is a huge canvas (more than 7 feet high by 12 feet long) that now belongs to the Metropolitan Museum of Art. Mignot set the scene with his landscape, and Rossiter added the figures. The picture is in many ways awkward and as a result it has been largely ignored in the literature, dismissed as something of an art historical embarrassment. One could argue, however, that its very lack of resolution makes it intriguing. What prompted Mignot to undertake a historical subject that placed considerable demands on his time and talent at the very moment when it seems that a South American picture would have been a far more advantageous career move? *Washington and Lafayette* was painted two years after he returned from his expedition to Ecuador. Simultaneously Church was preparing his *Heart of the Andes,* which was destined for great success. Why did Mignot forgo this opportunity to make a big splash with a tropical subject, and in a sense temporarily concede the field to Church?

Contemporary accounts emphasized the necessity to portray *American* subjects—its scenery and people—which constituted a kind of national artistic imperative.[33] The Washington Art Association's advocacy of using art to patriotic ends may also have influenced Mignot's decision. Its president, Horatio Stone, spoke in favor of establishing a national mausoleum at Mount Vernon for the tombs of all the presidents, and in 1858 Rembrandt Peale gave several lectures there on the life of Washington. Mignot perhaps believed he had found *his* quintessential subject in Washington's Mount Vernon. It was shown in a single-picture exhibition, complete with reproductive engraving (fig. 40) and explanatory pamphlet, which went though several editions. In its format one commentator recognized that it was perfectly pitched to the general public, observing: "it is large, with figures the size of life, and admirably calculated for its purpose, that of popular exhibition."[34] The painting received an enormous amount of attention in the press, from which the *Albion* is quoted at length as a measure of public assessment:

> Messrs. Rossiter and Mignot—both American painters of mark, the one a figure and portrait painter, the other a landscapist—have just finished a picture in collaboration, which is sure to be popular, and which to the elements of popularity adds intrinsic merit as a work of art. The composition, which is of life size, represents the home circle at the Mount Vernon after the peace of 1783. The family are upon that favourite American lounging place (if Washington ever could lounge), the verandah, or as it is here somewhat unaccountably called, the piazza. Mrs. Washington and her daughter, Mrs. Custis, are seated at a table; and Lafayette leans against a pillar talking to the First President who, in all his native dignity, stands the central figure of the group. So charming is the attitude and manner of the young French Marquis, that in spite of the idolization of Washington, he will surely be the favorite with all beholders, except those who may be won by the charms of Mrs. Custis. From these principal figures the eye is led out to the lawn by the introduction of a negro nurse playing upon the green sward with her little mistress. Mount Vernon is not very picturesque, but Mr. Mignot has made it unusually attractive by his skillful management of the points which the

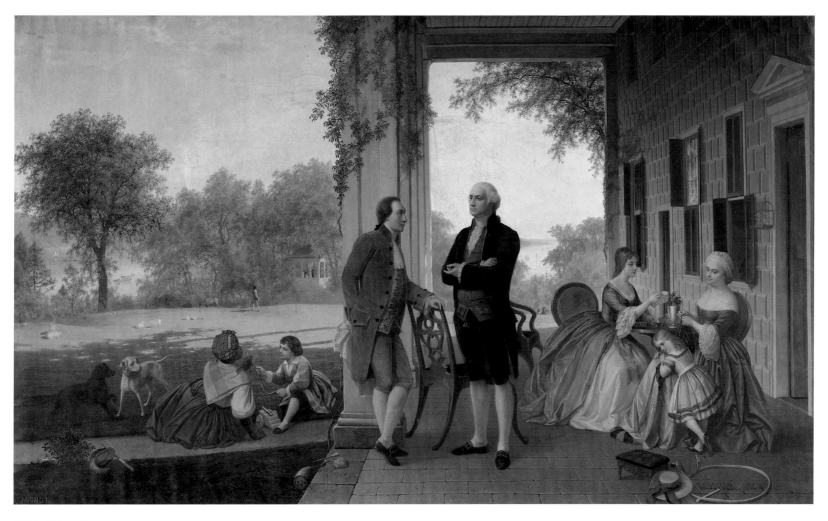

CAT. NO. 52.

Washington and Lafayette at Mount Vernon, 1784 (The Home of Washington after the War)

grounds and the distant view afforded him. The summer house embowered in shrubbery, and the far flowing Potomac make the landscape of this very pleasing picture no unimportant element of its beauty. We are informed that *The Home of Washington after the War* is to be engraved in the best manner.[35]

A good deal of paint was spilled over Washington's military maneuvers alone, of which Leutze's *Washington Crossing the Delaware* (1851; Metropolitan Museum of Art) is probably the most famous example. Increasingly in the 1850s attention came to focus on Washington the man, fueled by the publication of Richard Rush's *Washington in Domestic Life* and William Makepeace Thackeray's *The Virginians*,

FIGURE 40. Thomas O. Barlow, *The Home of Washington,* engraving after painting by Mignot and Rossiter. Kenneth M. Newman, The Old Print Shop, New York.

serialized in *Harper's* between 1857 and 1859. Also timely was the campaign to restore Mount Vernon and make it a national monument. On his visit Mignot had pointedly interviewed the old caretaker of the place, securing details that would allow him to render it as it was in Washington's own day, and not in the contemporary state of neglect and squalor into which it had been allowed to fall (fig. 41). Surely there were few names or causes more noble in their associations than Washington's Mount Vernon. On one level, therefore, we can assume he undertook this subject as a bid for widespread recognition with a sure-fire subject.

In this strategy Mignot was also following the example that had been set by fellow landscapists who made their premieres with such historic works. *Hooker and Company Journeying through the Wilderness from Plymouth to Hartford, in 1636* (1846; Wadsworth Athenaeum) was Church's first major picture shown at the national academy in 1846. A native of Hartford whose family traced its lineage to a member of the Hooker party, Church selected a subject with obvious national appeal but also with direct links to his own regional ties and claim to artistic attention. German immigrant Bierstadt's *Gosnold at Cuttyhunk, 1602* (1858; Whaling Museum, New Bedford), an early essay on the history of New Bedford, seems to have been similarly motivated to appeal to audiences in the town where his family had settled. A number of

FIGURE 41. *Mount Vernon, East Front of the Mansion*, 1858, photograph. Courtesy of Mount Vernon Archives.

artists plumbed national history with highly personal regional agendas. Mignot must have had equally deep-seated, individual reasons for his gravitation toward Washington, the Virginian whose plantation was worked by slaves. Depicting Washington as the southern gentleman was a recurrent motif among contemporary southern writers; in James Kirke Pauling's biography, for example, Washington is shown to possess the best of the southern cavalier tradition.[36]

The painting by Mignot and Rossiter emphasized many of these traits. The opening page of the pamphlet, "Description of the Picture," sets the stage: With the cares and anxieties of the Commander-in-Chief removed, the Hero at once devoted himself to restoring his neglected estates, resuming the agricultural habits and pursuits of an opulent planter." The prose transforms what might have remained vague or unrecognized into unavoidable fact: "On the river is a neigh-bor's barge,

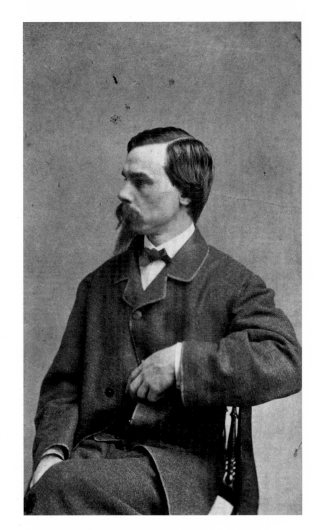

FIGURE 42. George G. Rockwood, *Portrait of Louis R. Mignot* (carte-de-visite photograph), c. 1860. Courtesy of Paul Hertzmann & Susan Herzig, Paul M. Herzmann, Inc., San Francisco.

rowed by six servants in red livery—suggestive of . . . the state which obtained among the planters of the Potomac at that period."[37]

Significantly, neither in this extensive text nor in the reams of subsequent critical commentary, have I been able to find a reference to these figures as slaves. They are called "servants" or "Negro servants." The author was careful to point out that Washington's "negroes were treated with particular kindness." They are part of his extended household, the caretakers of his grandchildren; their actions are described matter-of-factly, beginning with the male: "On the lawn, a negro servant in the family livery of white and crimson, is driving off some trespassing cows." On the surface, the female nanny seems to be involved in an equally commonplace and benign activity: "Leaning upon the grandmother's lap is Eleanor Parke Custis, who has sought her protective presence, while her brother, George Washington Parke Custis, fires a small canon, with the assistance of a negress, who is blowing a lighted match."[38] In retrospect, the motif is just too "loaded." In the fall of 1859, upriver from where Mignot was finishing his painting of this bucolic spot on the Potomac, abolitionist John Brown led a raid on the government arsenal at Harper's Ferry, an event that helped catalyze the war. That a black woman here holds the spark to ignite the cannon is all too revealing of such contemporary events. But how, specifically, does the work tie into Mignot's southern background?

Aside from the obvious bow to Washingtoniana, the canvas puts forth a subtle political and personal agenda: an exegesis on the values at the basis of nationhood, a plea for the preservation of the Republic. First, the picture depicts the moment when Washington had returned from the Revolutionary War after long service to his country, and it underscores his struggle to defend the way of life he and his country-men enjoy. But, as we are forced to recognize, the great man's way of life was that of a southern plantation owner, complete with black slaves as members of his household. This was a way of life in which Mignot's slave-owning family also participated.

Second, Washington is depicted not as a warrior, statesman, or even a farmer, but rather as a family man; instead, he is shown in his domestic sphere. Succumbing to the picture's supposed "photographic

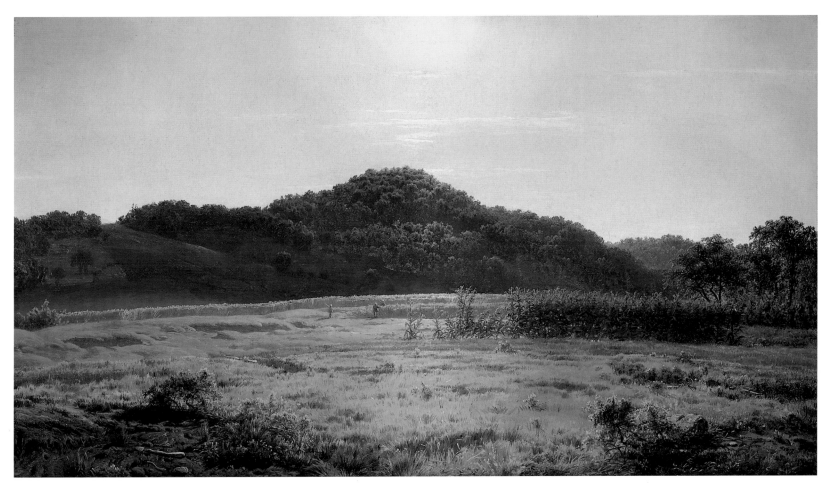

CAT. NO. 38.

View across the Valley of Pierstown, New York, from a Point above Cascade Hills

accuracy," audiences felt that they had been privileged to glimpse daily life at Mount Vernon. The familiar, the familial, evokes more than an intimate view of a famous household; Washington is not only the adoptive father of Mary and George Custis; but also the ultimate paternal figure, the Father of Our Country. Through him, the image of the nuclear family supports the explicate term Union.[39] Thus his family—America—will survive. Text and image construct the meaning: Washington himself endorsed a plantation system that included chattel slav-

ery; the southern way of life is no less American than that of the North, and the two can coexist.[40]

MATURITY

About 1860 Mignot (fig. 42) came into his own as an artist. In the wake of his travels with Church, he produced a series of South American pic-

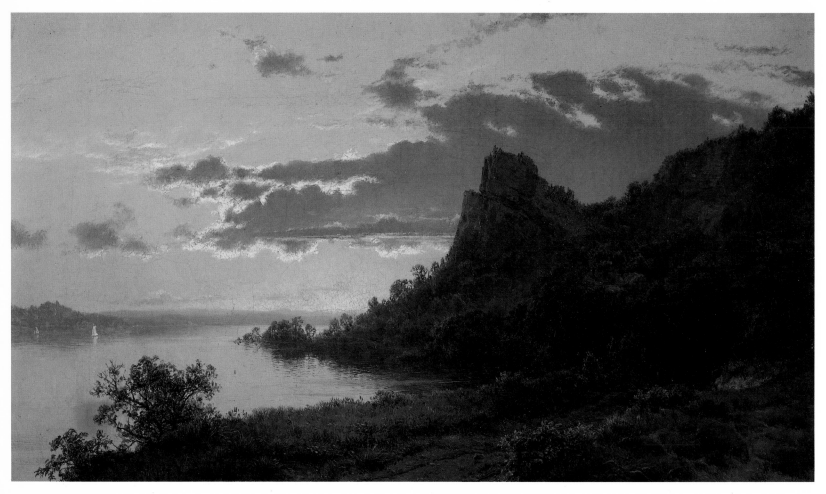

CAT. NO. 53.
The Day's Departure

tures that increasingly asserted his original perspective. Shortly after their return, Mignot must have been preoccupied in formulating his initial impressions of Ecuador to put to canvas, the unveiling of which he wanted to orchestrate with care. At the opening of the National Academy of Design on 12 April 1858 he showed only one work, *Among the Cordilleras,* which received an appreciative if sometimes mystified response. Perhaps unable to conceive to his satisfaction more than one exhibition piece drawing upon his recent expedition, he sent to the

Pennsylvania Academy of the Fine Arts a *View Near Otsego* (then in the collection of F. A. Eliot), which was the centerpiece of that year's entries. "We do not hesitate to say, there is no better landscape in the exhibition, native or foreign," one critic declared.[41] He probably refers to the work now in the Munson-Williams-Proctor Institute identified as *View across the Valley of Pierstown, New York, from a Point above Cascade Hills* (cat. no. 38), which is indeed in the region adjacent to Otsego.[42] In contrast to other Otsego pictures, this one was painted in

a brighter palette with subtler nuance in the vegetal greens that more properly belong to the period following his South American expedition.[43] It is most likely therefore that he painted it in 1858, as he simultaneously let loose his new chromatic observations on *Among the Cordilleras*.[44] Conceptually, too, it represents a further synthesis of his experiences in upstate New York, with the harvest itself now dominating the figures who reap it, and the very colors of autumn fixing the moment without distracting reference to narrative detail.

Following his joint efforts with Rossiter on the *Washington and Lafayette,* Mignot avoided another major collaborative effort, allowing his landscapes to convey their meaning through their natural forms without recourse to figural elements added by another hand. This new confidence carried over into his North American subjects (cat. no. 53). An independent vision gels in his work, evident in both style and content. He had, in effect, hit his stride as a painter. No longer referred to as "a young man of great promise,"[45] he was now regarded as an artist who had come of age. He had every reason to believe that he had gained a measure of acceptance as an artist, that he had passed his initiation into the American landscape school.

A shift can now be detected in the substantive content of his art. He begins to form a more intimate view of nature, in which terrain of an anonymous, unassuming character readily allows color and light to dominate. It is telling that whereas earlier he had been most closely associated with Church, he now numbers among his closest painter-friends Suydam and Kensett, whose vision of nature was one of quiet repose. Here we must be careful, however, to distinguish what Mignot's art has in common with that of his contemporaries and where it diverges from theirs. There was a general movement toward domesticated, settled landscape and away from the older preference for the natural sublime with which his art was in sympathy (cat. no. 54). But these distinctions between wild and cultivated diminish in importance as he rethinks the relationship between nature and art. Between 1855 and 1860 he created a series of pictures including the Cooperstown

scenes and *Washington and Lafayette* that by virtue of their subject matter alone demonstrated his allegiance to prevailing regional and national agendas. After 1860 he puts a different demand on the themes he chooses to paint: he stresses a concordance of nature with feeling rather than one of nature with idea. His pictures are becoming more subjective and concomitantly more formally experimental. This was the direction American art generally was to follow in the postwar years, but with few exceptions (George Inness, for one, stands out here) landscapists whose careers were forged in the fifties found this transition difficult, and the change is evident mainly in the work of the younger generation of painters. In Mignot's hand, however, landscape is permuted as he tentatively pushes toward a more personally expressive art. Henry Tuckerman identified the distinctiveness of his mature work most succinctly: "He has a remarkable facility of catching the expression, often the vague, but, therefore, more interesting, expression of a scene; he seizes upon the latent as well as the prominent effects. He is a master of color, and some of his atmospheric experiments are wonderful."[46]

Pictures such as *Harvest Moon* (cat. no. 55) announce his newly achieved artistic maturity. Its conception coincides with a moment of fulfillment he realized in his personal affairs. His marriage to Zairah Harris on 11 January 1860 marked the beginning of a partnership that provided a stability previously missing from his life. And since the painting must have been nearly complete when a reporter for the *Crayon* caught a glimpse of it in his studio in March, it may celebrate the promise of that occasion. In terms of subject it is modest. An initial report of the work-in-progress would hardly have aroused much curiosity: it "represents a corn-field, its produce ripe for gathering and rich with the hues of the harvest season, over which, on the horizon, the full moon is just appearing in a cool, blue, serene sky."[47] Scenes of harvest time and its related activities have been a staple of landscape painting throughout its history, and they were especially plentiful in American art around midcentury and again in the years just after the Civil

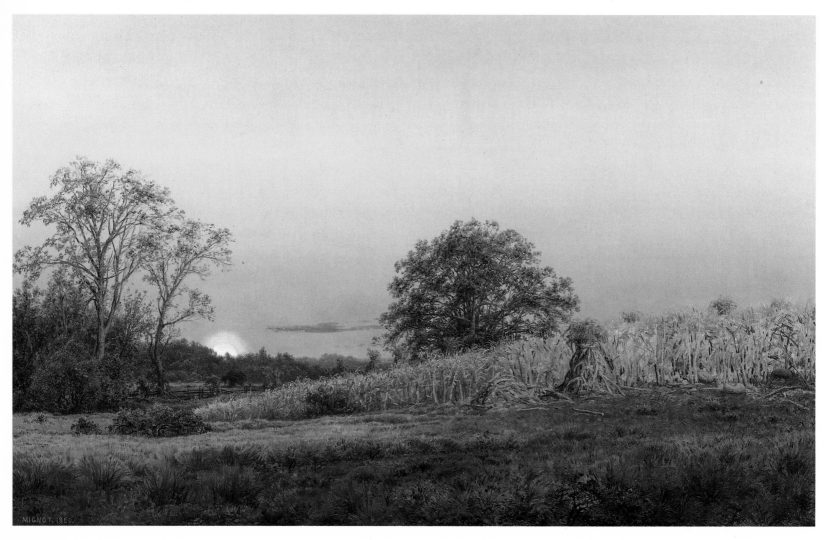

CAT. NO. 55.
The Harvest Moon

War. This artist himself had on several previous occasions given the harvest a prominent place in his views of upstate New York. In the right foreground of his *Cooperstown from Three Mile Point* (cat. no. 16) is the hops crop that was beginning to play an important a role in the area. *View across the Valley of Pierstown, New York, from a Point above*

Cascade Hills (cat. no 38) portrays the local farm field abutted by hills; and though the figures of the laborers are hardly prominent, they are nonetheless present. In *Harvest Moon*, however, he avoids any suggestion of the human efforts of sowing and reaping; in contrast to the precisely specified sites in the Cooperstown and Utica pictures, here he has

left its identity vague (indeed, Tuckerman had called it a "Southern Harvest," so nonspecific is its locale). The focus is instead on the state of nature itself: the harvest or full moon at or about the time of the autumnal equinox.

The subtlety of handling with which he evokes this particular moment is remarkable. Eschewing the conventional depiction of autumn foliage in the reds, oranges, and yellows much favored by his compatriots (and at which Mignot tried his hand on other occasions), he here created a study in mauves, greens, and yellows in a manner that will not appear with any consistency in American art until late in the century, when Impressionism takes root. He has attained a new mastery of painterly effects, which allow him to depict the ineffable. As a critic for the *Home Journal* recognized, "the purple pollen on the corn-plumes, and the very dew of evening, are almost visible."[48]

The sight of this expanse of dried golden corn stalks between which the rounded forms of the orange pumpkins partially emerge, all sheathed in purple mist, must have been startling. Indeed, as one observer of the National Academy exhibition insisted, "no one can pass by Mignot's *Harvest Moon*."[49] Why, then, did the picture make the rounds of all the major exhibits without finding a buyer? For soon after its completion *Harvest Moon* appeared in succession at the annual exhibitions of the National Academy of Design (April–June 1860), Boston Athenaeum (Summer 1860) and in the Pennsylvania Academy of the Fine Arts (April–June 1861). It remained unsold and was placed in the sale held in June 1862 on the eve of his departure; there it found a home in the collection of Robert L. Stuart, who already owned the artist's *Street View in Guayaquil, Ecuador.*[50] Times, it is true, were tough; this refrain was repeated by almost every artist active in this period. But Eliza Haldeman had reason to comment on the particular circumstances of this artist to her father in a letter of February 1860: "Mignot's landscape has been recently sold for 550 dollars, the original price being 1100." And although she added: "I suppose the hard times makes [sic] the difference,"[51] she implied that Mignot's dilemma was

somehow more acute. In retrospect it seems likely that this picture was a bit ahead of its time; lacking narrative, it represented not a place but a space and time in nature. Taking this oft-rendered theme, he demonstrated his ability for original reinterpretation. But as discerning critics of the time pointed out, it was one his audiences were not yet prepared to appreciate.

Circumstances constantly seemed to operate against Mignot being able to settled into a groove. By the end of September his father-in-law and early supporter Dr. Harris was dead and on 20 December 1860 South Carolina seceded from the Union. These events impinged upon the artist's life in ways that would be difficult to gauge precisely in the absence of personal documents; but the increased restlessness, the searching for themes, the switching from place to place in his summer travels without fully exploiting the potential of any single subject, are all indicators of inner turmoil. As hopes for the preservation of the Union expressed in *Washington and Lafayette at Mount Vernon* were dashed, Mignot must have been in a state of profound doubt about the impact of politics on the condition of his life, and about the course he should follow. Through the paintings produced in 1861–62, many of them reduced in scale from previous work (cat. nos. 61 and 62), it is possible to trace signs of the deepening crisis.

IN THE WHITE MOUNTAINS

The White Mountains lured most of the New York landscapists working at midcentury to New Hampshire. But by the time Mignot made his way there, apparently sometime between the springs of 1860 and 1861, a shift had already taken place in the manner of depicting its scenery, and in Mignot himself. The sublime heights of Mount Washington or the craggy peak of Mount Chocorua were being replaced by more domesticated views.[52] Mignot's *Sunset on White Mountains* of 1861 (cat. no. 63) partakes of these changing attitudes.[53] True, it is still based

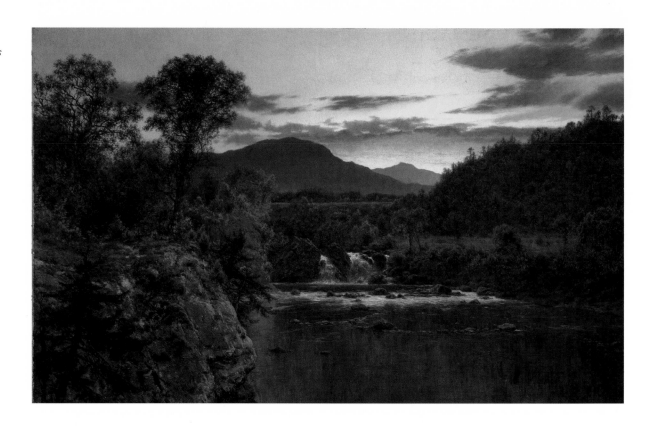

on the Claudian format relied upon earlier with its central body of water, framed by trees at right and left, and leading back to the central peaks. In contrast to his use of this composition several years before in a South American subject (see, for example, cat. no. 43), however, here its effect is altogether different. Although featured in a sense as the "centerpiece" of the design, the axial mountains actually appear as fading and rather nonspecific forms, a purple backdrop to the scene. Instead the wonderful twilight reflects over the rocks and water that lap the lower edge of the canvas, holding our attention on the reddened foreground with its lichen-covered boulders and churned -up white water. It is a strong work, well-painted; yet in it we can detect signs of the artist straining against the compositional prototypes that no longer

serve his needs, and perhaps trying out a subject that was not entirely congenial to him. He demonstrate no sustained interest in this subject matter, which is conspicuously absent from his exhibition records.[54] Subsequently he sought out the banks of the Passaic as well as the softer, gentler hills of the Berkshires and the Adirondacks, where—as William Stillman explained—"there is little . . . to compare with the White Mountain views. . . . There is no Alpine sublimity, few precipices or bold elevations, but the roll of unbroken green . . . the peaks heaving up one after the other, as near alike as may be without being alike."[55] For Mignot, the area could not have sounded more inviting. It offered just the balance he needed between topographical detail and effect, appropriate locales for his experiments.

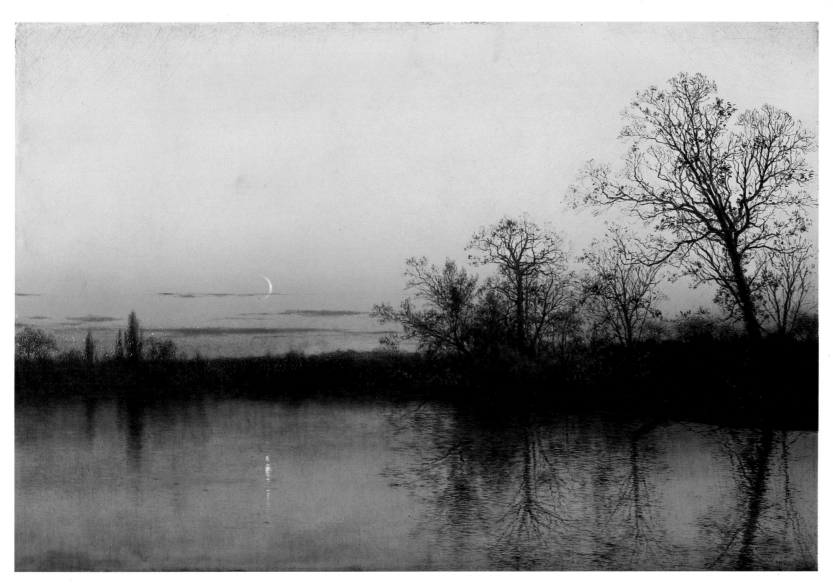

CAT. NO. 59.
Twilight on the Passaic

"I was rather hoping a Passaic River School might form, but so far it's just me."

THE PASSAIC RIVER

Always at home on riverways, he was throughout his career extremely sensitive to their nuances of terrain and mood. His excursions along the Hudson, to judge from works already mentioned as well as titles of unlocated works, had resulted in the predictable subjects favored by his colleagues: *Scene on the Hudson near West Point* (cat. no. 70); and *Palisades, Hudson,* and *On the Hudson.*[56] They served him in his need to establish his professional credentials. As he set about broadening his personal iconography he crossed the Hudson to New Jersey, where he followed the course of the Passaic. He must have been sketching in this area in summer/fall 1860, as reported in the *Crayon*: "Mignot brings studies from Maryland and from the Passaic River."[57] His trip may have been undertaken with the hope of a potential sale to the Stuyvesants. Records indicate that by February 1864 (and possibly earlier) Rutherfurd Stuyvesant owned Mignot's view of *Passaic Falls.*[58] The Passaic held a special spot in the hearts of this founding New York family. Lewis Rutherfurd, the father of Rutherfurd Stuyvesant, had written to his mother from Europe of his fond expectation of being reunited with his family on the banks of the Passaic and on other occasions he referred to them as "dear dwellers on the Passaic." Thus, it is possible that the Rutherfurd-Stuyvesants had commissioned a work from him, and even invited him to stay at their home.[59] G. T. Strong and John W. Ehninger were friends who could have brought Mignot in touch with the Rutherfurd-Stuyvesants, but since both Lewis Rutherfurd and his son Rutherfurd enjoyed easy and close relations with a number of New York artists there is every likelihood that Mignot numbered among their acquaintances. The appeal of these Passaic subjects, however, must have extended beyond the Stuyvesant sphere. Another well-known collector Cyrus Butler owned *On the Passaic*, which he showed at the Brooklyn & Long Island Fair of 1864, where Stuyvesant's *Passaic Falls* also hung.[60] Additional titles, not necessarily matched to known paintings, demonstrate his interest in further exploring the extent of the river and include *Basin of Passaic Falls* and *Newark From the Passaic.*[61] Although the falls of the Passaic are New Jersey's greatest natural wonder, much of the remainder of its waterway would be described as unspectacular.[62] This lack of visual excitement was perhaps part of its appeal for Mignot; it more recently led a *New Yorker* cartoonist to lampoon the lonely condition of the artist, who lamented his lack of company on the shores of the Passaic (fig. 43).

In the absence of the other canvases, *Twilight on the Passaic* (cat. no. 59) must stand for the group. Minimal in terms of subject, the

canvas is horizontally bisected by the shadowy river bank, separating sky from water. With the bands of the sunset sky composed of bands of blue, yellow, and pinkish purple repeated in reverse in the reflection below, the picture projects to the modern eye a semi-abstract quality. In all likelihood this was the sole canvas shown at the National Academy of Design, commented upon in rather neutral tones by one critic: "Mignot's *Twilight on the Passaic* is another fine work; the drawing of the leafless skeleton trees relieving on the sky, and the transparency of the water are particularly noticeable."[63] But comparing this work to the artist's submissions in previous years, writer Frank H. Norton detected a decrease in quality for, as he put it, this picture was "too much like resting" after his recent achievements. To understand his response, and the dilemma in which the artists were caught, we need to analyze it within the context of the academy exhibition that year.

"EXHIBITION OF THE YEAR OF THE REBELLION"

In an extensive review of the annual exhibition of 1861, Norton put forth the not-so-original argument that the worsening socioeconomic climate was debilitating even the best American painters:

> In examining the results of last year's labor among our Artists, it is impossible not to observe that exterior circumstances have been at work, repressing their usual ardor and energy, and in some degree disabling them from their usual efforts. And this is easily explainable; in the midst of the political and social excitement which has been sweeping over us for the past half-year, it would be unreasonable to suppose that great effect would not be produced upon men so dependent upon public prosperity as Artists. And as they can only show their condition of mind and feeling in their works, two very natural results may surely follow: *first,* that their exhibited works will be fewer; *second,* that they will generally possess less merit. We notice that where we have seen, therefore, powerful conceptions and cre-

ations by our greatest names, now they are entirely absent from the list, or represented by results far below their capacity. Thus we miss Gignoux, Mignot (except in one instance), Church (save in one other . . .), Geo. H. Hall, whose rich, luxurious color in times past, added so much to these exhibitions; James Hart, decidedly the most promising landscapist in the country; Cropsey, Colman, Boughton, Eliot, and many others.[64]

What makes his analysis interesting, however, is that he is struggling to understand just how these factors affected the creative process. He proposes that war and large-scale social conflict initially caused artists to become more conservative. Less willing to take risks, Mignot and his contemporaries retrenched. They painted pictures that were competent and even good, but safe—works that only maintained the status quo. It was as though the uncertainty all around them prevented advancing their art in new directions.

American artists faced very real problems, problems that threatened not only their creative growth but also their physical livelihood. This was a particularly lean year for the academy exhibition; it was in a transition period until the new building was constructed, and the temporary arrangements necessitated opening the show earlier than usual. During the run war broke out, pushing artistic concerns into the background. Cummings explained how these circumstances affected the 1861 exhibition:

> It was opened to the public on the 20th of March, and it closed on the 25th of April—making but twenty-eight working days—and received $2,596.50; average $92.60 per day; 577 works—it may justly be termed the "Exhibition of the Year of the Rebellion;" of course not meeting anything like its expenses. . . . After the commencement of the Exhibition, (finding the Galleries would not be occupied, and could be had by the month), it was proposed to extend the Exhibition to the usual time, and to engage the rooms therefor. The whole of that arrangement was frustrated by Civil War. On the 19th of

FIGURE 44. Unidentified photographer, *View of Stockbridge Inn (later the Red Lion Inn)*, 1885, photograph. Collection of the Stockbridge Library Association, Stockbridge, Mass.

April the receipts were reduced to the actual daily expenses; and a day or two after, very much below that point, and it became economy to stop it; and it was closed on the 25th.[65]

Art was the last thing on people's minds. "A panic," he concluded, "appeared to have seized on everybody and everything."[66]

THE BERKSHIRES, 1861

Perhaps there was a need to try to retain old habits in the face of adversity. Most of the artists spent their summer months, as usual, on a sketching tour; this time Mignot's destination was the Berkshires, apparently fresh stomping ground for him. Fellow Century Association member John H. Gourlie reported, "Mignot, a celebrated landscape painter in New York, is now sojourning at Stockbridge, and is engaged in painting several scenes from the beautiful mountains and valleys of that region. He has already painted Monument Mountain, from which engravings will soon be made."[67] The Berkshires, or more properly Berkshire County, is the westernmost region in Massachusetts. Physically the region has obvious boundaries, which contribute to its perception as a separate place of retreat: it is walled off from the Connecticut River Valley to the east by the Berkshire Plateau and from the Hudson River Valley to the west by the Taconic Mountains. Famous as a sum-

mer resort for more than a hundred years, it was the country seat of the rich and powerful during the Gilded Age in the wake of the boom that hit Lenox and Stockbridge about 1880. In Mignot's day, however, it still retained the character that led Henry Ward Beecher to cast it as the "American Lake District," home of the great poets and authors.[68] Even then industry had already invaded the area. Paper mills, first established there in 1801, had multiplied until by 1840 Lee mills were producing one-fifth the paper used in the United States. But like his literary predecessors, Mignot turned his back on the industrial environment to create idylls of unspoiled nature. He maintained the image of the Berkshires as a "secluded paradise," between its ranges of hills west of the Connecticut and east of the Hudson.

Painters had joined the swelling ranks of visitors to the area. Thomas Cole was apparently the first professional landscapist to work in the Berkshires. In August 1833 on his way from the Catskills and Albany to Northampton and Boston, he visited Pittsfield and made drawings that provided the basis for *View of Hoosac Mountain and Pontoosuc Lake Near Pittsfield, Massachusetts* (1834; Newark Museum). During the summer of 1847, Church visited the Berkshires, presumably at the invitation of Cyrus Field, a native of the region whose father served for many years as a Congregational minister there. In addition the artist's uncle Leonard Church was the owner of one of the paper mills in Lee, thus linking him closely to the land he depicted in *View Near Stockbridge* (1847; private collection).[69] George Inness also sought inspiration among these gentle slopes early in his career, painting *Hills of Berkshire* (1848) for Ogden Haggerty, one of the first of many wealthy New York businessmen to build a summer villa in Lenox (and the financier of Inness's trip to Italy in 1851–52). Durand and Kensett also found worthy subjects there.

Apparently, however, their numbers were still sufficiently low that more than one writer wrote positive descriptions of the region with the professed intention of trying to attract them there. One such instance occurred in August 1859 in the form of an anonymous letter to the *Crayon*; it reported enthusiastically on the natural and social charms offered by the region, including a small but "pleasant" community of artists staying at the hotel in Stockbridge.[70] Thus, Mignot may have been induced to go there in part by the expectation of finding a less-trammeled subject to market. In any case he established his headquarters in the same hotel in 1861. Now the Red Lion Inn, it was known as Stockbridge House (fig. 44) during that time.[71] Established in 1773 and expanded in 1748, it was the most popular spot for seasonal visitors. At five dollars per week for a room, the hotel catered primarily to an upper-middle-class clientele, but artists apparently justified the expenditure because of its amenities and convenient location. The train from New York arrived on Friday evening at the Stockbridge station, where carriages were on hand to take travelers to their hotels or summer houses. Although there is no mention of a traveling companion, Mignot may have crossed paths with Durand, who was reported to have returned to South Egremont to sketch and paint Bash-Bish Falls in preparation for the canvas completed later that year (Century Association).[72]

Mignot seems to have plunged himself into a painting frenzy on this trip and in its wake, for records indicate an unusually large number of studies and finished works produced in the twelve months between his arrival at Stockbridge (presumably in June) and the exhibition preceding the sale of his collection, which opened at the end of May 1862.[73] From his vantage point in Stockbridge and Great Barrington, just south of it, he created a variety of views: *View near Great Barrington; An Afternoon in the Fields of the Berkshires; Looking through a Bridge, Berkshire* and its related study; and *A Pastoral. Stockbridge.* A main objective was Monument Mountain, which he rendered in several versions, *Crags on Monument Mountain* and *Monument Mountain from Great Barrington* among them. At least one view of the mountain was completed while he was still in residence at Stockbridge in preparation for an intended engraving, as reported by Gourlie: "He has just finished an exquisite picture of Monument Mountain, from the valley of

the Housatonic, which is to be engraved by Schaus."[74] Most likely this would have resembled, if it is not actually identifiable with, the *Monument Mountain from Stockbridge. Painted from Nature* (cat. no. 65). But if, as Gourlie and others never tired of asserting, this "scenery is as varied with mountain, valley, and plain, that it affords an endless attraction to the eye of the poet and the artist," then what particularly induced him to expend so much time and effort on this one subject? Thoreau, for example, had written of his ascent up Mt. Greylock, and Kensett had created a masterful series on Bash-Bish Falls in South Egrement (see, e.g., the version in the National Academy of Design). The answer lies in its poetic associations, for—we are told— "the picture was suggested by the following lines of William Cullen Bryant in his poem 'Monument Mountain':

> Thou shalt look
> Upon the green and rolling forest tops,
> And down into the secrets of the glens,
> And streams that with their bordering thickets strive
> To hide their windings. [75]

Along with Catherine Maria Sedgwick, Bryant had publicized the beauty of the region early on, and helped to attract visitors to the area. Bryant grew up in the region and attended Williams College for a couple of terms before heading to New York. His "Thanatopsis," most of which was written before he was twenty-one, was inspired by that landscape. "Monument Mountain," part of that same tradition, invests the natural beauty of the Berkshires with the romance of legend; it was included in his first volume of poetry, published in 1821. Bryant's poetry may have offered the very tonic the painter needed in the months following the firing on Fort Sumter. Its soothing message reminded readers that the wilderness should not be viewed as an enemy to be subdued, but rather as a benign source of solace and moral uplift. Similarly, he softened his countrymen's Calvinist terror of death into a

calmly rational Unitarian acceptance of death as part of the natural cycle of being. Therefore his poems, and paintings linked to them, provided solace in those troubled times.

Through Bryant the mountain had ties to other figures in American letters to whom Mignot may also have intended to refer in his works. For Nathaniel Hawthorne was one of the party at the Monument Mountain picnic on Monday, 5 August 1850, where he met Herman Melville.[76] Two first-hand accounts of the picnic existed: one by the publisher James T. Field and another by Evert A. Duyckinck, editor and owner of the *Literary World,* who recounted their three-hour dinner and the reading of Bryant's poem thereafter. (This picnic is still reenacted on the Sunday nearest 5 August.) Melville moved there in 1850, living at Arrowhead. But it was Hawthorne who was probably the best observer the Berkshires ever had. During his residence in the "Red Cottage" in Lenox (actually over the Stockbridge line) in 1850–51, he wrote *A Wonder Book* in which he gave Tanglewood its name. And his frequent observations of the mountain were recorded in his journal: "Monument Mountain in the early sunshine; its base enveloped in mist, parts of which are floating in the sky; so that the great hill looks really as if it were founded on a cloud. Just emerging from the mist is seen a yellow field of rye, and above that, forest."[77] To judge from a photograph of the painting, the artist's rendering of "the great hill" possesses the same bucolic quality conveyed by Hawthorne, with the softly rounded trees echoing the shape of the mountain above and sheep grazing peacefully in the field.

His ongoing fascination with waterways led Mignot also to follow and paint the Housatonic River, which flows through almost the entire area, draining the western slopes of the Berkshire Plateau, the eastern slopes of the Taconic ridge, and the southern slopes of Mount Greylock. A work entitled *On the Housatonic* appeared in an exhibition at the Young Men's Association in Buffalo in 1861 and may be the same work shown at the Boston Athenaeum the next year.[78] Its salubrious qualities were immortalized in the words of another Berkshire resident,

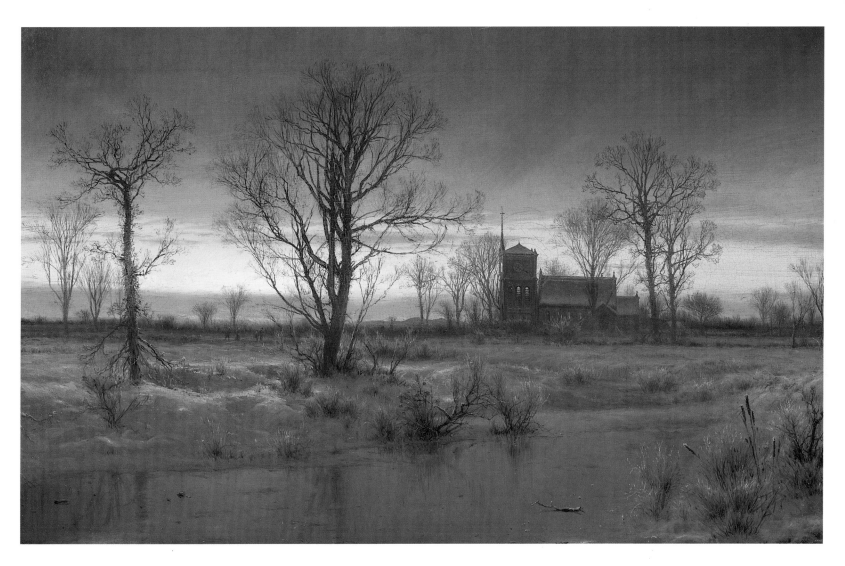

CAT. NO. 71.
Sunset, Winter

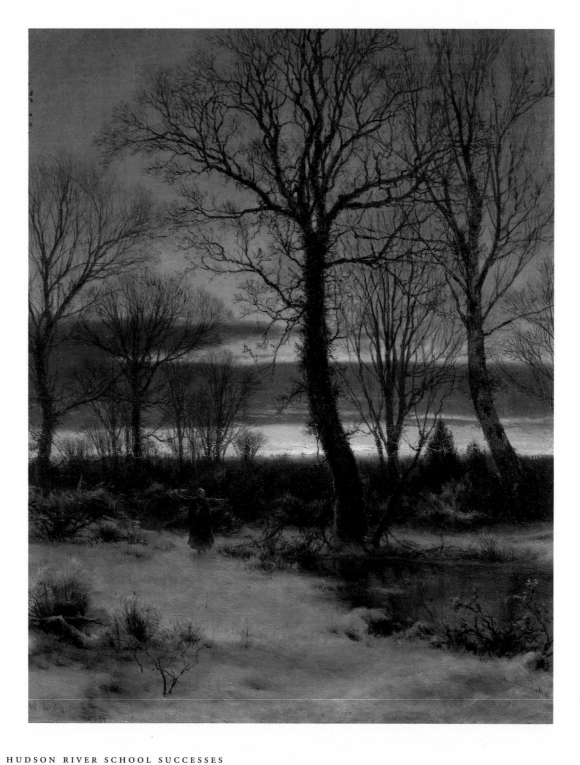

CAT. NO. 72.
Winter (Sunset in the Forest)

FIGURE 45. Unidentified photographer, *View of Old St. Paul's Episcopal Church, built in 1844, by Richard Upjohn,* n.d., photograph. Collection of the Stockbridge Library Association, Stockbridge, Mass.

Oliver Wendell Holmes: "The best tonic is the Housatonic."[79] To date, Mignot's pictures of this subject remain unlocated. An additional extant picture should be mentioned in connection with his Berkshire experiences: *Sunset, Winter* (cat. no. 71). Dated 1862, it must have been done just before his departure for London, the period when he was preoccupied with these western Massachusetts subjects. It depicts a screen of nearly leafless trees and between them a church edifice, backlit by the fading early evening light. Although difficult to identify precisely, the church boasts a square, rather solid-looking clock tower that bears resembles that of Old St. Paul's Episcopal Church, built in 1844 by Richard Upjohn and still standing in the 1860s (fig. 45).[80] These details are all consistent with a title that appeared in his memorial exhi-

bition: *Evening Vespers, Stockbridge Church, North America.*[81] The term *vespers* refers to a church service held in the late afternoon or evening, presumably the service to be attended by the figures approaching the church from the painting's left. This conception finds strong parallels in a South American scene that Mignot essayed several times and that became in fact a signature motif: the series of works known as *Ave Maria* (cat. nos. 64, 73, 86). Like its North American counterpart, it depicts a church on the far side of a body of water with worshipers filing in for prayer. But while Mignot had given the traces of religious faith—its church structures and clergy—a physical presence in Ecuadorian scenes, they had been largely missing from his northern scenes until now. Their absence there goes largely unnoticed without direct

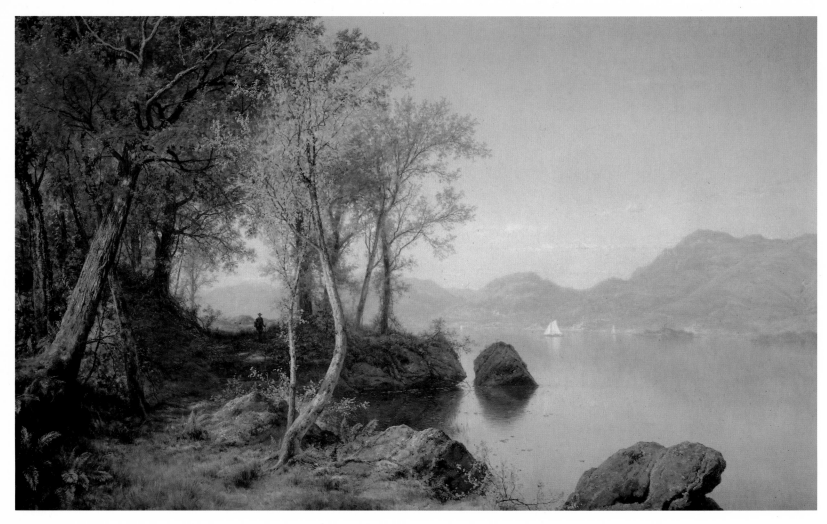

CAT. NO. 67.
Indian Summer, Lake George

comparison to Church's or Durand's New England or Hudson River views, in which the countryside is punctuated by white Protestant church steeples. Perhaps in the face of political crisis, Mignot constructed a world in which piety and religious devotion play a more conspicuous role, whether it be along a tropical lagoon or in the secluded fields of the Berkshires.

LAKE GEORGE AND THE ADIRONDACKS

After his stay in Stockbridge in the summer of 1861, Mignot probably headed north, touring the Adirondacks from late summer into fall. Nestled in the wilderness of the Adirondack foothills is Lake George, which provided the pictorial focus for many of the landscapes painted

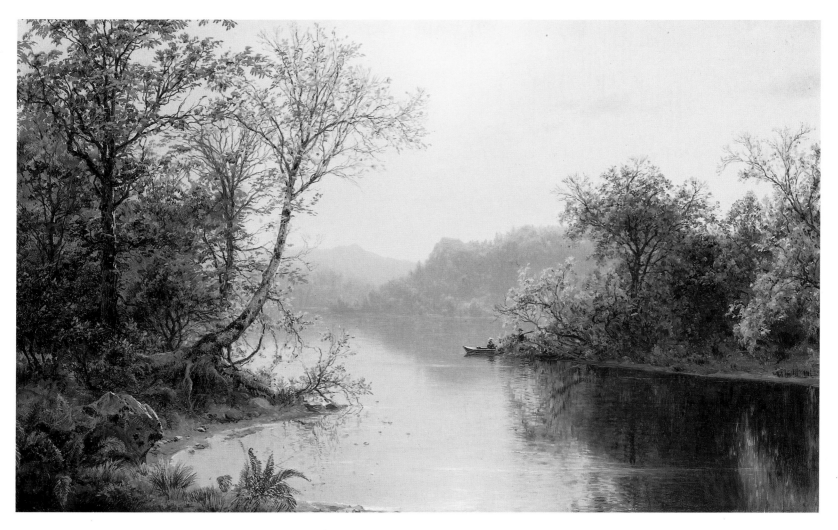

CAT. NO. 66.
Mountain Lake in Autumn

in this region. Its historical associations were probably as extensive as any site in the country, but its reputation as a site of serene beauty may have been what attracted Mignot there as war raged.[82] From a short list of his Adirondack titles recorded in exhibition and sales inventories, at least four have been located; together they fall into a series from high to late autumn. The coloration of *Indian Summer, Lake George* (cat. no.

67) corresponds to the height of the fall foliage, when "the purple, scarlet, and golden glories of the American 'Fall' were fused in gorgeous combination."[83] Here the alley of trees at left is composed of thick, bushy clumps of red and yellow, which weigh down the canvas on the left side, and open up to the vista onto the lake at right. The closest parallel here might be the work of Cropsey, who seemed to relish the

rich and varied tones nature had achieved. *Mountain Lake in Autumn* (cat. no. 66) marks the passage of the season; scarlet and gold tonalities still predominate, but the foliage itself has become more sparse, indicating the ongoing changes. Other pictures of the region, however, were rendered in a more somber, brown-based palette, suggesting that the artist had stayed on in the region into the late autumn and witnessed the later phases of the trees' changes as winter approached. Next we might place *Twilight in the Adirondacks with Hunters* (cat. no. 69), in which the fall gloaming bathes the entire scene in a shadowy reddish brown. *In the Adirondacks, New York* (cat. no. 68) represents a subsequent stage in this progression; its subdued, monochromatic tones are scaffolded by gentle hills that seem almost to fade into the surface of the picture. The orchestration of these muted tones is most effective, with the greens of the evergreens blending to brown, and the browns of the lower regions giving way to a light pinkish yellow above through a series of gradations of mustard hues. He conveys the Adirondack flavor through the characteristic inclusion of hunters in a variety of poses: here crouching behind a rock in the left foreground, apparently watching the barely visible string of ducks just above the surface of the water; in the others they are found in a boat, coming toward us from the middle distance through the clump of trees, or standing on the shore by a boat, accompanied by a dog. Visually its closest parallels are perhaps found in the work of Sanford R. Gifford, whose tonal studies of northern New York and New Hampshire evince a similar power. The words of Stillman probably best articulate the area's appeal: "The advantages to be found here by the artist are not of the pictorial kind so much as the impressional. The silence, the dreaminess, and the very want of forcible character in the landscape, having a lulling, harmonizing effect on the mind, and though the first sight is unsatisfactory, and though any particular view may be so, there is something in our memory of the Adirondack country more grand, more poetic, to me, than those found in any other country."[84]

Although it is unlikely that these works were created deliberately as a series, they nonetheless fall into a temporal progression of change in the Adirondack landscape through the fall months. The ceaseless rhythms of nature and changing seasons were an integral part of Mignot's art, which—unlike the oeuvre of many of his colleagues—did not "specialize" in one season but continued to trace the faces of the American landscape throughout the year. This group could therefore be comprehended, on one level, as part of his preoccupation with the cycles of nature. But these landscapes, especially *In the Adirondacks, New York,* project a mood of melancholy more pronounced than any other in his work, compelling us to address their emotional content. In both this picture and *Twilight in the Adirondacks with Hunters,* a single tree projects at an angle from the land, dislocated from their aggregated neighbors, whereas in *Mountain Lake in Autumn* and *Indian Summer in Lake George* the masses of foliage appeared united. And the lake surface in each changes substantially; in the first pair he has painted a reflective—and therefore active—surface, in which the local color of objects is preserved and repeated; in the final two the water appears murky and opaque, its surface lifeless. Given that he must have set out on the tour of the Berkshires and Adirondacks shortly after the firing on Fort Sumter, and that he finished the pictures in the months before he left the country as a confederate exile, it is hardly surprising that a mood of melancholy and sadness pervade the subjects in their finished versions. He has in a sense come full circle in his American career; the writings of Cooper that had directed him to Otsego Lake soon after his return to the United States now perhaps prompted him to seek the place referred to in *The Last of the Mohicans* as the "holy lake."[85] The hallowed tramping ground of the Hudson River School, into which he had made his first hopeful forays about 1855, now mirrored the sense of loss he felt for himself and his country as he prepared to leave it.

In the spring and early summer of 1862, Mignot visited western New York, where he made studies of Niagara Falls. According to a reviewer for the (London) *Art Journal*—who must have received information directly from the artist—they were made "from the top of the Terrapin Tower, which is joined to Goat Island by a wooden bridge."[86] Without sketches or other substantiating information, it is difficult to trace his steps with certainty but he had to have crossed to the Canadian side to gain a view of Table Rock; his timing turned out to be fortunate because part of that rock broke off shortly thereafter, leaving his picture witness to its earlier appearance. It was to be his only view of the falls, for he returned to New York City and set sail for Southhampton not long afterward. This path represents a reenactment of expeditions made by American landscapists before him who, as they prepared to depart the United States, made a pilgrimage to its national landscape shrine. Three decades earlier, Thomas Cole made his initial trip to the falls on the eve of his first departure for the Old World. As he wrote to his patron Robert Gilmor, Jr.: "I cannot think of going to Europe without having seen them. I wish to take a 'last lingering look' at our wild scenery. I shall endeavor to impress its features so strongly on my mind that, in the midst of the fine scenery of other countries, their grand and beautiful peculiarities shall not be erased."[87] Mignot may not have been aware of Cole's earlier journey, but their decisions were each likely rooted in a similar emotional turmoil at the thought of leaving their homeland, possibly for good. Mignot's motivation was not purely a matter of patriotic sentiment; he intended, as had Cole before him, to prepare sketches from which he would later create paintings to be sold in Britain. His finished paintings were done several years later, the products of his reminiscences of his native land from across the Atlantic.

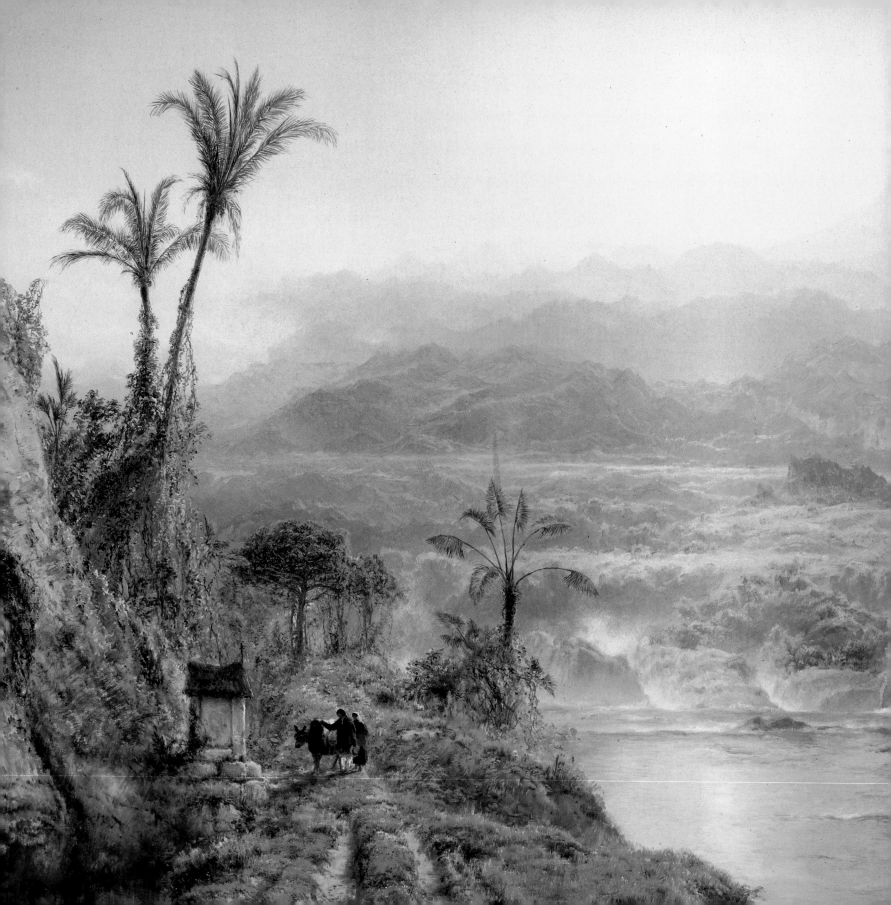

The Confederate Painter in Victorian Britain

LONDON DEBUT

An artistic renaissance was underway in Britain during the third quarter of the nineteenth century. Pre-Raphaelitism of the 1850s had by the following decade metamorphosed into a hybrid style, in which its rich color and detailed surfaces now served to evoke mood. Landscape remained a principal subject for painters, but their images moved increasingly away from the literal transcription of topography to become a vehicle for transmitting sensate experience of nature. The artists themselves were formulating more professional ambitions, anxious to develop new opportunities for exhibiting and marketing their work. British art was expanding in intellectual scope, more open to the stimulus of the art of the past, and eager for dialogue on the theory and value of art then being explored on the Continent.[1]

Into this atmosphere stepped Mignot in the summer of 1862, and he remained there until his death in 1870. The question arises why Mignot moved to London in the first place. Even if his Confederate sympathies dictated removal from New York City, there were other places he could have gone. For example, many exiled southerners headed for Latin America, a place with which he had some familiarity. But in 1862 Mignot was a young husband; in 1860 he had married Zairah Harris of Baltimore, and when her father Dr. Harris died later that year, she and Mignot apparently assumed some of the responsibility for

her mother (and perhaps sisters). Evidence suggests that upon the death of her husband Mrs. Harris decided to go back to England to rejoin her family. Given the mentions of Mrs. Harris that appear in the British material on Mignot, the most plausible scenario is that they all decided to head to across the Atlantic and set up housekeeping there.[2]

The prevalence of British artists among those who painted the southern landscape suggests the close cultural ties between the South and England before the war, resulting from vital economic and trade contacts between English manufacturers and the southern states.[3] During the war the Confederate cause found its chief foreign support among the English aristocracy, the wealthy mill owners and shipbuilders. In 1863 the Southern Independence Association was formed to represent these groups, who would perhaps have been interested in establishing ties with an artist from that region. Even if he was unaware of specific individuals or groups before his departure, he could not have been unaware of the national sympathy toward the South. The press in the North was filled with articles decrying Britain's national policy of neutrality, which it regarded as a traitorous act.[4] And British newspapers and journals continued to cover the controversial attitudes. One of the principal actors in the drama was in fact a neighbor of Mignot's on Portland Place during his first years in London: Charles Francis Adams, U.S. minister to Great Britain. Like many of his countrymen, Adams was unprepared for the hostility toward the northern states that emanated from the British governing classes. If it was true that the great body of the English people and the newspapers favored the free states, it was because their sympathy was largely rooted in antislavery sentiment. But this feeling soon dissipated in the face of mounting assertions by Northern leaders that the main objective of the war was not abolition of slavery, but reunion. Without a declared goal of abolition, most of the English felt that the war was pointless: Why didn't the southern states have the right to secede if they wished?[5] This sentiment might have been further reinforced by members of the Whistler family, for not only James McNeill Whistler but also several others

were in Britain at this time. In April 1865 Dr. William Whistler, who had been in the Confederate army, came to live in London.[6] A southern painter must have assumed he would have had a better chance for support and sales in Britain than he would have had back among the Yankees.

Mignot's immediate goal was to exhibit at the Royal Academy, the country's most prestigious venue. At that moment figure painting attracted the greatest praise and the largest crowds within the academy. Could an unknown landscape painter hope to compete in this arena? Once again, the aspiring newcomer adapted to his new milieu, subtly permuting content and style. Like his countrymen before him, he obviously hoped to capitalize on the novelty of New World subject matter. From Benjamin West's arrival in London in the 1750s, the British public had been successively exposed to depictions of America's natives, autumn foliage, and renown landmarks. When the American artist Jasper F. Cropsey showed his *Autumn on the Hudson* near Mignot's *Head Waters of the Susquehanna* at the Great London International Exhibition of 1862, he created something of a sensation. Commenting on the picture (now in the National Gallery of Art, Washington, D.C.), the London *Times* critic placed it in the context of those works with which the British public was already acquainted: "American artists are rapidly making the untraveled portion of the English public familiar with the scenery of the great Western continent. Mr. Church's *Falls of Niagara* and the *Heart of the Andes*, recently exhibited, have found a companion picture in Mr. Cropsey's *Autumn on the Hudson* now on view."[7]

This international exposition, still on view when Mignot arrived, would have provided him the opportunity to view a broad spectrum of British art and to gauge the prevailing taste for American pictures against which he too would be judged.[8] He avoided showing an autumn scene, in spite of the fact that he had produced some fine specimens. Instead he capitalized on his experiences in equatorial America, a subject less familiar to the British public at this time than was North

America. The exportation of Church's *Heart of the Andes* mentioned by the *Times* reviewer had been a rare opportunity; other Andean panoramas by him would not cross the Atlantic until war had ended. Mignot played his advantage, offering his new public his own dazzling interpretations of the South American scenery at a moment when he had the field all to himself. He did not intend, however, to cast himself solely as "the painter of the tropics." Carefully orchestrating his debut, wanting to impress audiences with the full range of his skills in portraying the most diverse climes and locales, he balanced the steamy tropics with an icy winter landscape.

Mignot's opening at the Royal Academy in 1863 was greeted with strong praise from British critics. The *Athenaeum's* notice read: "We have not often seen a landscape so brilliantly or artistically painted as Mr. Mignot's *Lagoon of the Guayaquil*. . . . That Mr. Mignot has been successful in this none will deny who looks at the manner in which he has treated the sky here... This artist shows like ability in a theme the reverse of the last, a snow-piece, *A Winter Morning* (677)."[9] But even before that, perhaps wishing to test the waters, he had submitted a picture entitled *Winter* to the newly opened gallery of the British Institution. There he demonstrated his affinity for local material with a snowscape set on the English heath (cat. no. 72). The warm response that he received provided the confidence he needed: "*Winter* (106), by Mr. L.R. Mignot, is a charming picture of snow upon a heath, with its bare-limbed trees, tracing fine lines against the pale, brassy sky, and soft band of cloud, style 'the Evening Band,' hanging behind. The warm hue of the pool that, barely frozen, reflects the sky, and the bluish shades that lie upon the snow in its ridges and undulations, show how well the artist has understood his theme."[10] His strategy paid off. He introduced himself as a painter capable of expressing extremes of nature, a theme that echoed throughout the commentary that appeared on his work. He continued to exhibit regularly in London. Between 1863 and 1871 his work was exhibited at the Royal Academy eight times. He showed at the British Institution on ten occasions; and at Suffolk

Street twice. His entire artistic "maturity"— from age thirty-one to thirty-nine— was spent primarily in Britain; yet this period has remained until now almost a complete art historical blank.

Some confusion has arisen over the identity of the tropical picture shown at the Royal Academy in 1863. A painting belonging to the Detroit Institute of Arts (cat. no. 78), dated that year, was mistakenly assumed to be the canvas in question, and therefore given the title *Lagoon of the Guayaquil*. It is clear at first glance, however, that the Detroit picture represents a scene in the Andes rather than the lowland lagoon further elaborated by the contemporary critic: "a sunset effect over a vast marsh, whose waters flash in pools as they lie smooth and still under a sky that is filled with coloured light from the sinking sun."[11] It seems rather more likely that the Detroit picture is properly titled *Morning in the Andes*, a name that appears on its recently rediscovered original frame.[12] The work exhibited at the Royal Academy is probably *Lagoon of the Guayaquil* (cat. no. 76), which was almost certainly painted that year.[13] It fits the both the specific topographical description provided by the *Athenaeum* and the claims to coloristic mastery, "effectiveness and originality."

Thus, Mignot spotlighted his familiarity with equatorial America: an area of the world rarely treated by British painters, but one that was becoming more topical as trade and political relations between Great Britain and Spanish America grew. When the American Civil War cut off cotton shipments to English manufacturers, for example, they turned to South American suppliers. In addition, there were increasing references in the press to conditions and events there. Simultaneously, this subject matter became the mainstay of his official exhibition repertoire: five of the eight works he showed at the Royal Academy were Ecuadorian scenes. But although the basic subject matter remained the same as that served up to audiences in the United States, the treatment was decidedly more in tune with local tastes.

The canvas now in the North Carolina Museum of Art (cat. no. 43) painted in 1859 is an example of one kind of work he did in the

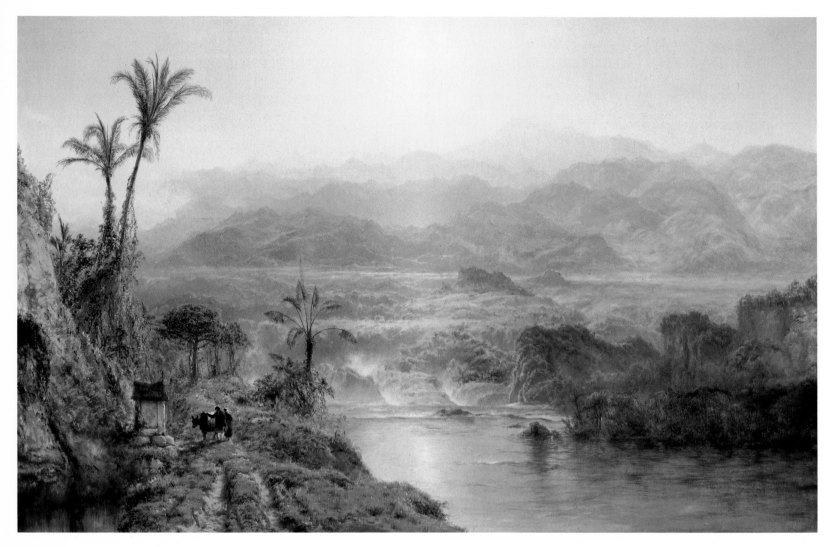

CAT. NO. 78.
Morning in the Andes

States, in which the kinship to Church's canvases is evident in the composition and the degree of detail accords with American preferences. Compare it with a canvas done in London (cat. no. 78). Now atmospheric handling takes preference over topographical detail in the style of Turner, and the palette is brighter, more high-keyed, in the manner of the English Pre-Raphaelites. The artist was calculating to win the approval of British critics, who praised his view of Ecuador as "quite the most artistic work in color and execution in the room." Annually his work won similar praise.

During these years Mignot made every effort to assimilate into his

new environment. *Figures by a Lake* of about 1863 (cat. no. 79) demonstrates the subtle shifts that were transforming his work.[14] Contrast it, for example, with *Indian Summer, Lake George* (cat. no. 67) completed in 1862, just prior to his departure from New York. They share a remarkably similar pictorial structure. Both look at the still waters of the lake ringed on three sides by land, and continuing off the canvas at right. The sections of shore that run along the left of each one trace V-shaped inlets that create plays of shadow on the water; openings appear in the trees that stand on each of the shorelines, between which stand single figures. The far shores in both undulate with the shapes of hills and foliage. The compositional underpinnings bear strong resemblance, but atmosphere, color, and painterly stroke combine to create a strikingly different effect. In the American work the rocks and trees are weighted and concrete; the autumn colors are strong and overripe. The word that comes to mind to characterize its British counterpart is "ethereal." In the later work tree trunks are elongated and stylized; the forms on the far shore are hazy and indistinct. In *Indian Summer, Lake George* the alley of trees at left form a canopy of leaves that extends to the top of the canvas, forming a substantial mass; in *Figures by a Lake* they are more airy, open to the sky above. In this he may be been responding in part to the new artistic influences available to him, to painters like John Linnell and Frank Walton, whose works evidence an imaginative sympathy with nature. Shedding the visual proclivities of the Hudson River School, he moved from a description of the tangible to a meditation on the evanescent.

LANDSCAPE PAINTING, 1864–1866

In spite of his auspicious start at the Royal Academy in 1863, the following year did not fulfill its promise. He went unrepresented in 1864, very likely because his work had been rejected. Judging by the policy of the Royal Academy, a number of landscapists shared that fate, as a critic for the *Illustrated London News* indicated: "LANDSCAPE ART— to a certain extent properly enough— occupies a secondary position, compared to figure-painting, in the estimation of the body of the Royal Academicians. This year— owing, perhaps, to the fact that there was no landscape-painter on the hanging committee— the practitioners of this branch of art have fared worse even than usual: a large number of landscapes have, we understand, been rejected, and among them many by men of mark; while the works actually hung were hardly ever so unsatisfactorily arranged."[15] Landscape painting in Britain at that moment was undergoing a critical transition. Although it was reported at the time that the public was literally turning its back on scenes from nature, Ann Bermingham has convincingly reinterpreted these changes of the sixties:

> In 1865 a contributor to the *Cornhill Magazine* regretfully observed the falling off of interest in landscape at the Royal Academy's annual exhibition. "While figure pictures have still the chance of being hung according to their merits, landscapes are being gradually excluded or placed in positions so unfavorable as to render them invisible." To clinch his point, he noted that in twenty-five years only two landscape artists had been elected to the Academy ranks. It would be a mistake, however, to conclude from such remarks that the Victorians had little love for landscape, although their preoccupation with it took different forms from that of the preceding period. For instance, while the ranks of landscape painters in the Royal Academy shrank, the number of new watercolor societies with their largely amateur membership increased markedly. Rather than decline, landscape painting by 1860 simply changed course as a new interest in scientific phenomenon and naturalistic representation replaced an older taste for picturesque topography and rustic scenery. What waned was not an interest in landscape but a particular tradition of landscape representation— specifically, the genre of the rustic landscape developed from Gainsborough to Constable and grounded on the rural experience of agricultural industrialization.[16]

This new focus on naturalism and especially scientific exploration favored Mignot's Latin American imagery. In fact even as the academy dismissed his work, other, more astute observers recognized its merits. He did, for example, have better luck at the British Institution. There no less a critic than William Michael Rossetti singled out his work as one of only three landscapes worthy of notice: "In landscape three painters may be named. Mr. Mignot's *Twilight in the Tropics* is a really fine work, notwithstanding some roughness of execution: its sky is full of light and space."[17] This issue of the vitality of landscape art continued to be debated throughout the period of his residence; indeed it must have been instrumental in the production of tropical images he maintained throughout his time in Britain, which balanced grand, luminous effect with near-scientific detail.

Mignot's art, however, was one predicated on growth and change; his painting mirrored his life, and displayed a restlessness, a searching that was ultimately the source of his creativity. So he sought new material, making sketching tours of England's picturesque and historic sites. Painting titles provide tantalizing evidence of these forays. A *View Near Bath*, for example, suggests his exploration in that unique area, with its Roman ruins. There is a reference to a work with an uncharacteristic subject, *Chateau Mont Orgueil—Island of Jersey. Built by Rolls, Father of William the Conqueror*[18]—perhaps an essay at a picture steeped in English historical association. The urban landscape was not a frequent subject, but the tiny panel *City Harbor at Dusk* (cat. no. 93) may be an exercise from this period, with the darkened silhouettes of buildings and spires set against a pale orange sky. Titles such as *Sketch of St. James' Pulpit, Paddington* and *Old St. Paul's from Waterloo Bridge* (cat. no. D), a watercolor of 1867, indicate that he hardly ignored the famous sites of London itself.[19] As was usual for him, he followed the river, and he painted the traffic on the Thames active beneath the cathedral dome.

About this time Mignot painted a pair of coastal views of matching dimensions (12⅛ × 18⅛"): *Harbor Scene, Figures on a Quay* and *Harbor Scene, Figures with Horse and Cart* (cat. nos. 91 and 92). They depict spots along a settled stretch of coast, although whether on the English or the French side of the channel it is difficult to pinpoint. (The flag might have offered identification, but it has wrapped itself around the flagpole, obscuring its face.) These pendants could be considered an early example of tourist art, just as the landscape they depict is an early tourist landscape. They have the look of souvenirs: small, quickly executed, and low-priced. But if it was his intention to stimulate the viewer into fond recall of a vacation enjoyed, he seems to have failed, for these are about as far removed from images of carefree frolicking as one can get. If they do depict a bathing beach, it is off-season; there are no cabanas, no one is dressed in bathing attire. The large sailing vessel suggests commercial use, rather than pleasure. Dogs and human figures are stiff (suggesting that in this case Mignot could well have done them himself rather than relying on a fellow artist to add them); they appear miniaturized, although they are placed in the foreground immediately before us. All in all, these scenes strike an odd note— they lack focus and so fail to involve us. But then, this artist was never much at home painting the human figure. *Punting on a River at Sunset* (cat. no. 99) also must belong to the same moment. The figures are similarly awkward, as they try to propel their flat, broad-ended boat along the water. Once again, however, there is a tension between the limited narrative provided by the human activity and the setting in which it takes place. Punting is a sport generally associated with the English countryside, and yet the group of wonderful, hyperextended trees that preside over the group, in the flushed afternoon light, hardly seems indigenous to the British Isles. Such incongruities provide the works with a pictorial tension and therefore interest that redeems them from being mere tourist art.

He went on to create views of misty lake views and moonlit scenes in the manner of his newly adopted brethren. And although many of the canvases themselves remain to date unidentified, records document his ongoing efforts with local scenery including Tintern, Twickenham,

Kenilworth Castle, and a much-appreciated *Sunset off Hastings,* shown at the Royal Academy in 1870. During his eight years abroad he lost some of his "Americanisms" and he began to adopt stylistic mannerisms and subjects more in keeping with local tastes. For inspiration he plumbed English literature.

LITERARY ASSOCIATIONS

Throughout Mignot's career, he created works that linked the pictorial with the literary. Drawing upon contemporary authors Bryant and especially Cooper during his American years, he provided a ready means of linking his pictures with mainstream ideas and native traditions. It was a device that had served him well, and he continued to rely on it in Britain. He created one recorded work based on John Bunyan's *Pilgrim's Progress,*[20] but for the most part he drew on more recent sources: the romantic writings of the earlier generation—the poetry of Byron, Coleridge, and Keats, and the novels of Scott—and the contemporary poetry of Tennyson. This was the literary fare of successful English painters John Millais, Arthur Hughes, and others. Equally telling, however, is that this was the body of work Romantic writers of the Old South took as their credo. Authors such as William Gilmore Simms, another native South Carolinian, were steeped in their words and firmly grounded southern romanticism in the work of the English romantics.[21] Thus Mignot unintentionally reverted to the aristocratic ways of the Old South in his effort to reinvent himself once more.

A brief analysis of subjects and literary references sheds light on Mignot's ambitions in the mid-to-late sixties. On one level, they undoubtedly were meant to send out a familiar signal to a public yet unfamiliar with him: an artistic welcome mat of sorts. Some, perhaps, provided nothing more than a gloss on an already conceived work. But others must have been more deeply integrated. Without a full complement of pictures it is impossible to make a final assessment, but preliminary evidence suggests that his selection of poetic works and specific lines quoted all feature evocative, somewhat weird moments of nature. Not surprisingly, he seemed to gravitate toward descriptive passages of sunrises, sunsets, and moonlit nights: just the transitory moments he tended to feature in his own painted landscapes.

At least some of these works treated South American themes. Through them we can detect something of Mignot's intent. For the appended literary references directed the viewer, and provided a means of apprehending the moods or states of nature, thus moving him away from the topographical specifics of site. In such an image the identity of a mountain or river depicted became secondary to its crepuscular or nocturnal evocation. Thomas Gray's "Elegy" may have functioned in this way for South American titles listed as *Incense-Breathing Morn— Gray's Elegy* and *Incense-Breathing Morn—In the Tropics.*[22] As we have seen in chapter 4, when Mignot exhibited a tropical scene entitled *Parting Day* (cat. no. 89) at the British Institution in 1867, it was accompanied by a quotation from the fourth canto of Byron's *Childe Harold's Pilgrimage.*[23] The artist has selected a line (italicized below) from a passage that describes a time of day and state of nature—twilight—and not a fixed action, place, or person in the poem:

Fill'd with the face of heaven, which, from afar,
Comes down upon the waters; all its hues,
From the rich sunset to the rising star
Their magical variety diffuse:
And now they change; a paler shadow strews
Its mantle o'er the mountains; *parting day*
Dies like the dolphin, whom each pang imbues
With a new colour as it gasps away,
The last still loveliest, till 'tis gone— and all is gray.[24]

The extensive commentary on the picture dismissed its terrestrial

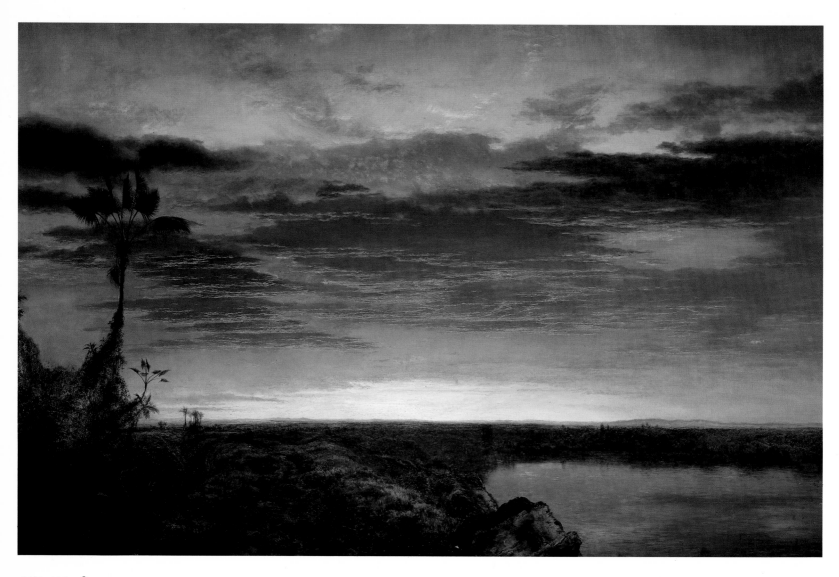

CAT. NO. 89.
Parting Day . . .

realm ("the landscape being a low, level, uninteresting swamp, occupying but a small portion of the canvas") and expressed uncertainty about what the ostensible subject was even supposed to be: "*probably* the picture records the glories of sunset in equatorial America," as one writer put it.[25] Its interest, in parallel with the poem, focused on the "the vast canopy overhead is one multitudinous mass of clouds still burning in the roseate and many hued splendor of a sun just sunk below the horizon."[26] The critical consensus was that Mignot had achieved a rare synthesis between the verbal and the visual: "Parting day here dies like the dolphin, with colours new and strange in each expiring gasp: greens, reds, yellows, blues, stare each other out of countenance. The attempt is bold, yet not without success. No small management was needed to preserve pictorial propriety."[27] The picture is "bold," daring in its emptiness, in its willingness to allow atmosphere and space to become the primary vehicle of a substantially sized field (of about 3 × 5'). In its downplay of place, and in its insistence—through the voice of the poet—on light and color, it shares something with the definition of the nocturne as Whistler articulated it some ten years later: "I have perhaps meant rather to indicate an artistic interest alone in the work, divesting the picture from any outside anecdotal sort of interest which might have been otherwise attached to it. It is an arrangement of line, form and colour first; and I make use of any incident of it which shall bring about a symmetrical result. Among my works are some night pieces, and I have chosen the word Nocturne because it generalizes and simplifies the whole set of them."[28] Even in works that in terms of subject suggest a look back at his experiences with Frederic Church, in method they in fact look to and even anticipate some of the attitude that Whistler and the Aesthetes were only just formulating.

Samuel Taylor Coleridge's "Rime of the Ancient Mariner"— a source of motifs for many nineteenth-century painters— fed Mignot's imagination as well. A critique of Gustave Doré's illustrated edition of "that unique and wondrous tale of Coleridge" sheds some light on the poem's appeal: "There is plenty of grim horror in the poem, plenty of supernatural terror and ghastliness of death and 'life in death,' yet the story is so vague, weird, and unearthly; over the whole there is such a fitful glamour of lambent imagination and dramatically conceived craze, that to interpret the incidents too literally as an illustrator must have a vulgar mind indeed."[29] Championed as a painter of vague, unusual, and peculiar effects, Mignot would probably have found the tale equally congenial. He is known to have done several versions of *A Painted Ship Upon a Painted Ocean—Ancient Mariner*, one of which was owned by John Kensett.[30]

John Keats's poem "The Eve of St. Agnes" (1820) provided Mignot inspiration for a watercolor that he sent to New York for auction in 1868 and apparently also for a related oil painting shown in the memorial exhibition.[31] The poem tells of the lovers Madeline and Porphyro; their tale is set against the events of Saint Agnes's Eve, January 20, when a young woman was supposed to have a revelation of her future husband if she performed certain superstitious rites.[32] Although we cannot be certain what Mignot would have made of the subject, some clue is perhaps provided in the work of his British contemporaries. For this poem of 1820 underwent revival and reinterpretation in the 1850s and 1860s in the hands of several well-known painters. In *Eve of St. Agnes* (1856; Tate Gallery), Arthur Hughes depicted three main incidents from the poem: Porphyro's approach to the castle, where a lavish banquet is in progress; his awakening of Madeline from her dreams; and the lovers's silent escape from the dark castle into the night. Probably more relevant was John Everett Millais's *The Eve of St. Agnes*, shown at the Royal Academy in 1863. Mignot could hardly have been unaware of the attention showered on Millais's picture that year, that of his own debut there. As one reviewer predicted, Millais's picture would provoke "a great deal of discussion in drawing rooms and studios"— including, no doubt, in Mignot's own. Given his own aversion to figure painting, the debate over Millais's handling of Madeline would probably have been of little concern. But the atmospheric effects and nocturnal light that set the stage for the poem would have appealed to him, and pro-

vided an avenue by which he could have approached the subject. A critic's commentary on Millais's handling of the setting provide a point of comparison: "the moonlight is painted with more literal truthfulness than, perhaps, moonlight has ever been painted, and that the means employed to this end prove the possession of some of the highest and rarest artistic gifts. The sensation of strangeness that this picture produces at first is far less than we can imagine the effect would be could we suddenly walk from the daylight into such a moonlit chamber after, of course, the first few moments of total darkness."[33] Given the popular attention Millais enjoyed at that moment, neither the literary subjects he selected nor his manner of conceiving them could have been lessons lost on the recently arrived American.

His interest in the contemporary poet laureate Alfred, Lord Tennyson may have been similarly directed by the work of fellow artists and illustrators to his "Enoch Arden."[34] In December 1865 there appeared in London a gift edition illustrated by Arthur Hughes, one of a number of such editions of this highly familiar work.[35] Fellow Americans had also explored its pictorial potential. In conjunction with Elihu Vedder, William J. Hennessy, and F. O. C. Darley, John La Farge contributed drawings to an illustrated edition published in Boston in 1864. La Farge's *The Island Home* was, according to Henry Adams, "the first work in a completely Japanese style by any Western artist."[36] Mignot himself did several such works, including *A Ship-Wrecked Sailor Waiting for a Sail—Enoch Arden*. Another, entitled *And Glories of the Broad Belt of the World,* was accompanied by the following lines in the auction catalogue:

> All these he saw; but what he fain had seen
> He could not see - the kindly human face
> Nor ever hear a kindly voice
> — Enoch Arden.[37]

Mignot also mined the territory of Sir Walter Scott's novels. Warwickshire, which played a key role in English letters, held a particular attractiveness for the artist. It has a soft, undulating rural landscape, characterized by small towns and neat fields bounded by hedgerows and streams. It was the kind of cultivated scenery he preferred, and he featured it in work such as *Farm View in Warwickshire* and *Sunny Afternoon, Warwickshire*.[38] The fidelity of his rendering in the latter painting was praised upon its exhibition in 1865 at the British Institution: "nothing can be more true to the character of our modest yet lovely English pastures and the grey aerial brightness of our country skies."[39] Rich in places of historical interest, Warwickshire includes Shakespeare's Stratford-upon-Avon and the beautiful town of Warwick, with its impressive castle. Another medieval castle is nearby, at Kenilworth, one of the grandest in Britain. Built of rich, warm sandstone, it inspired Scott's *Kenilworth*.[40]

Mignot demonstrated no interest in the Shakespearean sites and headed instead for the castles. *Warwick Castle from the River* was one product of this tour.[41] He also created a group of pictures in and around Kenilworth: *Storm over Kenilworth Castle; Kenilworth from the Brook; Banqueting Hall, Kenilworth*; and a watercolor of *Leicester's Window, Kenilworth*.[42] The paintings themselves remain unlocated, but the titles indicate that the artist sought prospects of the castle inside and out, identified with sufficient specificity to suggest an extensive study of the structure. This was done, I believe, as an homage to the Scottish poet and novelist, whose romantic tales were the literary fare Mignot found most to his liking.[43] Scott published *Kenilworth; A Romance* in 1821, precipitating a tremendous resurgence of interest in the castle. The castle was founded in 1125, and John of Gaunt transformed it into a fine palace in the fourteenth century. Henry VIII extended it, and finally the Earl of Leicester turned it into a magnificent monument to Tudor initiative and enterprise in preparation for his beloved Queen Elizabeth's visit in 1575. All this Mignot could have read in a related volume entitled *Kenilworth and its Castle Illustrated,*

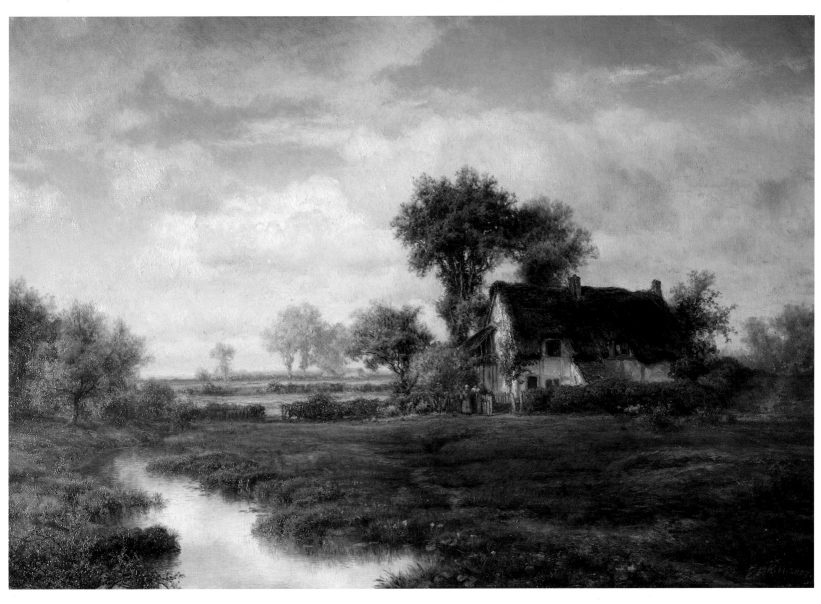

CAT. NO. 90.
Landscape with a Farmhouse by a Stream

which included a series of lithographic drawings by John Brandard. Published in 1865, it may very well have stirred him to seek out for himself the sites described by Scott.[44]

In the vicinity of the castle he also painted a spot known as Holly Cottage, Warwickshire in several versions. One rendering entitled *Desolation* was shown at the British Institution in 1866 and subsequently praised for its faithful rendering: "Look at the powerful little work representing a ruined cottage in Warwickshire, under the title *Desolation* (120), and we have in the perfect truthfulness of its tone and details an indication that the artist is to be trusted."[45] *Landscape with Farmhouse by a Stream* (cat. no. 90) may belong to this group. The two-story thatched roof cottage stands on the right surrounded by trees, and presides over the rich green fields evenly demarcated by the parallel hedgerows. Several woman dressed in country attire stand in the doorway, adding a touch of local color to the scene. Indeed, the entire conception strikes such an insistently charming and picturesque note as to amount to a deliberate, archaizing strategy: almost as if in recreating the setting of Elizabethan England, he has rehearsed the method and not just the subject of Scott's novel. Literature therefore provided him with both a vehicle for rethinking his own pictorial techniques and a means of establishing his credentials as a worthy member of the British artistic community.

EXPATRIATE OR EXILE?

With new appreciation for the complexities of American art and society gained over the past decade, we are rethinking expatriatism. Gender issues are integrated into accounts of Mary Cassatt's decision to abandon her native Philadelphia for Paris.[46] Class considerations provide an analytic focus for John Singer Sargent's cosmopolitan life.[47] And race has been factored into assessing the reasons Robert Duncanson sought acceptance abroad.[48] Historians of nineteenth-century art have been slower, however, to acknowledge the role that regionalism and sectionalism played at that time in artistic self-definition. The impulse here is to read Mignot's later works in psychological terms, as constructions of his own precarious material and emotional status as an expatriate, an American essentially out of context. The great literary voice of the age Henry James develops and refines this theme throughout his work. Most significant for the sake of comparison here is his early novel *Roderick Hudson* (1875), in which the principal character is an artist who removes himself permanently from his native New England: in his case, to Italy. Mignot's condition was in many ways more acute than that of Hudson.

The pattern of Mignot's career foregrounds his southern identity. He left his country in time of war, in many respects in a state of political exile, with no way of predicting when he might be able to return. Once the war had ended with a defeated South, Confederates were regarded as rebels, traitors, enemies of the state. It was not until Christmas Day, 1868, when President Andrew Johnson issued his Universal Amnesty Proclamation, that such charges were removed once and for all.[49] Given that Mignot's choices were in some ways dictated for him, his expatriatism is all the more poignant. This hazy status was pondered in the contemporary press. Categorizing American artists overseas, a writer for the *New York Albion* tried to differentiate "permanent residents in Europe" from "those who have more recently sailed, and whose period of absence is yet undetermined." His discussion evinced a nervous tone, for the decision to remain away amounted in the minds of many to a rejection of the homeland. Ironically, eight years after Mignot had left the country, and only a few months before he died on foreign soil, the writer concluded that he belonged in the latter category, for he might still return home.[50] No doubt the political realities of his southern identity affected the outward circumstances of his life, but the question remains how it was encoded into his art. Stylistically he absorbed local influences, but this is to be expected of an artist in a new environment and would not in itself be a sign of expatriate anxi-

ety. I would argue, however, that narrative content also shifted, with spaces becoming more open and desolate, sending the viewer on imaginary travels through his pictures further into the unknown. This metamorphosis was a direct response to the conditions of expatriatism or, as it is better termed in his case, transnationalism.

THE BIG PICTURES

With the end of the Civil War in April 1865, Mignot must have undergone a personal crisis. In the intervening years since his arrival in 1862 in London, he had accumulated a respectable exhibition record but had yet to make his mark with a single masterwork. Perhaps he was still biding his time until he could return to the United States. But this did not happen, and by 1866— with the decision apparently made to remain in Britain— Mignot made a bid for broader recognition (and higher prices) with several large and imposing canvases, including views of Riobamba and Niagara Falls.

Mount Chimborazo (Table Lands of Rio Bamba, Ecuador) (cat. no. 84), painted about 1866, was exhibited at the British Institution in the spring of that year. Its large scale (at 38⅝ × 63⅛", it was among his largest) and asking price of 500 pounds (the highest price he had set there) provide a measure of his new ambitions. The critics responded to this change in direction, singling out his contribution: "The landscapes on this occasion have more than the ordinary share of interest. Among them none are, on the whole, so varied in range of power, or beautiful and refined in style, as the contributions of Mr. Mignot."[51] They even called upon a new vocabulary to evoke its impact; this picture was declared "stupendous," "mighty," and "fiery."[52] The sky, in particular, evinced a deepening expressive power, as one reviewer tried to convey: "The lofty plateau stretches away as far as the eye can reach, its sandy surface broken into countless mounded waves, crested with stunted vegetation; above the horizontal mists of the table-land rise at

some immense distance a mountain range, probably of the Andes; in the foreground are strange plants and grasses, together with a vast earthquake chasm, the depths of which were lost in thick vapour. Over head the sky is dissipating in fantastic forms the morning exhalaations, and earth and sky flush together in the fervid glow of the tropics."[53] Crowned by a evanescent rainbow, the picture announced the artist's own rejuvenated attitude.

During the late summer and early fall of 1866, *Niagara* (cat. no. 102) was shown in a single-picture exhibition at D. Colnaghi's, an important art house on Old Bond Street that from its origins in the eighteenth century as a print seller had grown to become one of the leading London art dealers. During the 1860s the firm apparently rented space to selected artists. For example in 1864 British photographer Julia Margaret Cameron entered into an agreement with Colnaghi's for the sale of her photographs and two years later she hired the gallery for an exhibition. Perhaps Mignot entered into a similar arrangement for *Niagara*.[54] A major picture in sheer size alone—at 50½ × 92½", the largest of his works—it earned him what were among the most complimentary reviews of his career. One British reviewer enthusiastically described the view of the falls it afforded from above:

Of the many views of the Falls that have been exhibited, from time to time, there is not one which shows the state of the "rapid" just before the final plunge so perfectly as M. Mignot's picture, now in the gallery of Messrs. D. Colnaghi and Co. In the prospect from below, there is so much to tempt a painter, that this, from some striking point, is, nine times out of ten, the view presented. Inasmuch, therefore, as compared with the stupendous fall, there is a lack of the picturesque in association with the surface of the rapid, it is an enterprise requiring some courage to adopt the latter as a subject, and work it out as has been done in this case. But M. Mignot has been amply sustained in the fact that there yet remained something peculiar to the famous cataract that had not been described. Our first impression on seeing the picture was, that the grass-green colour of

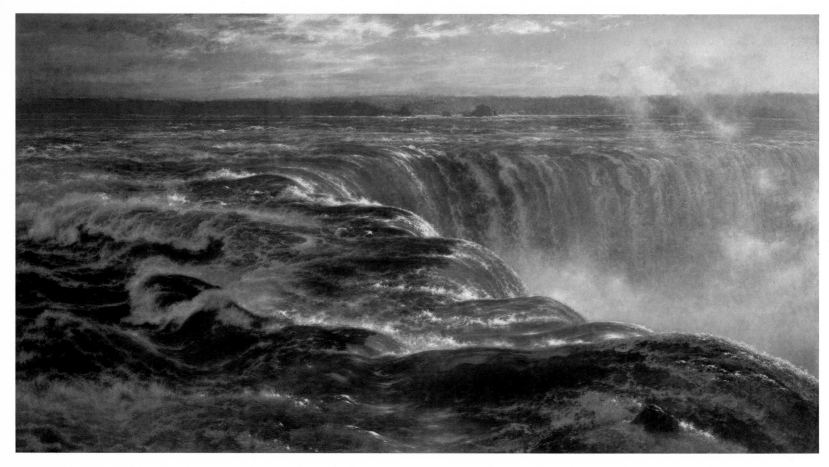

CAT. NO. 102.
Niagara

the water is an exaggeration; but, in justification of the tint, it is asserted by persons who have seen the current above the Falls, that the colour is quite true. . . . A careful examination of the work teaches us that every touch has a significance in the description of certain features of the Niagara, which have never before been set forth.[55]

There was a need to confirm the authenticity of the artist's rendering with a witness to American nature. Mignot, however, had moved into a new realm in his art. Gone are the terrestrial landmarks that had

embellished other versions; here he presents us with rushing, swirling, falling water in a daringly abstract composition. It provides a measure of just how far Mignot had progressed from his renderings of frozen lakes during his student days in Holland to this *tour de force* of rendering water in motion.

Another version of the subject (unlocated but known through an engraving; fig. 46) featured the view of *Table Rock, Niagara*; it remained unfinished but was presumably begun about the same time as *Niagara,* when the artist contemplated the vantage point and planned

FIGURE 46. *Table Rock, Niagara,*
after L. R. Mignot, from the
Illustrated London News 22 (July
1876): 80.

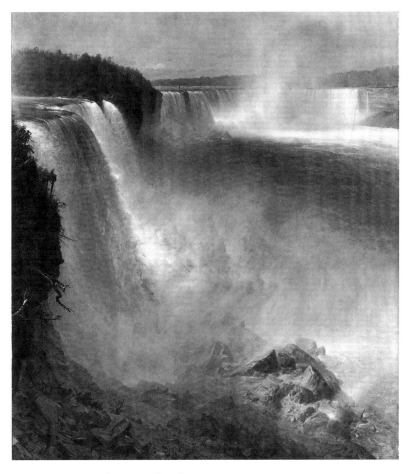

FIGURE 47. Frederic E. Church,
*Niagara Falls, from the American
Side,* 1867, oil on canvas, 102 ½ x
91". National Gallery of Scotland.

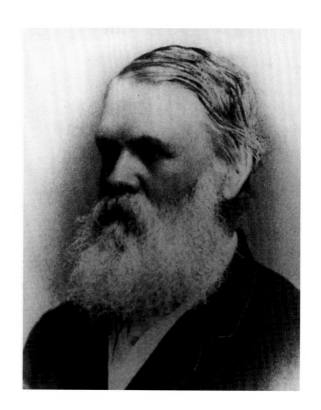

FIGURE 48. Unidentified photographer, *Portrait of Tom Taylor*, n.d. Collection of Punch Publications.

his conception. It possessed the special advantage of depicting the rocky outcropping that had broken off from the cliff shortly after his visit. And although it is impossible to judge the effect from the engraving, the artist's impression of the greenish-gray sheet of water was praised in terms that lead us to assume similarity to the masterpiece now in the Brooklyn Museum.[56]

What catalyzed this mental journeying back to these falls, visited just before he departed the United States? Given the precarious state in which he had existed in the intervening four years as a voluntary political exile, the timing of his return to this most American of subjects is telling. To what degree might he have intended this as his own testimony to the enduring life of the Union? Church, we remember, returned to the subject in 1867 in his *Niagara Falls from the American Side* (fig. 47); but this was undertaken on a commission from Michael Knoedler.[57] As Jeremy Adamson, Elizabeth McKinsey, and others have demonstrated, in the aftermath of the Civil War, and especially after 1870, the number of Niagara paintings declined dramatically. It is not possible to account for Mignot's interest in the subject, in other words, as part of a widespread trend; rather, it represents a highly individual response to the personal and aesthetic conditions under which he operated. Seen in this light, his *Niagara* must represent a bid for his identity with his reunited native country and a response to his transnational condition in which he as a southerner had existed.

FRIENDS AND PATRONS IN BRITAIN

Almost immediately upon his arrival, Mignot called upon fellow American landscapist Jasper Cropsey, whose Kensington Gate studio was near Mignot's Berkeley Gardens address of 1863. Cropsey had spent seven years in London and acquired many British friends, among whom were Ernest Gambart, influential art dealer and print publisher, the painters John Linnell and John Brett, the critic Ruskin, Sir Charles Eastlake, and Copley's son Lord Lyndhurst.[58] Would he have introduced Mignot to these influential and discriminating people? To judge from the disparaging remarks Cropsey made about his compatriot in his diary, probably not. Mignot seemed determined, however, to leave the prejudices and problems of his New York days behind him and to make a fresh start. To this end, he attempted to establish relations within the British art world of the day. Before his departure, he must have obtained letters of introduction to ease his entry into that world.

Elias Magoon, with whom he had been acquainted since his arrival in New York, could have lent assistance. Given the extensive personal network Magoon developed during his own travels to Britain, where he procured much of his collection, he would have been able to supply Mignot with introductions to a variety of contacts.[59] Among them would have been Ruskin, whose name appears several times in connection with the artist, especially with regard to his sympathetic aid to Mignot's widow upon his death. There is no reason to conclude, however, that theirs was anything more than a distant professional relationship.[60] We must look elsewhere for Mignot's critical supporters.

Within Mignot's British circle, the name of Tom Taylor (fig. 48) has been among the most conspicuous within these pages as author of the "Sketch of the Artist's Life" that appeared in the memorial exhibition catalogue of 1876. Playwright and editor of *Punch,* Taylor was an influential figure with access to the press. He demonstrated an enthusiasm for native landscape painting, sometimes writing commentary on the work of specific artists. On one occasion he wrote verses, or "pictures in words" as he called them, after drawings by Birket Foster, published in *Birket Foster's Pictures of English Landscape* of 1863.[61] John Linnell prevailed upon friends to introduce him to Taylor, extracting a promise from the writer to visit him and view his art. But the following account, provided by Linnell's biographer Alfred Story, raises the possibility that Taylor functioned at times a sort of "critic for hire":

> Tom Taylor paid his promised visit, which gratified Linnell, who greatly admired his poems and satirical writings in *Punch.* This was the only occasion, however, on which the art critic of the *Times* visited Redhill, and the two probably never met again. Taylor appears to have been a genuine admirer of Linnell's landscapes, and generally had a good word to say in their favour. One year, however, in writing of the Academy pictures, he ventured to be less complimentary than usual, and the artist was at once told by some of his friends that there was something wrong, and that he ought to send the critique a check

for £50. A strange reflection, surely, on the supposed relations between painter and critic![62]

Certainly Mrs. Mignot, planning the retrospective, could have commissioned the essay from him, and supplied him with the necessary information. But Taylor wrote of Mignot in a tone that suggested familiarity. He had a special interest in America and the Civil War: his play *Our American Cousin* was staged at Ford's Theater the night President Lincoln was assassinated by John Wilkes Booth, and he was one of the first to go against the tide of the British press to praise Lincoln's accomplishments. This proclivity may have led to a sympathetic bond with Mignot. He must have been, as he states, a "friend and patron" of the artist who lent works to the exhibition, although nowhere does he specify which pictures he possessed. But he does mention the name of other owners of his work, and therefore provides some insight into the network of Mignot's associations.

Within the rank of painters his friends included G. P. Boyce, a watercolorist and collector well known for his diaries, which chronicle his activities especially within the Rossetti circle. It is intriguing to imagine Mignot's involvement with Boyce, as well as W. M. Rossetti, who had written supportively of his work. William Stephen Coleman's name was also raised in this connection. Coleman was a book illustrator and painter whose work is sometimes likened to that of Birket Foster. As a member of the original committee of management of the Dudley Gallery, he may have been able to assist Mignot in making exhibition arrangements. Taylor also mentions Dr. C. R. Coffin, Esq., a Mr. Daniels, H. J. Turner, Esq., and Alfred Morison of Fonthill, although to date no further information about their ownership of Mignot's art has come to light.[63] At home it was assumed that Mignot was finding support for his work in Britain. Henry Tuckerman claimed, "Among his warmest patrons is a wealthy gentleman of taste, who is the present owner of Horace Walpole's famous domain— Strawberry Hill."[64] Middlesex, near Twickenham is the location of

Strawberry Hill. Perhaps on a visit to this "wealthy gentleman of taste" he painted *Twickenham Church* and *On the Thames Near Twickenham*.[65]

Mignot's work also appealed to businessmen and industrialists who made their home in the growing urban centers outside London. *Sunset on the Amazon* was owned by railway manager John Staats Forbes, who was regarded as a self-taught connoisseur: "Forbes was much interested in art and, though his judgment was sometimes at fault, enjoyed considerable reputation as a collector. His large collection of works of nineteenth century artists included many examples of the Barbizon and modern Dutch schools."[66] His *Lake of Lucerne with the Rigi* would find a home with H. J. Fairchild, an American who managed a branch of a company in Manchester. And Henry Willett, an important collector and founder of the museum in Brighton, owned a pair of his works. Although the evidence is still scanty, it is sufficient to demonstrate that he enjoyed the support of an enlightened circle of British friends and patrons.[67]

What was it that attracted them to Mignot's pictures? Did they consider him a Victorian painter, or might they have appreciated the distinct, and even unique, elements in his style and subjects? We still know too little about the British eye for American art. As Barbara Novak counsels, that eye was different. "The English critic praised Cropsey [his *Autumn on the Hudson*] for resisting the temptation 'to exaggerate, or revel in variety of hue and effect, like a Turner of the forest . . . his autumn is still brilliant, but not quite lost to sobriety, as we have sometimes, we think, seen it in that Western World. The result is a fine picture, full of points that are new, without being wholly foreign or strange to the European eye. It will take the ordinary observer into another sphere and region, while the execution will bear any technical criticism." "The European eye" here was confident, assured in its discrimination. Nonetheless, Cropsey felt the need to instruct it when he first showed the work in his Kensington Gate studio in 1860. He is said to have pasted real American leaves on the wall next to his canvas, testimony to the veracity of his autumnal colors.[68]

In the absence of the appraisal of Mignot by individual British collectors, we must rely on the assessments of the often anonymous critics published in the contemporary press. The *Pall Mall Gazette* called him "one of the few American artists whose work possesses a genuine claim to critical consideration."[69] The financial difficulties that continued to plague him, however, suggest that this did not translate into wide sales. Or, as another put it: "this artist was not appreciated nearly so highly as he deserved."[70] Clearly, there was something distinctive about his work that defied easy categorization, and therefore in all likelihood made buyers wary. He was "an artist who has not only won a foremost place, but also a place apart, among English landscape-painters."[71] Another writer, struggling to account for his position, attributed it to a class distinction: "In 1862 he came to England, and, with the exception of some sketching excursions to the Continent, lived among us till his death. But, though many of his works were painted and exhibited in this country and others found their way here and were highly prized by a few connoisseurs, we hesitate not to say that no artist of our time was so inadequately appreciated by the general public. The unfamiliarity of his American views might account partly for popular neglect; but the rare refinement and the search for novel effects in his English landscapes appear to have equally stood in the way of his acceptance with the vulgar."[72] Although he enjoyed chosen status within select circles, in essence he lacked popular appeal. This in itself is no startling revelation, and may relate in part to his own conflicted identity as a southerner, and its concomitant relation to class. What makes it significant, however, is that even as this artist appeared, on the surface, to be courting public favor, he was subconsciously repelling it. For even when he gravitated toward what he assumed were current, sure-fire subjects such as Niagara Falls, he treated them in such a refined and even rarefied manner that he put off the very audience he was attempting to attract. This subversive tendency would emerge again in the Swiss pictures that arose from his trips there in 1868 and 1869.

After 1865 Mignot set new challenges for himself. In *Mount*

Chimborazo he pushed the boundaries of scale and luminous effects. In the ambitious *Niagara* he had taken on the formidable task of rendering a frequent subject, and won his battle on the established ground of an Old Bond Street picture house. And with *Parting Day*, he synthesized text and image in a manner that further propelled his art in its new direction. These canvases helped to fix the artist's British reputation. He was entering a new phase of his career, no longer in the "holding pattern" imposed by war and by the conflicting demands of sectional and national affiliations. He made the transition from the American painter who remained for an extended period abroad to one who was content to live permanently as an expatriate. No sooner had the Anglo-American axis been resolved, however, than he seems to have begun looking across the channel to France.

CHAPTER 8

Continental Ambitions

PARIS

Beginning about 1867 Mignot began to set his sights on the Continent. From spring of that year until his death, his presence is recorded regularly in Paris and in Switzerland, where he spent the summers of 1868 and 1869. The initial incentive might very well have been a visit to the Paris Universal Exposition, where his *Sources of the Susquehanna* hung in the American section. He was there by mid-March, as reported by George Lucas (fig. 49), the art dealer who acted as an agent for Mignot in these years.[1] Thus, he could have been on hand for the opening ceremonies on 1 April, and perhaps visited more than once before it closed on 31 October. After being absent from the United States for almost five years, it would have given him the opportunity to see the work of old friends such as Eastman Johnson and Frederic Church as well as a group of four works by his new friend Whistler. Also, he could have viewed Manet, Courbet, and other French avant-garde painters. For after the initial years of expatriatism, Mignot seems to be restless, anxious for change. And several pictures that he created in the late sixties hint that, had he lived, he would have followed their lead and moved in a new direction.

Bal de Nuit (1867; cat. no. 96) was a product of what was probably his first taste of Paris. It depicts a stretch of quay with several stately Second Empire buildings viewed from across the river, through a filter

157

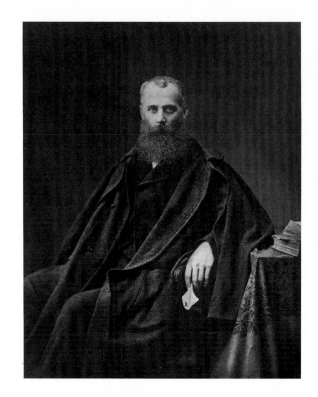

FIGURE 49. Anthony-Samuel Adam-Salomon, *Portrait of George A. Lucas,* 1869, photograph. The Walters Art Gallery, Baltimore, Md.

of trees. The lighting effects are masterfully handled; a bonfire on the riverbank fills the center with a yellowish glow, reverberated in the river reflection below and on the windows of the building behind. The painterly touch possesses a proto-Impressionist quality. In spite of its small scale, the progression of rooftops and towers one behind the other convey the effect of urban density, topped in the far upper right by a striated black and gray sky worthy of a Gustave Doré. In overall composition it seems a secular counterpart to the series of variations on the South American scene of *Ave Maria* (cat. nos. 64, 73, and 86). The title probably refers to a ball or gala taking place in the brightly lit residence, while the mysterious, nocturnal treatment likely found conceptual inspiration in Aestheticism.

The aesthetic response was a characteristic of the late 1850s and 1860s, introduced by critics who sanctioned the viewpoint that art was not subject to a moral interpretation but was capable of generating pleasure on its own. After 1858 Ruskin favored this position, which was carried further by Swinburne, who in 1866 insisted that art should never be the "handmaid of religion, exponent of duty"; rather, he advocated "art

FIGURE 50. James McNeill Whistler, *Sea and Rain,* 1865, oil on canvas, 19 7/8 x 28 5/8". University of Michigan Museum of Art, Bequest of Margaret Watson Parker, no. 1955/1.89.

for art's sake."[2] Moving in this direction, Mignot certainly would have been encouraged by his acquaintance with Whistler, recently returned from his sojourn in Chile. George Lucas recorded in his diary on 19 March 1867 from Paris: "Whistler to see me & with him to call on Mignot. . . . Whistler & brother dined with me—Mignot came in after dinner."[3] The passing mention of a joint rendezvous with Whistler suggests that they had an ongoing relationship, one carried out on both

sides of the channel. In fact, Whistler reported back to Lucas in December of that year from Chelsea, "Mignot is here and I see something of him."[4] It is hardly surprising that about this time Mignot created the Whistlerian *Low Tide, Hastings* (cat. no. 94), dated 1867. Located on the southeastern coast of England (not far from Brighton), Hastings is situated just across the channel from Boulogne, in an area similar to that which inspired some of Whistler's coastal studies, such as *Sea and Rain*

CAT. NO. 94.
Low Tide, Hastings

(fig. 50). By this time it was becoming known as a resort, with bathing beaches of the sort depicted here. It is likely that Mignot stopped to make studies of this area on his way between London and Paris. This canvas achieves an open, fluid handling of paint akin to that which Whistler was only beginning to exploit in formulating his conception of the nocturne. Thus, as is indicated by other titles of unlocated works by Mignot such as *Silver and Gold,* we can assume that in some ways they were following parallel directions.[5]

SWITZERLAND AND THE ALPS

Mignot's responses to Swiss scenery are revealing of his position within the art world of Britain and France in the late sixties. Although he had added various subjects to his repertoire, his mainstay throughout the decade had continued to be the South America pictures. Perhaps he came to feel that in the eleven years since he had first visited Ecuador they were becoming stale and out-of-date. Faced with the obligation to support his family, he needed to produce some salable works. Given that his vision of the English countryside received praise within only limited circles, he must have been in search of material that had the potential for a wider audience. It was in this frame of mind that he made the decision to devote two summers to Alpine travel. Perhaps these forays were a substitute for his thwarted ambition to paint the Himalayas, where Tuckerman had assumed he was headed when he left New York: "the artist's affinity [with local color] will find new and original scope in India, whither it is said he purposes to go, in search of new and congenial subjects."[6] But as Taylor explained: "In 1860 Mr. Mignot married. He had long cherished the design of devoting himself to the painting of the Himalayas. His way to India lay through England. . . . Mr. Mignot arrived in England in 1862, possessed with the high hope of recording upon canvas the awful sublimity of the Himalayan range. But study of English nature . . . and the new cares

and ties and happiness of home, drew around him chains which gradually grew too strong to be broken, and in England he continued to live, study, paint, and exhibit, for the rest of his too short life, with the exception of visits to Switzerland in 1868 and 1869 . . . and excursions to France in 1870."[7] Taylor does not provide precise travel dates, but we can be sure they were during the "season," between the end of the spring avalanches and the beginning of serious fall snow.

Only a few Swiss pictures have resurfaced: *Sunset on the Wetterhorn, Switzerland* (cat. no. 97) and the work that goes by the title *Picnic in the Mountains* (cat. no. 98) is likely set in the Alps. But to judge from the written records—contemporary exhibition catalogues and reviews—these trips gave rise to several large and significant canvases. *Lake of Lucerne, with the Rigi* (presently unlocated, as are all Swiss titles cited, unless otherwise indicated) was presumably the *chef d'oeuvre* of the group. It hung in the memorial exhibition between *Jungfrau, Morning* and *Jungfrau, Evening,* in effect reconstituting this Alpine trilogy. In addition to these, there were smaller, related pictures and studies, accounting for twenty titles in the show. The artist's investment of energy and time—two summers sketching the sites and months finishing the canvases—underscore the premium he placed on them. They constitute a significant portion of his mature European works, and they raise inquiries concerning both the artist and the history of taste for Alpine scenery. Why would Mignot have headed for Switzerland at that moment? Turner loomed as an important artistic precedent during his years in Britain, and here he would have been especially relevant given his multiple Alpine tours. And Ruskin had written persuasively of the importance of the Alps in *Modern Painters.* But by the late 1860s, it is questionable whether they still constituted primary operative influences. Mignot's activities must therefore be analyzed not only against their examples, but also against other emerging forces, including middle-class tourism, which mushroomed in these years in Switzerland. This lays the groundwork for speculation on the meaning of and market for the Swiss pictures.

Given Taylor's remarks, we can assume that Mignot made two separate topographical campaigns in consecutive summers. Painting titles suggest that his foci were the Bernese Oberland and the Lake of Lucerne and its environs. Although the details of Mignot's travel route remain unverified, the sights he painted in the first group were all enumerated along Route 29 as prescribed in Baedeker's *Switzerland*, proceeding from the city of Bern and leading to the giants of the Oberland: the Jungfrau, Wetterhorn, and Eiger.[8] He studied the Jungfrau from a number of prospects. Along the way he sketched at the picturesque valley of Lauterbrunnen and the Wengern Alp, from which—according to the guidebooks—the view was unrivaled: "The Jungfrau (13,671'), covered with an eternal shroud of snow, now appears in all her majesty. The two peaks, the Silberhorn (12,106') to the r[ight], and the Schneehorn (11,204') to the l[eft], tower above its immense fields of snow. Its proportions are so gigantic, that the traveler is bewildered in his vain attempts to estimate them; distance is annihilated by their vastness."[9] He then likely proceeded to Mürren, where he made studies for *Jung Frau, Morning (taken from Muhren)* and could possibly also have glimpsed the Wetterhorn, before approaching for a closer look in preparation for *Wetterhorn, Switzerland*. No excursion to this area would be complete without a side trip to the Rosenlaui Glacier, which Mignot dutifully sketched.[10] This portion of the tour probably terminated at Meiringen where, as Baedeker explained, six different Alpine routes converge,[11] but not before looking back for a view of the *Valley of Meringen, Switzerland*.

A second related group depicts the area around Lake Lucerne. Again the titles of works that hung in the memorial exhibition allow us to trace his movements. The city of Lucerne, on the lake shore between the Rigi and Mount Pilatus, would have afforded a convenient headquarters for a summer's sketching. There he would have made the studies that led to: *Lake of Lucerne; Lake of Lucerne, Mount Pilots–Sketch; Lake of Lucerne, Sketches on Same Canvas; Sunset on Lake Lucerne;* and *Lake of Lucerne, with the Rigi*. From Lucerne he took a steamer to the southernmost extreme of the lake, to a quiet, secluded spot where he produced *At Fluelen, Switzerland*. And he would have made the excursion to view and paint *Uri Rothstock*.[12] Some of Mignot's Alpine pictures went by titles such as *Swiss Mountains* and *Swiss View*—too general to allow site identification, but they do indicate his ongoing efforts to depict the region.[13]

Mignot's view of the Rigi and Lake Lucerne, like his pendants of the Jungfrau, portrayed the mountains at the opening or closing of day, sights that had become something of a mandatory tourist ritual. About the same time that Mignot visited the spot, Mark Twain confessed to falling asleep repeatedly in his desperate attempt to see the sun rise on the Rigi Kulm. Baedeker recounts that at such summertime gatherings, "Every grade of society is here represented; all the languages of Europe combine to produce a very Babel of incongruous sounds."[14] Alpine tourism was a thriving industry in the 1860s, despite the dangers that could still overtake even the more experienced mountaineers. Transportation and lodging had markedly improved since the 1830s, when a *diligence* or a *berline* left Geneva three times a week for the trip to Chamonix, which took about eighteen hours, including stages by horses, mules, and portered chairs.[15] Now, Lake Lucerne was easily accessible by frequent trains, and vistas of its most noteworthy sites could be reached by steamer. The entire experience could be orchestrated at home, coordinating rail schedules and hotel reservations, with the aid of books such as the *Practical Swiss Guide,* by "an Englishman Abroad," whose subtitle proclaimed in part, "in the Briefest Possible Space, Every Necessary Advice, to see all that ought to be seen in the shortest period and at the least expense." It directed fellow countrymen to shops that sold the latest London newspapers and hotels "well acquainted with English habits." Lodging in such reassuringly named establishments as the Hotel d'Angleterre, they could relax in the knowledge that while partaking of a foreign adventure, they would enjoy all the amenities of home.[16] Thus began what some mourned as the "cocknification" of the sacred peaks.[17]

Mignot sought to capture on canvas the most highly recommended (and therefore least original) sites on the tour. He was just one among many artists scrambling for the preferred views. In fact the entire region was so overrun with painters—professionals and amateur watercolorists alike—that the guidebooks advised them on locating less-trammeled spots. Clearly, these experiences were a far cry from those he and Church had shared in Ecuador, where they could at least maintain the illusion of an isolated wilderness encounter. In this corner of the Alps, no such illusion was possible, and that was exactly the point.

Modern mountaineering practices, which were replacing the earlier conventions of picturesque travel, also made excursions easier for artists and public alike. The experience of Edward Whymper typified this new approach. An English illustrator, it was only when he was hired to execute prints for the Alpine Club's anthology *Peaks, Passes, and Glaciers* that he found himself in the Alps at all. But the risk-taking and thrills suited him, and his *Scrambles Amongst the Alps in the Years 1860–69* is a perfect barometer of these changes. Written like a chronicle of a military campaign, he plots his "attack" on the "enemy"—the mountain heights.[18] Mont Blanc, for many years the object of Alpine ambition, had been replaced by the Matterhorn. When Whymper and his party made it to the top in 1865, the Jungfrau, the Wetterhorn, and other great monsters moved in turn into their sights. As one writer put it, "by 1865 more than a score of the major Alpine summits which had defied the native Swiss were beaten into submission by the carefully swung axes of British climbers and their guides."[19]

In August 1868 one of the most famous of English travelers was on Swiss soil: Queen Victoria made a month-long stay at Lucerne, along with the Princesses Louise and Beatrice and Prince Albert. Although supposedly traveling incognito as the Countess of Kent, the Swiss holiday attracted great attention in Britain, where her every move was reported by the press. This was the queen's first visit to Switzerland, and she was determined that it would have none of the trappings of an official state visit. She was a mother on holiday with her children, enjoying the sights like any tourist, albeit one with a royal retinue. By the time Queen Victoria began her journey home in September, she had "done" Mount Pilatus, the Rigi, and Fluelen: the very spots Mignot captured in paint.[20] The highly publicized nature of her trip focused new attention back in her homeland on the already popular area. What had earlier been regarded as a pleasure preserve for the aristocracy and landed class and later opened up to the upper-middle-class professionals was now being invaded by the *middle* middle class. During this decade Thomas Cook commenced taking tours to Chamonix and the Bernese Oberland. The sales potential for pictures associated with the royal itinerary could not have been lost on Mignot, who found himself in increasingly difficult financial straits. His rendering of Mount Pilatus, for example, would have been readily associated with the queen's ascent on her English pony, a "feat" that she accomplished in a pleasant four-hour ride.

Queen Victoria's visit added a royal accent to an area hallowed with literary and musical associations. "Nobody will ever get me out of here again," were Richard Wagner's words when he moved into his house on Lake Lucerne, where he composed his *Die Meistersinger* and *Siegfried*.[21] And the spirit of William Tell—legendary hero of Swiss independence immortalized by Schiller—lives on here. This was the kind of heady mix nineteenth-century travelers in general found impossible to resist. And for Mignot in particular it offered the domain of cultivated nature, that had always provided the inspiration for his best art. As he struggled with the fashioning of his own public persona, immersing himself ever deeper in the process of anglification, it was the middle-class tourist, the "souvenir" market that he attempted to target. And to some degree he must have succeeded; although exhibition and sales records for this period are spotty, *Lake of Lucerne with the Rigi* was sold to H. J. Fairchild, a businessman in Manchester and representative of Mignot's potentially strong new source of patronage among businessmen and industrialists outside London.[22]

There were many American and European painters who could have served as a influence and guide to Mignot's efforts. But given what appears to be a calculated push for the sightseer market, the local competition among Swiss painters—on-the-spot and ready to sell to visitors—might be more pertinent. Alexander Calame would have been familiar to him even from his days in New York, where his work was exhibited and admired in the 1850s. He would have had the opportunity to observe first-hand the strength of the native landscape contribution in the Swiss Pavilion at the Paris Exposition of 1867, which had been organized by Charles Gleyre.[23] In Lucerne he could not have missed the studio of landscapist Josef Zelger, prominently situated adjacent to the Hotel Schweizerhof on the main thoroughfare along the lake. Far removed from the more contemplative mode of his countryman Robert Zünd, Zelger devoted himself entirely to the burgeoning tourist trade; he glorified the natural wonders of the region with characteristic dramatic flourishes of light and dark in works such as *Bernina and Lago Bianco* (Kunstmuseum, Lucerne). Queen Victoria found her way there during her visit and commissioned several painted views as mementos of her journey—like rocks gathered from the mountain face, proof of the trek successfully completed.[24] Imagery created by artists such as Zelger could have served as a measure for Mignot as he planned his final itineraries and assembled his own impressions for finished works.

In Mignot's *Sunset on the Wetterhorn, Switzerland* (cat. no. 98) we confront the summit, snow-covered and luminous with its trailing crest. The viewer is perched on a foreground ledge, gazing across the tops of a fir forest at the mighty peak. Its sketchlike conception has expanded to a 2 × 3' canvas (almost kit-kat size). The contrast between the weighted foreground wedge of brown-green vegetation and the pinkish lavenders of the ethereal mountain is subtly handled and conveys well the spatial complexities of these high altitudes. This is as much a study in the atmospheric effects of this constantly changing spectacle, as it is in mountain topography. Mignot's ability to translate his physical sensations of landscape into spatial and coloristic terms was well honed during his travels in the Andes, where ever-shifting conditions teased the traveler, offering glimpses of the desired object without revealing the whole. The work also shares something with the Whistlerian coastal views he was now producing. A related work entitled *Jungfrau, Morning* was described in the contemporary press as "taken from near the village of Muhren on the Wengern Alp. The early morning sun giving a rosy hue upon the snow-clad mountains, such various atmospheric effects are happily rendered. The work is extremely successful in conveying a sense of vastness."[25] His large-scale picture *Lake of Lucerne, with the Rigi* was remarked upon for its treatment of mountain geography: "The singular strata of the Rigi has hitherto been avoided by artists as being unpicturesque; but, in this painting great skill has been shown in the rendering of the strata of the Rigi, producing a valuable auxiliary for effecting extreme distance. . . . The spectator is supposed to be on the Lake, and distant shore quite a mile from Lucerne, looking in an easterly direction, having the Rigi on the left. The faint snow lines of Mount Clariden are seen in the distance, while to the right we have the Neder and the Oder Bauen. The green of the water is one of the peculiar features of this grand and beautiful lake, which is insisted upon by the artist."[26] We get little sense of a geological emphasis in the painting itself; instead, the artist is praised for his atmospheric and coloristic abilities: "*The Lake of Lucerne, with the Rigi* . . . is a glorious piece of colouring, the clear greenness of the water, upon which the artist has insisted, being especially remarkable. Though positive in colour, the water has wonderful transparency, and the reflexes glance and sparkle like the varying tints of the opal."[27]

If, as I argue, Mignot's attention to this subject at this moment was tied to contemporary Alpine tourism, then we must place the pictures within the related debate. The sheer number of tourists, and the class from which they sprung, were not as critical as the manner in which they experienced the mountain. The premise of the mountaineers— articulated by its "natural aristocracy" the Alpine Club—was that only

by traversing the rock face, inching one's way up ice steps, was the climber able to see the mountain as it truly was. The conviction that only physical experience yielded truth separated the climbers from their opposites, who are sometimes termed Romantics. I find it impossible to imagine Mignot attached to a guide's rope, ice axe in hand. He was, I suspect, a dilettante, a low-incline walker who like Queen Victoria on Mount Pilatus preferred to take the less strenuous path to the summit. The small-scale *Picnic in the Mountains* (cat. no. 98) conveys just this level of enjoyment. He depicts a group of pleasure seekers gathered for their repast on a level spot, protected by a screen of conifers, through which they can just catch a view of the distant peak. In this attitude he would have found support in Ruskin, who argued that enthusiasts could register authentic mountain experiences by just looking. It was not Mignot's intention to "conquer" or "attack" the peak, to borrow the most frequently used verbs from the guide books of the period. The mountain was not some craggy, indomitable obstacle to be subjugated. In his Alpine vision curves dominant over angles, soft tones over harsh. His aim was not conquest but consummation: the sort that promises not knowledge of nature, but self-awareness.

In spite of the artist's intentions, he seems to have had difficulty creating lowbrow, tourist art, if by that is meant a picture that lacks authenticity and conviction. At the same time, however, it was perhaps the bid for commercial success that hindered him from his own most personal expression. In 1887 a critic writing for the *New York Times* recalled Mignot's overall achievement with great enthusiasm but could not disguise the boredom in his tone when he came to comment on the Alpine work: "The Swiss landscapes by Mignot are faithful and not unbeautiful productions; at the time of their making the taste for large canvases of the kind had not been surfeited, and Mignot was as good as any in rendering atmospheric effects."[28] Given that the artist's death occurred just a year after his second tour of the Alps, it is not entirely fair to judge him on a truncated body of work. Perhaps, however, that is its fascination—something akin to the aura of unfinished symphony—which brings us back to it. Mignot was an artist who conveys a sense of being more at home in flat open expanses than at the height of a great peak; a painter of the horizontal, not the vertical. Yet he was an infrequent painter of the sea and its coast, and he continued to long for the mountains; if he never reached the Himalayas, he could claim to have climbed the Andes and the Alps. His art was conflicted, profoundly subversive. His Alpine pictures would decidedly not have appealed to the mountaineering crowd, because they would have conveyed none of the sense of a victory won, a conquest made, that marked the Alpinist's attitude toward the mountain. His manner of painting mountains, softly colored with rounded contours, finds its closest analogies in the words of Ruskin: "Their operations are to be regarded with as full a depth of gratitude as the laws which bid the tree bear fruit or the seed multiply itself in the earth. And thus those desolate and threatening ranges of dark mountain which, in nearly all ages of the world, men have looked upon with aversion or terror and shrunk back from as if they were haunted by perpetual images of death are, in reality, sources of life and happiness far fuller and more beneficent than all the bright fruitfulness of the plain."[29]

THE LURE OF PARIS

There is no further mention of Mignot by George Lucas for about a year and a half (until November 1869), although other evidence indicates that he must stopped in Paris in 1868. His visit would probably have occurred either about May or September, on his way between London and Switzerland. One of his stops was the Louvre, where he registered as a copyist. According to the policy at the time, an artist could request permission either to work before a specific work of art, or to have more general access to the collection. Since Mignot did not make an application for specific works, we can only guess where he would have set up his easel.[30]

He did, however, spend the better part of the last year of his life in Paris, toward the end apparently prevented from leaving by the onset of the Franco-Prussian War.[31] And although few other canvases were completed, or survived, from this period, there are tantalizing references to two: *Paris from Chaeltot* and *Tour de Jean Sans Peur–Quartier de St. Denis.*[32] This second work depicted a landmark that still stands in Paris, at 20 Rue Etienne-Marcel, in the 2nd Arrondissement. Attached to the Hôtel de Bourgogne, it was constructed in the late Middle Ages, as a Parisian residence of the Dukes of Bourgogne. Its long history included the moment in 1407 when the assassins of Louis of Orleans, brother of King Charles VI, took refuge there,[33] but exactly what attracted Mignot to this subject above all the other medieval remains in Paris is difficult to say. Like the French photographer Hippolyte Bayard and others, he may have had some inclination to contribute to the vast pictorial archive that was being assembled in this period as Baron Haussmann was effecting the destruction of the old quarters of the city. And in fact the hotel was included in *Restitution Monuments historiques par Bérard* in 1874 (fig. 51), testimony to the importance of the structure. Or, Mignot may have assumed such a subject would have intrinsic value to the lovers of the old city.[34]

In any case, Mignot was becoming increasingly enchanted with Paris, and—had he lived—probably would have made it a more permanent residence. Just as Mignot probably linked up with southerners in London, so he could have done in Paris. With the cessation of the Civil War, many Confederates fled the United States. Brazil, Mexico, and Canada were popular locations for them, but many did head for Europe, with Paris as the center of their activities. Figures such as Ambrose Dudley Mann already lived in the city when the first influx of exiles arrived. Jacob Thompson, Generals John Preston, P. G. T. Beauregard, Robert Toombs, Alexander Lawton, and a host of others came after the initial surrender at Appomattox, and for the next four years hundreds, perhaps thousands, made their way to Paris and its environs. Most of the southerners residing in Europe had been officers or civil

officials who financed their travels with their own savings. William Gwin, for example, after the failure of his scheme in Mexico, took up residence there. The center of Confederate society in Paris was the Grand Hotel. Here several of the exiles had rooms, which provided them with a meeting spot. The Latin Quarter, Bois de Boulogne, and the International Exposition were among their favorite haunts, and they often wined and dined at the American Restaurant.

A typical day for the exiles began with breakfast at their hotel and a walk to their bank to peruse the latest newspaper from home. The favored spot—the one with the best supply of tabloids—was the general agency office of Major James A. Weston, formerly of the 33rd North Carolina Infantry. There Breckinridge, Mann, Caleb Huse (the Confederate ordnance agent in Europe), General Roswell S. Ripley, and many others ran into each other. Afternoons were spent calling on friends, driving through the Bois, attending the races, and corresponding with those back home. And in the evenings the Confederates met to dine, receive callers, and play cards. Many sought an education for their children, through private academies and tutors. For their own benefit, they formed garden clubs and literary and artistic circles.

Sometimes the discussion turned to the present plight of the South and specific plans for the future. Some continued to hope for southern independence; there was even a plan for a southern shipping trade to revive the South financially. Nothing came of these ideas, but they demonstrate that the Parisian exiles—in contrast to those in Mexico and South America—hoped to return one day and sought remedies for their homeland, rather than abandoning it. This group would not have placed the purchase of art as its highest priority, but given the descriptions of the strong views Mignot held on the Confederacy, one cannot help thinking that they would have found him congenial company in their continued quest for culture and refinement.[35]

In 1870 Mignot made his sole appearance at the Paris Salon, identifying himself in the catalogue as a pupil of Schelfhout with an address at 71 avenue des Champs Elysées.[36] His submissions repeated the com-

bination (if not the actual works) of tropical and snow scenes with which he had made his debut at the Royal Academy eight years before: *Lever du soleil, sur le flava Guayaquil (Sunrise on the Guayaquil)* and *Le givre (Frost).*[37] Did the French critics, we wonder, take any notice of Mignot's work? If so, what would they have made of it? Given that he was sometimes mistakenly assumed to be French on account of his name, they may have shown him more sympathy than they did American artists generally. To date, no evidence has been found of their response.[38] There must have been at least limited traffic of Mignot's works through the major dealers including Goupils and Charpentier. Lucas, for example, mentions having purchased two works by Mignot at Charpentier. Sales continued after his death, probably the results of his widow's efforts. For in May 1872 there was a report of a posthumous exhibition: "At Goupils in Paris there were recently offered several exquisite landscapes of the lamented Mignot."[39]

DEATH

Mystery still surrounds Mignot's death, as it does his birth. William Howe Downes, in his short account of the artist's life in the *Dictionary of American Biography*, states that "in 1870 he was in France and either by accident or design, was shut up in Paris during the Siege."[40] And although he fails to explain his remarks, they are—like all early biographies—impossible to dismiss completely, as they may well have been based on now-lost sources. Apparently Mignot eventually escaped Paris and made his way across the channel to Brighton.[41] A number of obituaries, with repetitions and contradictions, appeared in newspapers and journals in Great Britain and the United States, which provide additional insights. One of the most complete versions of those sad events was provided by the *Art Journal* (London): "Mr. Mignot had been some time in Paris, which, in common with many other sufferers in the disastrous war now raging, he was forced to quit precipitately,

abandoning finished pictures, and nearly executed commissions—in fact, everything he possessed of value. Anxiety, fatigue, and we may add privation, brought on an illness, which proved to be small-pox, and to that disease, aggravated by exposure to the air, this meritorious artist fell victim, at the early age of thirty-nine."[42] His death was recorded in Brighton, where he died in the local hospital on 22 September 1870.[43]

Mignot's tendency toward reinvention, with its concomitant range and versatility, is impressive on an aesthetic level, but one also senses a manic desperation, almost a schizophrenia, in his continual effort to suit his artistic persona to his new surroundings. This is attributable in large measure to his regional identity, which informed his persona as an artist at the same time it precipitated a series of dislocations in his personal life. The solitary figure Mignot placed on the path in his pictures, the *rückenfigur* of Romantic art, functions as a surrogate who plunges deeper into the deserted landscape in a metaphorical quest for self. Paradoxically, the regional identity that motivated his migratory life and artistic transformations—the fact in his life from which he seemed to be trying to escape—remained the constant feature of his identity. In spite of the national and international reputation he achieved, he would be remembered as the artist from South Carolina.

Catalogue of
Known Works

JOHN W. COFFEY

1.
Forest Scene with Waterfall

c. 1850

Oil on canvas, 22⅝ × 28⅜" (57.5 × 72.0 cm)

At lower right: *Louis R. Mignot*

Frank Mignot

Prov.: Kunsthandel Bastian, Eindhoven, The
Netherlands, 1943 (file photo, RKD, The
Hague); Kunsthandel de Wildt, The Hague;
Remy Mignot, Eindhoven.

2.
Two Figures on a Country Road next to a Cottage

1850 [?]

Oil on canvas, 30 × 41¾" (76.2 × 106.0 cm)

At lower right: *Louis R. Mignot f./[5?]o*

Mr. and Mrs. Edward Crawford

Prov.: Frank S. Schwarz and Son, Philadelphia; to
present owners, 1989.

Exh.: Philadelphia, Frank S. Schwarz and Son,
American Painting: Philadelphia Collection XL,
Nov. 1989, no. 21, illus.

3.
Winter Scene, Holland

c. 1850

Oil on canvas, 26⅜ × 36¼" (67.0 × 92.1 cm)

At lower right: *Louis R. Mignot f./[4?]8*

Present whereabouts unknown

Prov.: American Art-Union, New York, Dec. 1850,
lot 279 (as *Winter Scene, Holland*); distributed
to Peter E. Vose, Dennysville, Maine; Sale, New
York, Christie's, 27 Sept. 1990, lot 19 (as *A Distant Land*).

Ref.: *Bulletin of the American Art-Union*, 31 Dec.
1850, listed p. 173, no. 279.

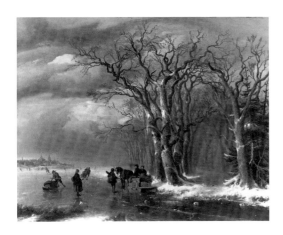

4.
Winter Scene in Holland

Early 1850s

Oil on canvas, 30×40" (76.2×101.6 cm)

At lower right: *L R Mignot.[f.] M.*

The Cooley Gallery, Old Lyme, Conn.

Prov.: Maxwell Galleries, San Francisco; private collection, c. 1972; Maxwell Galleries, 1994; to present owner, 1994.

Ref.: Martha Young Hutson, *George Henry Durrie (1820–1863), American Winter Landscapist: Renowned Through Currier and Ives* (Santa Barbara, Calif.: Santa Barbara Museum of Art, 1977), illus. fig.74; (Cooley Gallery advertisement), *Antiques* 146 (Nov. 1994), p. 595, illus.

Exh.: San Francisco, Maxwell Galleries, *American Painting, A Comprehensive Exhibition*, 23 Feb.–7 Apr. 1973, illus. (as *Winter*).

5.
Skaters on a River

Early 1850s

Oil on canvas, 10×12¾" (25.4×32.4 cm)

Present whereabouts unknown

Prov.: Sale, New York, Sotheby's, 3 Dec. 1987, lot 60 (as *Skaters on the River*), illus.

6.
Travelers on a Roadside

Early 1850s

Oil on canvas, 23½×28½" (59.7×72.4 cm)

At lower right: *Louis R. Mignot f.*

Katherine B. Burton

Prov.: New England Gallery, Inc., Andover, Mass.; Pensler Galleries, Washington, DC, 1987; Sale, Washington, D.C., Weschler's, 26 Sept. 1987, lot 1329 (as *Travelers on a Roadside*), illus.; Montrose Gallery, Fredericksburg, Va.

7.
Sunset on a Mountainous Landscape

Early 1850s

Oil on canvas, 32×42" (81.3×106.7 cm)

At lower left: *L.R.Mignot*

Mr. and Mrs. Louis B. Schoen

Prov.: B. G. Bouts, The Hague, 1955; P. A. Scheen, The Hague, 1957 (file photo, RKD, The Hague); Sale, Amsterdam, Christie's, 24 Apr. 1991, lot 55 (as *A ruin on a hill top in an extensive rocky landscape, at sunset*); Sale, San Francisco & Los Angeles, Butterfield & Butterfield, 9 Dec. 1993, lot 3810 (as *Sunset on a Mountainous Landscape*), illus.

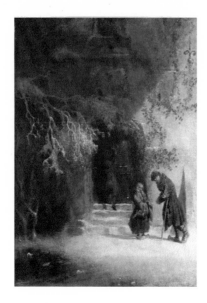

8.
Doorway of a Castle in Winter

c. 1852

Painted in collaboration with Eastman Johnson (1824–1906)

Oil on wood panel, 21½×15¾" (54.6×40.0 cm)

At lower right: *Louis R. Mignot*; at lower left: *East. Johnson*

Lawrence E. Bathgate, II

Prov.: George Folsom, The Hague, c. 1852; Sale, New York, Sotheby's, 19–20 Apr. 1972, lot 42, illus. (as *Winter Scene in Holland*); Sale, New York, Sotheby's, 24–26 Jan. 1974, lot 644, illus.; Sale, New York, Sotheby's, 17 Apr. 1975, lot 49, illus.

Exh.: [Probably Rotterdam, *Tentoonstelling van Schilder-en Kunstwerken*, 3 Mar.–?1852, no. 224 (as *Poort van een Kasteel bij winter*, figures by Eastman Johnson); probably New York, National Academy of Design, *32nd annual exhibition*, 18 Mar.–20 June 1857, no. 498 (as *Winter Scene in Holland*, figures by Johnson, owner Geo. Folsom).]

Note: A pencil drawing by Johnson for the figures is in the collection of the Brooklyn Museum, New York (1990.101.6).

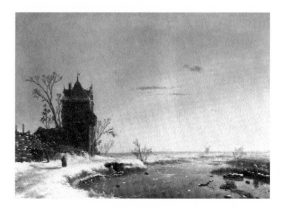

9.
Winter Scene, Holland

1853

Oil on canvas, 30⅛×42¼" (76.5×107.3 cm)

At lower right: *L R Mignot fl 1853*

Masco Collection

Prov.: Sale, Chicago, c. 1982; Hynes Fine Art, Chicago; Alexander Gallery, New York.

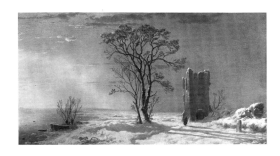

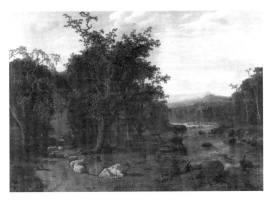

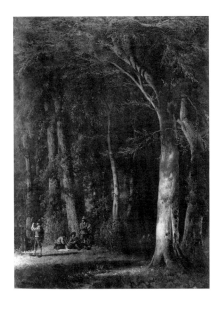

10.
Winter Sunset with Ruined Tower

c. 1853
Oil on canvas, 24⅞×45" (63.2×114.3 cm)
At lower left: *Louis R. Mignot*
Godel & Co., New York
Prov.: Art & Antique Gallery, Worcester, Mass., 1981; Sale, San Francisco, Butterfield & Butterfield, 17 Mar. 1982, lot 403 (as *Winter Sunset*), illus.; Post Road Gallery, Larchmont, N.Y.; Sale, New York, Christie's, 23 Mar. 1984, lot 207, illus.; private collection, Mass.; to present owner, 1985.
Ref.: Art & Antique Gallery advertisement, *Art & Antiques* 4 (July–Aug. 1981), p. 113, illus. (as *Sunset Winter*).

11.
A Pastoral Landscape

1853
Oil on canvas, 33×48½" (83.8×123.2 cm)
At lower right: *Louis R. Mignot '53*
Private collection
Prov.: Arthur M. Lawson, Woodbury, Conn., by 1931 (per label); Daniel B. Grossman, New York; Greenville County Museum of Art, Greenville, S.C., 1987; Babcock Galleries, New York, 1992; to present owner, 1992.
Ref: New York, Babcock Galleries, *Current Selections*, Spring 1994, illus. title page; Babcock Galleries advertisement, *American Art Review* 7 (Apr.–Mar 1995): illus. 161.

12.
Hunters in a Deep Wood

Mid-1850s
Oil on canvas, 42×32" (106.7×81.3 cm)
On tree at right foreground: *L. R. Mignot*
William and Helene Smart
Prov.: [Augustus F. Smith, New York; to daughter,] Lenore Smith Cobb, Milton, Mass.; by descent to present owners.

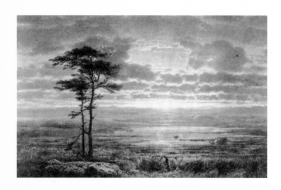

13.
Sunset over a Marsh Landscape

1855
Oil on canvas, 17½ × 31¼" (44.5 × 79.4 cm)
At lower left: *Mignot 1855*
Present whereabouts unknown
Prov.: Sale, New York, Sotheby Parke Bernet, 19
 Nov. 1976, lot 276 (as *Sunset Landscape*), illus.

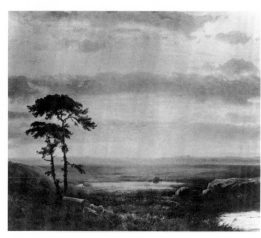

14.
Marsh Landscape with Architectural Fragments [Pontine Marshes ?]

c.1855
Oil on canvas, 30 × 40" (76.2 × 101.6 cm)
At lower right: *L.R. Mignot*
Present whereabouts unknown
Prov.: Sale, Los Angeles, Sotheby's, 24 June 1980,
 lot 381 (as *Landscape at Sunset*), illus.; Terry
 DeLapp Gallery, Los Angeles; Will Richeson,
 Jr., San Marino, Calif..
Exh.: [Possibly Charleston, South Carolina Insti-
 tute, *5th Annual Fair*, 11–26 Apr. 1855, no. 86 (as
 Pontine Marshes).]

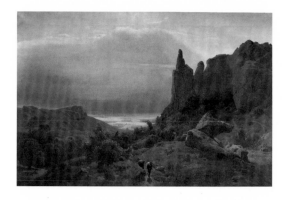

15.
Mountain Landscape in Germany

after Karl Friedrich Lessing (German, 1808–80)
Mid-1850s
Oil on canvas, 34½ × 52¼" (87.7 × 131.7 cm)
In graphite on canvas edge at lower right: *L R
 Mignot after Lessing*; in pencil on stretcher: *L R
 Mignot 526 Hudson [St.] NY*
Private collection
Prov.: Appleton family, Ipswich, Mass.; to present
 owner, c. 1979.

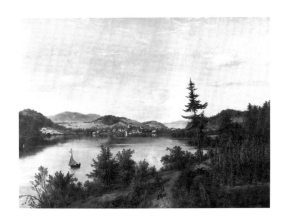

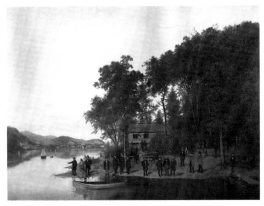

16.
Cooperstown from Three Mile Point, Otsego Lake, New York

c. 1855

Oil on canvas, 31×42" (78.7×106.7 cm)

At lower left: *MIGNOT*

New York State Historical Association, Cooperstown, N.Y.

Prov.: Levi C. Turner, Cooperstown, N.Y.; by descent to William Festus Morgan, Cooperstown; to present owner, 1955.

17.
Lake Party at Three Mile Point, Otsego Lake, New York

c. 1855

Painted in collaboration with Julius Gollmann (d. 1898)

Oil on canvas, 31×42" (78.7×106.7 cm)

At lower right: *Gollmann - Mignot*

New York State Historical Association, Cooperstown, N.Y.

Prov.: Edward Clark, by the 1870s; Alfred Corning Clark; Stephen C. Clark; Otsego County Historical Society, Cooperstown, N.Y.; to present owner, by 1944.

Ref.: Edward P. Alexander, "A View of a New York State Community: The Special Exhibition of Paintings at Cooperstown," *New York History* 20 (July 1939), p. 260. Clifford L. Lord, comp., *The Museum and Art Gallery of the New York State Historical Association* (Cooperstown: New York State Historical Association, 1942), p. 49, illus.; Edgar P. Richardson, *American Romantic Painting* (New York: E. Weyhe, 1944), no. 207 (as *Three Mile Point on Otsego Lake*, misdated 1850), illus.; Hans Hutch, "The American and

Nature," *Journal of the Warburg and Courtauld Institutes* 13 (Jan. 1950): 134, illus. pl. 33b; Esther I. Seaver, "Landscape Paintings (at Fenimore House, New York State Historical Association)," *Art in America* 38 (Apr. 1950), pp. 88–89, illus.; also listed (as *Otsego Lake at Three Mile Point*).

Exh: Cooperstown, N.Y., New York State Historical Association, Summer 1939 (lent by Otsego County Historical Society); Schenectady, N.Y., Union College, Art Gallery, *Hudson River School and Related Paintings*, Dec. 1952–Jan. 1953; Richmond, Virginia Museum of Fine Arts, *Home Front 1861*, 12 Mar.–3 Sept. 1961.

Note: The New York State Historical Association has a drawing by Henry J. Hardenbergh (1847–1918) identifying the members of the lake party (see fig. 16).

18.
The Old Bog Hole

1856
Oil on pressed board, 9⅞×13⅞" (25.1×35.2 cm)
At lower right: *The Old Bog Hole/ L.R. MIGNOT [5?]6*
Mr. and Mrs. Millard B. Prisant
Prov.: (Sale, Sotheby's, New York, 26–27 Jan. 1984, no. 400).

19.
A Winter View from Newburgh, New York

1856
Oil on wood panel, 15³⁄₁₆×12⅞" (38.6×32.7 cm)
At lower left: *MIGNOT. 1856./ Souvinir d'Hivir*
The Frances Lehman Loeb Art Center, Vassar College, Poughkeepsie, N.Y. (Gift of Matthew Vassar, 864.1.57)
Prov.: Rev. Elias L. Magoon, Albany, N.Y.; Matthew Vassar, Poughkeepsie, N.Y., 1864; to present owner, 1864.
Ref.: "Sketchings. Our Private Collections, No. VI," *Crayon* 3 (Dec. 1856): 374; *A Catalogue of the Art Collection Presented by Matthew Vassar* (Poughkeepsie, N.Y.: Vassar College, 1869), no. 83, as *A Winter View from Newburg*; *Vassar College Art Gallery Catalogue* (Poughkeepsie: Vassar College, 1939), listed p. 52; *Selections from the Permanent Collection* (Poughkeepsie: Vassar College Art Gallery, 1967), listed p. 42.
Exh.: Poughkeepsie, N.Y., Vassar College Art Gallery, *The Hudson River School*, 19 Nov.– 16 Dec. 1962; Poughkeepsie, Vassar College Art Gallery, *The Hudson River School*, 20 Apr.– 3 June 1979; Poughkeepsie, Vassar College Art Gallery, *All Seasons and Every Light: Nineteenth-Century Landscapes from the Collection of Elias Lyman Magoon*, 14 Oct.–16 Dec. 1983.

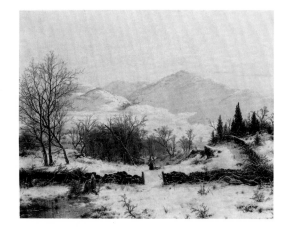

20.
Winter Scene

1856
Oil on canvas, 40×51⅛" (101.6×129.9 cm)
At lower left: *MIGNOT. 1856*; on verso of frame at top right: *Mignot Winter Scene*
Private collection
Prov.: (Possibly Sale, Henry H. Leeds & Co., New York, 16–17 Mar. 1859, no. 97, as *Winter Scene, N.H.*, 40×53"); sold to Mr. Armstrong ($345)]; John C. Force, Brooklyn, N.Y., by 1870; (Force Sale, Somerville Art Gallery, New York, 23 Apr. 1875, as *Winter in the White Mountains,* sold $200); (Sale, Sanders & Mock, Rye, NH, 7 July 1987, no. 1, as *Snow Scene*); (Alexander Gallery, New York).

Ref.: "Studios of American Artists, Second Sketch," *Home Journal*, 9 Feb. 1856, p. 1; "Closing Sale of the Force Paintings," *Evening Post* (New York), 24 Apr. 1875, p. 4; sale advertisement, *Antiques and Arts Weekly* (26 June 1987): illus.; sale advertisement, *Maine Antiques Digest* (July 1987): listed p. 14F; "On-Site Auction in Rye, New Hampshire," *Maine Antique Digest* (Sept. 1987): 6–7D, illus. p. 7D; Alexander Gallery advertisement, *Antiques* 132 (Dec. 1987): illus. p. 1195 (as *A Winter View near Newburgh*).

Exh.: New York, National Academy of Design, *4th winter exhibition*, 22 Nov. 1870–5 Mar. 1871, no. 48, as *Winter Scene*, owned by John C. Force; New York, Alexander Gallery, *The Hudson River School: Congenial Observations*, 24 Sept.–31 Oct. 1987, no. 29, as *American Winter Landscape*, illus.

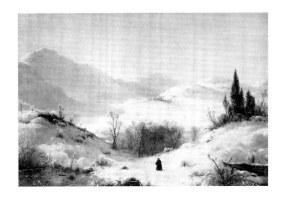

21.
Winter Landscape

c. 1856
Oil on canvas, 16×24" (40.6×61.0 cm)
AP Farm
Prov.: Private collection, Mass.; (Sale, Skinner's, Boston, 25 June 1988, no. 77); (Brown•Corbin Fine Art, Lincoln, Mass., 1988); (Richard York Gallery, New York, 1988); to present owner, 1995.
Ref.: An American Gallery, 5 (New York: Richard York Gallery, 1989), no. 4 (as *Winter*), illus.

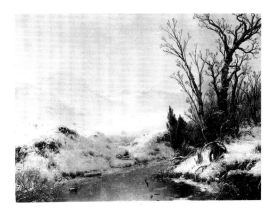

22.
Snow Scene

c. 1856
Oil on canvas, 17¾×24" (45.1×61.0 cm)
At lower left: *MIGNOT*
Masco Collection
Prov.: (Sale, Sotheby's, New York, 10–11 June 1976, no. 119, as *Snow Covered Landscape*); Steve Martin, Santa Barbara, Calif.
Exh.: Santa Barbara, Calif., Santa Barbara Museum of Art, *A Winter's Tale: Snow Scenes in Art*, 7 Dec. 1981–17 Jan. 1982 (as *Winter Landscape*).
Note: See related drawing (cat. no. B)

23.
Hunters in a Winter Landscape

c. 1856
Oil on canvas, 27×34" (68.6×86.4 cm)
At lower right: *MIGNOT.*
The Jordan-Volpe Gallery, Inc., New York
Prov.: (David Bendann's Fine Art Rooms, Balti-
more); (Sale, Christie's, New York, 21 Sept.
1984, no. 14, as *Winter Landscape with
Hunters*); private collection; (H.V. Allison Gal-
leries, Inc., New York, by 1986); (Dan Savage,
Toledo, Ohio); private collection; (Lagakos-
Turak Gallery, Philadelphia, 1993); (Sale,
Christie's, New York, 26 Mar. 1993, no. 28, as
Hunters near Poughkeepsie, unsold); to present
owner, 1994.
Ref.: *Fall '86: A Selection of Paintings, Watercolors
and Sculpture* (New York: H.V. Allison Gal-
leries, 1986), no. 6 (as *Hunters in a Winter
Landscape*), illus.; H.V. Allison Galleries
advertisement, *Antiques* 130 (Dec. 1986), illus.
p. 1142; Lagakos-Turak Gallery advertisement,
American Art Review 6 (June–July 1994): illus.
p. 27; Jordan-Volpe Gallery, *American Art*
(New York: Jordan-Volpe Gallery, 1994), p. 98,
illus. p. 99.

24.
The Foray (The Foraging Party)

Painted in collaboration with John Whetten
Ehninger (1827–1889)
1857
Oil on canvas, 36⅝×50¼" (93.0×127.6 cm)
On rock at lower right: *N.Y. 1857/MIGNOT/
EHNINGER*
The English Room, Charlotte, N.C.
Prov.: [Private collection, Long Island, N.Y.];
George Foggan, Port Washington, Long
Island); Patrick H. James, Garden City, Long
Island, 1964; (Sale, Sotheby's Arcade, 20 Mar.
1996, no. 24, as *Dutch Explorers above the Hud-
son River*).
Ref: Fidelius, "Art Matters in New York," *Boston
Evening Transcript*, 17 Mar. 1857, p. 2; "Sketch-
ings. Domestic Art Gossip," *Crayon* 4 (Apr.
1857), p. 123; "Exhibition of Art," *Daily Wash-
ington Intelligencer* (Washington, D.C.), 19 Mar.
1857, p. 1; "The National Academy of Design
Exhibition (Second Notice), *New-York Daily
Tribune*, 27 Mar. 1857, p. 5; "Louvre," "Fine
Arts. The Academy Exhibition (second notice),"
Albion 35 (13 June 1857): 285; "National Academy
of Design–No. III," *Evening Post* (New York),

19 June 1857, p. 2; *The Diary of George Temple-
ton Strong*, ed. by Allan Nevins and Milton
Halsey Thomas (New York: Octagon Books,
1974), 2:339.
Exh.: Washington, D.C., Washington Art Associa-
tion, *1st annual exhibition*, 7 Mar.–16 Mar.
1857, no. 29 (as *The Foraging Party*, owned by
the artists); New York, National Academy of
Design, *32nd annual exhibition*, 18 Mar.–
20 June 1857, no. 484 (as *The Foray*, for sale).

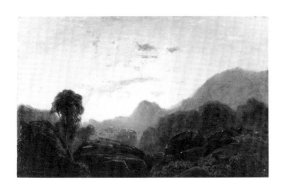

25.
Mountain Sunset

c. 1857

Oil on paperboard, mounted on canvas, 10⅛ × 15-¹⁵⁄₁₆" (25.7 × 40.5 cm)

At lower right in orange: *L.R. MIGNOT.* over *L.R.[M.]*

Mr. and Mrs. George Crummey

Prov.: P. Prapuolenis, Brooklyn, N.Y.; Frank McCoy, New York; by descent to present owners, 1957.

26.
Mountain Landscape, Otsego County, New York

c. 1857

Oil on canvas, 12½ × 18¼" (31.8 × 46.4 cm)

At lower left: *MIGNOT*

Collection of Mr. and Mrs. Allan J. Riley, on extended loan to the Snite Museum of Art, University of Notre Dame

Prov.: Richard Goodman, Hartford, Conn.; by descent to Mr. and Mrs. Robert W. Lawson, Charleston, W.V.; (Hirschl & Adler Galleries, New York, 1994); to present owner, 1994.

Note: Related to *Sources of the Susquehanna* (cat. no. 27).

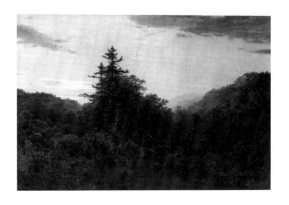

27.
Sources of the Susquehanna

1857

Oil on canvas, 24¼ × 36½" (61.9 × 92.7 cm)

Inscribed on rock at lower right: *MIGNOT 1857*

National Academy of Design, New York (Bequest of James A. Suydam)

Prov.: James A. Suydam, New York, 1857; to present owner, 1865.

Exh.: New York, National Academy of Design, *32nd annual exhibition*, 18 Mar.–20 June 1857, no. 526 (as *Sources of the Susquehanna*, owned by James A. Suydam); New York, National Academy of Design, *Next to Nature: Landscape Paintings from the National Academy of Design*, 12 Nov.1980–22 Feb. 1981, then traveling, discussed pp. 64–66, illus.; Binghamton, N.Y., Roberson Center for the Arts and Sciences, *Susquehanna: Images of the Settled Landscape*, 12 Apr.–5 July 1981, discussed pp. 54–55, illus. fig.43.

Note: Related to *Mountain Landscape, Otsego County, New York* (cat. no. 26).

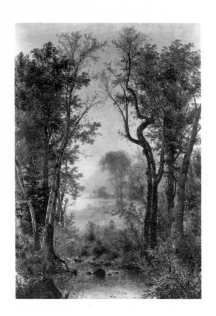

28.
Autumn (I)

1857
Oil on canvas, 30×21¼" (76.2×54.0 cm)
At lower left: *MIGNOT/ 1857.*
Private collection
Prov.: Mr. and Mrs. William Redmond, Jr., New-
port, R.I.; Rosalie Creighton, Newport, before
1900; William Preston Redmond, son of above,
Jackson Hole, Wyo., c. 1935; by descent in fam-
ily; (Sale, Sotheby's, New York, 25 Mar. 1988,
no. 22).
Ref.: [Probably "The National Academy of Design
Exhibition (Second Notice)," *New-York Daily
Tribune*, 27 Mar. 1857, p. 5; Fidelius, "Art Mat-
ters in New York," *Boston Evening Transcript*,
29 Mar. 1857, p. 1; "National Academy of
Design–No. III," *Evening Post* (New York),
19 June 1857, p. 2; "Sketchings. National Acad-
emy of Design," *Crayon* 4 (July 1857): 222.]
Exh.: [Probably New York, National Academy of

Design, *32nd annual exhibition*, 18 Mar.–
20 June 1857, no. 281 (as *Autumn*, for sale)].
Note: One of two known versions of this composi-
tion (see cat. no. 29).

29.
Autumn (II)

c. 1857
Oil on canvas, 30×18¾" (76.2×47.6 cm)
Alexander R. Raydon, Raydon Gallery, New York
Prov.: With present owner, by 1974.
Note: One of two known versions of this compo-
sition (see cat. no. 28).

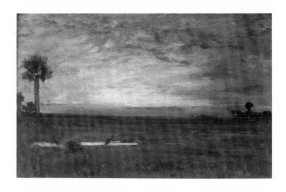

30.
Tropical Sunset

c. 1857
Oil on wood panel, 5⅞×9⁵⁄₁₆" (14.9×23.7 cm)
At lower left: *M.*
Samuel H. Vickers
Prov.: (Sale, Sotheby's, New York, 23 Sept. 1981,
no. 70, as *Sunset, Florida*).
Exh.: Gainesville, University of Florida, University
Gallery, *Florida Visionaries: 1870–1930*, 19 Feb.–
26 Mar. 1989, discussed pp. 26–27 (as *Sunset
Landscape*), illus. p. 27.

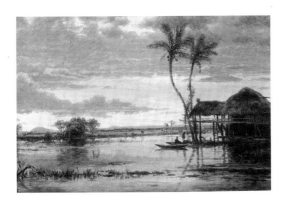

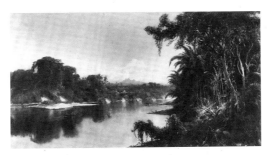

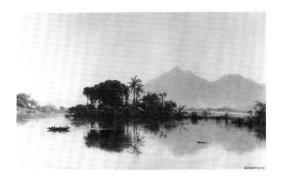

31.
South American River Scene

c. 1857

Oil on paper, laid down on canvas, 5¹³/₁₆ × 8¹³/₁₆"
 (14.8 × 22.4 cm)

At lower left: *M.*

Private collection

Prov.: James Maroney, New York.

32.
Tropical River Landscape

Late 1850s

Oil on canvas, 21 × 39" (53.3 × 99.1 cm)

On verso: *To Fred from L.R.Mignot, Riobamba,
 July 10, 1857* [per Sotheby's]

Present whereabouts unknown

Prov.: (Sale, Sotheby's, London, 1 Nov. 1973, no.
 157, as *Ecuador, Riobamba*); (Sale, Sotheby's,
 New York, 18–20 Nov. 1976, no. 277, as
 Tropical River Landscape); Lano Collection,
 Washington, D.C.

33.
River Scene, Ecuador (I)

1857

Oil on board, 11⅞ × 18⅛" (30.2 × 46.0 cm)

At lower right: *MIGNOT.1857.*

The Weimer Collection

Prov.: Charles M. Kurtz, Buffalo, N.Y.; (Kurtz
 Sale, Fifth Avenue Galleries, New York, 24–25
 Feb. 1910, no. 44, as *On the Orinoco River,
 Venezuela*); M. W. Nathing; (Sale, Christie's,
 New York, 18 Mar. 1983, no. 125); The Regis
 Collection, Minneapolis; (Sale, Christie's, New
 York, 26 Mar. 1988, no. 50).

Ref.: Katherine Emma Manthorne,. *Tropical
 Renaissance: North American Artists Exploring
 Latin America, 1839–1879* (Washington, D.C.:
 Smithsonian Institution Press, 1989), pp. 137,
 233, illus. fig.67.

Notes: One of two known versions of this compo-
 sition (see cat. no. 34). An unfinished tropical
 river scene is on the verso.

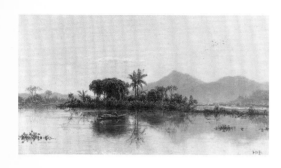

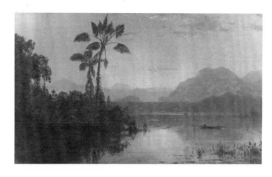

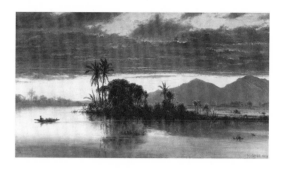

34.
River Scene, Ecuador (II)

1857

Oil on paper, laid down on canvas, 7 × 12¾" (17.8 × 32.4 cm)

At lower right a half-submerged monogram and date; inscribed in old hand on stretcher: *Painted in 1857*

Butler Fine Art, Inc., New Canaan, Conn.

Prov.: (Sale, Sotheby's, London, 7 June 1989, no. 135, as *On the Orinoco, Venezuela*, attributed to Mignot); (Godel & Co., New York, 1993); (David McCabe, New York, 1993); (to present owner, 1993).

Note: One of two known versions of this composition (see cat. no. 33).

35.
Guayaquil River

1857

Oil on canvas, 9⅛ × 15" (23.2 × 38.1 cm)

At lower right: *MIGNOT.57.*

Mr. and Mrs. Alvin Friedman

Prov.: (Victor Sparks, New York); (Terry DeLapp Gallery, Los Angeles); George F. McMurray, Calif., c. 1960; private collection; (Alexander Gallery, New York); to present owners, 1992.

Exh.: Los Angeles, Terry DeLapp Gallery, *American Landscape Painting (1840–1900)*, 1–31 Aug. 1960, illus. (as *The Guayaquil*, dated 1857)

36.
Tropical Landscape

1858

Oil on canvas, 10 × 18" (25.4 × 45.7 cm)

At lower right: *MIGNOT 1858*

C. Kevin Landry

Prov.: [Butler Family, Norfolk, Va.]; (Don Williams, Norfolk); (Taggart & Jorgenson, Washington, D.C., 1988); (Alexander Gallery, New York, by 1988); to present owner, 1988.

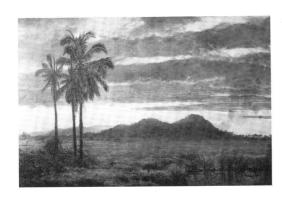

37.
Tropical Landscape

1858

Oil on [canvas?], no dimensions

At lower right: *MIGNOT./58.*

Present whereabouts unknown

Prov.: George Bliss; Georgetown University, June
1927; (Potomac Art & Antiques, Potomac, Md.,
c. 1980).

38.
View across the Valley of Pierstown, New York, from a Point above Cascade Hills [View near Otsego, New York ?]

c. 1858

Oil on canvas, 17½ × 31¼" (44.5 × 79.4 cm)

Inscription: at lower right: *MIGNOT*; on stretch-
er: *View across the Valley of Pierstown from a
Point above Cascade Hills/ No. 3*

Munson-Williams-Proctor Institute, Museum of
Art, Utica, N.Y. (Museum purchase)

Prov.: Private collection, New York State; (Robert
McLean, Albany, N.Y.); to present owner, 1988.

Ref.: [Possibly "Sketchings. Pennsylvania Academy
of the Fine Arts," *Crayon* 5 (June 1858): 179.]

Exh.: [Possibly Philadelphia, Pennsylvania Acade-
my of the Fine Arts, *35th annual exhibition,* 20
Apr.–19 June 1858, no. 183 (as *View near Otsego,
New York*)].

39.
Patterson River, Virginia

1858

Oil on canvas, 10¼ × 18¼" (26.0 × 46.4 cm)

At lower left: *MIGNOT. 58*

Present whereabouts unknown

Prov.: (James M. Hansen Antiques, Santa Barbara,
Calif,, 1977); (Sale, Butterfield & Butterfield,
San Francisco and Los Angeles, 8 Nov. 1984,
no. 2092, as *Sailboat on the Hudson, Autumn*).

Ref.: "Literature, Science, and Art," *Independent*
(New York), 18 Nov. 1858, p. 3; Hansen
Antiques advertisement, *Antiques* III (Mar.
1977): illus. p. 872 (as *Patterson River, Va.*).

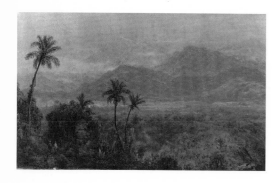

40.
[Morning, Looking over the Pampa ?]

Late 1850s
Oil on canvas, 8¼ × 14⅜" (21.0 × 36.5 cm)
Private collection
Prov.: (Possibly Mignot Sale, Henry H. Leeds & Co., New York, 2 June 1862, no. 38, as *Morning, Looking over the Pampa*, 8 × 14"); (Sale, Sotheby's, New York, 2 Feb. 1979, no. 473, as *Landscape in Ecuador*, by F. E. Church); (Alexander Gallery, New York); private collection; (Coe Kerr Gallery, New York, 1990); (William Vareika Fine Arts, Newport, R.I., 1992).
Ref.: Coe Kerr advertisement, *Antiques* 137 (Mar. 1990): 553 (as *South American Scene*, by F. E.Church), illus.; Vareika advertisement, *Antiques* 142 (Oct. 1992): 435 (as *South American Scene*, by F. E.Church), illus.

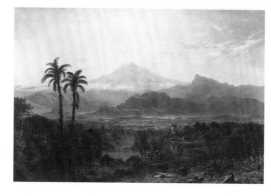

41.
The Andes of Ecuador

Late 1850s
Oil on canvas, 24⅛ × 36⁵⁄₁₆" (61.3 × 92.2 cm)
Mr. and Mrs. Robert Mayo
Prov.: Private collection; (Robert P. Weiman); (Mayo Gallery, Richmond, Va., c. 1985); private collection; (Mayo Gallery, 1992); to present owner, 1992.

42.
In the Andes

c. 1858
Oil on canvas, 15³⁄₁₆ × 22³⁄₁₆" (38.6 × 56.4 cm)
At lower left: *F.E.CHURCH*
The Butler Institute of American Art, Youngstown, Ohio
Prov.: Stuart Slavin, Clayton, Mo.; (Hirschl & Adler Galleries, New York); to present owner, 1978.
Ref.: *Annual Report, 1982–83* (Youngstown, Ohio: Butler Institute of American Art, 1983), illus. cover; *Selections from the Permanent Collection* (Youngstown: Butler Institute of American Art, 1979), illus. p. 24 (as by F .E. Church); William S. Talbot, "Frederic E. Church, *In the Andes*," in *Master Paintings from the Butler Institute of American Art*, ed. Irene S. Sweetkind (New York: Abrams, 1994), pp. 102–3 (as by F. E. Church), illus.
Exh.: Charlotte, N.C., Mint Museum of Art, *Nineteenth-Century American Painting*, 15 Sept.–13 Oct. 1974, no. 5, illus.; Mansfield, Ohio, Art Center, *The American Landscape*, 8 Mar.–5 Apr. 1981; Cincinnati, Taft Museum, *A Beautiful Order: Figures and Landscapes from The Butler Institute of American Art, Youngstown, Ohio*, 24 Sept.–4 Nov. 1983, no. 22 (as by F. E. Church), illus. p. 13; New York, IBM Gallery of Science and Art, *Highlights from the Butler Institute of American Art*, 9 Feb–10 Apr. 1993.

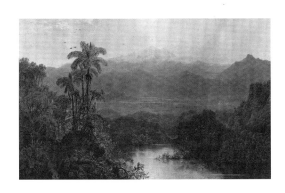

43.
Landscape in Ecuador

1859
Oil on canvas, 24×39½" (61.0×100.3 cm)
At lower left: *MIGNOT 59*
North Carolina Museum of Art, Raleigh (Purchased with funds from gifts by the American Credit Corporation, in memory of Guy T. Carswell; and various donors, by exchange, 91.2)
Prov.: [(Possibly Mignot Sale, Henry H. Leeds & Co., New York, 2 June 1862, no. 36, as *Landscape in Ecuador*, 24×38 in.)]; Rutherfurd B. Stuyvesant, Allemuchy, N.J.; by descent in Stuyvesant family; Veronica Rita Forgett, Teaneck, N.J., c. 1952; Sale, Skinner's, Bolton, Mass., 11 Mar. 1990, no. 17A, as *Tropical Panorama*); (Brown·Corbin Fine Art, Lincoln, Mass.); to present owner, 1991.
Ref.: "Annual Report: Acquisitions," *Preview* (North Carolina Museum of Art) (Winter 1991–92): illus. p. 42; Katherine E. Manthorne, "Louis Mignot's Landscape in Ecuador," *Preview* (North Carolina Museum of Art) (Spring 1992): 15–17, illus.; Katherine E. Manthorne, "On the Road: Louis Rémy Mignot's *Landscape in Ecuador*," *North Carolina Museum of*

Art Bulletin 16 (1993): 14–30, illus. fig. 1; *Introduction to the Collections*, rev. ed. (Raleigh: North Carolina Museum of Art, 1992), illus. p. 233; John W. Coffey and Katherine E. Manthorne, "Louis Rémy Mignot: Rediscovered," *American Art Review* 5 (Fall 1993):. 92–93, 159, discussed p. 93, illus.; William S. Talbot, "Frederic Edwin Church, In the Andes," in *Master Paintings from the Butler Institute of American Art* (New York: Abrams, 1995), pp. 102–3, 355 n.2.
Exh.: New York, Metropolitan Museum of Art, *Church's Great Picture, "The Heart of the Andes"*, 5 Oct. 1993–20 Jan. 1994, p. 49, fig. 32.

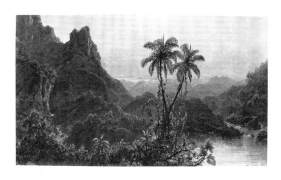

44.
Tropical Landscape

1859
Oil on canvas, 8×13½" (20.3×34.3 cm)
At lower left: *MIGNOT 59*
Mr. and Mrs. Garett Albert
Prov.: (Sale, PB 84, New York, 5 June 1980, no. 224); (Hirschl & Adler Galleries, New York).
Ref.: Hirschl & Adler advertisement, *Antiques* 119 (Jan. 1981): 6, illus.; Katherine E. Manthorne, "On the Road: Louis Rémy Mignot's *Landscape in Ecuador*," *North Carolina Museum of Art Bulletin* 16 (1993): 14–30, discussed pp. 19–20, fig. 4.

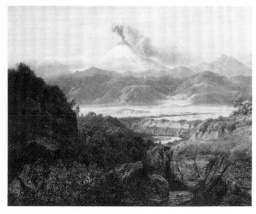

45.
Cotopaxi

185[9?]

Oil on canvas, 14¼ × 17⅛" (36.2 × 43.5 cm)

At lower center: *MIGNOT/ 5[9?]*

The Century Association, New York.

Prov.: Given by Century Association members, 1876.

Ref.: Century Association, *Constitution and By-Laws of The Century* (New York: Martin's Printing House, 1875), p. 76, listed in "Catalogue of Pictures," no. 61 (as *Landscape (S.A.)*); Viggo Conradt-Eberlin, comp., *Catalog of Paintings and Other Art Objects belonging to The Century Association*, unpublished, 1907, no. 184 (as *South American Landscape*); Charles Downing Lay and Theodore Bolton, *Works of Art, Silver and Furniture Belonging to The Century Association* (New York: Century Association, 1943), listed p. 15 (as *South American Landscape*); A. Hyatt Mayor and Mark Davis, *American Art at the Century* (New York: Century Association, 1977), listed p. 131.

Exh.: Chicago, *World's Columbian Exposition*, 1 Mar.–31 Oct. 1893, no. 2836 (as *Chimborazo*);

Washington, D.C., The Corcoran Gallery of Art, *Commemorative Exhibition by Members of the National Academy of Design, 1825–1925*, 17 Oct.–15 Nov. 1925, then traveling, listed p. 155 (as *Landscape*); New York, The New-York Historical Society, *The Century Association: American Masters and Masterworks*, 17 July–11 Oct. 1992; Washington, D.C., The Corcoran Gallery of Art, *The Century Association Collection*, 21 July–13 Sept. 1993.

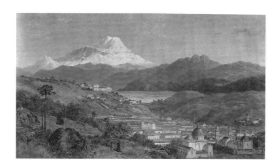

46.
View of Riobamba, Ecuador, Looking North towards Mt. Chimborazo

1859

Oil on canvas, 17⅜ × 31¼" (44.1 × 79.4 cm)

At lower left on rock: *MIGNOT/ 1859*

Private collection

Prov.: (Sale, Sloan's, Bethesda, Md., 4 Oct. 1986, no. 2125, *as Ecuadorian Panoramic Landscape with Figures*); (Hirschl & Adler Galleries, New York); to present owner, 1992.

Ref.: Katherine Emma Manthorne, *Tropical Renaissance: North American Artists Exploring Latin America, 1839–1879* (Washington, D.C.:

Smithsonian Institution Press, 1989), illus. fig. 74; Katherine E. Manthorne, "Louis Mignot's *Landscape in Ecuador*," *Preview* (North Carolina Museum of Art) (Spring 1992): 15–18, discussed p. 17, illus. p. 16; Katherine E. Manthorne, "On the Road: Louis Rémy Mignot's *Landscape in Ecuador*," *North Carolina Museum of Art Bulletin* 16 (1993): 14–30, discussed p. 21, illus. fig. 6.

Exh.: New York, Hirschl & Adler Galleries, *Adventure & Inspiration: American Artists in Other Lands*, 16 Apr.–3 June 1988, no. 47, illus.

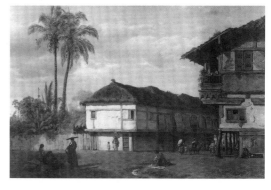

47.
Street View in Guayaquil, Ecuador

1859

Painted in collaboration with Eastman Johnson (1824–1906)

Oil on canvas, 24⅛ × 36⅛" (61.3 × 91.8 cm)

Inscribed at lower right: *MIGNOT/ 59*.

New York Public Library, Robert L. Stuart Collection, on permanent loan to The New-York Historical Society, New York

Prov.: Sheperd Gandy, New York, 1859; (Gandy

Sale, Somerville Gallery, New York, 24–25 Mar.
1875, no. 131, as *Village in South America*, fig-
ures by E. Johnson); Robert L. Stuart, New
York; Lenox Library (later New York Public
Library), New York, 1892–1944; on permanent
loan to The New-York Historical Society, New
York, 1944–present.

Ref.: "The Thirty-Fourth Exhibition of the
National Academy of Design," *Evening Post*
(New York), 25 Apr. 1859, p. 1; "Fine Arts.
National Academy of Design. Second Notice,"
Albion 37 (14 Mar. 1859): 237; "Fine Arts.
National Academy of Design." *Home Journal*,
11 June 1859, p. 2; *Catalogue of Paintings in the
Picture Galleries* (New York: New York Public
Library, 1941), p. 29, no. 188; Richard J. Koke,
*American Landscape and Genre Paintings in The
New-York Historical Society* (New York: New-
York Historical Society, 1982), no. 1828; Kather-
ine Emma Manthorne, *Tropical Renaissance:
North American Artists Exploring Latin America,
1839–1879* (Washington, D.C.: Smithsonian
Institution, 1989), p. 143, illus. fig.71; Katherine
E. Manthorne, "Louis Mignot's Landscape in
Ecuador," *Preview* (North Carolina Museum of
Art) (Spring 1992): 15–18, discussed p. 17, illus.
p. 18; Katherine E. Manthorne, "On the Road:
Louis Rémy Mignot's *Landscape in Ecuador*,"
North Carolina Museum of Art Bulletin 16
(1993): 14–30, discussed pp. 20–21, illus. fig.5.

Exh.: New York, National Academy of Design,
34th annual exhibition, 13 Apr.–25 June 1859,
no. 262 (as *Street View in Guayaquil*, lent by S.
Gandy).

Note: Painted, presumably by Eastman Johnson,
in oil colors on top stretcher bar: two figures, a
priest with wide-brimmed hat facing a man in
a striped serape.

48.
Beach at Sunset with Offshore Shipwreck

Late 1850s
Oil on canvas, 23¾ × 41½" (60.3 × 105.4 cm)
At lower left: *MIGNOT.185[?]*
Present whereabouts unknown
Prov.: (Sale, Sloan's, Bethesda, Md, 22 Sept. 1989,
no. 2300, as *Luminous Seascape; Ship Off
Shore*).

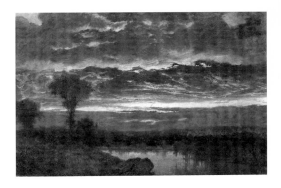

49.
Sunset

1859
Oil on canvas, 13 × 21" (33.0 × 53.3 cm)
At bottom center: *M.59*
Arthur J. Phelan, Jr.
Prov.: [(Possibly Mignot Sale, Henry H. Leeds &
Co., New York, 2 June 1862, no. 41, as *Sunset*,
13 × 21")]; (unidentified dealer, New Hope, Pa.);
to present owner, c. 1986.
Exh.: Hagerstown, Md., Washington County
Museum of Fine Arts, *Look Away: Reality and
Sentiment in Southern Art*, 1–31 July 1988.

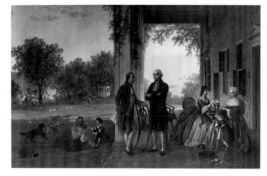

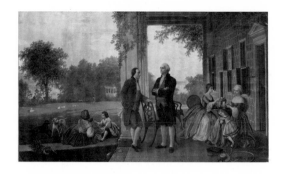

50.
Study for Washington and Lafayette at Mount Vernon, 1784

c. 1858

Oil on canvas, 25½ × 37½" (64.8 × 95.3 cm)

The Mount Vernon Ladies' Association of the Union, Mount Vernon, Va. (Gift of Mrs. Catherine M. Redington, Parsippany, N.J., in memory of her husband, John H. Redington)

Prov.: Thomas P. Rossiter, New York; by descent in Rossiter family; Mr. and Mrs. John H. Redington, Bolton, N.J., by 1980; to present owner, 1987.

Ref.: "Sketchings. Domestic Art Gossip," *Crayon* 5 (Nov. 1858): 328 (notes "a view from the piazza of the Washington Mansion"); *Mount Vernon Ladies' Association Annual Report 1987*, listed and discussed (as *View of Mount Vernon*) p. 51, illus.; Neil W. Horstman, "The Mount Vernon Ladies' Association of the Union." *Antiques* 135 (Feb. 1989): 454–61; illus. pl. 2, pp. 454–55.

51.
Study for Washington and Lafayette at Mount Vernon, 1784

1859

Painted in collaboration with Thomas P. Rossiter (1818–71)

Oil on canvas, 38½ × 60¼" (97.8 × 153.0 cm)

At lower left: *MIGNOT 1859*; at lower right: *T.P. ROSSITER*

Private collection

Prov.: Mrs. David Orr Edson; by descent in family to A. Robert Faesy; (Hirschl & Adler, New York); to present owner, 1990.

Ref.: "Sketchings. Domestic Art Gossip," *Crayon* 6 (Mar. 1859): 91.

Note: This painting was sent to London in 1859 for engraving. The print, engraved by Thomas Oldham Barlow, was published by J. McClure, New York and London, 1863.

52.
Washington and Lafayette at Mount Vernon, 1784 (The Home of Washington after the War)

1859

Painted in collaboration with Thomas P. Rossiter (1818–71)

Oil on canvas, 87 × 146½" (221.0 × 372.1 cm)

At lower left: *MIGNOT*; at lower right: *ROSSITER 1859*

The Metropolitan Museum of Art, New York (Bequest of William Nelson)

Prov.: Thomas P. Rossiter, New York, until 1871; Rossiter estate, 1871–73; (Rossiter Sale, George A. Leavitt and Co., New York, 5–8 Feb. 1873, no. 224); William Nelson, New York and Poughkeepsie, N.Y., 1873–1905; to present owner, 1905.

Ref.: "Fine Arts," *Evening Post* (New York), 31 Dec. 1858, p. 1; "Sketchings. Domestic Art Gossip," *Crayon* 6 (Jan. 1859): 25; "Fine Arts," *Evening Post* (New York), 8 Jan. 1859, p. 2.; "Personal," *Home Journal* (15 Jan. 1859): 3; "Sketchings. Domestic Art Gossip," *Crayon* 6 (Mar. 1859): 91; "Personal," *Home Journal* (2 July 1859): 2; "Sketchings. Domestic Art Gossip," *Crayon* 6 (Oct. 1859): 319; "City Items: Rossiter and

Mignot's Washington," *New-York Daily Tribune*, 16 Nov. 1859, p. 7; "Fine Arts. The Home of Washington," *Home Journal* (19 Nov. 1859): 2; *Boston Evening Transcript*, 22 Nov. 1859, p. 4; "Fine Arts," *Evening Post* (New York), 17 Nov. 1859: 2; "George Washington at Home," *Home Journal* 26 Nov. 1859): 2; "Fine Arts. Rossiter and Mignot's 'Home of Washington after the War," *Albion* 37 (26 Nov. 1859): 573; "Fine Arts," *Evening Post* (New York), 13 Dec. 1859, p. 2; "The Home of Washington after the War," *Evening Star* (Washington), 27 Feb. 1860; "Fine Art–The Home of Washington after the War," *Daily National Intelligencer* (Washington), 29 Feb. 1860, p. 3; Ezek Richards, quoted from the Philadelphia press in *The Illustrated Mount Vernon Record* 2 (July 1859–June 1860), p. 215; Milton Gallery advertisement, *New York Times*, 2 Mar. 1865, p. 7; "Art. Brooklyn Art Association," *Aldine* 7 (Feb. 1874): 48; "The Pictures," *Chicago Daily Tribune*, 9 Sept. 1874, p. 3; Gustavus A. Eisen, *Portraits of Washington* (New York: Robert Hamilton & Assoc., 1932), 2:558; Lois Fink, "American Artists in France," *American Art Journal* 5 (Nov. 1973), fig. 11; Natalie Spassky, *American Paintings in the Metropolitan Museum of Art*, vol.2 (New York: Metropolitan Museum of Art, 1985), pp. 85–91, illus.

Exh.: New York, private showing at Rossiter's residence, 14 Nov. 1859; New York, National Academy of Design, 18 Nov. 1859–28 Jan. 1860 (as *The Home of Washington after the War*); Washington, D.C., Philip and Solomons, 22 Feb.–6 Mar. 1860; New York, National Academy of Design, Aug.–early Fall 1860; New York, Fine Art Institute, [Derby Galleries], 3rd annual exhibition, 1863, no. 11 (as *Mount Vernon, or the Home of Washington after the War*); New York, Fine Art Institute, Derby Galleries, 4th annual exhibition, Summer 1863, no. 69 (as *The Home of Washington, or Mount Vernon after the American Revolution*); New York, Milton Gallery, Mar. 1865; Washington, D.C., U.S. Capitol, Rotunda, 1867; Brooklyn, N.Y., Brooklyn Art Association, *winter exhibition*, 8–20 Dec. 1873, no. 368 (as *Lafayette and Washington at Mt. Vernon*, lent by Wm. Nelson); Chicago, Inter-State Industrial Exposition, 9 Sept.–10 Oct. 1874, no. 582 (as *The Home of Washington after the War*, lent by J. Nelson, Jr.); New York, La Maison Française, *Lafayette Centenary Exhibition*, 4–31 Mar. 1934.

53.
The Day's Departure

1860
Oil on canvas, 11½ × 20¼" (29.2 × 51.4 cm)
At lower right: *MIGNOT. 60*
Graham Williford
Prov.: (Sale, 5th Avenue Gallery, New York, 14–15 Dec. 1892, no. 91, as *The Day's Departure*); private collection; (Sale, Christie's East, New York, 2 Dec. 1992, no. 23, as *The Day's Departure*).

54.
Autumn Landscape with View of River and Town

Late 1850s–early 1860s

Oil on paper, mounted on canvas, 10×8" (25.4× 20.3 cm)

At lower right: *M.*

Dr. and Mrs. Michel Hersen

Prov.: (The Albany Gallery, Albany, N.Y., 1992); private collection, Albany, 1993; (Mark LaSalle Fine Art); to present owners, 1994.

Exh.: St. Petersburg, Fla., Museum of Fine Arts, *Land, Light, and Sea in 19th-Century American Painting: Collection of Dr. and Mrs. Michel Hersen,* 9 Oct.–31 Dec. 1994 (as *Autumn along the Hudson*).

55.
The Harvest Moon

1860

Oil on canvas, 24×39" (61.0×99.1 cm)

Inscription: at lower left: *MIGNOT. 1860.*

New York Public Library, Robert L. Stuart Collection, on permanent loan to The New-York Historical Society, New York

Prov.: (Mignot Sale, Henry H. Leeds & Co., New York, 2 June 1862, no. 8, as *Harvest Moon,* 24× 38"); Robert L. Stuart, New York; Lenox Library (later New York Public Library), New York; on permanent loan to The New-York Historical Society, New York, 1944–present.

Ref.: "Sketchings. Domestic Art Gossip," *Crayon* 7 (Mar. 1860): 83; "Sketchings," *Crayon* 7 (Apr. 1860): 113; "Sketchings. National Academy of Design. First Notice," *Crayon* 7 (Mar. 1860): 140; "National Academy of Design," *Home Journal* (5 Mar. 1860): 2; Henry T. Tuckerman, *Book of the Artists* (New York: George P. Putnam, 1867; rpt., New York: James F. Carr, 1966), p. 564; *Catalogue of Paintings in the Picture Galleries* (New York: New York Public Library, 1936), p. 27, no. 160; Richard J. Koke, *American Landscape and Genre Paintings in The New-York Historical Society* (New York: New-York Historical Society, 1982), no. 1829, illus.

Exh.: New York, National Academy of Design, *35th annual exhibition,* 12 Apr.–16 June 1860, no. 226 (as *The Harvest Moon*); Boston, Boston Athenaeum, *36th annual exhibition,* 2 July– 8 Dec. 1860, no. 246; Philadelphia, Pennsylvania Academy of the Fine Arts, *38th annual exhibition,* 23 Apr.–29 June 1861, no. 121 (for sale).

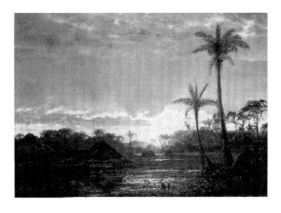

56.
[Lamona ?]

1860

Oil on canvas, 23⅝×34" (60.0×86.4 cm)

At lower left: *MIGNOT*

Nicholas Hammond

Prov.: [(Probably Mignot Sale, Henry H. Leeds & Co., New York, 2 June 1862, no. 30, as *Village of Lamona, Ecuador,* 24×38"); (probably Sale, Henry H. Leeds & Co., New York, 10–11 June 1863, no. 202, as *Village of Lamona, Ecuador)*]; property of an unidentified church, Montclair, N.J.; (Stanley Jernow, South Orange, N.J.); (Sale, William Doyle, New York, 30 Oct. 1985, no. 164, as *Twilight in the Tropics,* unsold); (Child's Gallery, Boston, 1987).

Ref.: "Sketchings. Domestic Art Gossip," *Crayon* 7 (Mar. 1860): 83; "Sketchings," *Crayon* 7 (Apr. 1860): 113; "Sketchings. National Academy of Design. First Notice," *Crayon* 7 (Mar. 1860): 140; Henry T. Tuckerman, *Book of the Artists* (New York: George P. Putnam, 1867; rpt., New York: James F. Carr, 1966), p. 564.]

Exh.: [Probably New York, National Academy of Design, *35th annual exhibition*, 12 Apr.–16 June 1860, no 552 (as *Lamona*); probably Boston, Boston Athenaeum, *36th annual exhibition*, 2 July–8 Dec. 1860, no. 292 (as *Lamona*)].

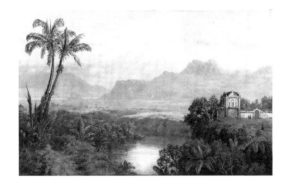

57.
Karhuikazo

1860
Oil on canvas, 10¼ × 16¼" (26.0 × 41.3 cm)
At lower left: *MIGNOT. 60*
Private collection
Prov.: Private collection, Pasadena, Calif.; (Sale, Butterfield & Butterfield, San Francisco and Los Angeles, 8 Dec. 1993, no. 3318, as *Karhuikazo*).
Ref.: T.T., "Art Matters in Baltimore," *Boston Evening Transcript*, 2 June 1860: supl. 1; Butterfield & Butterfield advertisement, *Maine Antiques Digest*, Nov. 1993, 35G, illus. "Collector Interest Spurs Painting Prices," *Mid-Atlantic Antiques Magazine* (Feb. 1994): 30A–31A, illus.
Exh.: Baltimore, Allston Association, *1st annual exhibition*, 14 Mar.–4 June 1860, no. 245 (as *Karhnizaro*).

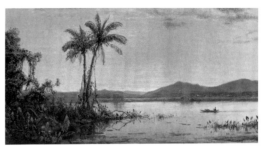

58.
In the Tropics

1860
Oil on canvas, 6 × 12" (15.2 × 30.5 cm)
At lower right: *M./60.*
Kenneth Lux Gallery, New York
Prov.: (Sale, Christie's East, New York, 30 Jan. 1981, no. 42, as *In the Tropics*).
Exh.: New York, Kenneth Lux Gallery, *Recent Acquisitions in American Paintings*, 13 Oct.–7 Nov. 1981, no. 22 (as *Lake Scene in Ecuador*), illus.

59.
Twilight on the Passaic

1861

Oil on canvas, 16×24" (40.6×61.0 cm)

At lower right: *MIGNOT/[61?]*

Mr. and Mrs. W. C. Krueger

Prov.: (Mignot Sale, Henry H. Leeds & Co., New York, 2 June 1862, no. 23, as *On the Passaic*, 16×24"); [probably Cyrus Butler, New York]; (Sale, Sotheby's, New York, 30 Nov. 1979, no. 893, as *Twilight on the Passaic*); (Harold Rowe, Chicago); to present owners, 1980.

Ref.: "Sketchings. National Academy of Design," *Crayon* 8 (Apr. 1861): 94; "Fine Arts. National Academy of Design—Second Notice," *Albion* 39 (13 Apr. 1861): 177; Frank H. Norton, *A Few Notes on the Thirty-Sixth Annual Exhibition of the National Academy of Design* (New York: William Schaus, 1861).

Exh.: New York, National Academy of Design, *36th annual exhibition*, 20 Mar.–25 Apr. 1861, no. 313 (as *Twilight on the Passaic*, for sale); [probably Philadelphia, Pennsylvania Academy of the Fine Arts, *38th annual exhibition*, 22 Apr.–29 June 1861, no. 549 (as *On the Passaic*, $100); Buffalo, N.Y., Young Men's Association, *1st annual exhibition*, 24 Dec. 1861–1 Feb. 1862,

no. 161 (as *On the Pasaic*); probably Brooklyn, N.Y., *Brooklyn and Long Island Fair*, 22 Feb.–? 1864, no. 67 (as *On the Passaic*, collection of Cyrus Butler); probably New Haven, Conn., Yale School of the Fine Arts, *2nd annual exhibition*, 8 June–early fall 1870, no. 76A (as *Passaic River*, collection of Cyrus Butler)]; Evanston, Ill., Terra Museum of American Art, *Two Hundred Years of American Painting from Private Chicago Collections*, 25 June–2 Sept. 1983, no. 15 (as *Passaic River*), pp. 14–15, illus.

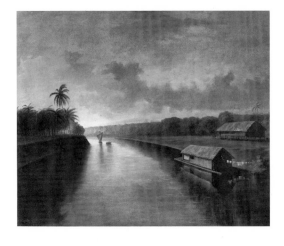

60.
Sunset on the Guayaquil, Ecuador

1861

Oil on canvas, 36×46" (91.4×116.8 cm)

Inscribed at lower left: *L. R. Mignot/ –61*

The Newark Museum, Newark, N.J. (Gift of Hirschl & Adler Galleries).

Prov.: (Hirschl & Adler Galleries, New York, by 1967); to present owner, 1969.

Ref.: "Recent Accessions of American and Canadian Museums," *Art Quarterly* 33 (Summer 1970): listed p. 188; *American Art in The Newark Museum* (Newark, N.J.: Newark Museum, 1981), listed p. 352 (as *Sunset on the Orinoco*), illus. p. 132; Katherine Emma Manthorne, *Tropical Renaissance: North American Artists Exploring Latin America, 1839–1879* (Washington, D.C.: Smithsonian Institution Press, 1989), p. 142, illus. fig.70.

Exh.: Montreal, Montreal Museum of Fine Arts, *The Painter and the New World*, 9 June–30 July 1967, no. 340 (as *On the Orinoco*, lent by Hirschl & Adler Galleries), illus.

61.
[Woods in Winter ?]

1861

Oil on wood panel, 11⅛×16¼" (28.3×41.3 cm)

At lower right: *M[/?]*

In ink on verso: *L.R. Mignot. 1861.*

Richard J. and Joan M. Whalen

Prov.: [(Possibly Mignot Sale, Henry H. Leeds & Co., New York, 2 June 1862, no. 3, as *Woods in Winter*, 11×15")]; (Sale, Christie's, New York, 20 Mar. 1987, no. 9, as *Among Woodlands*).

62.
Forest Interior

Early 1860s

Oil on paperboard, 11½ × 14¾" (29.2 × 37.5 cm)

At lower right: *M.*

Alexander Gallery, New York

Prov.: Private collection.

Exh.: New York, Alexander Gallery, *Water's Edge II*, 31 Jan–13 Mar. 1993.

63.
Sunset on White Mountains

1861

Oil on canvas, 16¼ × 26" (41.3 × 66.0 cm)

At lower left on rocks: *MIGNOT/ '61*

The Fine Arts Museums of San Francisco (Museum Purchase, Ednah Root Fund, in honor of Marc Simpson, 1994.108)

Prov.: Henry Freeman Clark, Cleveland, by 1864; by descent to Carl Boardman Cobb, Aurora, Ohio, 1978; to present owner, 1994.

Ref.: John W. Coffey and Katherine E. Manthorne, "Louis Rémy Mignot, Rediscovered," *American Art Review* 5 (Fall 1993): 92–93, 159, discussed p. 159, illus. p. 92.

Exh.: Cleveland, *Cleveland Sanitary Fair*, 22 Feb.–10 Mar. 1864, no. 3 (as *Sunset on White Mountains*), owned by H. F. Clark).

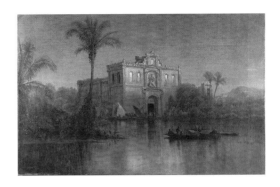

64.
"Ave Maria": Evening in the Tropics (I)

1861

Oil on canvas, 15¹/₁₆ × 24" (38.3 × 61.0 cm)

At lower left: *MIGNOT/ 61.*

House of Weltz, Port Chester, N.Y.

Prov.: Private collection, Greenwich, Conn.; to present owner, 1993.

Ref.: Henry T. Tuckerman, *Book of the Artists*, (New York: George P. Putnam, 1867; rpt., New York: James F. Carr, 1966), p. 564 (describes this picture or another version titled *Evening in the Tropics*).

Note: First of three known versions of this composition (see cat nos. 73 and 86).

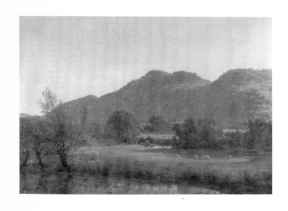

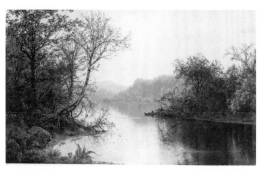

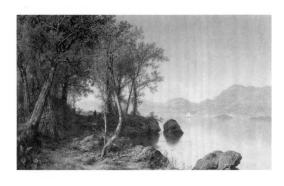

65.
Monument Mountain from Stockbridge

1861

Oil on canvas, 17×25¼" (43.2×64.1 cm)

At lower right: *M. 61.*; label from 1862 Mignot Sale on stretcher: *35 Monument Mountain from Stock[brid]ge./ Painted from Na[tur]e/ Painted By/...LOUIS..MIGNOT*

Present whereabouts unknown

Prov.: Mignot Sale, Henry H. Leeds & Co., New York, 2 June 1862, no. 35, as *Monument Mountain from Stockbridge*, 17×25"); (Sale, Christie's, New York, 6 Dec. 1985, no. 31, as *Meadow and Mountains*); (Frank S. Schwarz, & Son, Philadelphia), 1986.

Ref.: J.H.G. (John H. Gourlie), "Summer in Berkshire: Mignot the Artist," *Evening Post* (New York), 24 July 1861, p. 1.

Exh.: *American Paintings: Philadelphia Collection XXXIII*. Philadelphia: Frank S. Schwarz & Son, Dec. 1986, no. 14 (as *Monument Mountain*), illus.

66.
Mountain Lake in Autumn

1861

Oil on canvas, 12×20" (30.5×50.8 cm)

On rock at lower left: *MIGNOT/61*

Norman S. Rice

Prov.: Private collection, New York State

67.
Indian Summer, Lake George

1862

Oil on canvas, 24⅛×40⅛" (61.3×101.9 cm)

At lower left: *M.62*

Private collection

Prov.: (Mignot Sale, Henry H. Leeds & Co., New York, 2 June 1862, no. 19, as *Indian Summer, Lake George*, 24×40"); sold to Mr. Egerton, Baltimore; (M. Grover, Newport, Maine, by 1978); (Alexander Gallery, New York).

Ref.: Tom Taylor, "Sketch of the Artist's Life," in *Catalogue of the Mignot Pictures . . .* (London & Brighton, 1876), p. 4; M. Grover advertisement, *Maine Antiques Digest* (Mar. 1978): 19-A (as *River landscape*), illus.

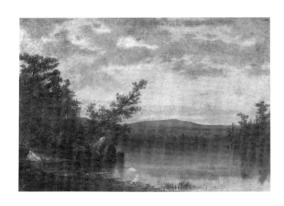

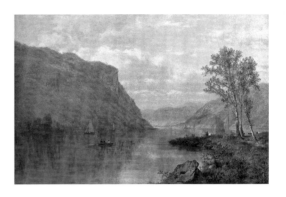

68.
In the Adirondacks, New York

1861–62

Oil on canvas, 11½ × 17½" (29.2 × 44.5 cm)

At lower right: *LRM*; in pencil on stretcher: *In the Adirondacks, L.R. Mignot*

Mr. and Mrs. David T. Sharon

Prov.: (Sale, Young Fine Arts Gallery, North Berwick, Maine, 2 July 1988, no. 160, as *In Adirondacks, New York*).

69.
Twilight in the Adirondacks with Hunters

1861–62

Oil on canvas, 12 × 19¾" (30.5 × 50.2 cm)

Signed at lower right (per Sotheby's)

Private collection

Prov.: (Sale, Sotheby Parke-Bernet, Los Angeles, 22 Mar. 1972, no. 69, mistakenly titled *Sunset off Hastings*); (Terry DeLapp Gallery, Los Angeles).

70.
Scene on the Hudson near West Point

Early 1860s

Oil on canvas, 24 × 36" (61.0 × 91.4 cm)

At lower right: *M.*

Dr. Bernard L. Kaye

Prov.: John Caverhill, Montreal, by 1865; private collection, Montreal; (Vose Galleries, Boston, 1971); to present owner, 1971.

Exh.: Montreal, Montreal Art Association, *4th annual exhibition*, 27 Feb. 1865, no. 1 (as *Scene on the Hudson near West Point*, owned by Jno. Caverhill).

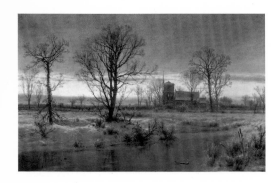

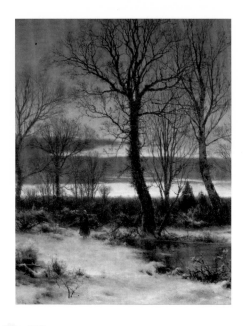

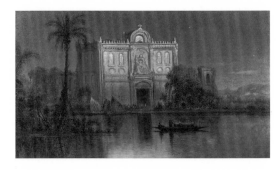

71.
Sunset, Winter

1862

Oil on canvas, 15¹⁄₁₆ × 24¹⁄₈" (38.3 × 61.3 cm)

At lower right: *M. 62.*; in pencil on bottom stretcher bar at left: *Sunset, Winter*

The West Foundation, on loan to the High Museum of Art, Atlanta

Prov.: (Mignot Sale, Henry H. Leeds & Co., New York, 2 June 1862, no. 27, as *Sunset, Winter*, 15 × 24"); (Sale, Phillips, New York, 30 Jan. 1985, no. 504, as *Winter Sunset with Clock Tower*, attributed to Monogrammist M); (Alexander Gallery, New York); to present owner, 1985.

Exh.: New York, Alexander Gallery, *The Water's Edge*, 29 Mar.–29 June 1985, no. 32 (as *Church at Dusk*), illus.; Atlanta, High Museum at Georgia-Pacific Center, *Arts in America: Land of the Free*, 22 Sept. 1986–2 Jan. 1987.

Ref.: Phillips sale report, *Maine Antiques Digest* (Apr. 1985): 3C, illus.

72.
Winter

1862

Oil on canvas, 15⅛ × 12¹⁄₁₆" (38.4 × 30.6 cm)

At lower left: *M./ 62.*

The Weimer Collection

Prov.: (Terry DeLapp Galleries, Los Angeles); (Hirschl & Adler Galleries, New York).

Exh.: London, British Institution, *Annual exhibition,* 7 Feb.–Mar. 1863, no. 106 (as *Winter,* for sale £40).

Ref: *Athenaeum,* 14 Feb. 1863, quoted in *Albion* 41 (7 Mar. 1863): 117; "Fine Arts. The British Institution. The Landscapes, Etc.," *Illustrated London News* 42 (21 Feb. 1863): 206; "Summary of Art News: Exhibitions," *Fine Arts Quarterly Review* 1 (May 1863): 196; unidentified London journal, quoted in Henry H. Tuckerman, *Book of the Artists* (New York: George P. Putnam, 1867; rpt. New York: James F. Carr, 1966), p. 564.

73.
"Ave Maria": Evening in the Tropics (II)

1862

Oil on canvas, 8 × 14" (20.3 × 35.6 cm)

At lower right: *M. 6[2?]*

Mr. and Mrs. Arthur Newman

Prov.: [Probably Samuel P. Avery, New York, 1862; Avery Sale, Henry H. Leeds & Miner, New York, 4 Feb 1867, no. 25, as *The Guayaquil River*)]; (Robert Vega de Bijou Fine Arts, San Francisco); private collection; (Sale, Hanzel Galleries, Chicago, 1987); (Robert Henry Adams Fine Art, Chicago); (Hollis Taggart Galleries, Washington, D.C., and Hynes Fine Art, Chicago); (Sale, Dunning's, Elgin, Ill., 18 Mar. 1990, no. 83, as *Guayaquil, Ecuador*); (Selker Fine Art, Shaker Heights, Ohio); (Sale, Christie's, New York, 22 Sept. 1994, no. 18, *as On the River*); (Leslie Rankow Fine Arts, Ltd.), to present owner, 1994.

Ref.: Henry T. Tuckerman, *Book of the Artists* (New York: George P. Putnam, 1867; rpt., New York: James F. Carr, 1966), p. 564 (describes this or another version titled *Evening in the Tropics*).

Exh.: [Possibly Brooklyn, N.Y., Brooklyn Art Association, *3rd annual exhibition*, 20–22 Mar. 1862, no. 73 (as *"Ave Maria"*, for sale)].

Notes: Second of three known versions of this composition (see cat. nos. 64 and 86). This version was engraved by S. V. Hunt. The print was registered by Samuel P. Avery and published by Goupil & Co., New York, in 1862.

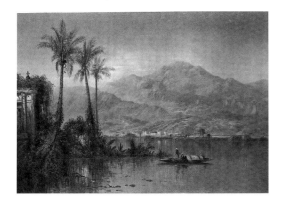

74.
[Vespers, Guayaquil River, Ecuador (I) ?]

1862

Oil on canvas, 14¾ × 22¼" (37.5 × 56.5 cm)

Inscription: at lower left: *M.62.*

The Art Museum, Princeton University, Princeton, N.J. (Gift of Mr. and Mrs. Stuart P. Feld, 1980–83)

Prov.: (Hirschl & Adler Galleries, New York); to present owner, 1980.

Ref.: "Acquisitions of The Art Museum 1980," *Record of The Art Museum, Princeton University* 40 (1981): listed (as *South American Scene*) p. 17, illus. p. 16.; Barbara T. Ross, "Nineteenth-Century American Landscape Paintings: Nine Recent Acquisitions," *Record of The Art Museum, Princeton University* 44 (1985), pp. 4–13,

discussed p. 9, illus. fig.9; *Selections from the Art Museum, Princeton University* (Princeton, N.J., 1986), illus. p. 274; Katherine Emma Manthorne, *Tropical Renaissance: North American Artists Exploring Latin America, 1839–1879* (Washington, D.C.: Smithsonian Institution Press, 1989), pp. 151–52 and n. 42, illus. fig. 81; Katherine E. Manthorne, "On the Road: Louis Rémy Mignot's *Landscape in Ecuador*," *North Carolina Museum of Art Bulletin* 16 (1993): 29, n.24.

Note: One of two known versions of this composition (see cat. no. 75).

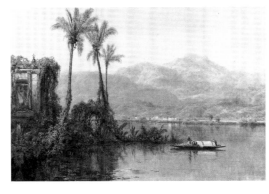

75.
[Vespers, Guayaquil River, Ecuador (II) ?]

c. 1862

Oil on canvas, 13⅝ × 21⅛" (34.6 × 53.7 cm)

Bowdoin College Museum of Art, Brunswick, Maine (Museum purchase, Hamlin Fund, 1985.18)

Prov.: [(Possibly Mignot Sale, Henry H. Leeds &

Co., New York, 2 June 1862, no. 39, as *Vespers, Guayaquil River,* 12½ × 21")]; Mrs. Miner W. Tuttle, Amherst, Mass, by 1962; to son, Dr. George S. Tuttle, New York; (Gene Shannon, New Haven, Conn., c. 1983); (Sale Christie's, New York, 1 June 1984, no. 27, as *River Scene, Ecuador,* unsold); (Rifkin-Young Fine Arts, Inc., Bronx, N.Y., 1984); to present owner, 1985.

Ref.: Katherine Emma Manthorne, *Tropical Renaissance: North American Artists Exploring Latin America, 1839–1879* (Washington, D.C.: Smithsonian Institution Press, 1989): 151–52, and n. 42, illus. fig. 82; Katherine E. Manthorne, "On the Road: Louis Rémy Mignot's *Landscape in Ecuador*," *North Carolina Museum of Art Bulletin* 16 (1993): 24, fig.7.

Note: One of two known versions of this composition (see cat. no. 74).

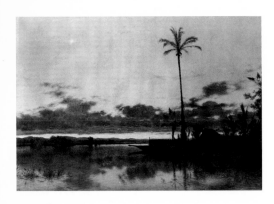

76.
Lagoon of the Guayaquil

1863
Oil on canvas, 17 × 25" (43.2 × 63.5 cm)
At lower left: *M/ 63.*
Private collection
Prov.: (Art Market, London); (Berry-Hill Galleries, New York, by 1954); (Schindler's Antique Shop, Charleston, S.C., by 1963); (Terry DeLapp Gallery, Los Angeles, 1965); Mr. and Mrs. Will Richeson, Jr., San Marino, Calif.; (Terry DeLapp Gallery); (Hirschl & Adler Galleries, New York, 1979); (Terry DeLapp Gallery, by 1982); (Taggart & Jorgenson Gallery, Washington, D.C.); (David Nisinson, New York, 1983); to present owners, 1983.
Ref.: Berry-Hill advertisement, *Antiques* 67 (Feb. 1955): 107 (as *Lagoon at Guayaquil*), illus.; Ruth Davidson, "Shop Talk: The Lagoon at Guayaquil," *Antiques* 83 (Aug. 1963): 144 (as offered by Schindler's Antique Shop, Charleston, S.C.); *A Selection of 19th Century American Paintings from the Terry DeLapp Gallery* (Los Angeles: Terry DeLapp Gallery, Spring 1965), p. 8 (as *On the Guayaquil*), illus.; Terry DeLapp Galleries advertisement, *Antiques* 121 (Mar. 1982): 532, illus.; Katherine

Manthorne, "The Quest for a Tropical Paradise: Palm Tree as Fact and Symbol in Latin American Landscape Imagery, 1850–1875," *Art Journal* 44 (Winter 1984): 374–82, discussed p. 376, fig. 2.; Katherine E. Manthorne, "Louis Rémy Mignot," in *American Paradise: The World of the Hudson River School* (New York: Metropolitan Museum of Art, 1987), pp. 298–301, illus. p. 300; Katherine Emma Manthorne, *Tropical Renaissance: North American Artists Exploring Latin America, 1839–1879* (Washington, D.C.: Smithsonian Institution Press, 1989), discussed (as *Lagoon of the Guayaquil*) pp. 2, 13, 18–19, 134–35, pl. 2; Katherine E. Manthorne, "On the Road: Louis Rémy Mignot's *Landscape in Ecuador*," *North Carolina Museum of Art Bulletin* 16 (1993): 14–30, discussed (as *Lagoon of the Guayaquil*) p. 25, fig. 9.
Exh.: Los Angeles, Terry DeLapp Gallery, 1965; New York, American Federation of Arts, Revealed Masters, *19th-Century American Art*, Sept. 1974–Sept. 1975, no. 29 (as *On the Guayaquil*), illus.; New York, Richard York Gallery, *Sunset to Dawn*, 8 Oct.–12 Nov. 1983.

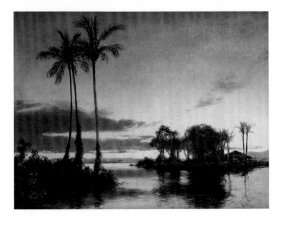

77.
[Lagoon of the Guayaquil, South America ?]

c. 1863
Oil on pressed board, 12⅜ × 16⅜" (31.4 × 41.6 cm)
At lower right: *M.*
Private collection
Prov.: Private collection, California; (Hirschl & Adler Galleries, New York, 1982); Walter B. Weimer, 1983; (Richard York Gallery, New York); to present owner, 1994.
Ref.: [Possibly "Fine Arts. Royal Academy," *Athenaeum* 1856 (23 Mar. 1863): 687; (Francis Turner Palgrave), "Royal Academy Exhibition (Third Notice)," *Saturday Review* 15 (30 Mar. 1863): 693; W. M. Rossetti, "The Royal Academy Exhibition," *Fraser's Magazine* 67 (June 1863): 793].
Exh.: [Possibly London, Royal Academy of Arts, *95th annual exhibition*, 4 Mar.–25 July 1863, no. 595 (as *Lagoon of the Guayaquil, South America*)]; New York, Richard York Gallery, *Paintings of Light: Nineteenth Century Landscapes by Americans*, Oct. 1–9 Nov. 1991.

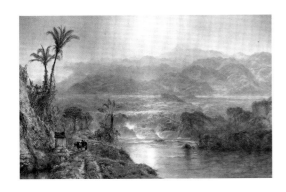

78.
Morning in the Andes

1863

Oil on canvas, 24¼ × 38" (61.6 × 96.5 cm)

At lower left: *M 63*

The Detroit Institute of Arts, Detroit (Founders
Society Purchase, Beatrice W. Rogers Bequest
Fund and funds from Robert H. Tannahill and
Al Borman, 68.345)

Prov.: Van Loan family, Athens, N.Y.; (Hirschl &
Adler Galleries, New York); to present owner,
1968.

Ref.: "Recent Accessions of American and Canadi-
an Museums," *Art Quarterly* 33 (Summer
1970): listed p. 188, illus. p. 195; Graham Hood
et al. "American Paintings Acquired during the
Last Decade," *Detroit Institute of Arts Bulletin*
55 (1977): 94–95, listed no. 14, illus.; Katherine
Emma Manthorne, *Tropical Renaissance: North
American Artists Exploring Latin America,
1839–1879* (Washington, D.C.: Smithsonian
Institution Press, 1989), pp. 81, 133, also n. 3:38,
fig.40; Louise Minks, *The Hudson River School:
The Landscape Art of Bierstadt, Cole, Church,
Durand, Heade, and Twenty Other Artists* (New
York: Crescent Books, 1989), pp. 108–9, illus.;
Katherine E. Manthorne, "On the Road: Louis

Rémy Mignot's *Landscape in Ecuador*," *North
Carolina Museum of Art Bulletin* 16 (1993):
14–30, discussed pp. 24–25, illus. fig.8.

Exh.: New York, Paul Rosenberg & Co., *The
American Vision: Paintings 1825–1875*, 9 Oct.–
2 Nov. 1968, no. 100; San Jose, Costa Rica,
Museo de Jade, *Cinco Siglos de Obras Maestras*,
6 Mar.–30 June 1978, no. 5, illus. pp. 21, 35;
New York, Metropolitan Museum of Art,
*American Paradise: The World of the Hudson
River School*, 4 Oct. 1987–3 Jan., 1988, pp.
298–301, illus. p. 299.

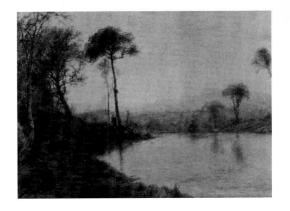

79.
Figures by a Lake

c. 1863

Oil on canvas, 24 × 38¼" (61.0 × 97.2 cm)

On stretcher: *Louis R. Mignot Berkely Gardens
Kensington W.* (per Sotheby's)

Present whereabouts unknown

Prov.: (Sale, Sotheby's, New York, 1–4 Feb. 1978,
no. 730, as *Figures by a Lake*, unsold).

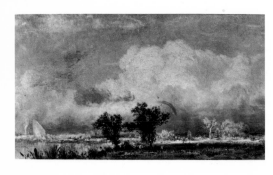

80.
Southern Idyll

1863

Oil on canvas, 6¼ × 12" (15.9 × 30.5 cm)

At lower right: *M/63*

Present whereabouts unknown

Prov.: Raydon Gallery, New York, by 1976.

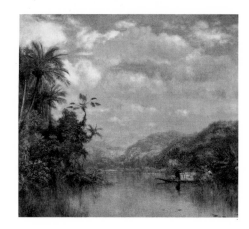

81.
Gathering Plantains, Guayaquil, Ecuador

1866

Oil on canvas, 21⅜ × 24¼" (54.3 × 61.6 cm)

At lower left: *M/66*; fragment of paper label on
 stretcher: *"Plantains, Guayaquil [?] × 23¾
 [Mig?]not.*

Private collection

Prov.: (Sale, Henry H. Leeds & Miner, New York,
 29–30 Mar. 1868, no. 35, as *Gathering
 Plantains–Guayaquil River*); (Old Print Shop,
 Inc., New York, 1962).

Ref.: *The Old Print Shop Portfolio* 21 (New York:
 Old Print Shop, Mar. 1962), no. 38 (as *Gather-
 ing Plantains on Guayaquil River*), illus.;
 Katherine Emma Manthorne, *Tropical Renais-
 sance: North American Artists Exploring Latin
 America, 1839–1879* (Washington, D.C.: Smith-
 sonian Institution Press, 1989), illus. 69.

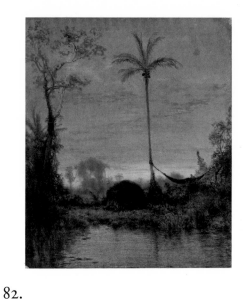

82.
Tropical Sunset

Mid-1860s

Oil on canvas, 13⅛ × 11⅜" (33.3 × 28.9 cm)

Joseph Dixon, III

Prov.: (Peter Gregorio, Consignment Arts Center,
 Tampa, Fla., c. 1980); to present owner, 1995.

83.
Two Women in a Tropical Landscape

Mid-1860s

Oil on board, 10×8" (25.4×20.3 cm)

Louis D. Liskin

Prov.: (Abraham Asch, New York); to present owner, c. 1959.

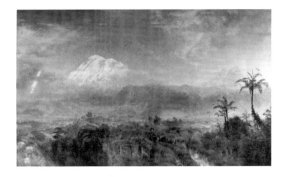

84.
Mount Chimborazo (Table Lands of Rio Bamba, Ecuador ?)

c. 1866

Oil on canvas, 38⅝×63⅛" (98.1×160.3 cm)

At lower right: *MIGNOT*

Greenville County Museum of Art, Greenville, S.C. (Museum purchase with funds donated by the Arthur and Holly Magill Foundation; The Museum Association's 1992 Collector's Group; the 1992 Museum Antiques Show, Elliott, Davis & Company, CPAs, sponsor; Museum Corporate Partners: Carolina First Corporation; Greenville News-Piedmont Company; Director's Circle Members: Laura E. duPont; Mr. and Mrs. Alester G. Furman III; Stanton D. and Jessica S. Loring; Mr. and Mrs. John J. Sakas; W. Thomas Smith; Corporate Benefactors: Alice Manufacturing Company; Barker Air and Hydraulics, Inc.; Carolina First Bank; Eastern Trading Company, Inc.; Greenville News-Piedmont Company; Hartness International, Inc.; Insignia Financial Group, Inc.; KEMET Corporation; Liberty Life Insurance Company; Odell Associates, Inc.; Pepsi-Cola Bottling Company of Greenville; Portman Marina, Inc.; Ryan's Family Steak Houses, Inc., 92.21.1)

Prov.: Irving Kouder, New Paltz, N.Y., until 1965; Floyd Patterson, New Paltz, 1965; (Sale, Amity Auction Galleries, Amityville, N.Y., 21 Sept. 1991); (Babcock Galleries, New York); to present owner,1992.

Ref.: [Probably "Fine Arts. British Institution," *Illustrated London News* (17 Feb. 1866): 166; "British Institution: Exhibition of Works by Living Artists," *Art-Journal* (London) 28 (1 Mar. 1866): 70]; (sale advertisement), *Antiques and The Arts Weekly* (13 Sept. 1991): listed (as *Mt. Chimborazo, Ecuador*) p. 154, illus.; "1992 Antiques Show Funds to Help Purchase Mount Chimborazo," *Museum News* (Greenville County Museum of Art (Nov.–Dec. 1992): 29, illus.; John Driscoll and Michael St. Clair, Babcock *Galleries: To the Manor Borne* (New York: Babcock Galleries, 1994), unpaginated, illus.; Martha R. Severens, "Greenville County Museum of Art, Greenville, South Carolina," *Antiques* 146 (Nov. 1994): 682–91, pl. IV; Martha R. Severens, *Greenville County Museum of Art: The Southern Collection* (New York: Hudson Hills Press, 1995), pp. 52–53, illus. (as *Mount Chimborazo*); Martha R. Severens, "The Southern Collection: A New Look at American Art History," *American Art Review* 7 (Dec. 1995–Jan. 1996): 143–44, illus. p. 143;

Exh.: [Probably London, British Institution, *Annual exhibition*, 5 Feb.–Mar. 1866, no. 55 (as *Table Lands of Rio Bamba, Ecuador*, for sale £500)].

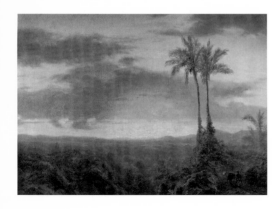

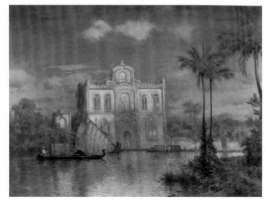

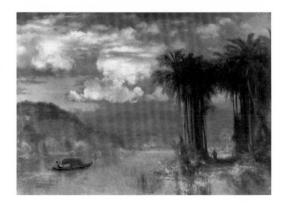

85.
Tropical Landscape

Mid-1860s

Oil on canvas, 16×22" (40.6×55.9 cm)

Dr. and Mrs. Stephen S. Leavitt

Prov.: Theodore Stebbins, Boston, (Knoke Gallery, Marietta, Ga.); (Sale, Butterfield & Butterfield, San Francisco, 6 Nov. 1985, no. 661).

Exh.: Chattanooga, Tenn., Hunter Museum of Art, *19th and 20th Century American Paintings*, 18 Mar.–7 July 1985.

86.
"Ave Maria": Scene of the Guayaquil River, Ecuador (III)

Mid-1860s

Oil on canvas, 16×22" (40.6×55.9 cm)

In artist's hand in pencil on top stretcher bar: *Ave Maria Scene of the Guayaquil River Ecuador L.R.Mignot*

Mr. and Mrs. Arthur Newman

Prov.: (Sale, Christie's–South Kensington, London, 10 June 1986, no. 11, as *"Ave Maria": Scene on the Guayaquil River, Ecuador*); (Sale, Christie's, New York, 21 Mar. 1991, no. 381); Spanierman Gallery, New York; (Sale, Mystic Fine Arts, Mystic, Conn., 28 Aug. 1991, unsold); (Leslie Rankow Fine Arts, New York), to present owners, 1991.

Note: Third of three known versions of this composition (see cat. nos. 64 and 73).

87.
In the Tropics (I) [Dolce Farniente, on the Guayaquil ?]

1866

Oil on canvas, 24¼×34⅜" (61.6×87.3 cm)

At lower right: *M./66*

Private collection, courtesy of Pensler Galleries, Washington, D.C.

Prov.: (Sale, Sotheby's Arcade, New York, 23 June 1987, no. 107, as *Exotic Landscape*); (Pensler Galleries, Washington, D.C.); (Sale, Christie's, New York, 26 Mar. 1988, no. 62, as *In the Tropics*).

Exh.: [Possibly London, 25 Old Bond Street, *Mignot Memorial Exhibition*, 12 June–July 1876, no. 101 (as *Dolce Farniente, on the Guayaquil*, annotated as 34×24 in, £500), then traveling to Brighton, The Royal Pavilion, 19 Sept.–Oct. 1876].

Note: One of two known versions of this composition (see cat. no. 88).

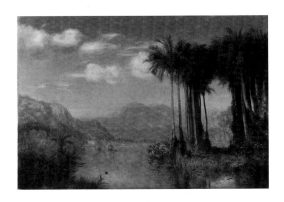

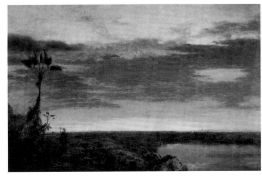

away.–Byron)]; Los Angeles, Los Angeles County Museum of Art, *American Paintings from Los Angeles Collections*, 7 Mar.–30 June 1974 (as *South American Landscape*, by Mignot).

88.
In the Tropics (II)

186[7?]

Oil on canvas, 24×36" (61.0×91.4 cm)

At lower right: *M./6[7?]*

Private collection

Prov.: (Kenneth Lux Gallery, New York); (Mastercraft Gallery, Fort Worth, Tex., 1981); (Galerie Kornye, Dallas, Tex).

Ref.: Mastercraft Gallery advertisement, *Architectural Digest* 38 (Oct. 1981): 296 (as *Tropical Landscape*), illus.

Exh.: New York, Kenneth Lux Gallery, *Recent Acquisitions in American Painting*, 14 Oct.– 18 Nov. 1980, no. 3 (as *Tropical Landscape*), illus.

Note: One of two known versions of this composition (see cat. no. 87).

89.
Parting day/ Dies like the dolphin, whom each/ Pang imbues/ With a new colour as it gasps/ away

c. 1867

Oil on canvas, 38×59" (96.5×149.9 cm)

Mr. and Mrs. Louis B. Schoen

Prov.: (Sale, Parke-Bernet, New York, 27–28 Oct. 1971, no. 110, as *Brazilian Landscape*, attributed to F. E. Church, unsold); Mr. and Mrs. Will Richeson, Jr., San Marino, Calif.; (Sale, Sotheby's, Los Angeles, 24 June 1980, no. 382, as *South American Landscape*, attributed to Mignot).

Ref.: [Probably "Fine Arts: The British Institution," *Illustrated London News* 53 (9 Feb. 1867): 143; "British Institution: Exhibition of Works by Living Artists," *Art-Journal* (London) 29 (1 Mar. 1867): 86]; Katherine Emma Manthorne, *Tropical Renaissance: North American Artists Exploring Latin America, 1839–1879* (Washington, D.C.: Smithsonian Institution Press, 1989), p. 157, fig. 84.

Exh.: [Probably London, British Institution, *Annual Exhibition*, late Jan.–25 Mar. 1867, no. 471 (as *Parting day/ Dies like the dolphin, whom each/ Pang imbues/ With a new colour as it gasps*

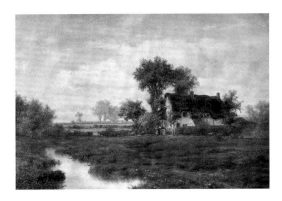

90.
Landscape with Farmhouse by a Stream

Mid-1860s

Oil on canvas, 17⅛×25⅛" (43.5×63.8 cm)

At lower right: *L.R. MIGNOT.*

Dr. & Mrs. Harold J. Krug

Prov.: Private collection, United Kingdom; (Sale, Phillips, London, 15 Mar. 1994, no. 84); (Bryan Roughton, Roughton Gallery, Dallas, 1994); to present owners, 1995.

 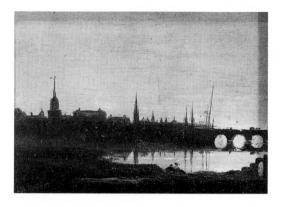

91.

Harbor Scene, Figures on a Quay

Mid-1860s

Oil on canvas, 12⅛ × 18⅛" (30.8 × 46.0 cm)

In ink on stretcher: *Louis R. Mignot*

Pittsford Picture Framing Co., Inc., Pittsford, N.Y.

Prov.: Private collection, United Kingdom; (Sale, Christie's–South Kensington, London, 16 Nov. 1989, no. 30B, as *Harbour Scenes*, one of a pair); (Sale, D. & J. Ritchie, Toronto, 1 Dec. 1992, no. 176, as *Provincial Harbor View: Figures by a Pier*, one of a pair, unsold); to present owner, 1992.

Note: One of a pair (see cat. no. 92).

92.

Harbor Scene, Figures with Horse and Cart

Mid-1860s

Oil on canvas, 12⅛ × 18⅛" (30.8 × 46.0 cm)

Pittsford Picture Framing Co., Inc., Pittsford, N.Y.

Prov.: Private collection, United Kingdom; (Sale, Christie's–South Kensington, London, 16 Nov. 1989, no. 30B, as *Harbour Scenes*, one of a pair); Sale, D. & J. Ritchie, Toronto, 1 Dec. 1992, no. 176, as *Provincial Harbor View: Horse and Carriage by Busy Inlet*, one of a pair, unsold); to present owner, 1992.

Note: One of a pair (see cat. no. 91).

93.

City Harbor at Dusk [London ?]

Mid-1860s

Oil on wood panel, 4⅜ × 5⅞" (11.1 × 14.9 cm)

At lower left: *L R MIGNOT*

Spanierman Gallery, New York

Prov.: (Sale, Christie's-East, New York, 23 Mar. 1994, no. 78, as *City Harbor at Dusk*).

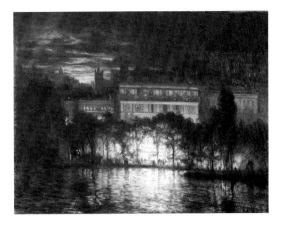

94.
Low Tide, Hastings

1867

Oil on canvas, 16½ × 23¾" (41.9 × 60.3 cm)

At lower right: *M./ 67.*; in ink on old label at top
 left of stretcher: *Low-tide, Hastings/ L.R.
 Mignot.*

Alexander R. Raydon, Raydon Gallery, New York

Prov.: (Sale, Henry H. Leeds & Miner, New York,
 29–30 Mar. 1868, no. 27, as *Low Tide, Hastings*).

95.
[Sunset, Coast of Wimeraux,
France?]

Mid–late 1860s

Oil on canvas, 17½ × 31" (44.5 × 78.7 cm)

At lower left: *MIGNOT*

Present whereabouts unknown

Prov.: Robert H. Hoppe, Jr., Mequon, Wis.;
 (Hoppe Estate Sale, Milwaukee Auction Gal-
 leries, Milwaukee, 26 June 1986, no. 2014, as
 Coastal Scene at Dusk, attributed to Johannes
 Mignot and alternately titled *Sunset Coast of
 Wilmeraux* [*sic*]*, France*).

96.
Bal de Nuit, Paris

1867

Oil on canvas, 13¾ × 18" (34.9 × 45.7 cm)

At lower right: *M.67.*

Dr. and Mrs. Carlton Valvo

Prov.: (Sale, Henry H. Leeds & Miner, New York,
 29–30 Mar. 1868, no. 13, as *Bal de Nuit, Paris*);
 (Kenneth Lux Gallery, New York, by 1977);
 (Sale, Sotheby's, New York, 28 Jan. 1982, no. 132).

Exh.: New York, Kenneth Lux Gallery, *Recent
 Acquisitions in American Paintings*, 18 Jan.–26
 Feb. 1977, no. 10.

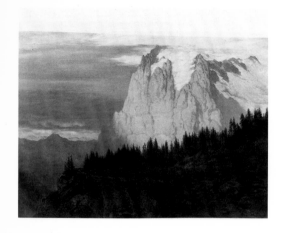

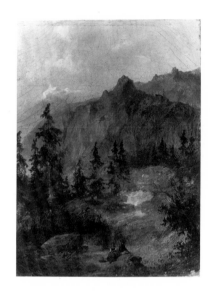

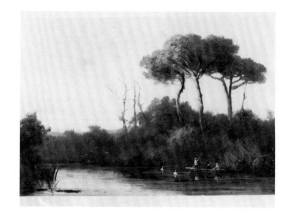

97.
Sunset on the Wetterhorn, Switzerland

1868–70

Oil on canvas, 20¾ × 30½" (52.7 × 77.5 cm)

At lower left: *M.*; at lower right: *M.*

Present whereabouts unknown

Prov.: Private collection, United Kingdom; John Burrows, London; (Sale, Sotheby's, New York, 23 Apr. 1982, no. 43, as *Sunset on Wetterhorn, Switzerland*).

98.
Picnic in the Mountains

1868–70

Oil on canvas, 13¼ × 10¼" (33.7 × 26.0 cm)

At lower left: *Mignot*

Lorraine W. Pearce

Prov.: (Sale, Freeman's, Philadelphia, n.d.); private collection, Pennsylvania; Cynthia Lee Johnson, Villanova, Pa., 1986; (Sale, Christie's, New York, 20 Mar. 1987, no. 25).

99.
Punting on a River at Sunset

Mid–late 1860s

Oil on canvas, 14 × 22¼" (35.6 × 56.5 cm)

At lower right: *Mignot*

Mr. and Mrs. Millard B. Prisant

Prov.: Private collection, United Kingdom; (Sale, Christie's–South Kensington, London, 25 Mar. 1983, no. 59).

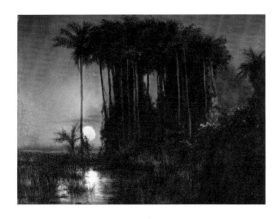

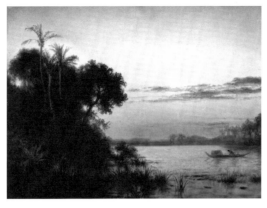

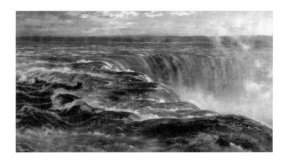

102.

Niagara

c. 1866–1870

Oil on canvas, 50½ × 92½" (128.3 × 235.0 cm)

On rock at lower right: *M./70*

The Brooklyn Museum, Brooklyn, N.Y. (Gift of
 Arthur S. Fairchild, 1993.118)

Prov.: Mignot-Harris family, until 1876; Horace J.
 Fairchild, Manchester, U.K., by 1884; to widow,
 Bellport, Long Island, N.Y., by 1902; on loan to
 the Brooklyn Museum, Brooklyn, N.Y., 1902;
 ownership transferred to Arthur S. Fairchild,
 1913; to present owner, 1993.

Ref.: Colnaghi advertisement, *The Times* (Lon-
 don), 7 July 1866, p. 1; "Niagara," *The Times*
 (London), 13 July 1860, p. 10; "Minor Topics of
 the Month: The Niagara," *Art-Journal* (Lon-
 don) 28 (1 Aug. 1866): 259; "Art Notes," *Round
 Table* (1 Sept. 1866): 77; "Fine Arts, Art Notes,"
 Albion (22 Sept. 1866): 453; "Art Items," *Daily
 Evening Bulletin* (San Francisco), 11 Mar. 1872,
 suppl. 1; "The International Exhibition. British
 Oil Paintings," *The Times* (London), 14 Mar.
 1872, p. 6; W. M. Rossetti, "The Mignot Col-
 lection," *Academy* 9 (17 June 1876): 593; review,
 Manchester Examiner, 1 June 1876, quoted in
 *Catalogue of the Mignot Collection with Sketch of
 the Artist's Life by Tom Taylor, Esq., and Opinions*

100.

Moonlight over a Marsh in Ecuador

c. 1869

Oil on paperboard, 9⅝ × 12⅞" (24.4 × 32.7 cm)

Sanford H. Goldstein

Prov.: Private collection, United Kingdom; (Sale,
 Sotheby's, London, 26 Jan. 1984, no. 33, as
 Moonlight Landscape with Palms, one of a pair);
 (David Nisinson, New York); (Sale, Christie's,
 New York, 1 June 1984, no. 22B, as *Moonlight
 over a Marsh in Ecuador,* one of a pair).

Ref.: Katherine Emma Manthorne, *Tropical
 Renaissance: North American Artists Exploring
 Latin America, 1839–1879* (Washington, D.C.:
 Smithsonian Institution Press, 1989), p. 170,
 fig. 95.

101.

Sunset on the Guayaquil

1869

Oil on paperboard, 9⅝ × 12⅞" (24.4 × 32.7 cm)

In ink at upper right of stretcher: *Painted by Louis
 R. Mignot/[?] 1869/ [Sadie] Harris Mignot*

Sanford H. Goldstein

Prov.: Private collection, United Kingdom; (Sale,
 Sotheby's, London, 26 Jan. 1984, no. 33, as *Sun-
 set over a Tropical Lake,* one of a pair); (David
 Nisinson, New York); (Sale, Christie's, New
 York, 1 June 1984, no. 22B, as *Sunset on the
 Guayaquil,* one of a pair).

of the Press (London & Brighton, 1876), p. 12; review, *World*, 12 June 1876, quoted in *Catalogue of the Mignot Collection*, p. 14; "Fine Arts. The Mignot Collection," *Illustrated London News* 68 (17 June 1876): 598; review, *Hour*, 20 June 1876, quoted in *Catalogue of the Mignot Collection*, p. 13; review, *Anglo-American Times*, 23 June 1876, p. 16; "Pictures by the Late L. R. Mignot," *Builder* 34 (24 June 1876): 607; "The Late Mr. Mignot's Landscapes," *Graphic* 13 (24 June 1876): 622; "Fine Art," *The Bazaar, The Exchange and Mart* (24 June 1876): 425; *Morning Post*, July 1876, quoted in *Catalogue of the Mignot Collection*, p. 7; "Fine Arts: The Mignot Gallery," *Bell's Weekly Messenger*, 1 (July 1876): 1; review, *Navy*, [1876], quoted in *Catalogue of the Mignot Collection*, p. 20; "The Mignot Collection of Pictures," *Metropolitan* (1 July 1876): 433; M. D. Conway, "A New Picture of Niagara" (excerpt from "London Letter to the Cincinnati Commercial"), *Evening Post* (New York), 19 July 1876, 1 (rpt. in "Art and Artists," *Boston Evening Transcript*, 20 Oct. 1876, p. 6); "The Mignot Collection," *Observer*, 23 July 1876, p. 5; "The Late Mr. Mignot's Pictures," *Paddington Times*, 5 Aug. 1876, p. 3; "Fine Arts." *Evening Post* (New York), 9 Aug. 1876, p. 1; "The Mignot Pictures at the Pavilion, *Brighton Gazette*, 16 Sept. 1876, quoted in *Catalogue of the Mignot Collection*, p. i; "The Mignot Pictures in the Masonic Rooms of the Pavilion," *Brighton Gazette*, 21 Sept. 1876, p. 5; "The Mignot Pictures in the Masonic Room, Royal Pavilion (Second Notice)," *Brighton Gazette*, 30 Sept. 1876, quoted in *Catalogue of the Mignot Collection*, pp. iii–iv; "Mignot's Pictures," *Pall Mall Gazette* 24 (12 Oct. 1876): 9; "Paintings by Louis R. Mignot," *New York*

Times, 7 Mar. 1887, p. 5; *Revisiting the White City: American Art at the 1893 World's Fair*, (Washington, D.C.: National Museum of American Art and National Portrait Gallery, 1993), listed p. 288 (as unlocated); William Grimes, "11 Almost-Masters Ascend From the Vaults," *New York Times*, 5 Feb. 1995, H35, 42, illus.

Exh.: London, P. and D. Colnaghi and Co., 7 July–Aug. 1866; London, *International Exhibition*, 6 Mar.– 19 Oct. 1872, no. 456 (as *Niagara Falls*, owned by Mrs. Harris, for sale £3000); London, 25 Old Bond Street, *Mignot Memorial Exhibition*, 12 June–July 1876, no. 86 (as *Falls of Niagara, taken from Terrapin Tower*), then traveling to Brighton, The Royal Pavilion, 19 Sept.– Oct. 1876; New Orleans, *World's Industrial and Cotton Centennial Exposition*, 16 Dec. 1884–1 June 1885, no. 148 (as *Niagara*, for sale $5,000); London, (unidentified gallery, Bishops Gate), Apr.–Mar. 1887 (as *Niagara*); Chicago, Chicago Art Institute, *1st annual exhibition of American paintings*, 28 Mar.–30 June 1888, no. 34 (as *Niagara*, for sale $2500); Chicago, *World's Columbian Exposition*, 1 Mar.– 31 Oct. 1893, no. 454 (as *Niagara*); Brooklyn, N.Y., The Brooklyn Museum, *Grand Reserves*, 3 Feb.–26 Mar. 1995.

A.
Tree Studies

Early–mid 1850s[?]
Pencil on paper, 11¾×14⅜" (29.8×36.5 cm)
In pencil on recto at lower right: *Louis R Mignot*
Kramer Gallery, Inc., Minneapolis
Prov.: [Julian Scott; by descent to] private collection, St. Paul

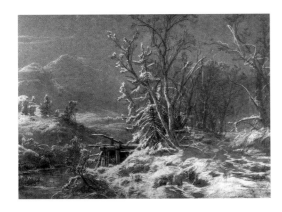

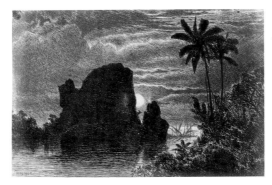

B.
Winter Scene

c. 1856

Lead pencil and chalk on paper

19 × 21¼" (48.3 × 54.0 cm)

At lower right: *Mignot*

Olana State Historic Site, Hudson, N.Y.

Prov.: Frederic E. Church, Olana, Hudson, N.Y.;
Louis Church, 1900; Sally Church, 1943; Estate
of Sally Church, 1964; to present owner, 1966
(OL1977.31).

Ref.: (S. G. W. Benjamin), "Fifty Years of Ameri-
can Art, 1828–1878 I." *Harper's New Monthly
Magazine* 59 (July 1879): 256–57, illus. (engrav-
ing, as *A Winter Scene*) p. 256; S. G. W. Ben-
jamin, *Art in America: A Critical and Historical
Sketch* (New York: Harper & Brothers, 1880),
illus. (engraving) p. 84.

Note: Related to painting, cat. no. 22.

C.
The Tropics

1859

Cliché-verre etching on paper, 5½ × 8" (14.0 × 20.3
cm) (image)

Inscribed on plate at lower left: *MIGNOT.*

Published in *Autograph Etchings by American Artists*
(New York: W. A. Townsend & Co., 1859).

D.
Old St. Paul's from
Waterloo Bridge

1867

Pencil and watercolor on paper, 12 × 15" (30.5 × 38.1
cm)

In pencil at lower left: *M. 67*; in ink on paper label
affixed to wood backing: *Old St. Pauls/ from
Waterloo bridge/ Mignot –/ Price of frame/ £
1"5"o Sterling*

Richard Coyle Prov.: (Sale, Henry H. Leeds &
Miner, New York, 29–30 Mar. 1868, no. 4, as
Old St. Paul's, from Waterloo Bridge); (Sale, *Pri-
vate Collection of Modern Oil Paintings belong-
ing to Col. James McKaye, New York, also a
number of paintings sold by order of Executors,
together with another Private Collection belong-
ing to a gentleman in Boston, etc.*, Leavitt, Stre-
beigh & Co., New York, 9–10 June 1869, no.
86, as *View of St. Paul's, London–watercolor*);
(unidentified dealer, Chatham, Mass.); to pre-
sent owner, c. 1981.

Chronology

JOHN W. COFFEY

1831
3 Feb.
Louis Rémy Mignot is born in Charleston, S.C., son of Rémy and, presumably, Elizabeth Mignot. His mother dies by 1834, and the child is reportedly raised in the home of his wealthy grandfather (probably his mother's father), near his birthplace.

1848
15 Aug.
Rémy Mignot dies at age 47 of "dropsy." A native of Granville, France, he had lived in Charleston for twenty-seven years. Louis Mignot is not a beneficiary of the estate.

22 Oct.
Seventeen-year-old Louis Rémy Mignot embarks for the Netherlands, possibly booking passage on the *Tremont,* the only ship to sail from Charleston to the Netherlands during this year.

1849
1 Jan.
Mignot enrolls in a drawing class at the Academie van Beeldende Kunsten, The Hague. Records note that Mignot is eighteen years old, a painter, and resides at 34 (later 6) Korte Houtstraat. Soon thereafter, Mignot enters the studio of Andreas Schelfhout (1787–1870).

1850
20 Dec.
From Holland, Mignot submits at least one painting for consideration to the American Art-Union, New York. *Winter Scene, Holland* (36 × 26") is selected for lottery distribution.

1851
Fall–winter
The American painter Eastman Johnson arrives in The Hague, where he soon makes the acquaintance of Mignot. The two collaborate on at least one painting, exhibited in 1852, Mignot providing the background for Johnson's figures. In 1854 Johnson executes a small portrait of Mignot. Johnson remains off-and-on at The Hague until 1855, when he returns to the United States. In December, Mignot complains that he is "in want of money."

1852
3 May–?
Annual exhibition *(Tentoonstelling van Schilder-en Kunstwerken),* Rotterdam: 224. *Poort van een Kasteel bij winter (Doorway of a Castle in Winter),* with figures by Eastman Johnson.

1853
19 Apr.–9 July
28th annual exhibition of the National Academy of Design, New York: 5. *Recollections of Germany* (for sale); 135. *View of the Hague Wood—Morning* (for sale); 336. *Birth Place of Rembrandt* (for sale). The paintings were probably submitted by Mignot's agent, Gabriel W. Coit.

1854
13 May
The *Charleston Daily Courier* announces, "Two exceedingly well executed oil paintings—'A Wood Scene,' and 'Solitude or Sun Set'—by Louis R. Mignot, a young native artist of our city, but now a resident of New-York, may be seen at the store of Messrs. Hayden, Bro. & Co., in King-st."

After 1 May
Mignot listed in official census records of The Hague, which identifies him as a Roman Catholic and an artist, but incorrectly gives his year of birth as 1830.

Late fall–early winter
Probable time of Mignot's return to the United States. Though it is possible that he visits Charleston, he takes up permanent residence in New York.

1855
11–26 Apr.
5th annual fair of the South Carolina Institute, Charleston: 86. *Pontine Marshes* (owner: artist); and 87. *Landscape* (owner: artist). The former won a silver medal.

Summer
Mignot travels to Upstate New York, sketching and painting around Cooperstown and Otsego County.

Winter
Mignot sketches in the Catskills.

1856
12 Mar.–10 May

31st annual exhibition of the National Academy of Design, New York: 180. *Fishkill Mountains: from "Highland Grove"* (for sale). Address listed as Astor Place Hotel, 733 & 735 Broadway, New York.

30 Apr.–
late June

33rd annual exhibition of the Pennsylvania Academy of the Fine Arts, Philadelphia: 122. *Solitude* (owner F. A. Eliot, Germantown, Pa.). Address inexplicably listed as Charleston, S.C.

1857

The New York City directory lists Mignot's studio at 497 Broadway—the Art-Union Building. Frederic E. Church is also listed at this address.

Mar 7.–16 May

1st annual exhibition of the Washington (D.C.) Art Association: 29. *The Foraging Party* (landscape by Mignot, figures by Ehninger; owner: artists); 121. *Snow Scene* (owner: artist); 122. *Autumn Scene* (owner: artist).

27 Apr.–27 June

34th annual exhibition of the Pennsylvania Academy of the Fine Arts, Philadelphia: 88. *Head Waters of the Susquehanna* (for sale by artist).

Early May–3 Sept.

Mignot accompanies Frederic E. Church on Church's second expedition to Central and South America.

18 May–20 June

32nd annual exhibition of the National Academy of Design, New York: 281. *Autumn* (for sale); 484. *The Foray* (landscape by Mignot; figures by J. W. Ehninger, for sale); 498. *Winter Scene in Holland* (landscape by Mignot, figures by Eastman Johnson, owner: Geo. Folsom); 526. *Sources of the Susquehanna* (owner: Jas. A. Suydam). Richard Morrell Staigg also exhibits a miniature portrait of Mignot (no. 295), owned by Mignot.

Late summer(?)

Mignot and Eastman Johnson visit Mount Vernon, Virginia, reportedly to sketch the mansion in preparation for a collaborative painting from the life of George Washington.

29 Sept.–31 Oct.

10th annual exhibition of the Maryland Institute for the Promotion of the Mechanic Arts, Baltimore: 19. *Source of the Susquehanna* (owner: Dr. Buckler); 156. *View in the Region of Cotopaxi* (owner: artist); 160. *View on the Hudson* (owner: Dr. Harris); 161. *View of the Fishkill Mountains* (owner: Dr. Harris); 162. *Autumn* (owner: Dr. Harris); 163. *View on a Tropical River* (owner: artist).

Dec.

Mignot is one of the first artists to move into the newly constructed Studio Building, 15 (later 51) Tenth St., New York. Other original tenants include Frederic Church, Sanford Gifford, Régis Gignoux, John La Farge, and James Suydam.

5 Dec.

John F. Kensett proposes Mignot for membership in the Century Association. He is elected on 7 January 1858, and he remains an active member until leaving for Europe in 1862.

15 Dec.–10 Feb.

2nd annual exhibition of the Washington Art Association: 57. *Autumnal Scene* (owner: artist).

1858
18 Feb.–27 Mar

1st annual exhibition of the Young Men's Association, Troy, N.Y.: 49. *Forest Scene at The Hague* (owner: G. B. Warren, Jr.); 124. *Winter Scene at The Hague* (owner: G. B. Warren, Jr.)

12 Apr.

At the annual meeting of the National Academy of Design, Mignot is elected an associate academician.

12 Apr.–30 June	33rd annual exhibition of the National Academy of Design, New York: 215. *Among the Cordilleras.*
20 Apr.–19 June	35th annual exhibition of the Pennsylvania Academy of the Fine Arts, Philadelphia: 52. *The Foray*—Landscape by L. R. Mignot; Figures by J. W. Ehninger (owner: G. F. Strong); 156. *Autumn* (for sale by artist); 183. *View near Otsego (New York)* (owner F. A. Eliot).
1–5 June	Mignot, along with Ehninger, Hicks, Rossiter, Gignoux and other artists primarily from New York and Baltimore, participates in the highly publicized "Artists' Excursion," sponsored by the B&O Railroad. Charles Gould of the Ohio and Mississippi Railroad probably selects the New York contingent, which checks into the Gilmor House, Baltimore, on 31 May. The company leave Baltimore and travel west as far as Wheeling, W.V., stopping occasionally to admire and sketch the scenery. From Wheeling, Mignot and most of the company return to Baltimore.
Summer	Mignot travels to Maryland and northern Virginia, where he works on landscape studies at Mount Vernon.
8 Nov.–1 Jan.	6th annual exhibition of the Maryland Historical Society, Baltimore: 113. *Landscape—View of the Cordilleras, near Cotopaxi, S. Amer. from Nature* (owner: artist); 121. *Volcanic Regions, near Cotopaxi, S. Amer. from Nature* (owner: Dr. Harris); 203. *Landscape near Otsego Lake, New York—Autumn* (owner: Dr. Harris); 225. *Fishkill Mountain and Hudson River—Winter* (owner: Dr. Harris); and 276. *View on the Guayaquil River, S.A.* (owner: Dr. Harris).
Dec.	Mignot attends a festive reunion of the participants in last June's "Artist's Excursion" on the B&O Railroad, held at the Madison Square residence of Charles Gould. The *Evening Post* reports that the grateful artists presented William Prescott Smith, "the master of transportation," with "personal souvenirs, more or less suggestive of scenes and characters encountered upon the road." Mignot gives an oil sketch. Others in attendance include Kensett, Rossiter, Suydam, and Ehninger.
20–21 Dec.	For the benefit of the family of the late artist William Ranney, Mignot joins other New York artists in organizing a well-publicized auction. Mignot reportedly contributes "a fine coast scene."

1859 Jan.	Inspired by the success of the Ranney benefit sale, Mignot and other New York artists form the Artists' Fund Society of New York. Members are required to contribute $75 or a comparably valued work of art to be sold at an annual benefit auction. The proceeds would provide assistance to indigent member artists and their families.
6 Jan.	Mignot exhibits *Sunset in South America* at the Festival of the Century Association, New York.
20 Jan.–4 Mar.	3rd annual exhibition of the Washington Art Association: 20. *Among the Cordilleras* (for sale); 21. *Sunset* (owner: D. R. Harris).
Feb.–Mar.	2nd annual exhibition at the rooms of the Young Men's Association, Troy, N.Y.: 50. *Winter Scene at The Hague* (owner: G. B. Warren, Jr.); 66. *Forest Scene at The Hague* (owner: G. B. Warren, Jr.); 78. *Autumn* (for sale); 79. *Winter* (for sale).
16–17 Mar.	Sale of "a superb collection of pictures, by living artists of Europe and America," Henry H. Leeds & Co., New York: 97. *Winter Scene, N.H.* (40 × 53"; $425 or $375); 197. *View in Ecuador;* 184. *Winter Scene* (24 × 26"; $245); and 185. *Autumn Scene* (24 × 26"; $300).
12 Apr.–25 June	34th annual exhibition of the National Academy of Design, New York: 262. *Street View in Guayaquil* (owner: S. Gandy).
19–20 Apr.	Sale of "a superb collection of oil paintings, comprising works of the American, English, French and Dusseldorf Schools," Henry H. Leeds & Co., New York: 178. *Lake Otsego.* Catalogue annotation indicates sale to a Mr. Russell for $95.
25 Apr.–25 June	36th annual exhibition of the Pennsylvania Academy of the Fine Arts, Philadelphia: 343. *In the Cordilleras, S.A.* (owner: artist).
11 May	At the annual meeting of the National Academy of Design, Mignot is elected a full academician.
11 July–fall	35th annual exhibition of the Boston Athenaeum: 291. *Sunset in the Tropics.*
Fall	First reception of the Allston Association, Baltimore. Exhibition includes works by Mignot, Church, Kensett, and Rossiter.
14 Nov.	Mignot and Rossiter host a private viewing of *Washington and Lafayette at Mount Vernon, 1784* at Rossiter's residence, 17 West 38th St., New York. The two artists publish an accompanying

pamphlet (*A Description of the Picture of the Home of Washington after the War Painted by T.P. Rossiter and L.R. Mignot. With Historical Sketches of the Personnages Introduced by T.P. Rossiter* [New York: D. Appleton and Co., 1859]).

18 Nov.–28 Jan. *The Home of Washington After the War,* described in advertisements as a "great National Picture," is exhibited at the National Academy of Design. Admission 25 cents.

Nov.–Dec. Publication of *Autograph Etchings by American Artists* by W. A. Townsend & Co., New York. Twelve *cliché-verre* etchings are featured, including *The Tropics* by Mignot, accompanied by a text by R. H. Stoddard. It is Mignot's only known work in a graphic medium. Though publication is timed to coincide with the holiday season, the book is not a popular success.

22 Dec. Sale of "superb modern oil paintings," Henry H. Leeds & Co., New York: 180. *Lands[cape] and Moonlight;* and 181. *Winter Scene Sunset.*

1860
11 Jan. In Baltimore, Mignot marries Zairah C. Harris, second daughter of Dr. Chapin A. Harris (1806–60), a prominent physician, dentist, and patron of the arts who already owns several paintings by Mignot.

22 Feb.–6 Mar. *The Home of Washington* is exhibited by Philip and Solomons at Sibley & Guy's Building, Pennsylvannia Ave., Washington, D.C. Admission 25 cents. The opening coincides auspiciously with the unveiling of Clark D. Mills's equestrian monument to Washington in Washington Circle. The exhibition is so popular that it is extended three days.

14–16 Mar. Sale of "a large and valuable collection of oil paintings . . . by the first artists in Europe & America," Henry H. Leeds & Co., New York: 60. *Sunset;* 61. *Moonlight;* and 372. *Landscape, Wood Scene.*

12 Apr.–16 June 35th annual exhibition of the National Academy of Design, New York: 226. *The Harvest Moon;* 552. *Lamona;* 613. *Twilight in the Tropics.* Mignot serves on the committee of arrangements for the exhibition.

14 May–4 June 1st annual exhibition of the Allston Association, Baltimore: 245. *Karhuizaro;* 247. *A Dreamy Day on the Guayaquil.*

2 July–8 Dec. 36th annual exhibition of the Boston Athenaeum: 246. *The Harvest Moon;* 277. *Twilight in the Tropics;* 292. *Lamona.*

Aug.–early fall *Home of Washington* returns for an exhibition at the National Academy of Design.

Summer Mignot makes sketches in Maryland and along the Passaic River, New Jersey.

29 Sept. Mignot's father-in-law, Dr. Chapin A. Harris, dies. The estate inventory lists 38 oil paintings and 11 engravings, all unidentified, but presumably including works by Mignot. Louis and Zairah C. Mignot receive a modest inheritance of $696.65.

20 Dec. South Carolina secedes from the Union.

22 Dec. 1st annual exhibition and sale to support the Artists' Fund Society of New York. Mignot donates three paintings: 22. *Study of Hemlock and Maple* (sold to a Mr. Burril[l] for $140); 52. *Chimborazo;* and 55. *Jersey Meadows.*

1861 Probably in late 1860 or 1861 a son, Rémy, is born to Louis and Zairah Mignot. The boy survives at least to adolescence: he is mentioned as a student in England in 1877.

24 Jan. Mignot named to the admissions committee of the Century Association.

1 Feb.–2 Mar. 4th annual exhibition of the Young Men's Association, Troy, N.Y.: 79. *Winter* (possessor: Wm. Schaus, for sale); 197. *Winter Twilight* (for sale); 198. *Winter Morning* (for sale).

12 Feb. At the annual meeting of the Artists' Fund Society of New York, Mignot is elected to the committee of inquiry.

16 Mar.–30 Nov. 37th annual exhibition of the Boston Athenaeum: 248. *Winter Evening;* 252. *Winter Morning.*

20 Mar.–25 Apr. 36th annual exhibition of the National Academy of Design, New York: 313. *Twilight on the Passaic* (for sale).

12 Apr. Fort Sumter is attacked. The Civil War begins.

22 Apr.–29 June 38th annual exhibition of the Pennsylvania Academy of the Fine Arts, Philadelphia: 74. *Chimborazo* (owner: W. S. Stewart); 121. *The Harvest Moon* (for sale by artist); 549. *On the Passaic* (for

sale by artist). These last two paintings apparently went unsold as they are returned to the artist.

29 May	Mignot joins other New York artists in donating paintings to an exhibition and sale on behalf of the Artists' Patriotic Fund "for the support of the families of those who have gone to fight the battles of our Country." The auction is conducted by Henry H. Leeds & Co. Mignot contributes 30. *Passaic Valley*.
16 July	Fellow Century Association member John H. Gourlie reports Mignot staying at the Hotel of Stockbridge, Massachusetts, where he "is industriously at work, transferring to the canvas the glorious scenery of the valleys and mountains of this region. He has just finished an exquisite picture of Monument Mountain from the valley of the Housatonic, which is to be engraved by Schaus."
Late summer–fall	Probably after Stockbridge, Mignot travels to northern New England, where he sketches at Lake George and in the White Mountains, New Hampshire.
21 Nov.–21 Dec.	2nd annual exhibition and sale to support the Artists' Fund Society of New York. Reportedly a lackluster sale in which Mignot's *Brook Scene* sells for a respectable $80.
24 Dec.–1 Feb.	1st annual exhibition of the Young Men's Association, American Hall, Buffalo, N.Y.: 65. *On the Housatonic* (for sale, $100); 161. *On the Pasaic* (for sale, $100).
1862	*Catalogue of Paintings, &c., on exhibition and for sale at Schaus's Gallery*, 749 Broadway, New York: 4. *Sunset in the Tropics;* 16. *Lake George;* 20. *White Mountain Scenery;* 35. *Winter.*
	Goupil & Co. publishes an engraving by Samuel V. Hunt after Mignot's *Evening in the Tropics*. The print is registered by the art dealer and collector Samuel P. Avery.
Feb.–Mar.	5th annual exhibition of the Young Men's Association, Troy, N.Y.: 6. *Twilight* (owner: Miss Buckley).
20–22 Mar.	3rd exhibition of the Brooklyn Art Association, Brooklyn, N.Y.: 13. *Sunset, Coast of Panama* (for sale); 67. *Ecuador* (for sale); 73. *"Ave Maria"* (for sale).
25 Apr.–late Oct.	38th annual exhibition of the Boston Athenaeum: 238. *Summer in South America;* 292. *On the Housatonic.*

1 May–15 Nov. 27	International Exhibition, London: 2869. *Head Waters of the Susquehanah.*
May–2 June	To raise funds for his passage to Europe, Mignot consigns 47 paintings and sketches to auction. The sale is conducted by Henry H. Leeds & Co., New York. Mignot reportedly realizes more than $5,000.
June–July	Mignot travels to western New York, where he makes studies of Niagara Falls.
26 July	Mignot departs on the British steamship *Great Eastern* for Liverpool, arriving in mid-August. His wife and son are not listed aboard. They may have earlier accompanied her widowed mother, who is reported to have left Baltimore for England following the death of Dr. Harris in September 1860.
23 Nov.–23 Dec.	3rd annual exhibition and sale of the Artists' Fund Society of New York: 57. *Twilight.*
19–20 Dec.	Winter exhibition of the Brooklyn Art Association, Brooklyn, N.Y.: 80. *A Cool Evening on the Housatonic* (owner: H. B. Cromwell); 81. *The Well of San Jose, Panama* (owner: H. B. Cromwell).
1863	*The Home of Washington* is published as an engraving by J. McClure, New York & London. Engraved by Thomas Oldham Barlow in London after the half-size version of the painting.
	3rd annual exhibition, Fine Art Institute, Derby Galleries, New York: 11. *Mount Vernon, or the Home of Washington after the War.*
7 Feb.–Mar.	Annual exhibition of the British Institution, London: 106. *Winter* (£40). Address listed as 9 Berkeley Gardens, Kensington.
3–7 Mar.	Spring exhibition of the Brooklyn Art Association, Brooklyn: 154. *Vespers on the Guayaquil* (owner: D. R. Barker).
16 Apr.	Sale of a "very valuable private collection of pictures by our most celebrated American artists," Henry H. Leeds & Co., New York: 45. *Snow Scene.* Other artists include Kensett, Rossiter, Durand, and Gifford.
4 May–25 July	95th annual exhibition of the Royal Academy of Arts, London: 595. *Lagoon of the Guayaquil, South America;* and 677. *A Winter Morning.*

7 May–11 July	40th annual exhibition of the Pennsylvania Academy of the Fine Arts, Philadelphia: 197. *Landscape* (owner: J. W. Casilear, New York).
3 June	Sale of the Rev. Henry Ward Beecher's "collection of valuable oil paintings, principally painted by eminent American artists," D. W. Ives & Co., New York: 15. *Landscape.*
10–11 June	Sale of a "valuable collection of ancient and modern oil paintings, marble statuary and bronzes," Henry H. Leeds & Co., New York: 184. *Landscape—Looking through a Bridge;* 202. *Village of Lamona, Ecuador;* and 229. *Midsummer.*
Summer	4th annual exhibition, Fine Art Institute, Derby Galleries, New York: 69. *The Home of Washington, or Mount Vernon after the American Revolution.*
2 Nov.–25 Jan.	3rd annual exhibition of the Glasgow Institute of the Fine Arts: 376. *A Frosty Evening* (£84).
Nov.–21 Dec.	4th annual exhibition and sale of the Artists' Fund Society of New York, conducted by H. H. Leeds & Co. at the Derby Gallery: 37. *Sunset, Lowlands of Guayaquil.*
1864 6 Feb.–Mar.	Annual exhibition of the British Institution, London: 109. *Twilight in the Tropics* (£55); 553. *Cotopaxi from the Vallée de Chillo, Ecuador.* Address listed as Mansfield Lodge, Portland Place, London.
22 Feb.–?	Brooklyn and Long Island Fair in aid of the U.S. Sanitary Commission, Brooklyn: 3. *Passaic Falls* (owner: R. Stuyvesant); 43. *Twin Elms* (owner: G. G. White); 67. *On the Passaic* (owner: Cyrus Butler).
22 Feb.–10 Mar.	Northern Ohio Sanitary Fair, Cleveland: 3. *Sunset on White Mountains* (owner: H. F. Clark); 120. *Twilight* (owner: J. Perkins).
11–14 Mar.	Spring exhibition of the Brooklyn Art Association, Brooklyn: 14. *Landscape* (owner: S. B. Caldwell).
16 Mar.–?	19th annual exhibition of the Bristol Academy for the Promotion of the Fine Arts, Bristol: 142. *A Winter's Evening* (£40); 336. *Vallée de Chillo, Ecuador, South America* (£20).
25 Apr.–mid-June	41st annual exhibition of the Pennsylvania Academy of the Fine Arts, Philadelphia: 21. *Crags on Monument Mountain* (owner: John Bohlen, Philadelphia).
28 Apr.	Sale of R. Brooking's collection of mostly modern European paintings, Henry H. Leeds & Co., New York: 88. *On the Hudson* (8 × 14").
2 May–30 July	R. M. Staigg exhibits a portrait of *L. R. Mignot, Esq.* (cat. 709) at the 96th annual exhibition of the Royal Academy of Arts, London. At this time Staigg is sharing the same Mansfield Lodge address as Mignot.
17 May–18 June	Mississippi Valley Sanitary Fair, St. Louis: 161. *White Mountains* (owner: G. W. Harding); and 234. *Tintoretto and his Daughter* (owner: Dr. Dickinson); 308. *Home of Washington* (by Rossiter and Mignot), probably the engraving.
7 June–6 July	Great Central Fair, Philadelphia, for the benefit of the U.S. Sanitary Commission: 326. *Chimborazo* (owner: W. S. Stewart); 485. *Sunset* (owner: John Bohlen).
13–17 Dec.	Fall exhibition of the Brooklyn Art Association, Brooklyn: 64. *Landscape* (owner: J. H. Kidder).
30 Dec.	Annual exhibition and sale of the Artists' Fund Society of New York, Derby Gallery: 29. *Jersey Meadows* (owner: J. S. Casilear); and *Twickenham Church* (unlisted in catalogue but reportedly sold for $325).
Winter?	Annual exhibition of the Buffalo (New York) Fine Arts Academy: 258. *Landscape* (owner: D.V. Benedict).
1865 6 Feb.–28 Apr.	5th annual exhibition of the Glasgow Institute of Fine Arts: 43. *The Valle de Chillo, Ecuador, South America* (£20); 494. *A Winter Evening* (£40).
Early Feb.–Mar.	Annual exhibition of the British Institution, London: 69. *A Sunny Afternoon, Warwickshire* (£70); 179. *The Cordilleras of Ecuador* (£500); 558. *Sunset, Guayaquil River* (no price).
27 Feb.	4th annual exhibition of the Art Association of Montreal, Quebec: 1. *Scene on the Hudson near West Point* (owner: Jno. Caverhill)
1 May–22 July	97th annual exhibition of the Royal Academy of Arts, London: 565. *Evening in the Tropics.*

Summer	Annual exhibition of the Liverpool Academy: 302. *The Cordilleras of Ecuador* (£525).
Late Nov.–29 Dec	6th annual exhibition and sale of the Artists' Fund Society of New York: 28. *Landscape* (owner: National Academy of Design); 56. *Vallee de Chillo* (sold for $75).
1866 5 Feb.–Mar.	Annual exhibition of the British Institution, London: 55. *Table Lands of Rio Bamba, Ecuador* (£500); 494. *Desolation* (£200); 537. *Woods at Richmond* (£200). Address listed as 50 Upper Harley Street, London.
7 May–28 July	98th annual exhibition of the Royal Academy of Arts, London: 367. *Under the Equator.*
7 July–Aug.	*Niagara* is exhibited at Messrs. P. and D. Colnaghi and Co., 13–14 Pall Mall East, London.
	Catalogue of the Wellington Gallery, 97 Remsen St., Brooklyn, lists two paintings by Mignot: 22. *Moonlight in the Tropics;* and 48. *Autumn Foliage.*
Late Oct.–20 Apr.	Annual exhibition of "cabinet pictures" at the British Gallery, 57–58 Pall Mall, London: 162. *Snow Storm in Kensington Gardens.*
1867 Jan.–18 Mar.	Exhibition and sale of H. W. Derby's collection, "formerly the private collection of W. P. Wright, Esq., of New Jersey," at Derby's New Art Rooms, 845 Broadway, New York: 98. *Source of the Susquehanna;* and 99. *Ave Maria.* Sale is conducted by Henry H. Leeds & Miner.
Jan.–25 Mar.	Annual exhibition of the British Institution, London: 471. *Parting day/ Dies like the dolphin, whom each/ Pang imbues/ With a new colour as it gasps away.—Byron* (£150). Address listed as 17 Warwick Street, London.
Feb.	Annual exhibition and sale of the Artists' Fund Society of Philadelphia: 16. *Chimborazo* (owner: W. S. Stewart).
4 Feb.–6 May	7th annual exhibition of the Glasgow Institute of the Fine Arts: 178. *Lagoon of the Guayaquil, Ecuador, South America* (£25); 192. *Noon—Warwickshire* (£25). Address listed as 37 avenue Josephine, Paris.
27–28 Mar.	Sale of the "entire private collections of . . . Mr. Alex. White, of

	Chicago," Henry H. Leeds & Miner, New York: 121. *October in the Adirondacks.*
Late winter–spring	From now until his death, Mignot divides his time between England and France, spending increasing time in Paris.
1 Apr.–31 Oct.	Exposition Universelle, Paris: 61. *Source of the Susquehanna* (owner H. W. Derby).
6 May– 27 July	99th annual exhibition of the Royal Academy of Arts, London: 363. *Close of a stormy day, Guayaquil river, Ecuador;* and 514. *Tintern.*
16 Nov.–11 Mar.	1st winter exhibition of the National Academy of Design, New York, including "Works from the American Art Department of the Paris Universal Exposition": 677. *Sources of the Susquehanna* (owner: H. W. Derby).
Nov.–21 Dec.	Annual exhibition and sale of the Artists' Fund Society of New York. Sale conducted by Leavitt, Strebeigh & Co.: 9. *The Cot and the Abbey.*
1868	H. W. Derby offers Mignot's *Source of the Susquehanna* among paintings to be awarded to patrons of the Derby Athenaeum, New York.
29–30 May	Mignot consigns to New York auction 43 paintings and 7 watercolors, "painted by him during the last two years, and comprising some of his latest and best works." Sale conducted by Henry H. Leeds & Miner.
Spring–summer	Mignot registers at the Louvre to copy paintings. During the summer he travels to Switzerland.
5–6 June	Sale of "one of the best and most desirable collection[s] of oil paintings offered for sale this season," Leavitt, Strebeigh & Co., New York: 14. *Landscape* (13 × 18"); and 46. *The Abbey and the Cottage* (12 × 12").
Nov.–Dec.	7th exhibition of the Maryland Historical Society, Baltimore: 61. *Landscape* (owner: D. L. Bartlett); 66. *South American Landscape* (owner: Dr. Wm. H. Keener).
16 Nov.–30 Jan.	Winter exhibition at the Corinthian Gallery, 7 Argyll St., London: 254. *Sunset in South America.*
17–21 Nov.	Fall exhibition of the Brooklyn Art Association, Brooklyn: 172. *Valley de Chillu* (for sale).

1869

9–10 June — Sale of the "private collection of modern oil paintings, belonging to Col. James McKaye, New York. Also a number of paintings sold by order of executors, etc.," Leavitt, Strebeigh & Co., New York: 7. *Chateau de Mont Arguiel;* 86. *View of St. Paul's, London* (watercolor); and 148. *Fairy Land.*

Summer — Mignot again visits Switzerland.

July — Crosby's Opera House, Chicago, exhibits *Mount Chimborazo.*

Nov. — Mignot in Paris.

1870

Mar. — Opera House Art Gallery, Chicago, exhibits *Mount Chimborazo.*

1 May–20 June — For the first and last time Mignot exhibits at the Paris Salon: 1980. *Lever du soleil, sur le fleuve Guayaquil (Sunrise on the Guayaquil River);* and 1981. *Le givre (Hoarfrost).* Address listed as 71 Avenue des Champs-Elysées, Paris.

2 May–30 July 13 — 102nd annual exhibition of the Royal Academy of Arts, London: 421. *Sunset off Hastings.* Address listed as 8 Old Bond Street, London.

13 May — Sale of the "entire collection of paintings belonging to Mrs. S. B. Caldwell, Brooklyn, L.I.," Leavitt, Strebeigh & Co., New York: 43. *Ave Maria* (25 × 34").

8 June–early fall — 2nd annual exhibition of the Yale School of the Fine Arts, New Haven, Conn.: 76A. *Passaic River* (owner: Cyrus Butler).

1 July–5 Nov. — 1st summer exhibition of the National Academy of Design, New York: 535. *Scene in South America.*

19 July–19 Sept. — War is declared between France and Prussia. The French Army surrenders and Napoleon III is deposed. The Third Republic is declared in Paris. The German army besieges Paris.

22 Sept. — Having fled Paris for England, Mignot contracts smallpox and dies at Brighton. John Ruskin reportedly attends the body to the home of Mignot's family. He is interred at Brighton Cemetery, Woodvale. Family is left destitute.

22 Nov.–5 Mar. — 4th winter exhibition of the National Academy of Design, New York: 21. *Landscape* (owner: J. W. Casilear); and 48. *Winter Scene* (owner: John C. Force).

1871

1 May–29 July — 103rd annual exhibition of the Royal Academy of Arts, London: 368. *Mount Chimborazo* (owner: Mr. J. Bourlett, 17 Nassau St., Middlesex Hospital).

June — A selection of Mignot's paintings, probably left behind by the artist during the war, is shown at the shop of the framemakers E. Carpentier fils, 16 bis rue Fontaine, Paris.

1872

7–8 Feb. — Sale of the "Wellington Gallery, comprising nearly 100 paintings, collected during many years by Mr. I. B. Wellington, Brooklyn, L.I.", Geo. A. Leavitt & Co., New York: 41. *Autumn Foliage;* and 70. *Moonlight in the Tropics.*

16 Feb. — Sale of "over 200 paintings of modern masters," Geo. A. Leavitt & Co., New York: 33. *Landscape. Mount Washington.*

6 May–19 Oct. — International Exhibition, London: 92. *Hoar Frost, Richmond* (owner: Mrs. Harris); 456. *Niagara Falls* (owner: Mrs. Harris; £3,000).

28 May–Aug. — Summer exhibition of the Brooklyn Art Association, Brooklyn: 140. *Twin Elms* (owner: A. M. White).

27 June — Zairah Mignot named as administrator of her husband's estate, valued at less than £20.

Winter — Annual exhibition of the Society of British Artists, London: 629. *A tropical sunset* (watercolor, £42) and 645. *Close of a stormy day* (watercolor, £42).

1873

23–24 Jan. — Sale of "the entire collection of paintings belonging to the late Mr. Joseph H. Higginson, of Brooklyn," Messrs. Leavitt, auctioneers, New York: 115. *Sangay Volcano and Falls of Pastozo, S.A.*

5–8 Feb. — Sale of the art collection of the late Thomas P. Rossiter, George A. Leavitt & Co., New York: 210. *Rock in the Sea;* and 224. *The Home of Washington after the War.*

24–29 Mar. — Sale of "over five hundred paintings and studies, by the late John F. Kensett," Robert Somerville, auctioneer, New York: 37. *A Painted Ship on a Painted Ocean* (15 × 12"; $18); 417. *Snow Scene* (12 × 14"); and *The Evening Bath* (10 × 12").

25 Sept.–12 Nov. — Inter-State Industrial Exposition, Chicago: 95. *Kensington Gardens* (owner: Emigh).

8–20 Dec.	Exhibition of the Brooklyn Art Association, Brooklyn: 368. *Lafayette and Washington at Mt. Vernon* (owner: William Nelson).
1874 9 Sept.–10 Oct.	Inter-State Industrial Exposition, Chicago: 582. *The Home of Washington after the War* (landscape by Mignot, figures by Rossiter) (owner: J. Nelson, Jr.).
20–21 Dec.	Sale of the "artistic property" of the late Col. J. Stricker Jenkins, Baltimore, Geo. A. Leavitt & Co., New York: 566. *Early Summer.*
1875 24–25 Mar.	Sale of "the collection of paintings by American and foreign artists, formed by Mr. Sheperd Gandy," Somerville Gallery, New York: 83. *Tropical Scene;* and 131. *Village in South America* (figures by E. Johnson).
21–23 Apr.	Sale of the collection of John C. Force, Somerville Art Gallery, New York: *Winter in the White Mountains.* The painting reportedly sells for $200.
1876 3 Jan.	*Mount Chimborazo* exhibited at the O'Brien Art Gallery, Chicago.
10 May–10 Nov.	Centennial Exposition, Philadelphia: 493. *Snow Scene* (owner: Century Club, New York).
12 June–July	Zairah Mignot organizes a memorial exhibition of her husband's works, presented in rented rooms at 25 Old Bond Street, London. On display are 119 works, including an undetermined number of loans from private collectors. The proceeds from admission and, presumably, sales are to benefit the family. The exhibition is accompanied by a catalogue with a biographical sketch by the British playwright and critic Tom Taylor and "opinions of the press," with an added supplement of notices from the Brighton press.
19 Sept.–Oct.	After closing in London, the Mignot memorial exhibition opens in the Masonic Rooms of the Pavilion, Brighton. It then returns to the gallery in 25 Old Bond Street, London. The exhibition must have been financially successful for Zairah Mignot soon writes that "the past few months have developed my own circumstances differently from what I feared."

CATALOGUE OF 1862 SALE

Catalogue of a choice collection of paintings and studies from nature, painted by Louis R. Mignot, who is about leaving for Europe and India, to be sold at auction by Henry H. Leeds & Co., on the evening of Monday, June 2d, 1862

1. *Lake George.* 7 × [omitted]"
2. *View near Great Barrington.* 12 × 18"
3. *Woods in Winter.* 11 × 15"
4. *Monument Mountain from Great Barrington.* 17 × 24"
5. *Basin of Passaic Falls.* 10 × 15"
6. *An Afternoon in the Fields of Berkshire.* 15 × 24"
7. *Twilight. Winter.* 6 × 12"
8. *The Harvest Moon.* 24 × 38"
9. *Jersey Meadows.* 7 × 13"
10. *Sunset. Coast of Panama.* 15 × 24"
11. *Druid Hill Park, Baltimore. Winter.* 16 × 24"
12. *Looking through a Bridge. Berkshire.* 16 × 26"
13. *Twilight in the Tropics.* 24 × 40"
14. *Falls of the Passaic.* 15 × 24"
15. *Close of a Showery day. Lake George.* 16 × 24"
16. *The Race. Painted from Nature.* 19½ × 29"
17. *Lagoon. Coast of Ecuador.* 16 × 24"
18. *Autumn. Painted from Nature.* 18½ × 29"
19. *Indian Summer. Lake George.* 24 × 40"
20. *Moonlight. Lake Otsego.* 11½ × 15"
21. *Study for large Picture. Looking thro' a Bridge.* 6 × 12"
22. *The Elms. Sisters.* 16 × 24"
23. *On the Passaic.* 16 × 24"
24. *Storm. Coast of Panama.* 16 × 24"
25. *Early Summer.* 22 × 36"
26. *The Well of San Jose. Panama.* 8 × 10"
27. *Sunset. Winter.* 15 × 24"
28. *The Hackensack.* 16 × 24"
29. *Morning. From Staten Island.* 9 × 14"
30. *Village of Lamona. Ecuador.* 24 × 38"
31. *Crags on Monument Mountain.* 12 × 15"
32. *A Pastoral. Stockbridge.* 17 × 23"
33. *October.* 17 × 21"
34. *The Jersey Champagna.* 24 × 36"
35. *Monument Mountain from Stockbridge. Painted from Nature.* 17 × 25"
36. *Landscape in Ecuador.* 24 × 38"
37. *A Cool Evening. Housatonic.* 16 × 26"
38. *Morning. Looking over the Pampa.* 8 × 14"
39. *Vespers. Guayaquil River.* 12½ × 21"
40. *Hill and Valley. Otsego County.* 25 × 40"
41. *Sunset.* 13 × 21"
42. *Islands in the Pacific.* 16 × 24"
43. *Vallee de Chillo. Near Quito.* 16 × 24"
44. *Twilight Dews.* 8 × 13"
45. *Palisades. Hudson.* 8 × 13½"
46. *Harvest Time. Otsego Co.* 23 × 38"
47. *Newark. From the Passaic.* 7 × 18"

CATALOGUE OF 1868 SALE

Special sale of fine oil paintings, including the collection of the well-known American artist, Mr. L. R. Mignot, now in London, comprising some of his latest and best works. Also, other fine pictures, by celebrated American and European artists . . . Henry H. Leeds & Miner, May 29 & 30th [1868].

Water Colors

1. *Childe "Harolds" Pilgrimage*
2. *St. Agnes Eve*
3. *Cotopaxi*
4. *Old St. Paul's, From Waterloo Bridge*
5. *Leicester's Window, Kenilworth*
6. *Tour de Jeans-Sans Peur—Study*
7. *Tintern, East Window*

Oil Paintings

8. *Afternoon on the Guayaquil*
9. *Evening*
10. *Noon [on the Guayaquil] River*
11. *On the Thames, Near Twickenham*
12. *Cotopaxi—A Study*
13. *Bal de Nuit, Paris*
14. *Study for Eternal Spring*
15. *A Painted Ship on a Painted Ocean—Ancient Mariner*
16. *Study for Close of a Stormy Day*
17. *Druid Hill Park, Baltimore*
18. *Sunset—A Study*
19. *Morning*
20. *Silver and Gold*
21. *A Ship-Wrecked Sailor Waiting for a Sail—Enoch Arden*
22. *Sunset—A Study*
23. *A Study for Woods in Winter*
24. *Winter—Kensington Gardens*
25. *On the Channel Between Dover and Calais*
26. *Sunset—A Study*
27. *Low Tide—Hastings*
28. *Chateau Mont Orgueil, Island of Jersey (Built by Rolls, father of William the Conqueror)*
29. *Close of a Stormy Day*
30. *"Out into the West"—Three Fishers*
31. *Under the Equator*
32. *Passing Squall—Hastings*
33. *Glimpse of the Bay of Panama*
34. *On the Banks of the Guayaquil*
35. *Gathering Plaintains—Guayaquil River*
36. *Tour de Jeans-Sans Peur, Quartier St. Denis, Paris*
37. *An English Pastoral*
38. *Mosque and Minaret*
39. *Eternal Spring*
40. *On the Sands, Hastings*
41. *And Glories of the Broad Belt of the World.* ("All these he saw; but what he fain had seen. / He could not see—the kindly human face, / Nor ever hear a kindly voice."—Enoch Arden).

42. *On the Avon, Near Kenilworth*

43. *Incense-Breathing Morn—Gray's Elegy*

44. *Paris from Chaeltot*

45. *Thames Study for a Large Picture*

46. *Aphrodite*

47. *Woods in Summer—Richmond-on-Thames*

48. *[Woods in] Winter [—Richmond-on-Thames]*

49. *Chimborazo*

51. *Winter*

89a. *Sunset*

CATALOGUE OF THE 1876 MEMORIAL EXHIBITION

1. *Jersey Coast*

2. *Jung Frau, from the Wingern Alp*

3. *Sea View—Sketch*

4. *A Farm View in Warwickshire*

5. *South American Temple*

6. *Tintern among the Hills*

7. *Swiss View—Sketch*

8. *The New Moon. South America*

9. *Study by a Roadside, North America*

10. *Holly Cottage, Warwickshire*

11. *Sunset on the Prairies, South America*

12. *Lake of Lucerne, Mount Pilatus—Sketch*

13. *Storm over Kenilworth Castle*

14. *Sunset Study, North America*

15. *On the Banks of Guayaquil*

16. *Banqueting Hall, Kenilworth*

17. *Bleak November*

18. *On the Ice*

19. *Off Dover*

20. *Sunset at Sea*

21. *"There is a Rock"*

22. *Solitude*

23. *Winter in Hyde Park*

24. *Swiss Mountains*

25. *Stormy Coast View*

26. *Twilight in the Tropics*

27. *Study of Trees, Richmond Park*

28. *Evening Vespers, Stockbridge Church, North America*

29. *The Lake of Lucerne, with the Rigi.* The spectator is supposed to be on the Lake, and distant shore quite a mile from Lucerne, looking in an easterly direction, having the Rigi on the left. The faint snow lines of Mount Clariden are seen in the distance, while to the right we have the Neder and Oder Bauen. The green of the water is one of the peculiar features of this grand and beautiful lake, which is insisted upon by the artist. The singular strata of the Rigi has hitherto been avoided by artists as being unpicturesque; but, in this painting great skill has been shown in the rendering of the strata of the Rigi, producing a valuable auxiliary for effecting extreme distance.

30. *The Wetterhorn, Switzerland*

31. *Hoar Frost—Richmond Park*

32. *Study of Trees*

33. *Mountain View*

34. *Rio Bamba*

35. *St. Agnes Eve*

36. *Valley of Meyringen, Switzerland*

37. *Sunset on the Pacific*

38. *Tintern*

39. *Thunder, North America*

40. *Jung Frau, Sunset. Study from Nature*

41. *Winter View*

42. *Rosenlaui Glacier—Sketch*

43. *Bouquet from Holly Cottage*

44. *Church Tower, Exeter*

45. *Kenilworth from the Brook*

46. *"Incense-breathing Morn," in the Tropics*

47. *Noon in the Tropics*

48. *Vase of Flowers*

49. *St. James' Pulpit, Paddington—Sketch*

50. *Lagoon of Guayaquil*

51. *Cliffs of Dover—Sketch*

52. *At Fluelen, Switzerland—Sketch*

53. *Drifting Storm*

54. *An English Pastoral*

55. *Sunset Study*

56. *Bit of Cloud and Rock, Sketch*

57. *Sunset, North America*

58. *Sea View*

59. *Study of Clouds*

60. *Sunset, near Highgate*

61. *Contentment, South America*

62. *Closing day, South America*

63. *Early day, South America*

64. *Autumn on the Susquehana, North America*

65. *Pilgrim's Progress*

66. *Table Rock, Niagara*

67. *Study of Clouds*

68. *Study of Clouds*

69. *Sunset, North America*

70. *Fishing Smack—earliest study*

71. *Study of Wreck at Sea*

72. *Cotopaxi*

73. *The Rigi—Sketch*

74. *Uri Rothstock*

75. *Study of Cotopaxi, with a View of the Falls*

76. *Lagoon of Guayaquil*

77. *Jung Frau, descending to Lauterbrunen—Study*

78. *Eruption of Cotopaxi by night*

79. *Jung Frau*

80. *Moonlight in the Tropics*

81. *Baltimore*

82. *Holly Cottage, Warwickshire*

83. *Sunset Study, North America*

84. *Sunset Study, North America*

85. *Jung Frau, Morning.* Taken from near the village of Muhren on the Wengern Alp. The early morning sun giving a rosy hue upon the snow-clad mountains, such various atmospheric effects are happily rendered. The work is extremely successful in conveying a sense of vastness.

86. *Falls of Niagara, taken from Terrapin Tower*

87. *Jung Frau, evening*

88. *Study of Clouds*

89. *One of the earliest Sunset Studies, Catskill Mountains*

90. *Mount Ætna*

91 & 92. *Views in Switzerland—Sketches on same canvas*

93 & 94. *Lake of Lucerne—Sketches on same canvas*

95. *Sunset on Lake Lucerne*

96. *Swiss View*

97. *Warwick Castle from the River*

98. *Original Study for Contentment*

99. *View near Bath*

100. *St. Paul's*

101. *Dolce Farniente, on the Guayaquil*

102. *Moonlight in Ecuador*

103. *Sunrise in Ecuador*

104. *Winter in North America, near Catskill*

105. *Woods at Richmond*

106. *Contentment*

107. *Falls of Guiranda*

108. *On the Avon*

109. *The Savannas*

110. *Mosque and Minaret*

111. *Winter View*

112. *Study of Winter*

113. *Snow Scene*

114. *Sunset at Sea*

115. *Sunlight through the Mist*

116. *Study of Light upon the Snow*

117. *Lake of Lucerne*

118. *Home of Washington, engraved from picture*

119. *Engraving from a South American picture*

120. *Desolation*

Notes

INTRODUCTION

1. The catalogue from that exhibition has proven to be an indispensable source of information on the artist. It appeared in two editions, the second of which incorporated excerpts of press notices. See *Catalogue of the Mignot Pictures with Sketch of the Artist's Life by Tom Taylor, Esq.* Price sixpence, season ticket five shillings. London, [1876].; its successor was *Catalogue of the Mignot Pictures with Sketch of the Artist's Life by Tom Taylor, Esq., and Opinions of the Press*, Galleries, 25 Old Bond Street, London, and The Pavilion, Brighton, 1876 (see Appendix). Since the first edition includes no date or mention of Brighton, it seems likely that it was produced early in the planning stages before the tour of the exhibition was finalized.

2. [Samuel G. W. Benjamin], "Fifty Years of American Art, 1828–1878," in *Harper's New Monthly Magazine* 59 (July 1879): 256–57; an almost identical passage appears in *Art in America: A Critical and Historical Sketch* (New York: Harper and Brothers, 1880), p. 83.

3. Benjamin, *Art in America,* p. 83.

4. Chapter 5 complements and expands my previous interpretations of Mignot's experiences in Latin America. See my *Tropical Renaissance: North American Artists Exploring Latin America, 1839–1879* (Washington, D.C.: Smithsonian Institution Press, 1989), pp. 133–57, and the more recent "On the Road: Louis Rémy Mignot's *Landscape in Ecuador,*" *North Carolina Museum of Art Bulletin* 16 (1993): 14–30.

I. LOUIS MIGNOT AND THE REDEFINITION OF SELF

1. Herman Melville, *The Confidence-Man: His Masquerade* (1857; London: Penguin Classics, 1990), p. 161.

2. Harold Beaver, *The Great American Masquerade* (London: Vision Press, 1985), p.

7; quoted in Stephen Matterson's introduction to Melville's *Confidence-Man*, pp. xxiv–xxv, who summarizes remarks on American identity as a literary tradition.

3. See, e.g., Angela Miller, "The Mechanism of Market and the Invention of Western Regionalism: The Example of George Caleb Bingham," in *American Iconology: New Approaches to Nineteenth-Century Art and Literature*, ed. David C. Miller (New Haven: Yale University Press, 1993), pp. 112–34; Nancy K. Anderson and Linda S. Ferber, *Albert Bierstadt: Art & Enterprise* (Brooklyn: Brooklyn Museum, 1990); and Nicolai Cikovsky Jr. with Charles Brock, "Whistler and America," in *James McNeill Whistler,* ed. Richard Dorment and Margaret F. MacDonald (New York: Harry N. Abrams, 1995), pp. 29–38.

4. Melville, *Confidence-Man,* p. 9.

5. Quoted in Edward Said, "Reflections on Exile," *Granta* 13 (1984): 169.

6. Quoted in Wayne Franklin and Michael Steiner, "Taking Place: Toward the Regrounding of American Studies," in *Mapping American Culture,* ed. Wayne Franklin and Michael Steiner (Iowa City: University of Iowa Press, 1992), p. 3. Additional points presented here were extracted from their essay, pp. 3–23.

7. Quoted in Barbara Novak, *American Painting of the Nineteenth Century* (New York: Praeger, 1969), p. 45.

8. Mignot may have visited Charleston in April 1855, during the Fifth Annual Fair of the South Carolina Institute, where *Pontine Marshes* and *Landscape* were exhibited, the former winning a silver medal. This trip is unconfirmed.

9. Vera Brodsky Lawrence, *Strong on Music: The New York Music Scene in the Days of George Templeton Strong,* vol. 1 (Chicago: University of Chicago Press, 1988), p. xiii.

10. Allan Nevins and Milton Halsey Thomas, eds., *The Diary of George Templeton Strong,* vol. 2 (1850–59; New York: Octagon Books, 1974): 470–71 (20 and 25 November 1859).

11. "Literature and Art: Artists' Patriotic Fund," *Home Journal* (8 June 1861): 3. Mignot contributed *Passaic Valley.*

12. Jasper Francis Cropsey, journal entry for 5 September 1862, Newington-Cropsey Foundation.

13. "Art Notes," *Evening Star* (Washington, D.C.), 11 May 1878, 1:5. The tone of this review is exceedingly knowledgeable about an artist who had left the country more than fifteen years before. The writer suggests that Mignot was highly vocal about his southern affiliations and that he "scornfully" shook the North from his boots.

14. Nationalism, regionalism, and sectionalism are discussed in relation to landscape art in Angela Miller, *The Empire of the Eye: Landscape Representation and American Cultural Politics, 1825–1875* (Ithaca: Cornell University Press, 1993), esp. chap. 6.

15. Henry T. Tuckerman, *Book of the Artists* (New York: G. P. Putnam & Son, 1867), p. 563.

16. Compare Mignot's situation with that of Bingham, who is still tagged as the artist from Missouri. This insistence stems in part from the fact that these artists arose from the periphery rather than the center, and therefore require that their credentials be stated. Some of this labeling, however, relates to an expanding America in the postwar years, when it fit with the larger national agenda to emphasize the inclusion of western and southern artists within the field of American art.

17. My formulation of this argument is based on Clarence Mondale, "Place-on-the-Move: Space and Place for the Migrant," in *Mapping American Culture,* ed. Franklin and Steiner, pp. 53–88. Quote, Benjamin, p. 83.

18. Allston's *Self-Portrait* (1805) is now in the Museum of Fine Arts, Boston.

19. See *Victorian Britain: An Encyclopedia,* ed. Sally Mitchell (New York: Garland, 1988), p. xviii. This source contains a useful chronology of events.

20. Tom Taylor, "Sketch of the Life," p. 6.

21. This classic dichotomy appears in William R. Taylor, *Cavalier & Yankee: The Old South and American National Character* (1957; Cambridge, Mass.: Harvard University Press, 1979).

22. F. Scott Fitzgerald, *The Great Gatsby* (London: Penguin Books, 1950), pp. 94–95.

23. Ibid., p. 95.

24. "Studios of American Artists," *Home Journal* 9 February 1856, 1:1–3.

25. Another undated *Autumn* (cat. no. 29) is extremely close in composition to this one (cat. no. 28) but rather more heavy-handed in its paint application. On Church, see the thorough chronology, which in this case fails to match record and picture, in Franklin Kelly, *Frederic Edwin Church* (Washington, D.C.: National Gallery of Art, 1989), p. 163.

26. Fidelius, "Art Matters in New York [N.A.D.]," *Boston Transcript,* 29 May 1857, 1:2. Reference located by Merl M. Moore Jr.

27. H. C. Westervelt to J. F. Cropsey, Brooklyn, N.Y., 4 June 1857; Newington-Cropsey Foundation. Thanks to Anthony Janson for assistance with the Cropsey reference.

28. "National Academy of Design. No. III," *Evening Post* (New York), 19 June 1857, p. 2.

29. Theodore Winthrop to Frederic Church, 26 July 1857, Olana State Historic Site.

30. "Topics Astir: National Academy of Design," *Home Journal* (13 June 1857): 2.

31. Z, "Correspondence of the Transcript, New York," *Boston Transcript,* 22 November 1859, 4:1–2. Reference from Merl M. Moore Jr.

32. Tuckerman, *Book of the Artists,* p. 564.

33. The tenth of July fell during the expedition to Sangay volcano, recorded in Church's diary. The night before they had camped along what Church called the "Rio Grande" and were going to spend part of the day on horseback, then on foot the rest of the way. At present there is no record of this picture having been in Church's possession. Archives, Olana State Historic Site.

34. For Church's activities, see Kelly, *Frederic Edwin Church,* p. 164.

35. "Mignot's Pictures," *Pall Mall Gazette* 24 (12 October 1876): 9.

36. Ibid. For an extended discussion of *Niagara,* see chap. 7.

37. See my *Creation and Renewal: Views of Cotopaxi by Frederic Edwin Church* (Washington, D.C.: National Museum of American Art, 1985).

38. Barbara Novak, *Dreams and Shadows: Thomas H. Hotchkiss in Nineteenth-Century Italy,* catalogue by Tracie Felker (New York: New-York Historical Society, 1993), p. 22.

39. Simon Schama, *Landscape and Memory* (New York: Alfred A. Knopf, 1995), p. 364.

40. Most of these subjects are discussed in the text that follows, the exception being *The Hackensack,* which remains unidentified although the title appears in the auction catalogue of 1862 (cat. no. 28, 16 × 24"). See Appendix.

41. For a provocative discussion of their work, see David Miller, *Dark Eden: The Swamp in Nineteenth-Century American Culture* (Cambridge: Cambridge University Press, 1989).

42. The scholar quoted is Drew Faust, whose ideas along with others presented here are discussed in Michael O'Brien, "The Lineaments of Antebellum Southern Romanticism," *Journal of American Studies* 20 (1986): 183.

43. Richard Gray, *Writing the South: Ideas of an American Region* (Cambridge: Cambridge University Press), p. 55.

44. *Navy* (London?), quoted in "Opinions of the Press," *Catalogue of the Mignot Pictures,* p. 20.

45. Franklin Kelly has written most extensively on this aspect of Church's work. See, e.g., his *Frederic Edwin Church and the National Landscape* (Washington, D.C.: Smithsonian Institution Press, 1988)., especially chap. 6.

46. *Mignot's Pictures,* p. 9.

47. Ibid.

2. ROOTS AND INFLUENCES

1. The sacramental records and tombstone inscriptions of St. Mary's Catholic Church, Charleston, refer to a number of individuals who came from Granville. Mignot's purchase of a slave from John Moisson on 3 December 1828 is recorded in Bills of Sale, vol. 5G, p. 649, South Carolina Department of Archives and History (hereafter referred to as SCDAH).

2. Mignot descendants in the Netherlands have this impression of their ancestors in Normandy.

3. Slave purchases are documented in the Bills of Sale volumes and the South Carolina Miscellaneous Records in SCDAH from 1828 through 1844. Loans from and to Mignot and legal actions surrounding them appear in Charleston District and Charleston District Court Records, Miscellaneous Records, Conveyances, Court of Common Pleas Judgement Rolls, Records of St. John's Parish, and South Carolina Miscellaneous Records in SCDAH.

4. The sacramental records of St. Mary's Church document perhaps a half-dozen instances when Rémy Mignot stood as a sponsor at a baptism. The *Proceedings of the Right Worthy Grand Lodge of the Independent Order of Odd-Fellows of South Carolina . . .* (Charleston: Burges & James, 1843), p. 37, lists Rémy Mignot among the "Initiated," the most recent members. The references in note 3, above, document Mignot's standing surety for notes.

5. Mignot was at 170 King Street by 1828 according to the *Directory . . . of the City of Charleston . . . 1829* (Charleston: n.p., 1828). The *Charleston Directory . . . for 1840 and 1841* (Charleston: T. C. Fay, 1840) lists Mignot at the corner of Anson and Hasell Streets, and the Charleston *Courier* lists advertisements for Mignot's Coffee House on East Bay St., so it may be that the Mignots had been burned out in the 1838 fire, especially since they later moved back to their former King Street neighborhood. The quotation is from Charles Fraser, *Reminiscences of Charleston . . .* (Charleston: John Russell, 1854), p. 13.

6. Inventory of Rémy Mignot's estate, filed 9 September 1848, Charleston County Inventories, vol. C, pp. 427–28 (microfilm, SCDAH). John Coffey of the North Carolina Museum of Art has emphasized these points about Rémy Mignot's assimilation and success.

7. See David Moltke-Hansen, "The Expansion of Intellectual Life: A Prospectus," in *Intellectual Life in Antebellum Charleston*, ed. Michael O'Brien and David Moltke-Hansen (Knoxville: University of Tennessee Press, 1986), pp. 384–85 n. 47.

8. Fraser, in his *Reminiscences*, p. 44, observed: "The great increase of French Population in Charleston . . . led to the establishment of a French theatre, which was opened on the 12th April, 1794. . . . It continued popular for some little time and then fell through, for want of encouragement." See also W. Stanley Hoole, *The Antebellum Charleston Theatre* (Tuscaloosa: University of Alabama Press, 1946). On newspapers, see "Periodicals in the Charleston Library Society" (typescript, Charleston Library Society) and William S. Hoole, *A Check-List and Finding List of Charleston Periodicals, 1732–1864* (Durham, N.C.: Duke University Press, 1936).

9. See Fraser, *Reminiscences*, pp. 44, 61, 106; also George Terry, "A Study of the Impact of the French Revolution and the Insurrections in Saint-Dominque upon South Carolina: 1790–1805" (M.A. thesis, University of South Carolina, 1975).

10. The marriage notices appeared in the *Southern Patriot* and the *United States Catholic Miscellany* for 18 October 1834.

11. See Lee Soltow, "Socioeconomic Classes in South Carolina and Massachusetts in the 1790s and the Observations of John Drayton," *South Carolina Historical Magazine* 81 (October 1980): 283–305; Michael P. Johnson, "Wealth and Class in Charleston in 1860," in *From the Old South to the New: Essays on the Transitional South*, ed. by Walter J. Fraser, Jr., and Winfred B. Moore, Jr. (Westport, Conn: Greenwood Press, 1981), 65–80.

12. See Sallie Doscher, "Art Exhibitions in Nineteenth-Century Charleston," in *Art in the Lives of South Carolinians: Nineteenth-Century Chapters,* ed. David Moltke-Hansen (Charleston: Carolina Art Association, 1979), p. SD-3; Paul Staiti, "The 1823 Exhibition of the South Carolina Academy of Fine Arts: A Paradigm of Charleston Taste," ibid.; Moltke-Hansen, "The Expansion of Intellectual Life," pp. 31ff.; Alfred Glaze Smith, Jr., *Economic Readjustment of an Old Cotton State: South Carolina 1820–1860* (Columbia: University of South Carolina Press, 1958); and Kenneth Severens, *Charleston: Antebellum Architecture and Civic Destiny* (Knoxville: University of Tennessee Press, 1988), esp. pt. 2.

13. Doscher, "Art Exhibitions," passim.

14. The conflicting and incomplete census data are discussed in Moltke-Hansen, "Expansion of Intellectual Life," p. 382 n. 26.

15. See Doscher, "Art Exhibitions."

16. See David Moltke-Hansen, "Between Plantation and Frontier: The South of William Gilmore Simms," in *William Gilmore Simms and the American Frontier*, ed. John C. Guilds and Caroline Collins (Athens: University of Georgia Press, forthcoming); and David Moltke-Hansen, "Conceiving Southern History," *Humanities in the South* 76 (fall 1992).

17. See Charleston County Court of Equity, Report Book, 17 January 1853–17 July 1853, p. 124, SCDAH.

18. See John McCardell, "Poetry and the Practical: William Gilmore Simms," in *Intellectual Life in Antebellum Charleston*, pp. 188ff.; and John C. Guilds, *Simms: A Literary Life* (Fayetteville: University of Arkansas Press, 1992).

19. See, e.g., *Catalogue of Paintings now on exhibition and for sale at H. W. Derby's New Art Rooms* (New York: Baldwin & Jones, 1867), p. 16; S. G. W. Benjamin, *Art in*

America: A Critical and Historical Sketch (New York: Harper and Brothers, 1880), p. 83; Keen Butterworth and James E. Kibler, *William Gilmore Simms: A Reference Guide* (Boston: G. K. Hall, 1980).

20. See Moltke-Hansen, "The Expansion of Intellectual Life," passim.

21. See William Douglas Smyth, "The Artistic Experience of South Carolinians Abroad in the 1850s," in *Art in the Lives of South Carolinians*.

22. See Moltke-Hansen, "Conceiving Southern History," and idem, "Between Plantation and Frontier."

23. See Fraser, *Reminiscences*, p. 106, and Elisabeth Muhlenfeld, *Mary Boykin Chesnut: A Biography* (Baton Rouge: Louisiana State University Press, 1981).

24. Samuel Henry Dickson, *An Oration Delivered at New Haven, Before the Phi Beta Kappa Society...* (New Haven, 1842), excerpted in *The Charleston Book,* [ed. by William Gilmore Simms] (Charleston: Samuel Hart, 1845), pp. 71ff.

25. William Dennison Porter, "The Value of the Arts and Sciences to the Practical Mechanic," Charleston *Courier,* 12 April 1843.

26. Daniel Kimball Whitaker, "The Periodical Press," *Southern Quarterly Review* 1 (January 1842), pp. 51–55.

27. Joel Roberts Poinsett, *Discourse on the Objects and Importance of the National Institution for the Promotion of Science, Established at Washington, 1840, Delivered at the First Anniversary* (Washington, D.C., 1841), excerpted in *The Charleston Book,* pp. 306–10.

28. See Doscher, "Art Exhibitions;" Staiti, "The 1823 Exhibition."

29. Charles Fraser, "An Essay on the Condition and Prospects of the Art of Painting in the United States of America," *American Monthly Magazine* 6 (November–December 1835), reprinted in *Art in the Lives of South Carolinians*, pp. CF-1, 4, 9.

30. Fraser, *Reminiscences*, p. 106.

31. Frederic Cople Jaher, *The Urban Establishment: Upper Strata in Boston, New York, Charleston, Chicago, and Los Angeles* (Urbana: University of Illinois Press, 1982), pp. 353–59; Anna Wells Rutledge, *Artists in the Life of Charleston: Through Colony and State from Restoration to Reconstruction. Transactions of the American Philosophical Society* 39:2 (Philadelphia, 1949).

32. See Moltke-Hansen, *Intellectual Life in Antebellum Charleston* and *Art in the Lives of South Carolinians*.

33. J. Fred Rippy, author of *Joel R. Poinsett, Versatile American* (Durham: Duke University Press, 1935), has explored Americans' involvements in Latin America in numerous volumes, but no one has yet paid adequate attention to the consequences of Charleston and other southern connections and interests in Latin America for American diplomacy or southern intellectual life.

34. John Bachman, "Morals of Entomology," *Southern Literary Journal* 2 (August 1836): 422.

35. Charles Fraser, "Claude Lorraine," *Magnolia*, n.s. 2 (May 1843): 315; *idem.,* "Nature Made for Man," ibid., n.s. 2 (June 1843): 383; idem., "An Essay . . . ," p. CF-13.

36. Martha R. Severens and Charles L. Wyrick, Jr., comps. and eds., *Charles Fraser of Charleston: Essays on the Man, His Art and His Times* (Charleston: Carolina Art Association, 1983), pp. 33 et passim.

37. See note 5, above.

38. The impact of the fire of 1838 is discussed by Fraser in *Reminiscences* and by Severens in *Charleston*.

39. See Ira Berlin and Herbert G. Gutman, "Natives and Immigrants, Free Men and Slaves: Urban Working Men in the Antebellum American South," *American Historical Review* 88 (October 1983): 1187 et passim; and Christopher Silver, "A New Look at Old South Urbanization: The Irish Worker in Charleston, South Carolina, 1840–1860," *South Atlantic Urban Studies* 3 (1979): 141–72.

40. See Anne W. Chapman, "Inadequacies of the 1848 Charleston Census," *South Carolina Historical Magazine* 81 (January 1980): 24–34.

41. Quoted in David Moltke-Hansen, "Why History Mattered: The Background of Ann Pamela Cunningham's Interest in the Preservation of Mount Vernon," *Furman Studies*, n.s. 26 (December 1980): 34–42.

42. Quoted from Charles Hosmer, *Presence of the Past: A History of the Preservation Movement in the United States before Williamsburg* (New York: Putnam, 1965), pp. 44–45.

43. See Miriam J. Shillingsburg, "Simms's Failed Lecture Tour of 1856: The Mind of the North," in *Long Years of Neglect*, pp. 183–201; and John Hope Franklin, "The North, the South, and the American Revolution," *Journal of American History* 62 (June 1975): 11–15.

3. TRAINING AT THE HAGUE

1. The ship Mignot took to Rotterdam may have been the *Tremont,* the only ship to sail from Charleston to the Netherlands in 1848.

2. Mignot registered for a drawing course. *Leerlingen bej Maand betalende over 1848–1849* (Pupils paying monthly, 1848–1849). Municipal Archives, The Hague.

3. The Hague never received city rights and could not build city walls or entrance gates; hence it offered easy accessibility to its surrounding meadows, woods, and dunes.

4. Quoted in Irving Katz, *August Belmont: A Political Biography* (New York: Columbia University Press, 1968), p. 34.

5. Tom Taylor, "Sketch of the Life of Louis Rémy Mignot," pp. 1–2.

6. In spite of Schelfhout's prominence, little has been known about him as an artist and an individual. This gap has begun to be remedied by the research of Frank

van der Velden, most recently published in *Andreas Schelfhout (1787–1870)* (Haarlem: Teylers Museum, 1994). Though it focuses mainly on a particular album of drawings, the text is the most comprehensive we found while preparing this work, and the treatment of Schelfhout presented here relies heavily upon it. Another source, which appeared subsequently, is Willem Laanstra, *Andreas Schelfhout (1787–1870)* (Amsterdam: Rokin Art Press, 1995). Also extremely useful is the *Catalogue de la Collection de Tableaux, dessins, esquisses, etudes, eaux-fortes, gravures, et objets d'arts de feu M. André Schelfhout* (Hague, 26 July 1876), copy Frick Art Reference Library.

7. *Catalogue de la Collection . . . Schelfhout* includes his drawing album from 1806 containing 40 sketches (no. 294), another from 1809 containing 12 (no. 295), and a third from 1811 containing 83 (no. 291), which is the only one specified as containing landscapes and is discussed by van der Velden, *Schelfhout,* pp. 9, 16, where he quotes earlier biographies on his sketching from nature. On Breckenheymer, see van der Velden, pp. 6, 27.

8. Van der Velden, *Schelfhout,* p. 7; the quotation appears on pp. 8–9. Here as elsewhere in this chapter the translations from the Dutch are by Louisette W. Zuidema.

9. Van der Velden, *Schelfhout,* p. 7.

10. J. Sillevis, "Romanticism and Realism," in *The Hague School: Dutch Masters of the 19th Century,* ed. R. de Leeuw, J. Sillevis, Ch. Dumas (The Hague, 1983), p. 44 and n. 19 and p. 45.

11. Ibid., p. 37.

12. Ibid.

13. Little has been recorded of these arrangements.

14. Sillevis, "Romanticism," p. 39.

15. *1947: Honderd jaar Pulchri Studio* (The Hague: Gemeente Museum, 1947), introduction by H. E. van Gelder.

16. Museum hours were published in the state newspaper. An illustrated catalogue of the collection also became available in four volumes between 1826 and 1830 highlighting 100 pictures from the collection. See Ben Broos, *Mauritshuis Gravenhage: Guide to the Royal Cabinet of Paintings* (The Hague, 1988), pp. 19–21, 23. See also *Mauritshuis: Illustrated General Catalogue* (Amsterdam: J. M. Meulenhoff, 1993), where through provenance records it is possible to determine which paintings were in the collection before 1850.

17. Letter from Eastman Johnson to Andrew Warner, 20 November 1851, New-York Historical Society, American Art-Union Papers, Letters from Artists. Quoted in Patricia Hills, *Eastman Johnson* (New York: Whitney Museum of American Art, 1972), p. 14.

18. Folsom in the meantime had returned to New York and lent the painting for the exhibit. His successor in that position was August Belmont, supporter of Eastman Johnson. See Katz, *Belmont,* p. 34. Although Belmont had an extensive art collection, which included many works acquired at The Hague—among them ones by Schelfhout, Koekkoek, and many others—Mignot's work was not represented. See, e.g., *The Belmont Gallery on Exhibition for the Benefit of the U.S. Sanitary Commission* (New York: John A. Gray & Green, Printers, 1864) and *The Belmont Collection of Paintings* (New York: Geo. A. Leavitt, Auctioneers, 12 November 1872).

19. This national preference was expressed in a poem recited at the celebration of his seventieth birthday. See van der Velden, *Schelfhout,* p. 5.

20. Extensive research has not turned up any works antedating the Dutch period.

21. Schelfhout's contemporary B. C. Koekkoek had left in 1834 for Cleves, where he set up a studio in 1841; Oosterbeek and Wolfheze drew others, including Anton Mauve, to Gelderland. See Sillevis, "Romanticism," p. 41.

22. *Catalogue de la Collection . . . Schelfhout,* pp. 27–34, lists the travel books in his private library. Some of his own albums of drawings might be fruitfully studied in this regard; see van der Velden, *Schelfhout,* for illustrations of a selection of the chalk drawings.

23. Barbara Novak, *Nature and Culture: American Landscape and Painting, 1825–1875* (New York: Oxford University Press, 1980), pp. 231–35, discusses relationships between American and Dutch art.

24. Taylor, "Sketch of the Life,", p. 2.

4. BECOMING AN AMERICAN LANDSCAPIST

1. Kenneth M. Stampp, *America in 1857: A Nation on the Brink* (New York and Oxford: Oxford University Press, 1990), pp. 16, 110–11.

2. Ibid., pp. 36–37.

3. He identified himself as a Roman Catholic on census records in the Netherlands. See Chronology for May 1854.

4. Taylor, "Sketch of the Life," p. 2.

5. The New York City directory (June 1855–May 1856) lists that address. Precisely when he arrived from Holland and moved in has not been determined, but it seems most likely he would have settled an address before going upstate. The New York State census canvassed on 20 June 1855 lists Mignot as a boarder in the small hotel of James Gooding of Otsego. His age is given as twenty-seven, though he was actually twenty-four.

6. Taylor, "Sketch of the Life," p. 2.

7. *Bulletin of the American Art-Union* (31 December 1850): 173; it went to Peter E. Vose, Dennysville, Maine. "No. 279. Winter Scene, Holland, 36 × 26. On the

right, a frozen stream, with figures, horses, and sledge, & c.; on the left a ruined tower, beside which a path leads into the woods."

8. At the time the address in the catalogue was 526 Hudson St.; according to city directories, this was the residence of James B. Oakly, a flour inspector. Perhaps Oakly acted as an agent, through the intercession of Coit. Oakly's business address was down near the port at 15 South Street. No listing under Mignot's name was found in 1852 or 1853. Information supplied by the U.S. History, Local History and Genealogy Branch, New York Public Library, from reverse directories and city directories. In February [?] 1858 at the first annual exhibition of the Young Men's Association, Troy, N.Y. Mignot's *Forest Scene at the Hague* (no. 49) and *Winter Scene at the Hague* (no. 124) emerged from the collection of G. B. Warren, Jr., one of which may be identifiable with the work shown at the National Academy of Design.

9. E. L. Magoon, "Scenery and Mind," in *The Home Book of the Picturesque: Or American Scenery, Art, and Literature* (1852; facsimile rpt. with an introduction by Motley F. Deakin, Gainesville, Fla.: Scholars' Facsimiles & Reprints, 1967), p. 3. As a perusal of this work indicates, "home" was defined almost exclusively by pictures and essays that focused on the New England and Middle Atlantic states.

10. On 30 December 1851, Mignot wrote from The Hague to Andrew Warner of the American Art-Union in New York: "I have previously sent several pictures through the hands of friends to the Art Union, but as it has been attended to with some delay and ceremony. I have concluded the most proper means must be to send them directly to the Art Union[.] accordingly I forward to the Art Union by ship . .. on 31st Dec, a landscape 5 feet by 4, which I wish to submit to your committee for purchase[.] it is the best that I have as yet painted I think, it is richly framed. I do not think (according to the price I received for the first painting I exposed at the Art Union) $400 too high, but I am in want of money. It is now already so long since the last pictures I sent which were shipped *eight or nine months ago* & from which I have heard no certain tidings of sale, that should your committee find the above price more than they would wish to give I shall be forced and indeed glad to have them except [*sic*] it at such a price as they themselves choose to set upon it, provided, they can forward the funds to me immediately on its acceptance. I would not hesitate to sacrifice such a discount on their draft as may be necessary to effect this, though it be more than the usual rate. You will confer a great favor by answering this on the arrival of the painting letting me know your determination. If I am not troubling you, I would ask some information concerning the paintings w[h]ich I have had in the Art Union this year, three I think, it is such a long period since I have heard about them, that it is somewhat disconsolating. You may judge then, what pleasure it would be to receive a letter from you. I hope that I shall be able to pursue my studies with more vigour next Spring if it should be my fortune to hear soon from you." American Art-Union Papers, New-York Historical Society, New York.

11. "Exhibition of the National Academy. First Article," *Crayon* 3 (1856): 118.

12. H. C. Westervelt to J. F. Cropsey, Brooklyn, N.Y., 4 June 1857; Newington-Cropsey Foundation. Thanks to Anthony Janson for assistance with the reference.

13. Benjamin, "Fifty Years of American Art," pp. 256–57; Tuckerman quoted a British critic's praise of a winter scene: "This is a gem; there is nothing to be said about it, but that it is the most complete little work in the room. We recognize at once its naturalness, not merely in passages, but in the harmonious treatment of the whole." See Tuckerman, *Book of the Artists*, p. 564.

14. According to Tuckerman, Church owned *Holland, Winter Scene*; see Tuckerman, *Book of the Artists*, p. 564. Since this drawing clearly depicts a scene of upstate New York, it seems that Tuckerman might refer to a now unlocated oil painting. The fact that the collections holdings he cites consist almost exclusively of oil paintings (unless he specifies otherwise) supports this contention.

15. "Studies of American Artists, Second Sketch," *Home Journal* (9 February 1856: 1).

16. "Sketchings. Our Private Collections. No. VI" [Elias Magoon], *Crayon* 3 (December 1856): 374.

17. It is also possible that Magoon saw and admired but could not afford the larger canvas, and so commissioned this small panel after it. He was best known as a connoisseur of small treasures. See E. L. Magoon, "Scenery and Mind," in *Home Book of the Picturesque*, p. 43. Miller, *Empire of the Eye*, p. 230, discusses Magoon's "circular reasoning."

18. In 1858 he exhibited *Fishkill Mt. and Hudson River—Winter*, owned by Dr. Harris, at the Maryland Historical Society. Whether this represented another painting or only a variation on the title of this one is not confirmed.

19. Letter to the author from Barry Hopkins, dated 23 September 1993.

20. The possibility exists that the choice of site was based on a commission, but the fact that the picture appeared in the academy exhibition for sale makes that rather unlikely.

21. N. Parker Willis, "The Highland Terrace Above West Point," *Home Book of the Picturesque*, p. 110.

22. Ibid., p. 111.

23. Ibid., p. 112.

24. For a thorough treatment of Cole's reputation and its relation to cultural politics at this moment, see J. Gray Sweeney, "The Advantages of Genius and Virtue: Thomas Cole's Influence, 1848–1858," in *Thomas Cole: Landscape into History*, ed. William H. Truettner and Alan Wallach (Washington, D.C.: National Museum of American Art, Smithsonian Institution, 1994), pp. 113–35.

25. James Fenimore Cooper, *The Chronicles of Cooperstown* (Cooperstown, N.Y.: H. & E. Phinney, 1838), chap. 7.

26. It seems virtually certain that Julius Gollmann, who depicted him in *The Lake Party,* also added him to the *Three Mile Point* canvas. Mignot seldom painted the figures in his work, certainly not one of this degree of specificity and detail.

27. This painting and a copy descended in the Turner family, and so Levi Turner was probably the first owner and very likely commissioned it. Information kindly supplied by Gilbert T. Vincent. See Levi Crosby Turner, "Auto-Biographic, 1806–1844," typescript (no. B-T-3) and his "Letters, 1836–1852" (William Holt Averell File), both in Special Collections, New York State Historical Association.

28. "Domestic Art Gossip," *Crayon* 3 (February 1856): 59.

29. "Studios of American Artists, Second Sketch," *Home Journal* (9 February 1856): 1.

30. I have found no previous published interpretations of this work. Research amassed at the New York State Historical Association by Paul D'Ambrosio and Dr. Gilbert T. Vincent was most generously put at the author's disposal. These efforts to unravel Mignot's activities in the area are therefore beholden to their exemplary detective work.

31. Ralph Birdsall, *The Story of Cooperstown* (Cooperstown, N.Y.: Augur's Book Store, 1948), p. 283.

32. See James Fenimore Cooper, *The Pioneers, or the Sources of the Susquehanna; A Descriptive Tale,* introduction by James Franklin Beard (1823; Albany: State University of New York Press, 1980), pp. 21–29, for the initial expression of the points reiterated throughout the novel in various forms.

33. G. Pomeroy Keese, *A Few Omitted Leaves in the History of Cooperstown* (files, New York State Historical Society), pp. 8–9, on background of blacks in Cooperstown; the quotation is on p. 9.

34. This suggestion was made by Paul D'Ambrosio.

35. Extensive research by local scholars at the New York State Historical Society has turned up little specific information on White.

36. "Studios of American Artists, Second Sketch," *Home Journal* (9 February 1856): 1

37. Documentation suggests the existence of at least one other version, owned by William Wright and then sold to Derby and exhibited at the Paris Exposition of 1867. *Catalogue of Paintings now on exhibition and for sale at H.W. Derby's New Art Rooms* (New York: Baldwin & Jones, 1867), p. 16; "Fine Arts," *New York Times,* 21 February 1867, p. 4; "The Wright-Derby Sale of Paintings," *Evening Post* (New York), 19 March 1867, p. 3; *Fine Arts Official Catalogue of the Paris Universal Exhibition* (London: J. M. Johnson & Sons, 1867), listed under the U.S. section, class I, no. 61.

38. James F. Beard, "Cooper and his Artistic Contemporaries," *New York History* 35 (1954): 485, for art based on *The Pioneers;* the quotation appears on p. 486.

39. "Domestic Art Gossip," *Crayon* 4 (February 1857): 55. Titles (still unmatched with known canvases) indicate additional subjects in the Cooperstown-Otsego region:

Harvest Time, Otsego County (1862; no. 46, 23 × 38"); *Hill and Valley, Otsego County* (1860; no. 40, 25 × 40"); *Landscape Near Otsego Lake, NY—Autumn* (1858; no. 203, Maryland, owned by Dr. Harris) and *View near Otsego.*

40. Cooper, *Pioneers,* p. 15.

41. Ibid., p. 83.

42. See Roger B. Stein, *Susquehanna: Images of the Settled Landscape* (Binghampton, N.Y.: Robertson Center for Arts and Sciences, 1981), where Mignot's picture is discussed on pp. 54–55.

43. This quotation appeared in the sales catalogue when the picture was put up for sale in March 1867 along with the remainder of Wright's impressive art collection after his death. The source is not given; presumably it was of earlier origin, and repeated in the catalogue, for few of the other pictures were catalogued with written commentary. This commentary has had a strange life, for Tuckerman quoted it (*Book of the Artists,* p. 564), but with two significant omissions: the second sentence left out the comparison to Church, and the final sentence was dropped. Did Tuckerman deliberately omit them, or was he working from an excerpted version himself? See *Catalogue of the Valuable Collection of Oil Paintings, Formerly the Private Collection of W.P. Wright, Esq., of New Jersey,* Henry H. Leeds & Miner, 18 March 1867, lot 98.

44. Bayard Taylor, *At Home and Abroad* (1859; New York: G.P. Putnam's, 1886), pp. 15–16.

45. "The Academy of Design: Spring Exhibition," *Putnam's Monthly* 9 (April 1857): 440–41.

46. Letter of 28 February 1857 from Mignot to Frank Eliot, Philadelphia (private collection).

47. From a letter written by Thomas Clarke, who had at one time owned Johnson's study *Kitchen at Mount Vernon.* Clarke to Messrs. Ortgies & Co., 4 December 1895; letter to accompany picture in sale *American 18th, 19th & 20th Century Paintings, Drawings, Watercolors, Sculpture,* Sotheby Parke Bernet, New York, 12 December 1975, sale no. 3823, item no. 23A.

48. Eastman Johnson to Mrs. Doud, 12 December 1895; ibid. in Sotheby Parke Bernet.

49. The most extensive documentation of this painting to date is Natalie Spassky, *American Paintings in the Metropolitan Museum of Art,* vol. 2 (New York: Metropolitan Museum of Art, 1985), pp. 88–91. It makes no mention of Johnson in the scheme.

5 . IN THE TROPICS

1. "Pictures by the Late L.R. Mignot," *Builder* 34 (24 June 1876): 607.

2. Erwin Panofsky, *Meaning in the Visual Arts* (Garden City, N.Y.: Doubleday

Anchor, 1955), p. 30. Several recent innovative studies on American art have employed this concept as underlying methodology; see David Miller, ed., *American Iconology: New Approaches to Nineteenth-Century Art and Literature* (New Haven, Conn.: Yale University Press, 1993), in this case adopting W. J. T. Mitchell's refashioning of the concept.

3. Church to Goodman, 27 May 1857, from Guayaquil; Collection of New York State Office of Parks, Recreation, and Historic Preservation, Olana State Historic Site, Taconic Region; gift of Mrs. David M. Hadlow.

4. Ibid.

5. The particulars of their itinerary are as follows: 15 May, leave Panama Bay for Ecuador; 23 May, arrive at the port city of Guayaquil, Ecuador; 29 May, on the Guayas River, proceeding to San Miguel (2 June) and Guaranda, in the vicinity of Mount Chimborazo; 3–14 June, in Guaranda and Guanajo; 15–17 June, pass through Mocha and Machachi, sketching Chimborazo; 23 June (or before) to 2/3 July, in Quito, from which they made excursions to the surrounding mountains; 26–27 June, at Pichinicha and Cayambe; 2/3–9 July, from Quito to Riobamba, where they spend two days preparing for excursion to Sangay; 9–13 July, outbound trip to Sangay volcano; 13–21 July, return to Riobamba, then on to Guaranda; 23 July, near Jorge; and 24 July, on Rio Guayas. Shortly afterward they depart by steamer for Panama, crossing the isthmus to arrive at Aspinwall on the Atlantic coast. They leave Panama on 19 August. After several delays—including running a reef—they arrive on 3 September at Staten Island, N.Y., where they are held in quarantine for several days. Katherine E. Manthorne, "On the Road: Louis Rémy Mignot's Landscape in Ecuador," *North Carolina Museum of Art Bulletin* 16 (1993): p. 29 n.13.

6. Quoted in Kenneth M. Stampp, *America in 1857: A Nation on the Brink* (New York & Oxford: Oxford University Press, 1990), p. 212.

7. The canvas currently bears a signature, "F. E. Church," that seems erroneous, given its close visual similarity to Mignot's work and its absence from the documentary literature on Church.

8. "Sketchings: Domestic Art Gossip," *Crayon* 5 (January 1858): 25.

9. The most detailed review was included in "National Academy of Design. III," *Evening Post* (New York), 8 May 1858, p. 1: "[*Among the Cordilleras*] is undoubtedly the most striking picture in this gallery, and perhaps in the exhibition. So different are the atmospheric and physical aspects of the tropics from those familiar to us, that it is difficult to realize that the singular contrasts of color which this picture presents can be genuine. The deep red tone of the rocks, varying in some instances to a vivid crimson, and the equally intense green of the fantastically interwoven tropical vegetation, have no parallel in a temperate clime, and we must take the artist's word for it that they are faithfully copied from nature.

Admitting this, however, and viewing the picture from all distances, it must be acknowledged that the general effect is unsatisfactory. The nice elaboration bestowed upon foliage and rocks, and the harmonious distribution of light and shadow, cannot reconcile us to the incongruous combination of colors in the foreground, and the eye turns with pleasure to the noble range of mountains which limit the picture and reflect on their snowy sides the crimson glories of the setting sun. The treatment of the background and of the clouds is wonderfully fine, and could it form a picture of itself, or could the rocks and trees of the foreground be removed, the view would be not merely a faithful delineation of nature, but a work of art of the most impressive character." See also "City Items," *New-York Daily Tribune,* 13 April 1858, p. 7; "Fine Arts. National Academy of Design. Second Notice," *Albion* 36 (1 May 1858), p. 213; "The National Academy of Design," *New-York Daily Tribune,* 4 May 1858, p. 6; "Sketchings. Exhibition of the National Academy of Design (Concluded)," *Crayon* 5 (June 1858), p. 175; "A Last Visit to the National Academy," *Independent* (New York), 17 June 1858, p. 1. Whereas *Among the Cordilleras* is several times described as a large canvas, the Butler picture is clearly of moderate size, but the descriptions seem to coincide closely with the Butler picture, hence the supposition that it was a large-scale and highly finished study for the exhibition piece.

10. "The National Academy of Design," *New-York Daily Tribune,* 4 May 1858, p. 6.

11. Frederic Church, Sangay Diary, July 1857, Olana State Historic Site, Hudson, New York.

12. For a comparative photograph of El Altar, see Loren McIntyre, "Ecuador: Low and Lofty Land Astride the Equator," *National Geographic* 133 (February 1968): 280–81.

13. Frederic Church, Sangay Diary, 11 July 1857, Olana State Historic Site, Hudson, New York.

14. On the verso of the picture, on an upper stretcher bar at right, are painted in oil sketches of two little figures—facing one another—a cleric with a wide hat and at left a man in a red-and-white-striped serape. They must have been intended as a tryout of sorts for figures in the composition, as the artists discussed the desired effect, before Johnson inserted them in the composition. It is possible that Mignot had access to prints or book publications that included *costumbrista* pictures—or those depicting the habits and customs of the people—which were popular in Latin America. The authorship of the figures is mentioned in the Gandy auction sale of 1875; see catalogue no. 47.

15. "National Academy of Design," *Home Journal* (New York) (11 June 1859): 2.

16. "Fine Arts. National Academy of Design. Second Notice," *Albion* 37, no. 20 (14 May 1859): 237.

17. "The New World and the New Man," *Atlantic Monthly* 2, no. 12 (October 1858):

518–519; quoted in Angela Miller, "The Mechanisms of the Market and the Invention of Western Regionalism: The Example of George Caleb Bingham," in *American Iconology*, p. 122.

18. See Lewis William Herndon and Lardner Gibbon, *Exploration of the Valley of the Amazon, Made under the Direction of the Navy Department* (1854; rpt. New York: McGraw-Hill, 1952), and Thomas Jefferson Page, *La Plata: The Argentine Confederacy and Paraguay* (New York: Harper & Bros, 1859), where such rhetoric can be found throughout.

19. See my *Tropical Renaissance*, pp. 52–53, 138–40.

20. Stacy May and Galo Plaza, *The United Fruit Company in Latin America*, Seventh Case Study in NPA Series on United States Business Performance Abroad (New York: National Planning Assoc., 1958), p. 4.

21. Charles Morrow Wilson, *Empire in Green and Gold: The Story of the American Banana Trade* (Henry Holt & Co., 1947), chap. 1, provides background.

22. José David Saldívar, "'Squeezed by the Banana Company': Dependency and Ideology in Macondo," in *The Dialectics of Our America: Genealogy, Cultural Critique, and Literary History* (Durham, N.C.: Duke University Press, 1991), pp. 23–48; Neruda is quoted on p. 41.

23. Pablo Neruda, from "La United Fruit Co.," *Canto General*, trans. Jack Schmitt (Berkeley: University of California Press, 1990).

24. Gabriel García Márquez, *One Hundred Years of Solitude*, trans. Gregory Rabassa (New York: Harper and Row, 1970), p. 215.

25. Rev. J. C. Fletcher, "Review of Thomas Page's *La Plata, the Argentine Confederation, and Paraguay*," *North American Review* 88 (April 1859): 430.

26. "Sketchings. Domestic Art Gossip," *Crayon* 7 (March 1860): 83.

27. See my *Tropical Renaissance*, esp. chap. 3.

28. The native landscapist Luis A. Martinez painted a canvas of the same subject, dated 1906, which is now Museo del Banco Central, Quito.

29. Alexander von Humboldt, *Researches Concerning the Institutions and Monuments of the Ancient Inhabitants of America, with Descriptions and Views of Some of the Most Striking Scenes in the Cordilleras*, trans. Helen Maria Williams (London: Longman, Hurst, Rees, Orme & Brown, J. Murray & H. Colburn, 1814), 1: 230–39, for his "View of Chimborazo and Carguairazo." Since there is no record of Mignot's personal library, it is of course difficult to establish his reading practices. For the importance of this book by Humboldt, see my *Tropical Renaissance*, pp. 100–104. Travel descriptions of the Guayas River were not as common as those of the Andes; for compilation of writings on Guayaquil and its environs, some of which were published after Mignot's visit, see Juan Castro y Velázquez, "Descripciones de Guayaquil," *Revista del Archivo Historico del Guayas* 7, no. 14 (December 1978): 27–75.

30. The description is from *Catalogue for the Entire Collection of Paintings belonging to Mrs. S. B. Caldwell, Brooklyn, L.I.* (New York: Leavitt, Strebeigh & Co., 13 May 1870).

31. The bulk of Church's drawings are divided between the collections at Olana State Historic Site and the Cooper-Hewitt, National Design Museum, Smithsonian Institution; no comprehensive publication exists of these holdings, but the Cooper-Hewitt collection is available on microfilm through the Archives of American Art.

32. A good selection of color plates of these monuments can be found in *Arte de Ecuador (Siglos XVIII–XIX* (Quito: Salvat Editores Ecuatoriana, S.A., 1977), pp. 31–45.

33. Some of these ideas were first presented in *Tropical Renaissance* and are expanded here; since at the time of that publication the paintings had not resurfaced, my discussion was based on the engraving alone.

34. Quoted in David Levin, *History as Romantic Art: Bancroft, Prescott, Motley, and Parkman* (Stanford: Stanford University Press, 1959), p. 125.

35. These ideas are discussed in William R. Taylor, *Cavalier and Yankee: The Old South and American National Character* (1957; Cambridge, Mass.: Harvard University Press, 1979), pp. 200–201.

36. For discussion of the painting's reception, see chap. 7.

37. "Mignot's Pictures," *Pall Mall Gazette* 24 (12 October 1876): 9.

38. Mignot's utilization of this and other literary texts is discussed from a different perspective in chap. 7.

6. HUDSON RIVER SCHOOL SUCCESSES

1. Stampp, *America in 1857*, pp. 213–19, describes the "flush times."

2. Ibid., pp. 221–38, describes the panic.

3. On 23 November 1857 Mignot gave his address as Astor Place, Broadway, in a letter to J. R. Lambdin. By 31 December he wrote again to Lambdin and gave his address as 15 Tenth Street.

4. See Annette Blaugrund, *The Tenth Street Studio Building* (Ph.D. diss., Columbia University, 1987; rpt. Ann Arbor: U.M.I., 1993), pp. 75–120, for a general overview.

5. Ibid., pp. 12–124, on the first tenants. For a roster of the tenants, see pp. 357–60.

6. The [unlocated] Rowse portrait is mentioned as follows: "A head of Mignot, by Rowse, is one of this artist's standard productions; it may be cited as an example of the true ideal in portrait Art." See "Sketchings. National Academy of Design. First Notice," *Crayon* 7 (May 1860): 139.

7. They appeared in *Executors' Sale: The Collection of over Five Hundred Paintings*

and *Studies by the late John F. Kensett* (New York: Association Hall, 24 March 1873): *The Evening Bath* (no. 674; 10 × 12"); *A Painted Ship on a Painted Ocean* (no. 37; 15 × 12"); and *Snow Scene* (no. 417; 12 × 14") remain unidentified. It is not known when he acquired them.

8. On his relations with Church, see chap. 1.

9. For the change in patronage from the aristocratic to the bourgeois in Cole's lifetime, see Alan Wallach, "Thomas Cole: Landscape and the Course of American Empire," in *Thomas Cole: Landscape into History*, ed. William H. Truettner and Alan Wallach (Washington, D.C.: National Museum of American Art, Smithsonian Institution, 1994), pp. 34–42.

10. Allan Nevins and Milton Halsey Thomas, eds., *The Diary of George Templeton Strong*, vol. 2 (1850–59; New York: Octagon Books, 1974): 397 (21 April 1858).

11. [Elias Magoon], "Sketchings. Our Private Collections. No. VI," *Crayon* 3 (December 1856): 374. In 1864 Magoon sold his art collection to Matthew Vassar, providing the foundation for the Vassar College Art Gallery.

12. On Stuart, see Manthorne, *Tropical Renaissance*, pp. 101–3. See also an unpublished paper by Paul Spencer Sternberger, "Portrait of a Collector and Patron: Robert Leighton Stuart," n.d., in the files of The New-York Historical Society. My thanks to the author for sharing his material and to Annette Blaugrund for bringing it to my attention.

13. Wright (1794–1866) was a significant figure who deserves further attention; see *Catalogue of the Valuable Oil Paintings, formerly in the Private Collection of W.P. Wright, Esq. of New Jersey* (New York: Henry H. Leeds & Miner, 18 March 1867). See also *Crayon* 4: 123, 377 and 7:166–68, on his collection. His wide intellectual interests are manifest in the contents of his private library, documented in *Catalogue of a Library at Weehawken, N.J., the Property of William P. Wright, Esq.* (New York: Geo. A. Leavitt, 30 May 1872). See *Appleton's Cyclopaedia of American Biography* 6 (1888): 87, for biographical details.

14. See *Catalogue of the Entire Collection of Paintings belonging to Mrs. S.B. Caldwell, Brooklyn, L.I.* (New York: Leavitt, Strebeigh & Co., 13 May 1870), no. 43.

15. *Appleton's Cyclopedia of American Biography* (1888), p. 87.

16. The only match located to date is a Jerome Henry Kidder, who was born 1842 in Baltimore County, Maryland. But if that birth date is correct, it would make him only twenty-two at the time the picture was exhibited, when he was serving in the army. If it is the same individual, it would make Kidder another member of the medical profession from Baltimore who procured his work (probably through the connections of Dr. Harris). In 1862 he entered the national army and served until the close of the war as a medical cadet in the military hospitals. He was appointed an assistant surgeon in the United States Navy and became a surgeon in 1876. See American Biographical Index entry no. 372, from *Herringshaw's National Library of American Biography* (1909–14).

17. Thomas Seir Cummings, *Historic Annals of the National Academy of Design* (Philadelphia: George W. Childs, 1865), p. 282.

18. It strikes me that the opportunities that such organizations represented, and their mode of operation, deserve further study. Too much attention is placed on the collectors in Manhattan, when Brooklyn and several of the growing cities upstate and outside the state boasted at least short-lived organizations where these artists exhibited and which deserve attention.

19. Correspondence from Troy, N.Y., 18 March 1858, *Crayon* 5 (April 1858): 116.

20. For background, see Josephine Cobb, *The Washington Art Association: An Exhibition Record, 1856–1860* (Washington, D.C.: Columbia Historical Society, 1966).

21. At the tenth annual exhibition of the Maryland Institute for the Promotion of the Mechanic Arts, Baltimore, Mignot's entries were: 19. *Source of the Susquehanna* (owner: Dr. Buckler); 156. *View in the Region of Cotopaxi* (owner: artist); 160. *View on the Hudson* (owner: Dr. Harris); 161. *View of the Fishkill Mountains* (owner: Dr. Harris); 162. *Autumn* (owner: Dr. Harris); 163. *View on a Tropical River* (owner: artist). At the sixth annual exhibition of the Maryland Historical Society, Baltimore, they were: 113. *Landscape—View of the Cordilleras, near Cotopaxi, S. Amer. from Nature* (owner: artist); 121. *Volcanic Regions, near Cotopaxi, S. Amer. from Nature* (owner: Dr. Harris); 203. *Landscape near Otsego Lake, New York—Autumn* (owner: Dr. Harris); 225. *Fishkill Mountain and Hudson River—Winter* (owner: Dr. Harris); and 276. *View on the Guayaquil River, S.A.* (owner: Dr. Harris). At the first annual exhibition of the Allston Association, Baltimore, he entered: 245. *Karhuizaro*; 247. *A Dreamy Day on the Guayaquil*. For background, see Anna Wells Rutledge, "Early Art Exhibitions of the Maryland Historical Society," *Maryland Historical Magazine* 42 (June 1947): 124–36. On the Allston Association, see Jean Jepson Page, "Notes on the Contributions of Francis Blackwell Mayer and his Family to the Cultural History of Baltimore," *Maryland Historical Magazine* 76 (September 1981), pp. 225–26. See also Latrobe Weston, "Art and Artists in Baltimore," *Maryland Historical Magazine* 33 (September 1938): 213–27.

22. Mignot to Rossiter, 6 July 1859, Rossiter Papers, Archives of American Art, reel D33: 402–3.

23. For a biographical sketch, see Eugene Fauntleroy Cordell, *The Medical Annals of Maryland, 1799–1899* (Baltimore, 1903), p. 464. See William Sener Rusk, ed. "New Rinehart Letters," *Maryland Historical Magazine* 31 (1936), pp. 234, 236, on Keener's activities.

24. William B. Atkinson, *A Biographical Dictionary of Contemporary American Physicians and Surgeons* (Philadelphia: Brinton, 1880).

25. For biographical information, see the sketch in *History of Baltimore*, Henry Elliott Shepherd, ed. (Baltimore: S. B. Nelson, 1898), p. 625; also [author unidentified],

"Success of Century-Old Concern Here Due to a Chance Meeting of Brothers," *Baltimore* 29 (April 1936): 13–17.

26. One turned up in the memorial exhibition of 1876 in London and Brighton: no. 81. *Baltimore. Druid Hill Park, Baltimore* was listed as no. 17 in the 1868 sale in New York (see Appendix), and *Druid Hill Park, Baltimore, Winter* was no. 11 in the sale of 1862 with its dimensions of 16 × 24". No record exists to show that Harris owned a Baltimore view.

27. Edith Rossiter Bevan, "Druid Hill, Country Seat of the Rogers and Buchanan Families," *Maryland Historical Magazine* 44, no. 3 (September 1949): 196.

28. For information on Johnson's portrait and others, see Gerald J. Rose, "The Likenesses of Chapin A. Harris," *Journal of the American College of Dentists* 16 (March 1949): 11–23.

29. The associations are made explicit in an ode recited by school children at the dedication of the park goes as follows: "Cathedrals are there, in the distance / There are ships from remotest seas/ There enterprize garners in triumphs. / But where are there trophies like these? / Lost race of the fierce Susquehanna— / Now unknown but in sounding name— / Lost tribes of the gallant / "Six Nations," / These thickets once harbored your game." Quoted in Becky Mangus, ed., *Druid Hill Park Revisited: A Pictorial Essay* (Baltimore: Friends of Druid Hill Park, 1985), p. 5. I would like to thank James Cooke for his fine assistance with research in Baltimore.

30. See Mangus, *Druid Hill Park Revisited*, pp. 7–10, for the development of the park.

31. Kenneth Maddox, "The Railroad in the Eastern Landscape, 1850–1900," in *The Railroad in the American Landscape, 1850–1950,* Susan Danly Walther, guest curator (Wellesley, Mass.: Wellesley College Museum, 1981), pp. 26–33, summarizes the excursion, which has and continues to receive sufficient attention as to require no further elaboration here.

32. James D. Dilts, who is working on a book based on the artists' work that resulted from the excursion, confirmed my identification of the picture with that event. I would like to express my thanks for his gracious assistance.

33. Worthington Whittredge in his *Autobiography* is one of many who described the pressure he felt to paint American subjects. See John I. H. Baur, ed., *The Autobiography of Worthington Whittredge, 1820–1910* (1942; rpt. New York: Arno Press, 1969).

34. "George Washington at Home," *Home Journal,* 26 November 1859, 2:4.

35. "Fine Arts: Rossiter and Mignot's *Home of Washington after the War,*" *Albion* 37, no. 48 (26 November 1859): 573.

36. William R. Taylor, *Cavalier and Yankee: The Old South and American National Character* (1957; Cambridge, Mass.: Harvard University Press, 1979), pp. 249–53. See also discussion in this volume, chap. 2.

37. Rossiter, *A Description of the Picture of the Home of Washington After the War. Painted by T.P. Rossiter and L.R. Mignot* (New York: D. Appleton and Co., 1859), p. 5.

38. Ibid.

39. Alan Trachtenberg's interpretation of Mathew Brady's *Gallery of Illustrious Americans* (1850), with its pro-Union message, has informed my reading of this picture. See Alan Trachtenberg, *Reading American Photographs: Images as History, Mathew Brady to Walker Evans* (New York: Noonday Press, 1990), chap. 1, "Illustrious Americans," esp. pp. 45–52.

40. Although it was not an uncommon strategy for artistic promotion, the fact that the *Washington* was copied in a mechanically reproduced and mass-distributed print reinforces its political message and intent.

41. It opened almost simultaneously with the National Academy of Design that year, on 19 April. His exhibited works included *The Foray* (painted in collaboration with Ehninger, shown the previous year at the academy and the Washington D.C. Art Association), an *Autumn* (probably also the one shown at the academy in 1857). For a review, see "Pennsylvania Academy of the Fine Arts," *Crayon* 5 (June 1858): 179.

42. See F. W. Beers, *Atlas of Otsego Co., New York* (New York: F. W. Beers, N. D. Ellis, & G. G. Soule, 1868), p. 16; nowhere does this precise designation appear, but Cascade Hill is indicated in District 6, south and west of Three Mile Point.

43. The picture is inscribed at right "Mignot 5[?]" (with the last digit illegible).

44. Shown at the National Academy of Design in 1858. For a discussion of it and the related *In the Andes* (cat. no. 42), see chap. 5.

45. Fidelius, "Art Matters in New York," *Boston Transcript* (29 May 1857): 1.

46. Tuckerman, *Book of the Artists,* p. 563. Although his book was published in 1867, Tuckerman's remarks were based on his acquaintance with Mignot before his departure in July 1862, and therefore relate directly to the period discussed here.

47. *Crayon* 7 (March 1860): 83. *Lamona* can likely be identified with cat. no. 56.

48. "National Academy of Design," *Home Journal* (5 May 1860): 2.

49. Ibid.

50. *Harvest Moon* had originally been paired with the tropical subject *Lamona*; thus, although that pair was broken up, Stuart did end up with North and South American pendants; see note 47, above.

51. Eliza Haldeman to Samuel Haldeman, Philadelphia, 4 February 1860; letter reprinted in Nancy Mowll Mathews, *Cassatt and her Circle. Selected Letters* (New York: Abbeville Press, 1984), pp. 24–25. It is not sure to which painting she refers.

52. For a fine overview that chronicles these changes, see *"A Sweet Foretaste of Heaven": Artists in the White Mountains, 1830–1930,* with essays by Robert L. McGrath and Barbara J. MacAdam (Hanover, N.H.: University Press of New England, 1988).

53. On a visit in February 1856 to the studios in the Art-Union building, a writer for the *Home Journal* reported that "Mignot . . . is painting a large and impressive winter-scene." See "Studies of American Artists, Second Sketch," *Home Journal* (9 February 1856): 1. This is likely the picture subsequently referred to as *Winter in the White Mountains* (1856; 40 × 50⅛"; cat. no. 20), completed and dated later that year. In March 1859 a canvas measuring 40 × 53" and entitled *Winter Scene, New Hampshire*—presumably the same one—was sold at auction for $345. See *Catalogue of a Superb Collection of Pictures by Living Artists of Europe and America* (New York: Leeds, 17 March 1859). Penciled in are sale price and buyer [Armstrong]. The *Crayon* (6 [1859]: 126) records the price as $345. It seems likely, however, that the New Hampshire tag was erroneous, however, for the picture demonstrates strong relationship to the Vassar canvas and others known for certain to have been done in New York State.

54. This work , then in the collection of H. F. Clark, was shown at the Cleveland Sanitary Fair in 1864. Additional mentions of this subject include his *White Mountains* (owned by G. W. Harding), which was shown between May and June 1864 at the Mississippi Sanitary Fair in St. Louis. A work entitled *White Mountain Scenery* was shown at Schaus's Gallery in 1862, which may be identical with either of these works (cited in *The National Museum of American Art's Index to American Art Catalogues: From the Beginning through the 1876 Centennial Year,* comp. James L. Yarnall and William H. Gerdts [Boston: G. K. Hall, 1986], cat. no. 61858). In the highly social artistic circles of North Conway, Mignot's name is largely absent.

55. W.J.S. [William J. Stillman], "Editorial Correspondence," *Crayon* 2 (5 December 1855): 360. The quotation appears in *"A Sweet Foretaste of Heaven,"* p. 28.

56. *Palisades, Hudson* (1862; no. 45; 8 × 13½ ") and *On the Hudson* (Brooking Sale, 1864, no. 88, 8 × 14"); see *R. Brooking Collection Sale*, 28 April 1864, New York City, no. 88 (Archives of American Art, roll N312).

57. "Domestic Art Gossip," *Crayon* 7 (December 1860): 353.

58. It is unclear whether this is the same picture that appeared in the Leeds sale of 1862 as *Falls of the Passaic* (1862; no. 14, 15 × 24").

59. Rutherfurd Stuyvesant also operated Tranquillity Farm in Warren Co., New Jersey.

60. *Passaic Falls* (no. 3; owner: R. Stuyvesant); *On the Passaic* (no. 67; owner: Cyrus Butler) in *Catalogue of the Works of Art Exhibited at the Brooklyn and Long Island Fair in Aid of the U.S. Sanitary Commission.* (Brooklyn: "The Union" Steam Presses, 22 February 1864).

61. *Basin of Passaic Falls* (1862; no. 5; 10 × 15") and *Newark. From the Passaic* (1862; no. 47; 7 × 18").

62. See William H. Gerdts, Jr. *Painting and Sculpture in New Jersey,* The New Jersey Historical Series, vol. 24 (Princeton, N.J.: D. Van Nostrand Col, 1964), pp. 23,

51–52, 55–56, and 75, for general background on pictures of the Passaic.

63. It is in all likelihood the work shown at the National Academy of Design in (March–April; NAD, 1861, no. 313), at the Pennsylvania Academy of the Fine Arts (April–June; PAFA, 1861), and at the Young Men's Association, Buffalo in December 1861–February 1862 (no. 161; $100). Apparently not finding a buyer at any of these locations, it was then placed in the Leeds auction of 1862 (no. 23; 16 × 24"). For a review, see "National Academy of Design," *Crayon* 8 (April 1861): 94.

64. Frank H. Norton, "A Few Notes on the Thirty-Sixth Annual Exhibition of the National Academy of Design, 1861" (pamphlet; New York: William Schaus, 1861), copy, New York Public Library.

65. Cummings, *Historic Annals*, p. 300.

66. Ibid., p. 298.

67. "Personal Items," *Boston Transcript* 26 July 1861, 2:4.

68. Henry Ward Beecher, *Star Papers; or, Experiences of Art and Nature* (New York: J. C. Derby, 1855), p. 181.

69. The Reverend David Dudley Field (1781–1867) was minister of Stockbridge from 1819 to 1837, and after retirement in 1851 returned to live in Stockbridge until his death. A pioneer in local history, he edited and wrote most of the *History of the County of Berkshire* (1829). Cyrus was one of four extraordinary sons: David, a railroad lawyer and legal reformer; Cyrus, the entrepreneur who laid the transatlantic cable; Stephen, justice of the U.S. Supreme Court; and Henry, author and liberal Presbyterian reformer. Cyrus Field or Church may have acted in some capacity as sponsors of Mignot's visit.

70. Unsigned letter from Stockbridge, dated 13 August 1859, *Crayon* 6 (1859): 286–87.

71. Letter to the author from Laurie Werner of the Berkshire County Historical Society, 8 June 1995.

72. The most complete account of visual artists in the area is Maureen Johnson Hickey and William T. Oedel, *A Return to Arcadia: Nineteenth-Century Berkshire County Landscapes* (Pittsfield, Mass.: Berkshire Museum, 1990), from which this information is summarized.

73. The auction offered studies from nature as well as finished paintings; but given that at least 9 out of 47 entries depict some aspect of the Berkshires, this subject represents 20 percent of works on sale. It is possible that, anticipating the sale, he rushed to complete a number of new pictures of this recent addition to his oeuvre.

74. "Literature and Art," *Home Journal* (3 August 1861): 3. Whether the intended engraving was ever made remains unclear.

75. Ibid.

76. *The Berkshire Reader: Writings from New England's Secluded Paradise* (Stockbridge, Mass.: Berkshire House, 1992), p. 180.

77. Nathaniel Hawthorne, journal extracts, 19 August 1850; quoted in *Berkshire Reader,* p. 195.

78. *On the Housatonic* (no. 292; Boston Athenaeum, 1862). *On the Housatonic* (Young Men's Association, Buffalo, 1861; no. 65; $100). A picture with the title *A Cool Evening. Housatonic* that appeared in the auction of 1862 (no. 37; 16 × 26") may be the same picture.

79. The line appears in "The Autocrat of the Breakfast Table." In 1849 Holmes built a summer villa at Canoe Meadows, the 280-acre farm that was the remnant of the Wendell family land holdings in the Berkshires. There he spent "seven happy summers," eventually selling the place because the upkeep was too expensive. See *Berkshire Reader,* p. 169.

80. Information kindly supplied by Pauline Pierce of the Stockbridge Library Association.

81. No. 28 in the 1876 catalogue; it is possible that the picture remained unsold before his departure and traveled with him to England. Conceivably, the title could refer to another version of this work redone in London, as Mignot was known to do close copies of popular subjects. There seems little doubt, however, that this title describes this scene, which means that Mignot probably revisited the area during the winter months; but easy access from New York City would not have precluded that probability.

82. James Collins Moore, *The Storm and the Harvest: The Image of Nature in Mid-Nineteenth Century American Landscape Art* (Ph.D. diss., Indiana University, 1974; U.M.I. rpt., 1994), pp. 174–77, summarizes the attractions of Lake George and its depiction by painters.

83. The quotation is from Tom Taylor's description of a work entitled *Indian Summer, Lake George* that had been purchased, according to him, from the sale of pictures held in 1862 by Mr. Egerton of Baltimore. It may correspond to cat. no. 67, although without additional information it is impossible to be certain. See Taylor, "Sketch of the Life," p. 4. Additional titles include *Lake George* (1862; no. 1; 7 × [omitted]") and *October in the Adirondacks* (White Sale, 1867; no. 121)

84. W.J.S., "Editorial Correspondence," 360.

85. James Fenimore Cooper, *The Last of the Mohicans* (1826; New York: Hurd and Houghton, 1876), p. 161.

86. "The Niagara," [London] *Art Journal* 28 (1 August 1866): 259.

87. Letter from Cole to Gilmor, 26 April 1829; quoted in Jeremy Elwell Adamson, *Niagara: Two Centuries of Changing Attitudes, 1697–1901* (Washington, D.C.: Corcoran Gallery of Art, 1985), p. 48.

7 . THE CONFEDERATE PAINTER IN VICTORIAN BRITAIN

1. These points are summarized in Christopher Newall, *The Grosvenor Gallery Exhibitions: Change and Continuity in the Victorian art world* (Cambridge: Cambridge University Press, 1995), pp. 3–4.

2. Passenger lists for *The Great Eastern* list only Louis Mignot, with no accompanying family members, suggesting that perhaps his wife and mother-in-law actually preceded him there, while he arranged for the sale of his pictures and other details in New York.

3. Angela Miller, *Empire of the Eye,* p. 239.

4. A classic study on the subject remains Ephraim Douglass Adams, *Great Britain and the American Civil War* (New York: Russell & Russell, 1958).

5. Brian N. Morton, *Americans in London* (New York: Quill edition, William Morrow, 1986), pp. 170–71.

6. Richard Dormont and Margaret F. MacDonald, *James McNeill Whistler* (New York: M. N. Abrams, 1995), p. 307.

7. Quoted in Barbara Novak, Introduction to *Nineteenth-Century American Painting: The Thyssen-Bornemisza Collection* (New York: Vendome Press, 1986), p. 13.

8. *Cassell's Illustrated Family Paper Exhibitor; containing about 300 illustrations of all the Principal Objects of the International Exhibition of 1862* (London: Cassell's, 1862) is a good general source; see p. 174 on Cropsey. The exhibition opened in May; 1 November was officially its last day. The American showing was small. It was reported that "the American Fine-Art display is small, numbering about a dozen pictures and engravings, the chief of which is Mr. Cropsey's *Autumn on the Hudson.*" Primary attention was focused on the British School of Painters, with a modest Foreign Division. Mignot's work was included posthumously in the London International Exhibition of 1872.

9. "Fine Arts: Royal Academy," *Athenaeum* 1856 (23 May 1863): 687.

10. From a review of the British Institution exhibition that originally appeared in the *Athenaeum* 14 February, quoted in *Albion* 41 (7 March 1863): 117. Since the identity of this picture is unclear, it cannot be determined whether he submitted this work to both the British Institution and the Royal Academy. Comparison between the published descriptions suggests a close similarity: "This artist shows like ability in a theme the reverse of the last, a snow-piece, *A Winter Morning* (677), snow upon a level piece of land with trees behind. The sky is grey and warm with the colour of a second fall to come. Some water, in the foreground, is truly painted of a warm colour, as contrasted with the snow about it." ("Fine Arts: Royal Academy," *Athenaeum* 1856 [23 May 1863]: 687). It seems inappropriate, however, to show an already exhibited work at the Royal Academy; more likely, it

was of a similar subject, varied according to the time of day and therefore the coloristic handling.

11. "Fine Arts: Royal Academy," *Athenaeum* 1856 (23 May 1863): 687.

12. The title of the picture, on record in the curatorial files, appears on an earlier frame for the picture discovered in the collection of the Metropolitan Museum of Art. For an elaboration of these details, see my entry in *American Paradise: The World of the Hudson River School,* introduction by John K. Howat (New York: Metropolitan Museum of Art, 1987), pp. 298–301.

13. Close examination has revealed an inscription at the lower left: "M/63 [?]." When I had published the picture previously I had not been allowed to examine it closely, and therefore had missed the inscription. William Gerdts, who should be given the credit for recognizing the merit of this picture, published it in his *Revealed Masters: 19th Century American Art* (New York: American Federation of Arts, 1974); no inscription is mentioned there.

14. Although undated, it is inscribed on the stretcher "Louis R. Mignot, Berkely Gardens, Kensington W." Since this address matches that provided in the British Institution annual exhibition catalogue for 1863 (the address changed in 1864), the picture falls into that year's production. See Algernon Graves, *The British Institution, 1806–1867* (London: George Bell and Sons, 1908), p. 378.

15. "Fine Arts. Exhibition of the Royal Academy. The Landscapes, & c." *Illustrated London News* 44 (26 May 1864): 518–19.

16. *Cornhill Magazine* (London) 2 (1865): 291 was included in this quotation from Ann Bermingham, *Landscape and Ideology. The English Rustic Tradition, 1740–1860* (Berkeley and Los Angeles: University of California Press, 1986), p. 157.

17. W. M. Rossetti, "Art-Exhibitions in London," *Fine Arts Quarterly Review* (London) 2 (May 1864): 311. The other two landscapists noticed were Elijah Walton and George Sant.

18. 1868 catalogue, no. 28. The Isle of Jersey is located in the group of Channel Islands just west of Cherbourg, France. This is the only reference to a work by Mignot of this location.

19. The sketch was listed in the 1876 catalogue, no. 49. The watercolor was listed in the catalogue for the New York sale of 1868, no. 4. Perhaps it was a study for the painting *St. Paul's* (1876 catalogue; no. 100).

20. One such work, *Pilgrim's Progress,* appeared in the memorial exhibition, no. 65. In this he resembled many American artists who looked to the seventeenth-century English author and preacher.

21. For a useful discussion, see Drew Faust, *A Sacred Circle: The Dilemma of the Intellectual in the Old South, 1840–1860* (Baltimore: Johns Hopkins University Press, 1977).

22. They were listed as *Incense-Breathing Morn—Gray's Elegy* (1868 catalogue; no. 43) and *Incense-Breathing Morn—In the Tropics* (1876 catalogue; no. 46).

23. Graves, *British Institution,* p. 378. The painting was listed as no. 471, selling price £150. *Childe "Harolds" Pilgrimage—watercolor* was offered in the New York auction of 1868, no. 1, another instance of his interest in Byron. Identification of this painting with the one in the 1867 exhibition at the British Institution is based on lengthy description in two reviews. "Mr. Mignot combines in a remarkable degree artistic force with delicacy in No. 471, which is primarily a 'skyscape,' the landscape being a low, level, uninteresting swamp, occupying but a small portion of the canvas. Probably the picture records the glories of sunset in equatorial America; the vast canopy overhead is one multitudinous mass of clouds still burning in the roseate and many hued splendor of a sun just sunk below the horizon." ("Fine Arts: The British Institution," *Illustrated London News* 53 [9 Feb. 1867]: 143.) "This gallery has long been conspicuous for ambitious landscapes which make a display scarcely justified by intrinsic merit. This year the sins against retiring modesty are scarcely so flagrant as they have been. L.H. Mignot has set his canvas in a blaze by contact with a tropical sun. There is, however, method in the artist's madness. Parting day here dies like the dolphin, with colours new and strange in each expiring gasp: greens, reds, yellows, blues, stare each other out of countenance. The attempt is bold, yet not without success. No small management was needed to preserve pictorial propriety." ("British Institution: Exhibition of Works by Living Artists," *Art-Journal* (London) 29 [1 Mar. 1867]: 86.) The painting's large size (38 × 59") argues for its being an exhibition piece.

24. Lord Byron, *The Complete Poetical Works,* ed. Jerome J. McGann (Oxford: Clarendon Press, 1980), 2:134.

25. "Fine Arts: The British Institution," *Illustrated London News* 53 (9 February 1867): 143. Italics mine.

26. Ibid.

27. "British Institution: Exhibition of Works by Living Artists," *Art-Journal* (London) 29 (1 March 1867): 86.

28. Quoted in Novak, *American Painting of the Nineteenth Century,* pp. 248–49. The remarks were made in the context of the Whistler-Ruskin trial of 1878.

29. "The Rime of the Ancient Mariner," *Illustrated London News* 68 (15 January 1876): 59.

30. They include *A Painted Ship Upon a Painted Ocean—Ancient Mariner* (1868; no. 15); and *Painted Ship Upon a Painted Ocean* (no. 417; 15 × 12"). *The Collection of Over Five Hundred Paintings and Studies by the Late John F. Kensett* (New York: National Academy of Design and Robert Somerville, Auctioneer, 24–29 March 1873). It is perhaps worth reminding ourselves that fellow South Carolinian Washington Allston and Coleridge were friends.

31. Two citations to titles of works by Mignot include: *St. Agnes Eve* (no. 35 in 1876 memorial catalogue) and *St. Agnes Eve-watercolor* (no. 2 in 1868 catalogue, New York City). Although it is possible that the two citations refer to the same work, it seems more likely that the watercolor, sent to New York City, remained there.

Generally, titles in the memorial catalogue referred to finished oil paintings, unless otherwise specified.

32. See John Keats, *Complete Poems*, ed. Jack Stillinger (Cambridge, Mass.: Belknap Press of Harvard University Press, 1982), pp. 229–39.

33. "Fine Arts: Exhibition of the Royal Academy," *Illustrated London News* 42 (9 May 1863): 518.

34. For the complete text, see Tennyson, *Young Folk's Library of Choice Literature* (Boston: Educational Publishing, 1894), pp. 3–32.

35. "Illustrated Books for Christmas," *Illustrated London News* 47 (December 1865): 608.

36. Henry Adams et al., *John La Farge* (New York: Abbeville Press, 1987), pp. 132, 36.

37. See *A Ship-Wrecked Sailor Waiting for a Sail—Enoch Arden* (no. 21 in sale of 1868) along with *And Glories of the Broad Belt of the World* (no. 41 in 1868 catalogue).

38. In the memorial catalogue *Farm View in Warwickshire* was item no. 4. *Sunny Afternoon, Warwickshire* appeared at the British Institution exhibition of 1865, no. 69, for sale for 70 pounds.

39. "Fine Art: Exhibition of the British Institution (Second and Concluding Notice)," *Illustrated London News* 46 (18 February 1865): 166. This was a portion of an extensive notice of all three of Mignot's entries, all the more noteworthy because most other landscapes in the exhibition were mentioned only in passing.

40. Information summarized in *English Heritage Properties: 1994 Guide* (London: English Heritage, 1994), pp. 145–46.

41. It was no. 97 in the memorial exhibition.

42. They were included in the memorial exhibition with the following item numbers: *Storm over Kenilworth Castle* (13); *Kenilworth from the Brook* (45); *Banqueting Hall, Kenilworth* (16). The watercolor *Leicester's Window, Kenilworth* may have been paired with another watercolor of a window, the *Tintern, East Window*, both of which were sent to New York for auction in 1868 (nos. 5 and 7 respectively in the sale).

43. Walter Scott, *Kenilworth: A Romance*, ed. J. H. Alexander (1821; Edinburgh University Press, 1993).

44. Originally published c. 1865, *Kenilworth and its Castle Illustrated* is a series of lithograph drawings by John Brandard with descriptive letterpress by H.T. Cooke, including illustrations of "Kenilworth Castle from the Banks of the Lake" and "The Great Hall, Kenilworth Castle, in 1575," which may have inspired the views by Mignot. It was reprinted in a facsimile edition: John H. Drew, *Kenilworth Castle Illustrated* (Buckingham: Barracuda Books, 1982).

45. The titles from the memorial exhibition catalogue include *Holly Cottage, Warwickshire* (no. 10); *Holly Cottage, Warwickshire* (no. 82); *Bouquet from Holly Cottage* (no. 43), and *Desolation* (no. 120) *Desolation* had earlier appeared in the British Institution exhibition for 1866, no. 494, for sale for 200 pounds.

46. See Griselda Pollock, *Mary Cassatt* (London: Jupiter Books, 1980).

47. Patricia Hills, *John Singer Sargent* (New York: Whitney Museum Of American Art, 1986).

48. Joseph D. Ketner, *The Emergence of the African-American Artist: Robert S. Duncanson, 1821–1872* (Columbia: University of Missouri Press, 1993), and David M. Lubin, *Picturing a Nation: Art and Social Change in Nineteenth-Century America* (New Haven, Conn.: Yale University Press, 1994).

49. William C. Davis, "Confederate Exiles," *American History Illustrated* 5 (June 1970): 40.

50. "Art Notes," *New York Albion* (28 May 1870).

51. "Fine Arts: British Institution," *Illustrated London News* 48 (17 February 1866): 166.

52. "Fine Arts: The Mignot Collection," *Illustrated London News* 68 (17 June 1876): 598.

53. "Fine Arts: British Institution," *Illustrated London News* 48 (17 February 1866): 166.

54. *Art, Commerce, Scholarship: A Window onto the Art World—Colnaghi, 1760 to 1984* (London: P. & D. Colnaghi, 1984), p. 19.

55. "The Niagara," *Art-Journal* (London) 28 (1 August 1866): 259. *Niagara* has recently been conserved and reframed with the support of the Henry Luce Foundation.

56. The following remarks presumably apply to this image: "Another—a picture of Table Rock—not entirely finished, is a masterly sketch." See "Art Items," *Daily Evening Bulletin* (San Francisco), 11 May 1872, sup. 1:6.

57. Jeremy Elwell Adamson, *Niagara: Two Centuries of Changing Attitudes, 1697–1901* (Washington, D.C.: Corcoran Gallery of Art, 1985), p. 70.

58. Novak, *Nineteenth-Century American Painting*, p. 13.

59. For additional information on Magoon, see my review "The Elias Magoon Collection," *Arts Magazine* 55 (September 1980): 12.

60. Among all Ruskin's voluminous and well-documented correspondence and other writings, Mignot's name does not appear once.

61. *Birket Foster's Pictures of English Landscape* (Engraved by the Brothers Dalziel) w/ Pictures in Words by Tom Taylor (London: Routledge, Warne, and Routledge, 1863).

62. Alfred T. Story, *The Life of John Linnell* (London: Richard Bentley and Son, 1892), 2: 200.

63. Taylor, "Sketch of the Artist's Life," p. 5.

64. Tuckerman, *Book of the Artists*, p. 564. Strawberry Hill is now St. Mary's Training College, Strawberry Hill, Twickenham, Middlesex. Efforts to locate works by Mignot either through the college or through descendants of the residents have so far proved futile.

65. *On the Thames Near Twickenham* was no. 11 in the auction sale of 1868.

66. A painting with that (erroneous) title was exhibited in Brighton in 1875. For review of a small selection of his collection, see *Athenaeum* (27 May 1905): 664.

67. For thoughtful treatments of British art patronage in this period, see Dianne Sachko Macleod, "Art Collecting and Victorian Middle-Class Taste," *Art History* 10 (September 1987): 328–50; and *Pre-Raphaelites: Painters and Patrons in the North East* (Newcastle upon Tyne: Laing Art Gallery, 1989).

68. Novak, *Nineteenth-Century American Painting*, p. 13.

69. "The Mignot Pictures," *Pall Mall Gazette* 24 (12 October 1876): 9.

70. "Fine Arts," *Illustrated London News* 68 (10 June 1876): 559.

71. "Fine Arts: British Institution," *Illustrated London News* 48 (17 February 1866): 166.

72. "Fine Arts: The Mignot Collection," *Illustrated London News* 68 (17 June 1876): 598. His distinction between the tasteful connoisseurs and the vulgar masses raises intriguing questions about the class composition of the British art-going public at that moment, which are largely beyond the scope of this essay.

8. CONTINENTAL AMBITIONS

1. *The Diary of George A. Lucas, 1857–1909,* transcribed and with introduction by Lilian M. C. Randall (Princeton: Princeton University Press, 1979), p. 236.

2. For an insightful summary of these stages, see: Dianne Sachko Macleod, "Art Collecting and Victorian Middle-Class Taste," *Art History* 10 (September 1987): 328–50.

3. *Diary of George A. Lucas,* p. 236.

4. Joseph Pennell Papers, Library of Congress. Whistler to George Lucas, postmarked from 2 Lindsay Row, Old Battersea Bridge, Chelsea, 12 December 1867. Thanks to Nicolai Cikovsky Jr. for sharing this reference.

5. *Silver and Gold* appeared as no. 20 in the auction catalogue of 1868.

6. Tuckerman, *Book of the Artists,* p. 564. The full title on the cover of the auction catalogue of 1862 had made specific mention of the Indian destination at the time of Mignot's departure, presumably reported by the artist himself: *Catalogue of a Choice Collection of Paintings, and Studies from Nature, painted by Louis R. Mignot, who is about leaving for Europe and India* (New York: Henry H. Leeds, 1862).

7. Taylor, "Sketch of the Life," p. 4.

8. Karl Baedeker, *Switzerland, and the Adjacent Portions of Italy, Savoy, and the Tyrol: Handbook for Travellers* (Coblenz: Karl Baedecker, 1869); route 29 is on pp. 98–128. Although no records have come to light to date to indicate the contents of Mignot's library, this was one of the most commonly used guides of the period, and undoubtedly contains the kind of information to which he would have had access.

9. Ibid., p. 115.

10. The titles of Mignot's pictures appear as follows in the 1876 catalogue: *Jung Frau, Descending to Lauterbrunen (Study)* (no. 77); *Jung Frau, from the Wingern Alp* (no. 2); *JungFrau, Sunset, Study from Nature* (no. 40); *Jung Frau, Morning (taken from Muhren)* (no. 85); *Jung Frau, Evening* (no. 87); *The Wetterhorn, Switzerland* (no. 30); *Valley of Meringen, Switzerland* (no. 36); and *Rosenlaui Glacier—Sketch* (no. 42). See Appendix.

11. Baedeker, *Switzerland,* p. 124.

12. They appeared in the memorial exhibition of 1876 with the following catalogue numbers: *Lake of Lucerne* (117); *Lake of Lucerne, Mount Pilatus—Sketch* (12); *At Fluelen, Switzerland* (52); *Uri Rothstock* (74); *Lake of Lucerne, Sketches on Same Canvas* (93–94); *Sunset on Lake Lucerne* (95); and *Lake of Lucerne, with the Rigi* (29).

13. They appeared in the memorial exhibition of 1876 with the following catalogue numbers: *Swiss Mountains* (24); *Swiss View—Sketch* (7); and *Swiss View* (96).

14. Baedeker, *Switzerland,* pp. 63–64.

15. Simon Schama, *Landscape and Memory* (New York: Alfred A. Knopf, 1995), p. 494.

16. "An Englishman Abroad," *Practical Swiss Guide: Red Book for Switzerland, the Adjoining Districts of Savoy, Piedmont, North Italy* (London: Simpkin, Marshall, and Co, 1869), p. 82.

17. The phrase, used by members of the Alpine Club, is discussed in Schama, *Landscape and Memory,* p. 502.

18. Edward Whymper, *Scrambles Amongst the Alps in the Years 1860–69* (1871; London: John Murray, 1900). Whymper later went on to explore the Andes.

19. Ronald William Clark, *The Victorian Mountaineers* (London, 1953), p. 61; quoted in Schama, *Landscape and Memory,* p. 504.

20. For details of Queen Victoria's Swiss travels, see David Duff, *Victoria Travels: Journeys of Queen Victoria between 1830 and 1900, with Extracts from Her Journal* (New York: Taplinger Co., 1971), pp. 208–18.

21. From a pamphlet furnished by the Richard Wagner Museum, Lucerne (Spring 1994).

22. It subsequently appeared for sale in World's Industrial and Cotton Centennial Exposition, New Orleans, which opened on 15 February 1884: "13. *Lake of Lucerne with the Rigi* loaned by H. J. Fairchild, Esq., Manchester, England. For sale."

23. For background, see William Hauptman, "Charles Gleyre and the Swiss Fine Arts Section of the Exposition Universel of 1867," in *Zeitschrift für Schweizerische Archäologie und Kunstgeschichte* 43, 4 (1986): 368–70.

24. On Josef Zelger (1812–85), see *Kunstmuseum Luzern Sammlungskatalog: Gemalde vom 15. bis 20. Jahrhundert,* ed. Tina Grutter and Martin Kunz (Luzern: Kunst-

museum, 1983), pp. 72–73, including illustration of his work. On the more interesting Robert Zünd (1827–1909), see ibid, pp. 66–73.

25. "Opinions of the Press," *Catalogue of the Mignot Collection,* p. 23.

26. Ibid., pp. 21–22.

27. "The Mignot Pictures in the Masonic Room, Royal Pavilion (Second Notice), *Brighton Gazette,* 30 September 1876.

28. "Paintings by Louis R. Mignot," *New York Times,* 7 May 1887, p. 5. This may account for why so few of these works have been unidentified: they are barely distinguishable from the myriad works done of these subjects. In fact, Mignot's one known Swiss painting first came to my attention as a work by an unidentified German painter "M."

29. Ruskin, *Modern Painters* (Boston, 1876) 4:133–34; quoted in Schama, *Landscape and Memory,* p. 513.

30. Enregistrement du cartes d'artistes [Register of Artists Cards], Archives du Louvre. The records are incomplete and vary in their format over the course of time they were kept. Under the permissions for 1868 (listed by year only) was entered "1868 Mignot, no. 87." During the period 1866–69 the books are arranged alphabetically, which means that checking whose name was before and after him would not be any indication of people he was with. My thanks to the staff in the archives for assistance with the records.

31. Mention of Mignot is made on and off by Lucas between 15 November 1869 and 30 June 1870, when Lucas departed Paris; see *Diary of George A. Lucas,* pp. 308–9, 311, 313, 314, 323–27.

32. Titles appeared in the 1868 auction catalogue, nos. 36 and 44.

33. *Le Guide du Patrimone Paris* (Paris: Hachette, 1994), p. 139.

34. For Hôtel de Burgogne, see *Paris: Le Guide du Patrimoine* (Paris: Hachette, 1994). For a fine analysis of the rise of interest in the documentation and restoration of such structures, although with no specific reference to this one, see David Van Zanten, *Building Paris: Architectural Institutions and the Transformation of the French Capital, 1830–1870* (Cambridge: Cambridge University Press, 1994), esp. chap. 7, "Churches and Historic Monuments."

35. William C. Davis, "Confederate Exiles," *American History Illustrated* 5 (June 1970): 38–40.

36. This is not one of the buildings where artists regularly had their studios in this period, according to the records of Madeleine Beaufort, whose assistance while I was on a research trip to Paris in the spring of 1994 is gratefully acknowledged.

37. *Explication des ouvrages de peinture, sculpture, architecture, gravure et lithographie des artistes vivants* (Paris: Salon, 1870), no. 1981. Once more the pictures lack secure identification. Perhaps the winter scene was identical with the *Hoar Frost, Richmond* submitted by Mrs. Harris to the London International Exhibition in 1872.

38. A perusal of a substantial number of salon reviews catalogued in the Bibliothèque Nationale de France turned up no reviews or descriptions of these works, nor were any dimensions provided.

39. "Art Items," *Daily Evening Bulletin* (San Francisco), 11 May 1872, sup. 1:6.

40. William Howe Downes, *Dictionary of American Biography,* 12: 610.

41. Puzzled by why Mignot crossed the channel here instead of the more usual Folkstone-Calais crossing, I did find one source that offers some explanation. An unidentified nineteenth-century clipping states that steam vessels sail from Brighton to Dieppe, whence the route to Paris is not only 90 miles shorter than that from Calais, but passes through Rouen and a finer part of the country. From "A Collection of Newspaper Articles, Extracts from Magazines, Pamphlets and Advertisements, Portraits, Views, Pictures, and other illustrations relating to Brighton, Sussex," Public Library, Brighton, England.

42. "Obituary: Louis Henry [sic] Mignot," *Art Journal* (London) 10 (1 January 1871): 6. The detailed account provided here strongly suggests an intimate source, most likely the widow.

43. Death certificate, 22 September 1870. Registration district of Brighton, subdistrict of St. Peter in the County of Sussex. The cause of death was listed as variola, a term for the family of diseases to which smallpox belongs. On his death certificate, however, two additional mysteries appear. Under the column designated "Signature, description, and resident information" appears: "X- The mark of Ann Farley present at the death. Hospital, Brighton." The identity of the witness remains unknown. Under the column designed "Occupation" is entered: "Gentleman." Mignot was buried in section R52, no. 22, in the Brighton Cemetery, Woodvale. There is no memorial on the grave. Information on the grave supplied by Alan Virgo of the Cemeteries and Crematorium Office, Woodvale Lodge, Brighton.

Selected Bibliography

BOOKS AND ARTICLES

American Paradise. The World of the Hudson River School. Introduction by John K. Howat. New York: Metropolitan Museum of Art, 1987.

[Benjamin, Samuel G. W.], "Fifty Years of American Art, 1828–1878," in *Harper's New Monthly Magazine* 59 (July 1879): 256–57. An almost identical passage appears in his *Art in America: A Critical and Historical Sketch*. New York: Harper and Brothers, 1880.

Catalogue of a Choice Collection of Paintings and Studies from Nature Painted by Louis R. Mignot . New York: Henry H. Leeds & Co., 2 June 1862.

Catalogue of the Mignot Pictures with Sketch of the Artist's Life by Tom Taylor, Esq., and Opinions of the Press . 25 Old Bond Street, London, and The Pavilion, Brighton, 1876.

Catalogue: Special Sale of Fine Oil Paintings Including the Collection of the well-known American Artist, Mr. L.R. Mignot, Now in London, comprising some of his latest and best Works . New York: Henry H. Leeds & Miner, 29 and 30 May 1868.

Gerdts, William H., Jr. *Revealed Masters: 19th Century American Art*. New York: American Federation of Arts, 1974.

Manthorne, Katherine Emma. *Tropical Renaissance: North American Artists Exploring Latin America, 1839–1879* . Washington, D.C.: Smithsonian Institution Press, 1989.

Manthorne, Katherine E. "On the Road: Louis Rémy Mignot 's *Landscape in Ecuador*." *North Carolina Museum of Art Bulletin* 16 (1993): 14–30.

Miller, Angela. *The Empire of the Eye: Landscape Representation and American Cultural Politics, 1825–1875* . Ithaca: Cornell University Press, 1993.

Miller, David, ed. *American Iconology: New Approaches to Nineteenth Century American Art and Literature* . New Haven: Yale University Press, 1993.

O'Leary, Jean. "Louis Rémy Mignot: Nineteenth-Century American Landscapist." Unpublished Research Paper, Columbia University, 1978.

Nevins, Allan, and Milton Halsey Thomas, eds. *The Diary of George Templeton Strong*. Vol. 2 (1850–59). New York: Octagon Books, 1974.

Novak, Barbara. *Nineteenth-Century American Painting: The Thyssen-Bornemisza Collection*. London: Philip Wilson Publishers, 1986.

Novak, Barbara, ed. *Next to Nature: Landscape Paintings from the National Academy of Design*. New York: National Academy of Design, 1980.

Randall, Lillian M. C., ed. *The Diary of George A. Lucas: An American Art Agent in Paris, 1857–1909*. Vol. 2. Princeton, N.J.: Princeton University Press, 1979.

Rossiter, T[homas] P. *A Description of the Picture of the Home of Washington After the War. Painted by T.P. Rossiter and L.R. Mignot*. New York: D. Appleton and Co., 1859.

Schama, Simon, *Landscape and Memory*. New York: Alfred A. Knopf, 1995.

Spassky, Natalie. *American Paintings in the Metropolitan Museum of Art*. Vol. 2. New York: Metropolitan Museum of Art, 1985.

Stampp, Kenneth M. *America in 1857: A Nation on the Brink*. New York and Oxford: Oxford University Press, 1990.

Stein, Roger B., *Susquehanna: Images of the Settled Landscape*. Binghamton, N.Y.: Roberson Center for the Arts and Sciences, 1981.

Tuckerman, Henry T. *Book of the Artists* . New York: G. P. Putnam & Son, 1867.

Walther, Susan Danly, guest curator. *The Railroad in the American Landscape, 1850–1950*. Wellesley, Mass.: Wellesley College, 1981.

MANUSCRIPT COLLECTIONS

American Art-Union Papers, New-York Historical Society.

Church, Frederic. Library, letters, diaries, and papers. Olana State Historic Site. Taconic State Park Region, Hudson, New York.

Cropsey, Jasper F. Archives. Newington-Cropsey Foundation. Hastings-on-Hudson, New York.

Duveen, Albert. Collection. Archives of American Art, Reel DDU1.

Hart, Charles Henry. Autograph Collection. Archives of American Art, Reel D5.

Mignot Family Collection, Eindhoven, the Netherlands.

Rossiter, Thomas P. Papers, Archives of American Art, Reel D33.

Sadik, Marvin. Collection. Falmouth, Maine.

South Carolina Dept. of Archives and History, Columbia.

South Carolina Historical Society, Charleston

St. Mary's Church, Parish Records, Charleston

Index